MEDITATIONS
ON THE LIFE OF CHRIST

—

An Illustrated Manuscript of the
Fourteenth Century

Princeton Monographs
in Art and Archaeology
XXXV

INDEX OF CHRISTIAN ART
Published for the
Department of Art and Archaeology
Princeton University

Meditations
on the Life of Christ

AN ILLUSTRATED MANUSCRIPT

OF

To the Memory of
Charles Rufus Morey

CONTENTS

ILLUSTRATIONS

xviii

For list of pictures planned but not executed see pp. 447ff.

INTRODUCTION

Ms. ITAL. 115 in the Bibliothèque Nationale, Paris,[1] is a copiously illustrated fourteenth century Italian manuscript of the famous *Meditations on the Life of Christ*, a text at one time attributed to Saint Bonaventura.[2]

[1] Léopold Delisle, *Le cabinet des manuscrits de la Bibliothèque impériale*, Paris, 1874, p. 304, notes for the year 1855 "acquisition d'un manuscrit italien du XIVe siècle orné de dessins fort remarquables (no. 115 du fonds italien)." See also G. Raynaud, *Inventaire des manuscrits italiens de la Bibliothèque nationale qui ne figurent pas dans le catalogue de Marsand,* Paris, 1882, p. 8, "115, Méditations sur la vie de Jésus-Christ—XIVe s. (suppl. fr. 5139); nombreuses miniatures, dont plusieurs inachevées"; and Giuseppe Mazzatinti, *Inventario dei manoscritti italiani delle biblioteche di Francia,* Rome, I, 1886, p. 15, "115 (Suppl. fr. 5139; Sec. XIV) 'Meditatione de la uita del nostro Signore y.ᵘ x.°' (con molte e finissime miniat. fino a f. 74: nel resto del Cod. le figure sono semplicemente delineata a penna)."

According to information from M. Jean Porcher, Ms. ital. 115 was bought by the Bibliothèque Nationale on August 22, 1855, from the dealer Benjamin Duprat, for 2,070 francs. Its previous history is unknown, but in 1853 it was still in Italy, where it was copied by hand by Police Inspector Leopoldo Cecchi in Pisa. (This copy is now in the Vatican Library, Ms. Ferraioli 423; see pp. 352f. of the article by Vaccari cited below in this note.)

It is written on paper measuring 305 mm. by 210 mm. (ca. 12 × 8¼ in.). Two hundred and six folios survive, in a modern binding. The original foliation appears on the upper corner of each verso; a later hand has numbered the recto pages as well. There is no title on the manuscript itself. The last quarter of the manuscript is missing. The first and last pages are stained and the edges here and in other places are torn and sometimes mended. There are 193 pen drawings, 113 of which are finished with color washes. The ink is brown; the colors are mainly brown, blue, yellow, green, and rose. Spaces for 104 illustrations are left blank. For descriptions of the watermarks, prickings, gatherings, and other technical details, see the article by Dalbanne cited below in this note.

The manuscript was exhibited in 1926 (*Catalogue de l'exposition du livre italien,* Paris, Bibliothèque Nationale, 1926, p. 4, no. 31) but has been mentioned only rarely in art historical literature. The main references are as follows: Claude Dalbanne, "Un manuscrit italien des 'Meditationes vitae Christi' à la Bibliothèque nationale," *Les Trésors des bibliothèques de France,* III, 1930, pp. 51–60, giving a useful physical description of the manuscript and reproducing 14 pictures (pls. xxv–xxxviii), four in color; and Hans Wentzel, "Maria mit dem Jesusknaben an der Hand, ein seltenes deutsches Bildmotif," *Zeitschrift des deutschen Vereins für Kunstwissenschaft,* IX, 1942, pp. 248f., with four illustrations from our manuscript (figs. 52–54) among the other examples of the motif studied.

Ms. ital. 115 is discussed from the textual point of view by Alberto Vaccari, "Le 'Meditazioni della vita di Cristo' in volgare," *Scritti di erudizione e di filologia,* I, 1952, pp. 353f., 358ff.; and C. Fischer, "Die 'Meditationes vitae Christi,' ihre handschriftliche Überlieferung u. die Verfasserfrage," *Archivum franciscanum historicum,* XXV, 1932, p. 185, in whose list it is no. 155.

[2] The *Meditations,* given to Bonaventura and published among his works until the eighteenth century, continued to appear in the final volume of the complete

This popular text, dating from the end of the thirteenth century, has been called "a life of Christ, a biography of the Blessed Virgin, the fifth gospel, the last of the apocrypha, one of the masterpieces of Franciscan literature, a summary of medieval spirituality, a religious handbook of contemplation, a manual of christian iconography, one of the chief sources of the mystery plays." [3] It relates the story of Christ in chronological order, beginning with God's plan for the redemption of the world and ending with the mission of the Holy Spirit after Christ's Ascension. The narrative section of the *Meditations* introduces many details, even many whole episodes, not in the Gospels, so that we may learn here, for instance, that Christ preferred His mother's cooking to angelic fare. Also included are long homilies on Franciscan virtues, and exhortations to the reader to meditate upon the events narrated. The simple style and tender sentiments of the narrative part of the text and the inspiration of the sermonizing sections led to the rapid, wide diffusion of the work throughout Europe. Many copies, in many languages and versions, were made: most of the translations into vulgar tongues, however, are abbreviated with respect to the original. [4]

Among the numerous copies, Ms. ital. 115, hitherto un-

works of the saint even after the author was reduced to an unknown "Pseudo"-Bonaventura. Several suggestions as to authorship have been advanced, none convincing enough to end conjecture. Modern scholars agree, however, that the author must have been a Franciscan monk living in Tuscany during the second half of the thirteenth century. For a discussion of the problem of authorship (as well as of the sources of the text), see Livario Oliger, "Le *Meditationes vitae Christi* del Pseudo-Bonaventura," *Studi Francescani,* n.s., vii, 1921, pp. 143–183, viii, 1922, pp. 18–47; also Fischer, *op. cit.,* pp. 3–35, 175–209, 305–348, 449–483.

[3] *Smaointe Beatha Chríost,* ed. Cainneach Ó Maonaigh, Dublin, 1944, pp. 325f.

[4] Fischer, *op. cit.,* was the first to identify three forms of the text: a long one (the "grosse Text"); a short one (omitting parts of the section on the public life of Christ and all on the contemplative and active lives); and one consisting solely of the Passion. He also classified by language all manuscripts known to him. He alone had already found 217 manuscripts: more have since been added by other scholars. Fischer's suggestion that the original text was in Italian has not been accepted. (The study of the Italian versions by Vaccari has been cited above in n. 1.) The publication of the Gaelic version, *Smaointe Beatha Chríost* (see n. 3 above), includes a valuable survey of the history and influence of the text, with further bibliography. Here we cannot attempt to list even the more important references to the *Meditations,* for its bibliography would fill a volume of its own.

published, is outstanding because it belongs to the "grosse Text" and because of the number and quality of its illustrations. Although the *Meditations* circulated in hundreds of manuscripts—over two hundred still exist—that undoubtedly influenced pictorial art, fewer than twenty manuscripts with pictures have come down to us.[5] Ms. ital. 115 is the earliest and most fully illustrated of these, as well as the one in which the pictures relate most closely to the text.

Complete publication of the picture cycle seemed to us, as soon as we had studied the Paris manuscript, a long-overdue necessity. Our first plan included only the complete presentation of the 193 illustrations and a brief commentary on them. The present book is more ambitious, giving in addition a translation of the text of Ms. ital. 115. The translation was undertaken (and preferred to facsimile publication or transcription of the original Italian) for the following reasons:

[5] The illustrated manuscripts of the *Meditations* known to us are:
Como, Bibl. Comunale, 45, xiv cent., in Italian (Fischer 117)
Edinburgh, Advocates' Lib., 18.1.17, xv cent., in English (Fischer 172)
London, British Mus., Royal 20.b.iv, ca. 1422, in French (Fischer 195)
New York, Pierpont Morgan Lib., 648, xv cent., in English
Oxford, Bodleian Lib., Bodl. 162, xv cent., in Latin (Fischer 68)
———, ———, Rawl. A 387b, xv cent., in English (Fischer 187)
———, ———, Rawl. A 398, xv cent., in Latin (Fischer 74)
———, ———, Rawl. C 287, xv cent., in Latin (Fischer 73)
———, Brasenose College, 9, xv cent., in English (Fischer 188)
———, Corpus Christi College, 410, xiv–xv cent., in Latin (Fischer 76)
Paris, Bibl. Nationale, fr. 921–922, xv cent., in French (Fischer 201)
———, ———, fr. 966, xv cent., in French (Fischer 203)
———, ———, fr. 978, xv cent., in French (Fischer 206)
———, ———, fr. 992, xv cent., in French (Fischer 208)
———, ———, fr. 12441, xv cent., in French (Fischer 216)
———, ———, fr. 17116, xv cent., in French (Fischer 217)
———, ———, ital. 115, xv cent., in Italian (Fischer 155)
In many cases these illustrated manuscripts have only a few miniatures each (those with author portraits only are not listed) and as far as we can see there is no pictorial tradition relating the various examples. There are two manuscripts that approach Ms. ital. 115 in number of illustrations—Royal 20.b.iv in London has 98 (British Museum, *Catalogue of Western Manuscripts in the Old Royal and King's Collections,* by Sir George F. Warner . . . and Julius P. Gilson, London, 1921, ii, pp. 360f.; iv, pl. 114); and Oxford, Corpus Christi College, 410, has 154 (information kindly sent to us by Dr. Otto Paecht).
We have made no systematic attempt to extend this list of illustrated manuscripts and assume that more will eventually come to light.

1. The Vatican Library has announced plans for publication of a critical edition of the various Italian versions, especially using the Paris manuscript.[6]

2. Ms. ital. 115 contains many abbreviations, ligatures, mutilations, and illegible or unintelligible passages. The mediaeval Italian would be unfamiliar to most readers. Even Latin is more easily understandable by most modern scholars. (The lines of original text reproduced together with the pictures in the body of the present edition will suggest the quality of the writing and the language.) Furthermore, the manuscript is defective, lacking the final fourth of the text.

3. No translation of the *Meditations* into English is now in print.

4. Previous English translations, although numerous, seemed to us to fail in usefulness through inaccuracy or incompleteness. For example, the edition most frequently quoted, that of Nicholas Love, of 1410, called *The Mirrour of the Blessed Lyf of Jesu Christ,*[7] is an abridgement that should be used with great caution. The archaic language of this edition is often charming but frequently no more than a paraphrase. The following sentence from chapter VII is offered for comparison:

Latin: Nunc autem diligentissime inspice omnia, maxime quia referre intendo quae ab ipsa Domina revelata & ostensa fuerunt, prout a quodam sancto nostri ordinis fide digno habui, cui puto revelata fuisse.

Ital. 115: Un(de) ora dilige(nte)m(en)te risgua(r)da og(ni) cosa maximam(en)te p(er)o ch(e) i(n)te(n)do di dire q(ue)lle cose ch(e) da la don(n)a funo revelate e mostrate se(con)do ch(e) io l'ebbi da uno s(an)c(t)o fr(at)e d(e)l n(ost)ro ordine d(e)gno di fede al q(ua)le io pe(n)so ch(e) li fusseno revelate.

[6] Vaccari, *op. cit.,* pp. 361f., graciously confirmed by the author in an interview in the summer of 1955.

[7] Ed. Lawrence F. Powell, London, 1908.

Present translation: Now pay careful attention to every-thing, especially as I intend to recount what the Lady revealed and disclosed, as told to me by a trustworthy holy brother of our order, to whom I think it had been revealed.

Nicholas Love: But now furthermore to ſpeke of the bliſſed birth of Jeſuᴈ and of that clene and holy deliueraunce of his dere moder marye / as it is writen in party by reuelacioun of oure lady made here of to a deuowte man.

Modern translations too must answer to a criticism of incompleteness. The most recent one known to us[8] con-denses the same passage to the following:

S. M. Emmanuel: What I have just set down is believed to have been revealed by Our Lady herself to one of our order.

In our translation, we have tried to be as faithful as pos-sible both to the words and to the spirit of our original. We believe ourselves justified in this even when a certain awk-wardness has resulted. We have not smoothed out the original to make it more polished but have tried to preserve its popular character. For example, the frequent changes of tense, sometimes within one sentence, seemed to us at times related to the author's purpose of making past events im-mediately present to the reader ("you must be present at the same things that it is related that Christ did and said"): therefore we have not always changed tenses in order to be consistent in any given passage. We have translated such words as *suore,* "sister," literally, leaving undecided the question of just what relationship is implied by the term. Cognate words have been preferred to more common words, e.g., "supernal" rather than "divine" for *supernali,* "embassy"

[8] *Meditations on the Life of Christ, Attributed to St. Bonaventura,* translated from the Latin by Sister M. Emmanuel, o.s.b., St. Louis, 1934. The publisher, the B. Herder Book Co., generously allowed the microfilming of the Library of Congress copy of this out-of-print edition.

rather than "message" for *ambasciata;* but we have avoided the archaic. We have not aimed at variety but have retained the repetitiousness of the original, as part of its flavor.

We have already mentioned that our manuscript is defective, lacking the last quarter. It is also poorly preserved, and parts are illegible. To overcome these difficulties we turned to published Latin texts of the *Meditations,* for Ms. ital. 115 adheres much more scrupulously to the Latin than do other Italian versions.[9] (In a published Italian edition based on Vat. Ms. Ross. 848,[10] the passage quoted above in the discussion of translations reads, "Poni ben mente ogne cosa, inperò che, quelle cose che io te dirò, fuoro revelate e mostrate da la Donna nostra, secondamento ch'io ebbi da uno santo frate de l'Ordine nostro, al quale io penso che fóssaro revelate queste cose, et era molto degno de fede.") The authority of the Latin edition has been used for paragraphing. Chapter numbers (and sometimes headings), words and phrases, and Biblical references have been derived from the Latin edition: these appear in parentheses in our translation. We have used editions of 1761, printed in Venice, and of 1868, printed in Paris. In the footnotes, variations from the Latin were noted when significant. Alterations have been made in our text only where it was demonstrably incorrect: such changes are mentioned in footnotes. Quotations from the Bible have been left in Latin when so given in our manuscript but have been put into English wherever translated into Italian in the manuscript. In the latter case our translation was made from the Italian, which is often a paraphrase or a quotation from memory, and was not changed to conform to the Vulgate.

Where our author omitted passages within a sermon or letter quoted from Bernard of Clairvaux—his most usual authority—we have marked such omissions by ellipses. Saint Bernard's writings apparently presented grave problems to the scribe or the translator into Italian. We should

[9] Vaccari, *op. cit.,* pp. 358ff., with examples.
[10] *Prosatori minori del trecento,* ed. Giuseppe de Luca, Milan, i, 1954, pp. 1005f.

not have been able to reconstruct the sense of some of the quotations without recourse to the Latin. Therefore all quotations from Bernard have been compared with a printed edition.[11]

As a text, the *Meditations* combines the weightiness of sermons, mainly borrowed from Bernard, with the gentleness of the author's own treatment of the human side of the life of Christ. The author justifies the second by reference to the first: "You will not be introduced to these three kinds [of contemplation] if you do not know how to enter, unless you first meditate on the humanity of Christ, which is given you in this little book" (p. 263). He uses a style that he himself calls "rough and unpolished" (p. 4), but one that we see today as personal and appealing. He makes it clear at the very beginning that he is addressing a nun. Because she is a Poor Clare (and he a Franciscan), the Franciscan atmosphere of humility and poverty is evoked: "The Boy felt shame at taking [money], but for love of poverty He extended His little hand" (p. 80); "He who loved humility did not turn away from it" (p. 53). Because she is a woman, family relationships and domestic details find a part: "The Lady of the world worked for money with distaff and needle and did the other housework as was necessary, as you yourself know" (p. 101). In a simple way he repeatedly adjures the nun to take part in the life of the Holy Family: "Accompany them and help to carry the Child and serve them in every way" (p. 68); "Beg His mother to offer to let you hold Him a while. Pick Him up and hold Him in your arms" (p. 38). Repetition is, indeed, a favorite didactic device. The reader is often instructed in method: "Be present at this event and be attentive to everything, for, as I have said before, herein lies the whole strength of these contemplations" (p. 50). Almost all of chapter XII, on the Flight into Egypt, is a guide to meditation. Such passages of instruction punctuate the narrative and bring in the more abstract considerations.

[11] Migne, *Patrologia latina*, CLXXXII–CLXXXV.

The narrative events are told "as they occurred or as they might have occurred according to the devout belief of the imagination and the varying interpretation of the mind" (p. 5) because "the evangelists left out many things" (p. 96). The additions to the Gospel are taken from both scholarly and popular writing, including the personal accounts of monk travellers, the *Historia scholastica,* the *Glossa ordinaria,* the *Legenda aurea,* and the writings of the Fathers, and from the author's sympathetic, pictorial imagination. Surprisingly vivid images emerge and at times almost overwhelm the original account. For example, the Sermon on the Mount is described only briefly, the reader being advised to read the Gospel text for himself. The author is more interested in the human reaction of the disciples to the Lord's teaching and describes what they do after the conclusion of the Sermon, when the Lord speaks familiarly with them and "this group of simple people follows, not in careful, orderly fashion, but like chickens following the hen, so that they might better hear Him, each one trying to come close to Him" (p. 155).

The author's wish to make the reader an eye-witness of the events narrated leads him both to invention, as in the example just given, and to an emphasis on those details from older sources that particularly stress visual aspects. Therefore it is not surprising that the text has furnished many of the motifs in the pictorial representations of the later Middle Ages.[12] Among these are the following from the Infancy cycle: the Virgin at the birth of John the Baptist; the ox on the Journey to Bethlehem; the saddle and column in the Nativity; the old Magus kissing the foot of the Christ Child in the Adoration of the Magi; the young John the Baptist with the Madonna and Child. Among those from the Passion cycle: the meeting of the Virgin and Christ at the crossroads in the Bearing of the Cross; the two ladders in the Deposition; Christ appearing

[12] Émile Mâle, *L'Art religieux de la fin du moyen âge en France . . .* , Paris, 1922, pp. 27ff. *et passim.*

to His mother after the Resurrection. Paintings of the fourteenth and fifteenth centuries (and even later) often incorporate these motifs based on the text of the *Meditations.* An important example is the column, frequently included in Flemish fifteenth century representations of the Nativity, as mentioned in the Note to no. 27. Although we feel that there is no relation between our illustration and the monumental versions of the same subject—this particular manuscript can hardly have been widely known and our illustration is different in everything except the column from the Flemish paintings—the picture cycle retains a unique importance.

The text of Ms. ital. 115 was written first and spaces left for the pictures. Instructions to guide the artists were placed in the margins; and, presumably after the drawings were made, the artists added the explanatory inscriptions.[13] Haste is apparent: in no. 114 color is abandoned, and after no. 193 the drawings stop and only frames with their marginal instructions remain. There is no conclusive internal evidence apparent to us as to whether the artists were composing or copying the pictures. Consideration of the style does not help in settling the question. We have not succeeded in identifying either the artists or the locality where the manuscript was produced but, while material for detailed comparison is still lacking, must agree with the attribution to the region of Siena or Pisa. We hope that further publication and study in the field of fourteenth century Italian manuscripts and drawings will follow the presentation of this work and help to solve its problems.

It is unfortunate that our sequence of pictures ends in the midst of the public life of Christ and that not even instructions exist beyond the Arrest. The whole Passion is therefore lacking; and the comments that follow refer of necessity to the Infancy and the public life.

In looking at the pictures that exist, one is struck at once

[13] The vocabulary of the inscriptions differs from that of the text. Some of the new words used are *maida, puella, desco, banco.*

by their large number and their density. The plan provided illustrations for every narrative; and many episodes receive an unprecedented treatment with an illustration for each moment of the action. The Marriage at Cana sequence, for instance (nos. 121–132), begins with the journey of Maria Salome to the Virgin to invite her to the wedding, the greeting between the women, and the return of the Virgin with Maria Salome. There follow the preparation of the wedding feast, the opening of the celebration, the servants informing the Virgin of the shortage of wine, the Virgin relaying the news to her Son, the Virgin instructing the servants to follow Christ's orders, the servants going to Christ, and Christ sending wine to the master of the feast. The sequence concludes with the calling of John (identified as the bridegroom) and the departure, making a total of twelve pictures expanded from what is usually shown in a single scene. In this case the expansion denotes the special interest of the lesson to be learned from the subject; but it also implies that the artists must have enjoyed a certain freedom from traditional modes. It may be noted here that the scene of the Multiplication of the Loaves is not similarly expanded, although it is another of the picturesque social scenes that seem to be especially well liked.

Other unusually long sequences are the Nativity, the Presentation, the Feast of Herod, and Christ and the Samaritan Woman. Unexecuted but planned for treatment *in extenso* are Christ in the House of Mary and Martha, the Raising of Lazarus, the Entry into Jerusalem, the Last Supper, and Christ in Gethsemane. Of these the Nativity, the Presentation, the Entry, the Last Supper, and Gethsemane (the last-named as the beginning of the Passion) are not unexpected choices. Less obvious are the selections of the scenes of the Marriage at Cana, the Feast of Herod, the Samaritan Woman, the House of Mary and Martha, and the Raising of Lazarus (in the public life), in preference to, let us say, the Baptism. It may be supposed that this choice is connected with the addressing of the *Medita-*

tions to a nun. The author, as we have said, makes much of the religious vocation and of scenes where women occur or that stress subjects of interest to women, like fancywork and cooking. (But even though he wishes to instruct Sister Cecilia, he is careful not to offend her delicacy by details of too much brutality; and in the Herod scenes and the episode of the woman with the issue of blood, he chooses his words with great restraint.)

The text includes especially long passages justifying the Mary and Martha picture sequence. Other sequences, such as the Feast of Herod, derive from extremely brief descriptions. Of all the illustrations, whether single pictures or sequences, more than half were apparently inspired by the text of the *Meditations*. They include some of our most charming and unexpected pictures.

After the arrival in Egypt the Holy Family is seen within the city gates, which have been opened for the entry, negotiating for the rental of a very small house (no. 60). A little later, safely installed at home, the Virgin, who has been industriously sewing, with an admonishing gesture sends her little Boy to deliver a finished garment (no. 62). On the return from Egypt, the Holy Family meets the relatives from whom the parting has been long. The Virgin seems loath to relinquish the Christ Child, who tenderly embraces the young John kneeling respectfully before Him (no. 68). In the next picture a naïve, vertical Jordan River bounds the desert as the Holy Family reaches the house of Elizabeth, and the Virgin and Elizabeth embrace in an echo of their previous Visitation (no. 69). After the visit to the Feast, and the anguish suffered by the parents when they suppose that they have lost the Child, the reunion is full of emotion, with Joseph reaching out and the Virgin falling to her knees to enfold the Child in her embrace (no. 82). Then they depart, with the childlike Boy firmly grasped by the hand by His mother (no. 83). Later, Christ, now adult although still sharing His parents' house, has more private quarters than when—in the preceding picture

—He was still a child (nos. 88, 89). He leaves home after touching scenes of blessing and farewell (nos. 91–93). After the Temptations, the solicitous ministrations of the angels are made secondary to a delightful series (nos. 102–106). Christ announces that no food pleases Him so much as His mother's. Two dutiful little angels fly to her, then rush back carrying the parents' modest meal of bread, fish, and perhaps some wine, and a tablecloth. When He has eaten "politely and soberly," sitting on the ground, in an idyllic setting with gentle beasts, the angels attending Him ceremoniously like well-trained servants, the same two messengers restore the dirty plates and the tablecloth—to Joseph. Later, when the disciples have been called, the benign Lord, caring for them "as a mother for her son," covers them as they sleep out-of-doors (no. 120). A particularly beautiful sketch shows the single figure of Mary Magdalen, her fine garments in a graceful flutter, hurrying toward the house of Simon (no. 154). Another picture is notable for the emotion expressed in the faces and hands of Christ, the Virgin, and the apostles, when they receive the tragic news of John the Baptist's death (no. 168).

These scenes illustrate episodes that form parts of the narrative cycles of the lives of Christ and the Virgin. Other parts of the cycles follow common traditional models, both in sequences and in isolated pictures, from sources both scriptural and apocryphal. The Notes on the Pictures give a few of the more striking relationships, especially with the Italian art of the period; but we have not by any means tried to explore all the possibilities of these iconographic connections.

Accompanying the exposition but not related to the narratives are a few isolated images, such as St. Francis Receiving the Stigmata (no. 2), which repeats a well-known type; the "author portrait" (no. 1) with the patron saint of the nun, a picture no doubt made up by the artist; and the Dispute (no. 3), which, as we suggest in the Notes, may be a transposition from another composition.

Some subjects that might reasonably have been expected to appear in illustrations are absent. A few of these are the annunciation of the Nativity to the angels in heaven (p. 38); the placing of the stone in the manger (mentioned out of order in the account of the Circumcision on p. 43); the rebuff of the Child when He was acting as messenger (pp. 69f.). Other subjects are unaccountably misunderstood by the artist. For examples, see the Notes on the Pictures (e.g., nos. 84, 152). In some pictures he has confused the characters (nos. 156, 157). In one case, he has disobeyed the instructions (no. 189). In another, a picture already completed is cancelled and replaced (no. 153).

Once at least the picture type as handed down by tradition may have influenced the text of Ms. ital. 115. This manuscript is the only one among the Latin or Italian versions to locate the Nativity in a cave. (The other versions mention only a common or covered place; cf. Note to no. 26). The cave is, of course, usual in one pictorial tradition.

As to style, one can easily see that, despite the homogeneous character of the whole, there are pronounced differences between the beginning and the end. The pictures at the beginning, which are somewhat gross in drawing and proportions and stiff in execution, may stem from a provincial hand. Later, especially after the abandonment of the thin washes of flat color, much greater suavity and elegance are visible. Then the line is at times very beautiful, particularly in the last, unfinished sketch, perhaps the most distinguished of all in freshness and spontaneity.

The artists have a special predilection for scenes of departure, journeying, and arriving; feast scenes; domestic scenes; and healing miracles. The compositions usually consist mainly of figures ranged on one level, but occasionally a more elaborate multi-level scheme is employed. At the beginning the accompanying figures are few: later, larger groups, sometimes in convincing group motion, appear. Most pictures are placed in the text column

unframed, close to the part of the narrative that they illustrate. Nos. 36 and 37, on opposite pages, form a unit, but this composition is rare.

Settings, when present, include a few leafy or globular trees and rocky mounds to suggest landscape, and enclosures or small stage-like buildings, both simple and complex, for architecture. Even within one sequence, the architectural frame for the same event may be varied, as befits an unreal and unnatural milieu. Landscape and architecture as well as figures composed in depth are combined in no. 59. No. 152 is particularly complicated architecturally.

Details are taken from contemporary usage—chests, baskets, tables, vessels, and the trappings and accouterments of horses no doubt reflect the times. So do the techniques of spinning, carpentry, commerce, fishing, and inn-keeping. Costumes are conventional for many of the figures, but contemporary for the secondary ones, such as cripples, midwives, beggars, soldiers, and ordinary people of both upper and lower class. Animals are introduced often, very well characterized and delineated: these interest the artists more than do devils, who appear only in the Temptations.

Although a great deal more remains to be said about the iconography and style of these illustrations, we have decided that our first responsibility is to make the text and pictures of Ms. ital. 115 available.

In summary, this book consists of the following:

1. A new translation of the *Meditations on the Life of Christ* into English. This is based on Ms. ital. 115 in Paris and completed from the Latin. It attempts to be literal, correct, and readable, that is, to offer as accurate a text as possible without losing the original simplicity and directness.

2. Reproduction of all 193 illustrations in their original positions in the text (occasionally moved forward or backward a page in order to preserve the location on recto or

verso), thus in a sense simulating the appearance of the manuscript itself. The illustrations are consecutively numbered in the margin and identified by the same numbers in the Notes on the Pictures at the end of the book. Where the illustrations cease and only the instructions to the artist remain, we have continued these marginal numbers, placing them at the points where in the manuscript blank rectangles occur.

3. Notes on the text, including important variations from the Latin, errors, and sources.

4. Notes on the pictures (numbered consecutively and identified by original folio number and by page number in the present edition). Each illustration is given a title based on its subject; the original instructions and inscriptions (often highly illegible or mutilated) are given in translation; and there is a short comment in which we try to relate the picture to known pictorial tradition. We use the term "text illustration" to denote that the picture is directly inspired by the text rather than by an earlier pictorial model. In making the frequent statement, "No earlier examples known to us," we have used the authority of the files of the Index of Christian Art, although again acknowledging the regrettable lack of complete publication of the necessary material for comparison. The final part of this section continues the system of enumeration for the projected, unexecuted illustrations.

5. An index for the location of literary and pictorial motifs.

The work was undertaken with the permission of the Bibliothèque Nationale, Paris, and the encouragement of M. Jean Porcher, Conservateur en Chef of the Cabinet des Manuscrits, and Mlle. Marie-Thérèse d'Alverny, Conservateur in the same department.

The costs of photography were met by a grant from the Spears Fund of the Department of Art and Archaeology of Princeton University.

We are most especially grateful for the support, advice,

and hard work of Mrs. Anna Ragusa, particularly during the trying time when we first faced the difficult problems of transcription and translation.

Mrs. Virginia Wylie Egbert, Miss Mary Teresky, and Miss Elizabeth G. C. Menzies, our colleagues in the Index of Christian Art in Princeton, have been enthusiastic and cooperative, serving whenever called upon as critics and aides. In the later stages of the work, Mrs. Egbert, Senior Reader in the Index, whose experience in iconography was always at our service, acted as our most perspicacious critic. In the *Copia Vaticana* of the Index of Christian Art, the curator, Father Guy Ferrari, O.S.B., obligingly read and criticized our translation.

We have also been fortunate in being able to consult Professor Millard Meiss and Dr. Gertrude Coor-Achenbach of the Institute for Advanced Study, Princeton, authorities on fourteenth century Italian art, who have been gratifyingly aware of the intrinsic interest of our manuscript. Mrs. Coor lent us an otherwise unavailable Italian edition of the *Meditations*.[14] Still another member of the Institute for Advanced Study, Professor Erwin Panofsky, gave the encouragement that bridged the gap between contemplation and action.

"Thanks be to the living God forevermore."

<div align="right">

Isa Ragusa
Rosalie B. Green

</div>

October, 1959
The Index of Christian Art

[14] Giovanni da S. Gimignano, *Cento meditazioni sulla vita di Gesù Cristo,* ed. Arrigo Levasti, Florence, 1931.

MEDITATIONS
ON THE LIFE OF CHRIST

MEDITATIONS
ON THE LIFE OF CHRIST

Here Begins the Prologue
to the Meditations on the Life of Our Lord
Jesus Christ

AMONG the noteworthy virtues and excellences of the most
holy Saint Cecilia, we read that she always carried the
Gospel of Christ hidden in her bosom, which I think means
that she had chosen the most pious facts of the life of Jesus,

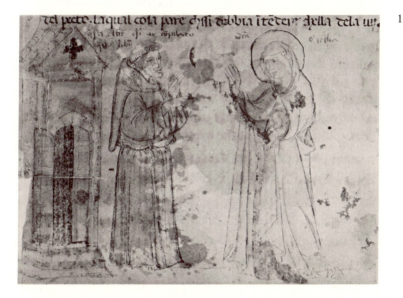

as shown in the Gospel, on which to meditate day and
night with pure and undivided heart and single-minded
and fervent intent.[1] And when she had finished the text
she began again with sweet and pleasant enjoyment to
ponder on these things, cultivating them in the secret of
her heart with prudent consideration. I wish to encourage

1

you to do likewise because, above all the studies of spiritual exercise, I believe that this one is the most necessary and the most fruitful and the one that may lead to the highest level. You will never find better instruction against vain and fleeting blandishments, against tribulation and adversity, against the temptations of enemies and vices, than in the life of Christ, which was without blemish and most perfect. Through frequent and continued meditation on His life the soul attains so much familiarity, confidence, and love that it will disdain and disregard other things and be exercised and trained as to what to do and what to avoid.

I say first that the continuous contemplation of the life of Jesus Christ fortifies and steadies the intellect against trivial and transient things, as is disclosed in the example of the Blessed Cecilia, whose heart was so permeated with the life of Christ that trivial things could not enter. Thus during the pomp of the wedding, when there was so much vanity, with the organs singing, and dishonest hearts, she attended only to God, saying, "O Lord, may my heart and my body become pure, that I may be untroubled." [2]

In the second place it fortifies against trials and adversity, as is shown by the holy martyrs about whom Bernard in his 61st sermon on the Canticles said, "In this way martyrdom is endured, that you consider the wounds of Christ in all devotion and dwell in continued contemplation. In this will the martyr remain happy though his whole body be lacerated and iron torture his sides. Thus where is the soul of the martyr? Surely in the wounds of Christ, since the wounds are clearly an entrance. If it were inside himself, he would feel the iron searching him; he could not bear the pain but would feel it and recant." [3] So Bernard says. However, not only the martyrs but also the confessors bore their tribulations and infirmities with great patience, and have to this day. If you read about the Blessed Francis and the Blessed virgin Clara, your mother and leader, you will discover how they remained not only patient but even

2

cheerful throughout many tribulations, poverty, and illness. And also you will continue to see this quality in those who lead a saintly life, because their souls were not and are not in their bodies but in Christ, owing to their devoted contemplation of His life.

In the third place I declare that one should be instructed on how to avoid enemies and vices leading to fall and deception, because in this is found the perfection of virtue. Where can you find examples and teachings of charity, of great poverty, of faultless humility, of profound wisdom, of prayer, meekness, obedience, and patience, and of all the virtues to equal those in the holy life of the Lord, full of all virtues? On this Bernard spoke briefly in his 22nd sermon on the Canticles: "In vain does he exert himself in acquiring virtue if he thinks to have it other than from the Lord of virtue, whose doctrine is the diffusion of wisdom, whose death is a demonstration of fortitude." [4] So Bernard says. Therefore the heart of one who wishes to follow and win Him must take fire and become animated by frequent contemplation: illuminated by divine virtue, it is clothed by virtue and is able to distinguish false things from true. Thus it is more the illiterate and simple people who have recognized in this way the greatness and intensity of divine things. Do you believe that the Blessed Francis would have attained such abundance of virtue and such illuminated knowledge of the Scriptures and such subtle experience of the deception of the enemy and of vices if not by familiar conversation with and contemplation of his Lord Jesus? With such ardor did he change himself that he had become almost one with Him[5] and tried to follow Him as completely as possible in all virtues, and when he was finally complete and perfect in Jesus, by the impression of the sacred stigmata he was transformed into Him. Thus you see to what a high level the contemplation of the life of the merciful Jesus Christ may lead, and that a strong foundation lifts you to a higher degree of contemplation; and therefore is discovered an unction that purifies step by step

and raises the soul, instructed by all those things of which
we need not speak at present.

2

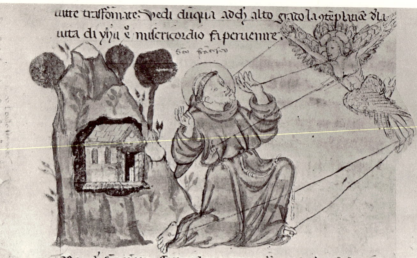

I intended you to be introduced to the contemplation of
the life of Christ in some way, but I wished this to be done
by someone more experienced and learned than I, who am
very wanting in these matters. However, judging it to be
better to say at least something than to remain completely
silent, I shall attempt to overcome my inadequacy and
speak to you in a familiar manner, in a rough and unpol-
ished sermon, so that you may better understand what is
said, not that the ear may be pleased but that the mind
may seek to be filled. For one should be diligent not in
ornate sermons but in the contemplation of our Lord
Jesus. The teachings of Christ[6] that say that the rough
sermon reaches the heart while the polished one feeds the
ear lead us to the same conclusion. I hope that my poor
instruction will have an effect on your ignorance, but I
have the greater hope that if you wish to exercise yourself
in these things by continued contemplation, your master

will be this Lord Jesus of whom we are speaking. However, you must not believe that all things said and done by Him on which we may meditate are known to us in writing. For the sake of greater impressiveness I shall tell them to you as they occurred or as they might have occurred according to the devout belief of the imagination and the varying interpretation of the mind. It is possible to contemplate, explain, and understand the Holy Scriptures in as many ways as we consider necessary, in such a manner as not to contradict the truth of life and justice and not to oppose faith and morality. Thus when you find it said here, "This was said and done by the Lord Jesus," and by others of whom we read, if it cannot be demonstrated by the Scriptures, you must consider it only as a requirement of devout contemplation. Take it as if I had said, "Suppose that this is what the Lord Jesus said and did," and also for similar things. And if you wish to profit you must be present at the same things that it is related that Christ did and said, joyfully and rightly, leaving behind all other cares and anxieties. Therefore, dear daughter, I pray you to receive this work, which I undertook in praise of the Lord Jesus for your accomplishment and my benefit, with gladness, and to train yourself with more joy, devotion, and solicitude. Let us begin with the Incarnation; but we can include some previous events, those concerning God and his blessed angels in heaven as well as those concerning the glorious Virgin on earth, which I believe I should describe first. Therefore let us first speak of these.

(I.) *Of the Meditations on What Came Before the Incarnation of the Lord, Beginning with the Solicitous Intercession of the Angels to God on Our Behalf*

For a very long time, for the space of over five thousand years, the human race had been living in misery, and, because of the sin of the first man, no one was able to rise to his Home. Feeling compassion for the downfall and hoping to effect a restoration, the first and most blessed spirits

often but then at the destined time with even more solicitude and pious devotion prostrated themselves all together in front of His throne to pray, saying, "O Lord, it pleased your Majesty to make the noble and rational creature, man, through your benevolence, that his salvation might be here with us, so that the reparation of our fall might occur. But see, Lord, how all perish and no one is saved, and throughout an untold succession of years we have seen no one. They do not inhabit our wastes but fill the infernal caverns, to the exultation of the enemies. Why, O Lord, are they born? Why are the souls that acknowledge us given to the beasts? And if these things are done according to your justice, now the time has come for mercy. Although the first parents rashly violated your commandment, let your mercy help. Remember that you created man in your image and likeness; Lord, spread your hand compassionately and impart benediction. The eyes of all are turned to you as the eyes of servants to the hands of the masters (Psalm cxxii, 2), in the hope that you may have mercy and give beneficient aid."

(11.) *Of the Dispute Between Mercy and Truth*

Having said these things, Mercy, with Peace on her side, incessantly begged the Father for aid, but since Truth, together with Justice, opposed her, there arose a great dispute, according to the beautiful and lengthy first sermon of the Blessed Bernard on the Annunciation.[7] I shall try to tell you briefly its substance, frequently repeating his gentle words, but often summarizing to avoid prolixity. Here is the substance of his remarks. Peace and Mercy said to God, "O Lord, will you banish them forever and forget to exercise compassion?" (Psalm lxxvi, 8–10). After they had repeated this for a long time, the Lord replied, "Let your sisters who are prepared to oppose you be called and let us listen to them also." When they had been called, Mercy began to speak: "The rational being needs divine mercy, for it has become vile and wretched. The time for mercy

6

has come; indeed it is already past." But Truth spoke contrarily: "It is proper that the admonition you delivered be

fulfilled, that Adam perish completely, with all who were in him, when, trespassing against your commandment, he tasted the forbidden apple." Mercy said, "Lord, why did you then create Mercy? Truth knows that I shall perish if you will never again be merciful." Truth replied in opposition, "If the transgressor escapes the punishment you foretold, your Truth will perish and not abide in eternity." These questions were transferred by the Father to the Son. Truth and Mercy repeated the same things before Him, and Truth added, "Lord, I realize that Mercy is moved by

commendable zeal, but not justly, since she would rather pardon a sinner than her sister." And Mercy answered, "You pardon neither the one nor the other but, hardened by cruelty against the sinner, implicate your sister together with him." But still Truth continued to argue strongly: "Lord, you must solve this question and you must see that the word of the Father is not broken." Peace now said, "Cease this debate. It is not virtuous so to contend." You see here a great controversy and strong and effectual reasons. One does not see how both Truth and Mercy can survive. Then the King wrote His decision, which He gave to Peace, who was standing nearest Him, to read, and it contained the following: "The one side says, 'I perish if Adam does not die,' and the other, 'I perish if he does not receive mercy.' Let death become good and each one will have what she desires." Everyone marvelled at these words of wisdom and agreed that Adam should die receiving mercy. But they asked how death could be made good, as it was a thing terrible even to mention. The King replied, "The death of sinners is noxious but that of saints is precious and a door of life (Psalms xxxiii, 22, and cxv, 15). Let there be found someone prepared to die out of charity, yet not guilty of death. Death will not be able to keep the innocent man, and he will make a passage through which the freed can pass." The sermon pleased them. But where could such a one be found? Thereupon Truth returned to the earth and Mercy remained in heaven, as the prophet said: "Lord, your mercy is in heaven and your truth (extends) to the clouds" (Psalm xxxv, 6). Truth searched the earth but found no one pure of evil, not even a new-born child. And Mercy searched in heaven and found no one with sufficient charity, for we are all servants, and even when we do good we must say that we are worthless servants (Luke xvii, 10). Thus the victory was rightly His, for no one had greater charity or would give his soul for the worthless servants. On the appointed day they returned, greatly fatigued and without having found what they

desired. Said Peace, "You know and think nothing. There is no one who will do good, not a single one (Psalm xiii, 1). But let Him who gave the advice now lend His help." The King heard this and said, "I regret that I made man and now I must do penance for the man I created" (Gen. vi, 7). And He called Gabriel and said, "Go and say to the daughter of Sion, 'Here is your King who is coming'" (Zach. ix, 9). All this is told by Bernard. Thus you see how sin was and is of great danger and how difficult it was to find a remedy for it; but the Virtues agreed on the Son. Since the person of the Father appears at times terrible and powerful, Peace and Mercy might have had some doubts, while the person of the Spirit is very benign and might have caused suspicions in Truth and Justice. Thus the person of the Son as a median was accepted to effect the remedy. This you must understand not literally but figuratively. Accordingly the words of the prophet were fulfilled: "Mercy and Truth oppose one another, Justice and Peace kiss each other" (Psalm lxxxiv, 11). Thus we can imagine what may have happened in heaven!

(III.) *Of the Life of the Virgin Mary Before the Incarnation of the Son*

4

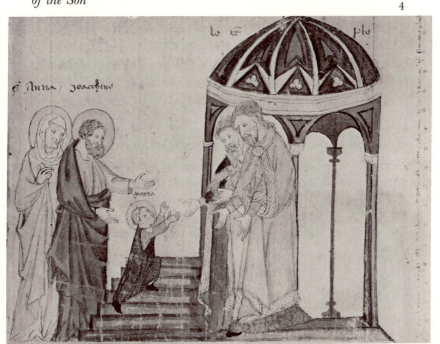

Let us contemplate the life of the Virgin in whom the Incarnation was effected. You must know that when she was three years old she was offered in the temple by her father and mother and stayed there until she was fourteen. We know what she did while in the temple through disclosures she made to a devoted friend whom we suppose to be Saint Elizabeth, whose feast we devoutly celebrate. Among other things she said this: "When my father and mother left me in the temple I resolved in my heart to have God for my father. Continually and with devotion I pondered on what I should do and what would be most pleasing to Him so that He might deign to give me His grace. I asked to be taught the laws of my God and, of all the commandments of the divine law, I observed three particularly in my heart: Love the Lord your God with all your heart and soul, with all your intellect and all your strength; Love your neighbor as yourself; Hate your enemy. These," she said, "I kept in my soul and forthwith realized the virtues they contained. The soul can have no virtue if it does not love God with its whole heart. From this love descends

5

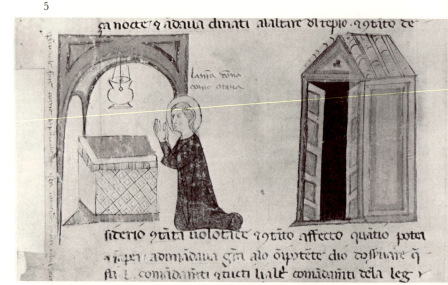

10

all bounty of grace, for after it descends it would not stay in the soul but flow on like water if it did not hate its enemies, vice and sin. Thus he who would have and keep grace must order his heart to love and hate; and I would have you do as I did. At midnight I always arose to go before the altar of the temple and with all the desire, will, and affection I could, I begged the grace of almighty God that I might observe these three and all the other commandments of the law. I stayed before the altar and made seven requests, which were these:

"The first grace I asked was to learn the commandment of love, that is, to love with all my heart, etc.

"The second was that I might love my neighbor according to God's will and pleasure and that He would instill in me love for everything that He loved.

"The third was that He would help me to hate and escape all the things that He hated.

"The fourth petition was for humility, patience, benignity, and meekness, and all virtues by which I might win favor before Him.

"The fifth was that I might live to see the birth of the holy virgin who was to bear the Son of God, that God would preserve my eyes to see her, my ears to hear her, my tongue to praise her, my hands to serve her, my feet to take me to her service, my knees to adore the Son of God in her womb.

"The sixth was that I might obey the commandments and orders of the priests of the temple.

"The seventh was that the temple and the people be preserved for His service."

Upon this the servant of Christ said to her, "My gentle Lady, were you not full of grace and all virtues?" And the Blessed Virgin replied, "Truly you must know that I considered myself as bad and evil and unworthy of the grace of God as you, but I prayed for mercy and virtue. You, beloved (daughter), also believe that I had every grace with no effort, but this is not so; in fact, I must say that I

11

never received a favor or gift or virtue without great endeavor and constant prayer, ardent desire and profound devotion, with many tears and hardships, saying, doing, and thinking only things to please Him as best I could, except for the grace of sanctification with which I was blessed in my mother's womb." And she added, "Truly you must know that grace does not descend to the soul except by prayer and corporal affliction. But when we have given God everything we can, although it is very little, He Himself comes to the soul, which becomes inadequate and loses its memory and does not remember having said or done anything pleasing to God, and then it considers itself more wretched and unworthy than ever." Here ends this revelation.[8]

The Blessed Jerome writes this about her life:[9] "The Blessed Virgin established this rule, that in the morning she prayed until the third hour, from the third to the ninth hour she was busy spinning, and from the ninth she again

6

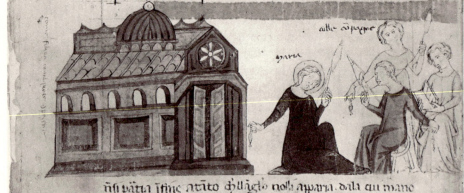

prayed, continuing until the appearance of the angel from whose hands she received her food. She improved so constantly in her study of the works of God that she became first in the vigils, the best informed in the law of God, the

most humble in humility, the best read in the verses of
David, the most gracious in charity, the purest in purity,
the most perfect in all virtues. She was constant and stead-
fast, improving always. No one ever saw or heard her in

7

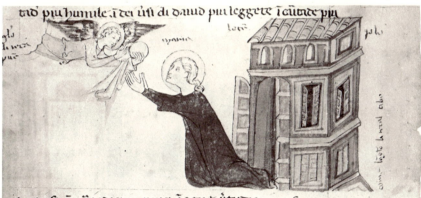

tr̄o pīu humile. ī cei ū̄fi di dauid pīu leggete ī cāūtate pīu

gratiofa īpūitate pīu pura. ī ogne ūtute pīu p̄fecta :

anger. Her discourse was always so graceful that God was
recognized in her speech. She was ever in prayer and in
the exercise of the law of God and was always concerned
lest her companions might sin in any word, or raise their

8

voices in laughter, or that one of them might wrong
another or show arrogance toward her equal. Untiringly
she blessed God, and, perhaps so that the praise of God

should never be interrupted even in a salutation, if someone greeted her she would reply, 'Deo gratias.' Thus the

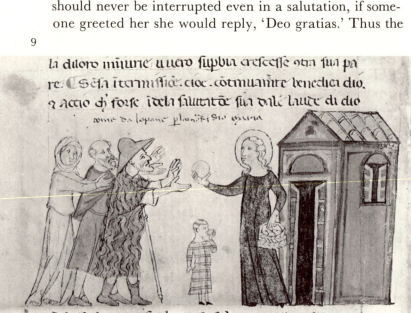

holy Virgin Mary was the first to give the salutation 'Deo gratias' later used by saintly men. She nourished herself with food that she accepted from the hands of the angels and gave to the poor what she received from the priests of the temple. Often it seemed that the angel spoke to her and was devoted to her as to a beloved (sister or mother)." So Jerome says.

In her fourteenth year[10] the Blessed Virgin was married to Joseph, in accord with a divine revelation, and returned to Nazareth, as is written in the legend of her birth.[11] These are the events prior to the Incarnation of our Lord Jesus Christ that we can contemplate. Weigh them affectionately and delight in them, commit them to memory and follow their example, for they are most pious and beneficial to the soul. We must love them in consideration of the excellent fruits that devoted meditation on them will bring to us.

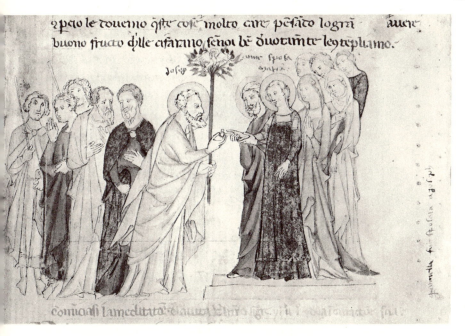

e pero le couerno qste cose molto care pesato logra auere
buono fructo delle afarano, senor be duotante legteplamo.

Josep

summ sposa agabri

conuasi la meditata Claura Bruega ygre yi u i euatantator sui

(iv.) *Here Begins the Meditation on the Life of Our Lord Jesus Christ and on His Incarnation*

The time for the Incarnation of the Son, moved in His mercy by His love of the human race, entreated by the supernal spirits for the aid of the human race, as decided upon by the Supreme Trinity, had come. And since the Blessed Virgin had returned to Nazareth, the omnipotent God called the archangel Gabriel and said to him, "Go to our beloved daughter Mary, wedded to Joseph, and dear to us above all creatures, and tell her that my Son, desiring her beauty, has chosen her as His mother. Beg her to receive Him with gladness, for I have ordered the salvation of the human race to be effected by her and will forget the injury done to me." Let us pause here and remember what I told you in the beginning, that you must learn all the things said and done as though you were present. Thus here you may imagine God and regard Him as best you

15

can, although He has no body, beholding Him as a great
God seated on a raised chair, with benign face, compas-
sionate and paternal almost as though wishing to be or
already reconciled as He speaks these words. And Gabriel,

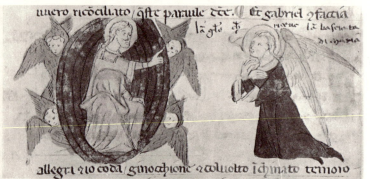

with glad and joyful face, kneeling with bowed head,
respectful and reverent, received attentively the embassy of
his Lord. Then he arose cheerfully and gaily and flew down
from heaven and in a minute stood in human form before
the Virgin, who was in a room of her little house. But his
flight was not so swift that God did not enter before him,
and thus the Holy Trinity was present, entering before His
messenger.

For you must know that the exalted labor of the Incar-
nation belonged to the whole Trinity, though only the per-
son of the Son was incarnated, as when one person is
dressing with the aid of two others who stand at his sides
holding the sleeves of the gown. Now give heed to under-
stand everything that was said and done, as though you
had been present. What a small house it was in which
these Persons entered, and what events They caused! Al-
though the Holy Trinity is everywhere, consider that at
this time and place It was here in a singular way for a
singular purpose. When the faithful emissary[12] Gabriel
entered, he said to the Virgin, "Ave gratia plena; dominus
tecum; benedicta tu in mulieribus" (Luke i, 28). "Hail,
you who are full of grace; the Lord is with you; blessed are

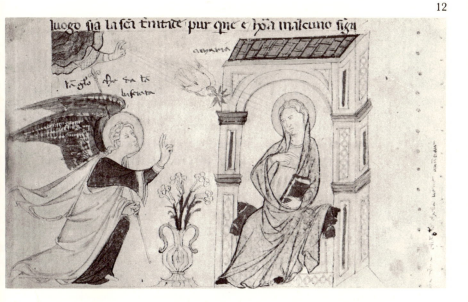

you among women." But she was perturbed and did not reply. It was not guilt that confused her or the sight of the angel, for she was accustomed to seeing him often. But according to the Gospel she was perturbed by his words, meditating on the innovation in his words, that is, his salutation, because he had not greeted her in that way before. Hearing herself thrice commended in this salutation, the humble woman could not but be disturbed. She was praised that she was full of grace, that God was with her, and that she was blessed above all women. Since humble persons are unable to hear praise of themselves without shame and agitation, she was perturbed with an honest and virtuous shame. She also began to fear that it was not true, not that she did (not) believe that the angel spoke truthfully, but that like all humble people she did not consider her own virtues but memorized her defects, always considering a great virtue to be small and a little defect very big. Therefore, because she was sagacious and cautious, modest and timorous, she did not reply at all. What should she have said? Learn by this example to remain silent and

17

to love taciturnity, as this virtue is great and very benefi-
cial. Twice she heard before she replied once, for a loqua-
cious virgin is an odious thing. But the angel, recognizing
the cause of her doubts, said, "Do not fear, Mary, or feel
shame at the praise I have spoken, for it is true; and you
are not only full of grace but with it you have redeemed
all mankind. Behold, you will conceive and give birth to a
sublime Son, who has elected you to be His mother and
who will save all who hope in Him." Then she replied,
neither admitting nor denying the earlier praise but desir-
ing to allay her doubts by ascertaining how she might not
lose her virginity. Therefore she asked the angel about the
nature of this conception, saying, "How can this be, since
I have firmly promised my virginity to my Lord who is
God and may never at any time know a man?" The angel
said, "This will be by the Holy Spirit, who will pervade
you in a singular way. By His virtue you will conceive and
yet keep your virginity intact. And thus your son will be
called the Son of God, for with Him nothing is impossible.
Behold your kinswoman Elizabeth, old and barren, who
conceived a son six months ago by virtue of God."

Consider this for God's sake, contemplate how the whole
Trinity is here, awaiting the answer and the consent of this
unique maiden, considering her modesty and her manner
and words with love and delight. See also how the angel
wisely and assiduously introduces and chooses his words,

13

kneeling reverently before his Lady with pleasing and joyful countenance and fulfilling his embassy faithfully. Attentively he heeds the words of his Lady, that he may reply appropriately and accomplish the will of God regarding this wonderful deed. And see how the Lady remains timorous and humble, with modest face, as she is accosted by the angel, not becoming proud and boastful after his unforeseen words, in hearing such wonderful things as had never been told to anyone before, but attributing everything to divine grace. Thus you may learn by her example to be modest and humble, because without these attributes virginity is worth little. But finally the prudent Virgin understood the words of the angel and consented, and, as is related in the aforementioned revelations, she knelt with profound devotion and, folding her hands, said, "Behold the handmaid of God; let it be to me according to your word" (Luke i, 38). Then the Son of God forthwith entered her womb without delay and from her acquired human flesh, wholly remaining in His Father's bosom. Your devout imagination can now show you how, on assuming His painful mission, the Son bowed obediently and commended Himself to the Father. At that very point the spirit was created and placed into the sanctified womb as a human being complete in all parts of His body, though very small and childlike. He was then to grow naturally in the womb

14

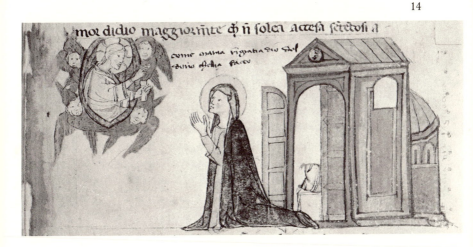

like other children, but the infusion of the soul and the separation of the limbs were not delayed as in others. Thus He was a perfect God as well as a perfect man and as wise and powerful then as now. Then Gabriel and the Lady both knelt and, when they rose after a few seconds, he bowed again to the ground. Bidding farewell to the Lady, he disappeared and returned to his Home. He recounted everything and there was again joy and festivity and great exultation in heaven. Glowing with an even greater love of God than ever and feeling that she had conceived, our Lady knelt in happiness and rendered thanks to God for this great gift. With humility and devotion she prayed that He condescend to teach her about the events ahead of her that she might do without error whatever was necessary for the Son.

You must consider how great is the festivity of this day and jubilate in your heart and make merry. Such happiness had not been heard from the beginning of time to the end, and never was there such. Today is the festivity of God the Father, who wedded human nature to His Son who is today united to it inseparably. Today is the festivity of the wedding of the Son and the day of His birth in the womb from which He will later be born. Today is the festivity of the Holy Spirit to whom is ascribed this marvelous and unique deed of the Incarnation, and who today begins to manifest unexampled benignity toward the human race. Today is the glorious festivity of the Lady acknowledged and received as daughter by the Father, as mother by the Son, as bride by the Holy Spirit. Today is the festivity of the whole celestial court because this is the beginning of their restoration. Today is even more the festivity of human nature, for its salvation and redemption have begun, and the reconciliation of the whole world is taken up and sanctified. Today the Son bore anew obedience to the Father in order to effect our salvation. Today, leaving supreme heaven, He rejoices like a giant racing (Psalm xviii, 6) and encloses Himself in the garden of the virginal

womb. Today He has become one of us, our brother, and has begun to go on pilgrimage with us. Today the true light has descended from heaven to lift and expel our darkness. Today the living bread that animates the world has begun to be baked in the oven of the virginal womb. Today the Word has become flesh that it may live within us (John i, 14). Today the entreaty and the desires of the patriarchs and prophets are heard and fulfilled. They implored with marvelous longing, saying, "Send the lamb, Lord" etc. (Isa. xvi, 1), and also "Rorate, caeli, desuper" etc. (Isa. xlv, 8), "Drop down, heavens, from above; skies, pour down righteousness; let the earth open and let them bring forth salvation," and also "Utinam dirumperes caelos, et descenderes" (Isa. lxiv, 1), "O God, I desire you to burst the heavens, and come down," and also "Domine, inclina caelos tuos, et descende" (Psalm cxliii, 5), "Lower the heavens and descend," and also "Domine, ostende faciem tuam, et salvi erimus" (Psalm lxxix, 4), "Lord, show us your face and we shall be saved." The Scriptures are filled with these and many other sayings. This is the day that was awaited with great desire. Today is the beginning and the foundation of all festivities and the inception of all our welfare. Up to now God had been indignant with the human race because of the fault of the first parent, but now, seeing the Son become a man, He will no longer be angry. Today is said to be the fullness of time. Now you see what a wonderful deed and most solemn feast this is, full of delight and joy, to be desired and received with all devotion, to make merry and exult about, and worthy of every veneration. Meditate on these things, delight in them, and you will become happy and perhaps the Lord will show you greater things.

(v.) *How Our Lady Went to Elizabeth*

When our Lady recalled the words of the angel about her cousin Elizabeth, she decided to visit her, that she might rejoice with her and serve her. Therefore she went, alone with her husband Joseph, from Nazareth to her

21

15

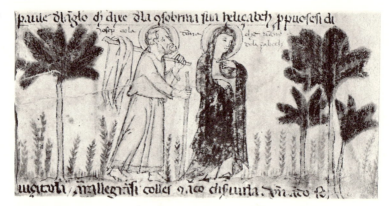

house, a distance of 74 or 75 (14 or 15) miles from Jerusalem. The roughness and length of the road did not delay her; instead she walked rapidly because she did not want to be long in the public view. Thus the conception of the Son had not burdened her, as usually happens to other women, for our Lord Jesus Christ was not heavy for His mother. Consider her therefore, the queen of heaven and earth, going alone with her husband, not mounted but on foot and not attended by horsemen, knights, or barons, or

16

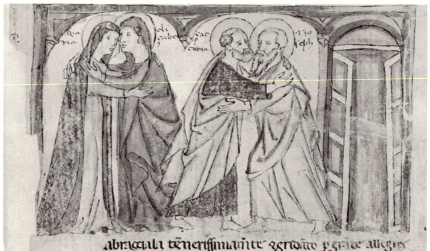

by groups of servants and handmaidens. Instead she was accompanied by poverty, humility, and shame, and all the honest virtues. The Lord is with her: a large and honorable assembly she has, but no worldly vanity or pomp! As she entered the house she greeted Elizabeth and said, "God be with you, my sister." Full of joy and happiness and animated by the Holy Spirit, Elizabeth rose and embraced her tenderly and cried in exultation, "Blessed are you among women and blessed is the fruit of your womb. And why is it that the mother of our Lord comes to me?" (Luke i, 42–43). That is, when the Virgin greeted Elizabeth, John, in the womb, became so imbued with the Holy Spirit that he communicated it to his mother, who had not felt it before. The abundance of grace in the child also filled the mother, for the Holy Spirit did not act on her soul even though something in her deserved sanctification. In John, the grace of the Holy Spirit was stronger than in the mother, therefore she heard Mary but he felt the Advent of the Lord and exulted, causing her to speak a prophecy. You see that the words of the Lady were so full of virtue that the Holy Spirit was invoked by their utterance. Because of her merits, she was overflowing with the Holy Spirit and imbued the others with it too. Mary replied to Elizabeth, "Magnificat anima mea dominum" etc. (Luke i, 46), "My soul magnifies the Lord," and completed the whole canticle of joy and praise. Then as they sat the Lady

17

humbly placed herself at the feet of Elizabeth, but Elizabeth would not suffer this and immediately raised her to

23

an equal position. They began to converse, and our Lady asked about Elizabeth's conception and Elizabeth about our Lady's, and they reasoned about these things, rejoicing together and praising God for both gifts, giving thanks and celebrating. The Lady stayed with Elizabeth for almost three months, aiding her and waiting on her in everything possible, with humility, reverence, and devotion, as though she had forgotten that she was the mother of God and queen of the whole world. Oh, the house, the room, the bed in which live and rest together the mothers of two such sons, Jesus and John! And those magnificent old men Zacharias

18

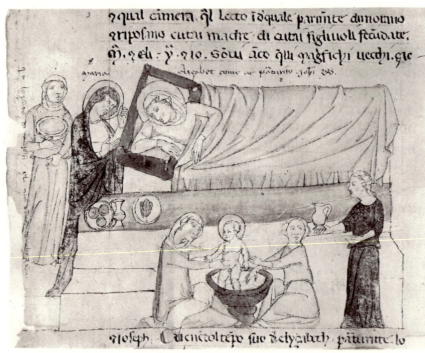

and Joseph are there also. When her time had come Elizabeth gave birth to the son whom our Lady lifted from

the ground and diligently cared for as was necessary. The
child loved her deeply, as though he understood her, and
even when she gave him to his mother he turned his face
to the Lady, delighting only in her. She played with him,
gaily embracing and kissing him with joy. Contemplate the
magnificence of the precious John! No one ever had a
nurse or governess like this; and he possessed many other
prerogatives of which I will not tell now. On the eighth day,
when the child was circumcised and named John, Zacha-
rias spoke and prophesied, saying, "Benedictus Dominus
Deus Israel" etc. (Luke i, 68), "Blessed be the Lord, the
God of Israel, for He has visited His people and wrought
their redemption." Thus two beautiful canticles were cre-
ated in this house, the Magnificat and the Benedictus. Our

19

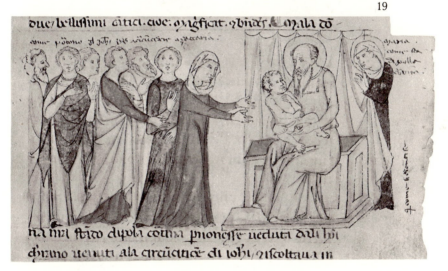

Lady, who was standing behind a curtain that she might be
invisible to the men attending the circumcision of John,
listened intently to the hymn in which her Son was men-
tioned and secured everything in her heart, most wisely.

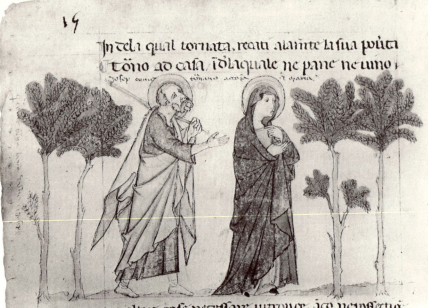

When all was done, (saying farewell to Elizabeth and Zacharias and blessing John,) our Lady wished to return to her house in Nazareth. Consider her poverty. She returned to a house in which she would find neither bread nor wine nor other necessities, and she had neither possessions nor money. For three months she had stayed with people who were perhaps wealthy, but now she and Joseph returned to their poverty and to the necessity of earning their living with their own hands. Feel compassion for her and kindle your love of poverty.

(VI.) *How Joseph Wished to Leave the Lady Secretly*
—MATT. i

While our Lady was living together with her husband Joseph, and Jesus was growing in His mother's womb, Joseph saw that she was pregnant and grieved inwardly. Now give heed, for you can learn many beautiful things. If

26

you ask why the Lord wished His mother to have a husband and yet remain always a virgin, I can answer with three good reasons: that she might not be in ill repute, though pregnant; that she might have the consolation of a husband's service and company; and thirdly that the appearance of the Son of God might remain concealed from the demon. Joseph observed his wife again and again, in great grief and trouble, his face agitated. Then he turned his eyes away, with evil

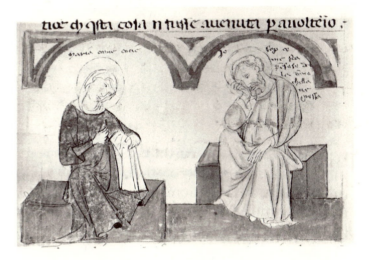

thought, suspecting this to have come about through adultery. Now you see how the Lord permits His own to be tormented by tribulations, and their crowns imperilled. Thus Joseph thought of leaving her secretly. Verily, one may say this, that the Gospel speaks his praises: it is said that he was a just man, of great virtue. Although it is commonly said that the adultery of his wife causes a husband great shame, sorrow, and wrath, Joseph virtuously restrained himself from accusing her, patiently disregarding the injury and not seeking revenge; but overcome by pity he wished

ſtudioſamnte ſitẽpaua ẽñlauolen accuſãt
mapaticteñnte paſſaua q̃ſta grãte iluria ñ
uẽdicãdoſi maunto di pieta uolẽto dalluogo
occultanite lauolen laſſare. Et ſco ladõna

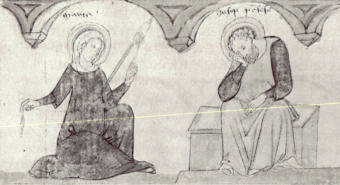

ñ paſſo q̃ſte coſe ſeſa tbulactõe. Et ella
molto lominnua / ẽuedẽtolo coſi torbato / ẽ
diſſto ella ãco ena tõbata. Ma ella come ſa
uiſſima humile ñnte tacen ẽoccultaua lodõno
dicho. iñmãti uolea eſſe reputata uile ẽ ña q̃
palegurlo / eduſe alauna coſa palẽ q̃ ad uãta
ñnto ſipoteſſe peſare q̃ ptemeſſe. Pregaua

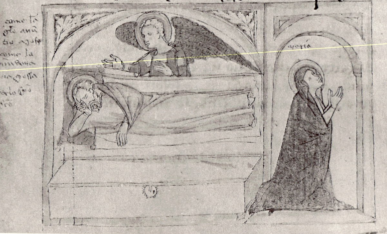

to leave her secretly. The Lady also experienced tribulations. She watched him and, seeing him distressed, became disturbed too. However, she was very prudent and humbly remained silent, hiding the gift of God. She would rather seem wicked and bad than divulge it, and would not speak anything of herself that might be mistaken for boasting. She prayed that God might deign to remedy this and alleviate the trials of her husband and herself. Consider their great tribulation and anguish. Our Lord God provided both the one and the other. Then He sent His angel to Joseph in his sleep to tell him that his wife had conceived by the Holy Spirit and that he should stay with her confi-

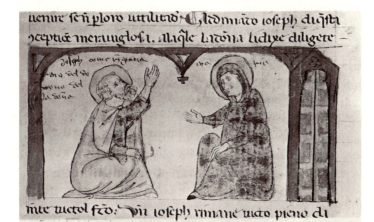

dently and happily. Thus his torment ceased and turned to great happiness. This would happen to us too, if we knew how to remain patient in the face of tribulation, for the Lord causes tranquillity to come after the storm. Do not be doubtful, because He permits nothing to reach His own that is not for their good. Joseph asked the Lady about this marvelous conception and she told him carefully the

whole thing. After this Joseph was full of great joy, and stayed with his blessed wife, loving her beyond what can be said, with deep and chaste love, and taking faithful care of her; and the Lady lived safely and happily together with him in their poverty. The Lord Jesus remained enclosed in the womb for nine months according to the human manner, benignly and patiently enduring and waiting for the proper time. Feel compassion for Him who reached these depths of humility! We must greatly desire this virtue and should never rise to pride, since the Lord of majesty has stooped so low that we can never sufficiently thank Him for this one benefit attained by such long imprisonment for us. But at least we are aware of this benefit in our hearts, and in great affection render thanks to Him that He has elected us above the others. Therefore we should requite Him for this short time and remain in His service alone, for it was not our merit but His benefaction that was great, very welcome and venerable. It is not as punishment but for security that we are confined in the most secure sacristy of religion, in which the poisoned arrows of this wicked world, the dangers of the stormy seas, cannot reach or seize us except through our own folly. Let us therefore try with all our power, our minds closed and separate from all evil and imperfect things, to contemplate Him with purity of heart, since without the aid of the intellect, corporal restraint is worth little. Feel compassion for the Lord Jesus, (who is in continuous affliction, and was from His conception) until His death, in this too: that His father, whom He loved above all, knew that He would be abandoned in favor of idols and abused by sinners, and that He took pity on the souls created in His image, whom He saw so wretched and almost universally damned. And this was greater pain to Him than the corporal passion, for to relieve the one He endured the other. See the delicious food prepared for you here: to taste its sweetness you must chew it diligently and delight often in these beautiful and devout things.

When nine months had passed, the emperor issued a proclamation that the whole world should be registered, that is, everyone should go to his city.[13] Wishing to obey the command, Joseph started on his way with the Lady, taking with him an ox and an ass, since the Lady was

25

pregnant and the road five miles long from Bethlehem to Jerusalem.[14] And thus they went like poor merchants of beasts. When they arrived in Bethlehem they could not find an inn, because they were poor and many others had come for the same purpose. Have pity on the Lady, and watch the delicate young girl, for she was only fifteen years old, as she walks ashamed among the people, fatigued by the journey and looking for a place to rest but not being able to find it because of the crowds. By all they were sent away,

31

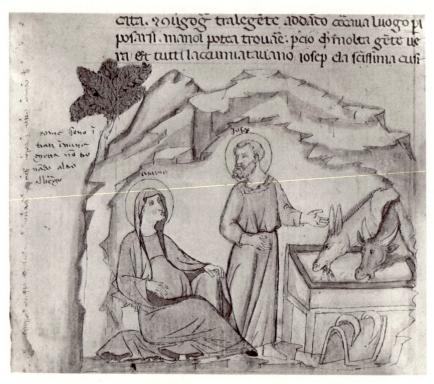

the holy childlike Lady and the old man Joseph, her hus-
band. When they saw an empty cave that men used when
it rained, they entered to lodge themselves.[15] And Joseph,
who was a master carpenter, possibly closed it in some way.
Now pay careful attention to everything, especially as I in-
tend to recount what the Lady revealed and disclosed, as
told to me by a trustworthy holy brother of our order, to
whom I think it had been revealed.

At midnight on Sunday, when the hour of birth came,
the Virgin rose and stood erect against a column that was
there. But Joseph remained seated, downcast perhaps be-
cause he could not prepare what was necessary. Then he
rose and, taking some hay from the manger, placed it at

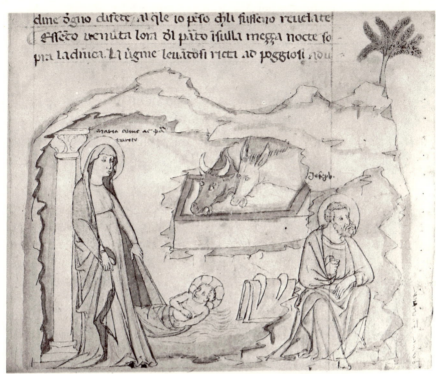

the Lady's feet and turned away. Then the Son of the eternal God came out of the womb of the mother without a murmur or lesion, in a moment; as He had been in the womb so He was now outside, on the hay at His mother's feet. Unable to contain herself, the mother stooped to pick Him up, embraced Him tenderly and, guided by the Holy Spirit, placed Him in her lap and began to wash Him with her milk, her breasts filled by heaven. When this was done, she (wrapped Him in the veil from her head and) laid Him in the manger. The ox and the ass knelt with their mouths above the manger and breathed on the Infant as though they possessed reason and knew that the Child was so poorly wrapped that He needed to be warmed, in that cold

season. The mother also knelt to adore Him and to render thanks to God, saying, "I thank you, most holy Father, that you gave me your Son and I adore you, eternal God, and you, Son of the living God, my Son." Joseph adored Him

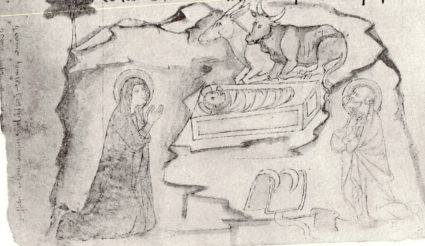

likewise. Then he took the pack-saddle of the ass and pulled

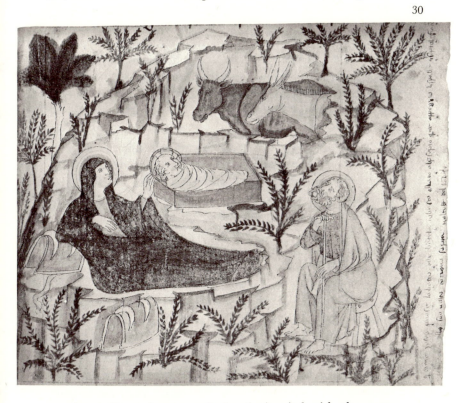

out the stuffing of straw or hair, placing it beside the manger that the Lady might rest on it. She sat down and he put the saddle at her side. Thus the Lady of the world stayed, her face turned constantly toward the manger, her eyes fixed affectionately on her sweet Son. Here ends the revelation.

Having thus shown these things, the Lady disappeared and the angel remained to speak great praises, which he told me, but I did not have the presence of mind to learn them or write them down. Now you have seen the rise of the consecrated prince. You have seen likewise the delivery of the celestial queen, and in both cases you were able to

consider the most dire poverty, for they were in need of many necessary things. The Lord found this the highest virtue; this is the heavenly pearl for which it appears one must exchange everything (Matt. xiii, 46). It is the main foundation of the whole spiritual edifice. The spirit cannot rise to God under the weight of temporal things. On this the Blessed Francis said, "Brothers, you know that poverty is the peculiar road of salvation, for it is the nourishment of humility and root of perfection, whose fruit is abundant but secret." Thus it is to our great shame and injury that we do not embrace it with all our might, but are bowed down by the superfluous, when the Lord of the world and the Lady, His mother, observed poverty so rigidly and diligently. Bernard in his sermon after the vigil of the Nativity of the Lord says this: "This beauty abounded on the earth and man did not know its price. Since the Son of God desired the Lady, He descended to unite her to Himself and to us and to make her precious to us in His estimation. Adorn your room with humble arts and poverty. This vestment is suitable and, with Mary as witness, these clothes of silk are delightful wrappings. Sacrifice the abomination of the Egyptians to your God" (Exod. viii, 26).[16] This was said by Bernard. He also says, in the fifth sermon on the Nativity, "Finally His people were consoled. . . . Do you wish to know His people? 'The people are abandoned to you' (Psalm [x], 14), says the man according to the heart of God. And it says in the Gospel, 'Woe upon you who are rich, for you have your consolation here' (Luke vi, 24). . . . Why should He console those who have their consolation? The infancy of Christ does not console the garrulous; the tears of Christ do not console the jeering ones; His rags do not console those who wear ornate clothes; the stable and the manger do not console those who love the first seats in the synagogue. . . . To the shepherds who watched is announced the joy of the light and to them it is told that the Savior is born; to the poor and to those who work hard, not to you

who are rich and have your consolations but have abandoned divine joy. . . ." [17] So Bernard says. You were able to observe in both examples a profound humility in this Nativity, which did not disdain the stable or the beasts or the hay and the other ignoble things. This virtue lies in their every action, and the Lord and His mother observed it faultlessly and commend it to us. Let us try with all possible zeal to embrace it, for without humility there is no salvation. Nothing done with pride can be pleasing to God. According to the Blessed Augustine, "Pride makes angels resemble demons and humility makes men like the angels." [18] And Bernard, before the vision of Isaiah: "What man do you think must be found, who chooses the place of the rejected angel? . . . Once pride disturbed that rule and shook the walls, even throwing not a small part to the ground. Therefore what can we say? . . . Now, does He not hate that city and abhor that pestilence violently? You may be certain, brothers, that He who did not pardon the arrogant angels will not pardon men, for He does not contradict Himself." [19] So Bernard says. You were also able to see in the one and the other and especially in the infant Jesus no small corporal affliction. On this Bernard speaks in the third sermon on the Nativity of the Lord: "The Son of the Lord is born, in whose power it was to choose any time He desired, and He chose what was most tormenting, especially for a child, to be the son of a mother who could not swaddle Him but with the most wretched clothes, who hardly had rags to wrap Him in, and who had to place Him in a manger. Since they lacked all necessities there can be no mention of skins." Further he says, "Christ, who is no deceiver, elected that which is most mortifying to the flesh. Therefore this is the best, the most beneficial, the most desirable, and if anyone teaches or counsels differently, one must safeguard oneself from him as from a deceiver." And again he says, "And I tell you, brothers, this was foretold by Isaiah, 'This is a child who knows how to refuse evil and

elect the good' (Isa. vii, 14–16). For evil follows the desire of the body and the good is its affliction. And the wise Child, the infant Word, steadfastly elects the latter and rejects the former." [20] So Bernard says. Go and do likewise, but with discretion, that you may not pass beyond your powers; of these virtues we may be able to speak another time. Let us return to the Nativity of our Lord.

When the Lord was born a great multitude of angels came around Him, to adore their Lord. One went swiftly to the shepherds who were nearby, about a mile away, to announce the Nativity and also the place. Then they flew to heaven with songs and gladness to announce these things likewise to their companions in the celestial city. The whole supernal court rejoiced and celebrated, praising God the Father and rendering thanks to Him. All the ones who were there came in the order of their rank to see the face of their Lord God. They adored Him and also His mother with great reverence, singing praises and hymns. Which one of them on hearing the exalted news would have remained in heaven and not visited the Lord, so humbly come to the earth? None would have succumbed to such pride. Therefore the apostle in the first (chapter) to the Hebrews says, "And when He brings His firstborn into the world, He says, 'May all the angels of God adore Him'" (Heb. i, 6). I think it is pleasant to contemplate this scene of the angels, regardless of the truth of the matter. The shepherds also came to adore Him, relating what they had heard from the angel; and the mother wisely kept these things in her heart. Then they went on their way cheerfully. You too, who lingered so long, kneel and adore your Lord God, and then His mother, and reverently greet the saintly old Joseph. Kiss the beautiful little feet of the infant Jesus who lies in the manger and beg His mother to offer to let you hold Him a while. Pick Him up and hold Him in your arms. Gaze on His face with devotion and reverently kiss Him and delight in Him. You may freely do this, because

He came to sinners to deliver them, and for their salvation humbly conversed with them and even left Himself as food for them. His benignity will patiently let Himself be touched by you as you wish and will not attribute it to presumption but to great love. But always do these things with veneration and fear, for He is the Saint of saints. Then return Him to the mother and watch her attentively as she cares for Him assiduously and wisely, nursing Him and rendering all services, and remain to help her if you can. Rejoice in

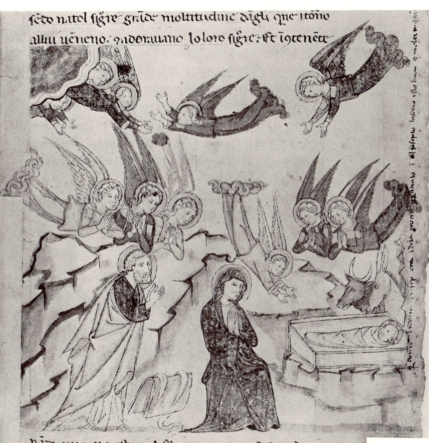

these events and think of them continually; familiarize yourself as much as you can with the Lady and the boy Jesus. Look often at His face, on which the angels wish to gaze, but, as I said before, do this always with reverence and love, that you may not be driven away, since you must consider yourself unworthy of conversing with such as He.

You must also think with joy of the solemnity of the day. Today Christ is born and today is truly the Nativity of the eternal King and of the Son of the living God. Today the Son is given to us and the Boy is born for us (Isa. ix, 6). Today the Sun of justice, which had been hidden behind clouds, shines brightly. Today the Bridegroom of the Church, the Head of the elect, has left His chamber. Today

He showed His longed-for face, He who is beautiful above all the sons of men (Psalm xliv, 3). Today is made the angelic (hymn), "Et gloria in excelsis deo." Today peace is announced to men, as is said in this hymn. Today, since

the Church chants throughout the world, the skies become mellifluent, full of sweetness, and on earth the angels sing. Today for the first time there appear the benignity and hu-

manity of our divine Savior (Titus iii, 4). Today God is adored in the likeness of sinful flesh. Today those two miracles came about that transcend all understanding and can be perceived only by faith: that God is born and that a virgin gives birth. Today countless other miracles resplend. And lastly all things foretold in the Incarnation shine almost more brightly. Here is the beginning; here is the manifestation. See it in this way; turn your thoughts to it. This (day) is worthy of jubilation, gladness, and great exultation.

(VIII.) *Of the Circumcision of Our Lord Jesus Christ* — LUKE ii

34

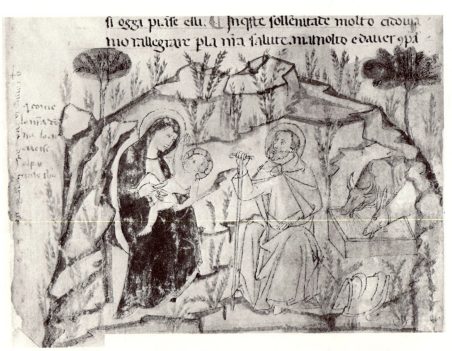

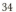

On the eighth day the Boy was circumcised. Two great events occurred today. The one is that the name of salva-

tion is revealed, that is, Jesus, which had been eternally
established and had been uttered by the angel before He
was conceived in the womb. Today it was revealed and
named and He was called Jesus and Jesus is called the Sa-
vior. This name is superior to every other (Phil. ii, 9), and,
as is stated by the apostle Peter, there is no name under
heaven by which we can be saved other than this one (Acts
iv, 12). The second event is that today our Lord Jesus
Christ began to shed His consecrated blood for us. From
the very first, He who had not sinned began to suffer pain
for us, and for our sins He bore torment. Feel compassion
for Him and weep with Him, for perhaps He wept today.
On this feast we must be very joyful at our salvation, but
have great pity and sorrow for His pains and sorrows. In
the Nativity, you heard how much affliction and discom-
fort He bore. Among them was this, that when the mother
laid Him in the manger she placed a stone under His head,
with perhaps a little hay on top between it and the stone,

35

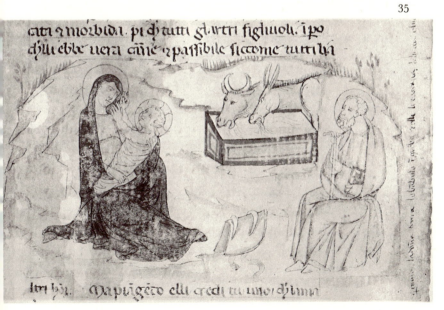

as I heard from one of our brothers who saw it: this stone is still to be seen to commemorate the fact. You must believe that she would much rather have used a feather pillow if she had had it, but having nothing else she put the stone there, with sorrowful heart. And hear that today His precious blood flowed. His flesh was cut with a stone knife by His mother.[21] Must one not pity Him? Surely, and His mother also. The child Jesus cries today because of the pain He felt in His soft and delicate flesh, like that of all other children, for He had real and susceptible flesh like all other humans. But when He cries, do you think the mother will not cry? She too wept, and as she wept the Child in her lap placed His tiny hand on His mother's mouth and face as though to comfort her by His gestures, that she should not cry, because He loved her tenderly and wished her to cease crying. Deeply stirred, in sorrow and tears for her Son, she in turn consoled Him with gestures and words. Most intelligently she understood His desires, even though He could not yet speak, and she said, "My son, if you wish me to cease from weeping, you must not cry, for as long as you cry I shall too." Then out of pity for the mother the Child stopped sobbing. And the mother wiped His eyes and hers, laid her cheek on His, nursed Him, and comforted Him in every way she could. This she did whenever He cried, as perhaps He often did, according to the custom of children, to show the misery of the human nature that He had truly taken, and also to conceal Himself, that He might not be recognized by the demon. Of Him the Church sings, "Vagit infans inter arcta" etc., "The Child placed in the narrow manger suffers." From that time corporal circumcision was abolished and we have baptism, of more grace and less pain. But we must undergo spiritual circumcision, that is, refuse all superfluous things. This is what commends poverty: the truly poor is really spiritually circumcised. This, according to Bernard, the apostle relates in a few words, saying, "Habentes victum et vestimentum his

contenti simus," "Having food and clothing we must be content with these things." [22] Moreover, spiritual circumcision must occur in all the senses of our body; in seeing, hearing, tasting, and touching we must exercise temperance, and especially in speaking too much.

(Loquacity) is the worst vice, odious and displeasing to God and men. Therefore we must be circumcised in the tongue, that is, speak few and only necessary things. It is a mark of levity to speak much, while silence is virtuous and for good reason is commanded in religion. The Blessed Gregory says the following about this matter: "Ille loqui veraciter novit, qui prius bene tacere didicerit. Censura cum silentii est verbi necessarium instrumentum," "He truly knows how to speak who has first learned silence. The judgment of silence is the necessary instrument of speech." [23] And he says elsewhere, "Qui sensu leves sunt et in locutione praecipites (erunt): quia quod levis conscientia concipit, levius protinus lingua promit," "Those who are light in judgment are fluent in speech: what the light conscience conceives, the tongue produces more easily." [24] On this, Bernard in the sermon on the Epiphany also speaks: "The Lord says how much the tongue of him who does not know soils by vain speech, lies, deceit, and flattery, words of malice or boasting. For all these things it is necessary to have the fifth hydria, that is, silence, as guardian of religion, in which our strength rests." [25] And in another place he says, "Idleness is the mother of folly and stepmother of virtues. Among laymen mockery is idle talk, but in the mouths of priests it is blasphemy, and if derision may occur by chance, it may be borne, but it should never be relayed. Consecrated men, the lips of the Gospel, should not permit these words to issue from their mouths." [26]

(IX.) *Of the Epiphany or Manifestation of Our Lord Jesus Christ*—MATT. ii

On the thirteenth day the boy Jesus manifested Himself

to the gentiles,[27] that is, to the Magi, who were pagan. Mind this well, for you will scarcely find another feast as solemnized by the Church with beautiful sermons and other things pertaining to festivity as this one, not because it is the most important but because many great things were accomplished on this day for the Lord Jesus and especially concerning the Church.

The first is that today the Church is received by Him in the person of the Magi, since the Church is assembled from the gentiles, that is, the pagans. On the day of His birth

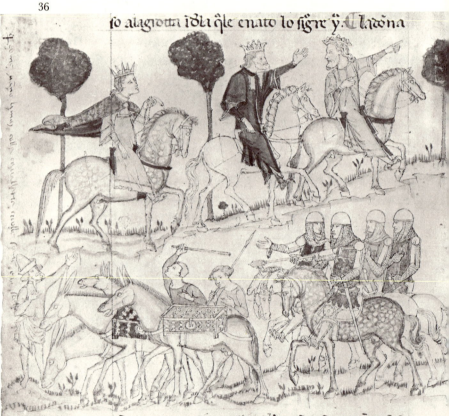

fo alagioan ioli qle enato lo figre y. Cllacona

fere loromā oi ciualli røle gēte/ī meņēte pfr lo picaolo babulino q recofelo īgreło. elli mai

He appeared to the Jews, as personified by the shepherds, but only a few of the Jews received the Word, that is, the Son of God. Today He appears to the gentiles, or pagans, and this is the Church of the elect. For this reason, today's feast is really the feast of the Church and of the faithful Christians.

The second is that the Church is today wedded to Him and truly united by the Baptism, which He received on the same day when He was twenty-nine years old. Thus we sing joyfully, "Hodie caelesti sponso juncta est ecclesia" [37]

etc., "Today the Church is joined to the celestial Bridegroom." [28] Through baptism, souls are wedded to Christ, who received virtue through His Baptism; the congregation of baptized souls is called the Church.

47

The third is that on this day, a year after the Baptism, He performed the first miracle, at the marriage, which can also be related to the Church and to spiritual marriage. It is also said that on the same day He effected the miracle of the multiplication of loaves and fishes, but the Church presents only the first three events on this day. You see therefore how venerable is this day, on which the Lord elected to perform so many marvelous and magnificent things, when you consider that today the Church received these many great benefits from her Bridegroom, and on this day she wishes you to celebrate with joy and exultation and great solemnity.

Now we shall speak of the first event, for it is more fitting to tell of the others in their order in the life of Christ. Of the first event, that is, the coming of the Magi to Christ, I do

not intend to narrate the morality and the exposition that have been so diligently presented by the saints. To learn how the Magi came from the Orient to Jerusalem, how Herod dealt with them, how they were guided by the star, why they made their offerings, and the other things that are part of this matter, read the text of the Gospel and the expositions of the saints and you will find all. As I said at the beginning, in this and other events of the life of Christ, I intend to recount a few meditations according to imagined representations, which the soul can comprehend differently, according to how they happened and how they can be credible in a holy manner. Rarely will I impede my

exposition with narration, for I am inadequate for this and also because my work would become too long. Therefore be present at this event and be attentive to everything, for, as I have said before, herein lies the whole strength of these contemplations.

These three kings came with a great multitude and a noble following to the vicinity of the cave in which the Lord Jesus was born. The Lady heard the sounds of the horses and the people and, quickly taking the tiny Child, gathered Him into her lap. The Magi, arriving at the holy cave, dismounted, entered, and knelt impulsively before the Boy, adoring Jesus reverently, honoring Him as King and worshipping Him as God. You see how great was their faith, which asked them to believe that this Child, so scantily clothed and found with His poor mother in so wretched a place, with no attendants or family, and lacking all furnishings, was King and true God. And yet they believed both. These kings remained kneeling before Him, conversing with the Lady, for they were very wise and perhaps knew the Hebrew tongue. They asked her about the

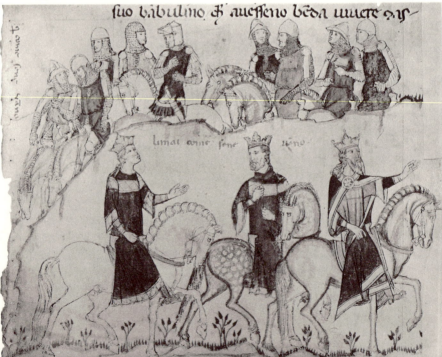

condition of this Child and believed everything the Lady related. Regard them well as they reverently speak and listen; and see also the Lady as, with great modesty in speech, her eyes always turned to the ground, she finds no pleasure in speaking much or in being seen. But God gave her strength for her great task, for the kings represented the universal Church that was to come from the pagans. Behold also the child Jesus, who does not speak as yet, but watches them benignly, with maturity and gravity, as though He understood them; and they delighted in Him, instructed by inward vision and illuminated (by His appearance), for He was beautiful above all the children of men. Finally, having received great comfort, they offered gold, incense, and myrrh. Opening the strong-boxes and ordering a rug spread at the feet of the Lord Jesus, each one offered Him gifts in great quantities, as otherwise, for a small gift, they would not have needed to open their treasuries but their seneschals would easily have had it at hand; and with reverence and devotion they kissed His feet. Perhaps at this the judicious Child gave them His hand to kiss and blessed them to give greater solace and to fortify them in their love for Him. They bowed and joyously took leave, returning to their country by a different road. What would you have done with the gold they offered, which was of great value? Did the poverty-stricken Lady keep it for herself, her old husband, and the little Child, that they might have the means to live, to spend or to save or to buy houses, fields, vineyards? God forbid that those devoted to poverty should concern themselves with these things. Since the Lady deeply longed for poverty and understood the desire of the Child, who taught her inwardly as well as by showing His desire by signs, perhaps by turning His face away from the gold in disdain, she distributed everything to the poor within a few days. It was too big a burden to keep or to delay in giving away, therefore she dispersed it all; for when she entered the temple she had

nothing left for purchasing the lamb to offer for the Son and bought turtledoves or pigeons. Thus it is reasonable to believe that the gift of the Magi was very generous, and that the Lady, desiring poverty, charitably gave it all to the poor.

Their poverty was made public in two ways, as you will see now. The first was that today the child Jesus and also His mother received alms like poor people. The second, that not only were they indifferent about acquiring and gathering what had been given them, but they did not want to keep it; and their desire for poverty continued to grow. But you have not yet heard about their humility: pay attention to see how their humility grew. There are some who consider themselves mean and offensive in their own souls and do not rise to pride in their own eyes, but who do not wish to be likewise considered by others and will not endure to be looked at as base or to be mocked by

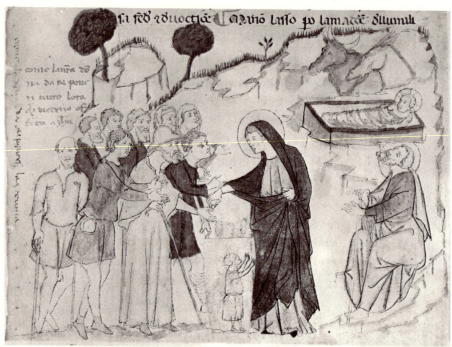

others and do not want their baseness and defects to be revealed to others, that they may not be loathed by them. The child Jesus, the Lord of all, did not act thus but wished to show his misery, not to a few insignificant people but to many and great ones, to the kings and their retinue. This was a venturesome thing in this time and place. Those who had come to find the King of the Jews, whom they believed also to be God, might doubt after having seen Him in this way and consider themselves fooled and deceived and have left without faith and devotion. But He who loved humility did not turn away from it but set an example for us that, even when faced by an apparent good, we should not part from humility but learn to appear vile and contemptible in the eyes of others.

(x.) *Of the Stay of the Lady at the Manger*

42

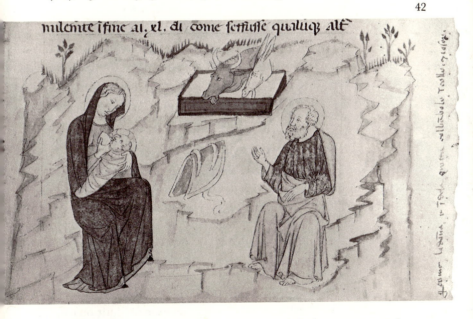

When the Magi had left to return to their country and all their gifts had been distributed among the poor, the

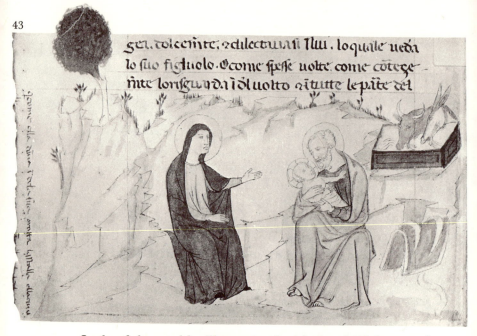

Lady of the world still remained with the child Jesus and
the foster father, the saintly old Joseph, at the manger in
the cave, patiently and humbly waiting, for forty days, as
though she were like any other woman of her people and
the boy Jesus an impure[29] human who must observe the
law.

Since they did not want special favors, they obeyed the
law like all others. There are many who, living in a com-
mon congregation, do not do this but ask for special pre-
rogatives and expect to be distinguished from the others as
being more honorable. But true humility will not suffer
such things, and therefore the Lady behaved according to
the custom of others, awaiting the proper day for entering
the temple. Solicitously and intently she watched over the
care of her beloved Son. O Lord, with how much concern
and diligence she nursed Him, that He might not have the
least trouble! And with how much reverence, caution, and
saintly fear did he who knew it was his God and Lord
treat the Child, kneeling to take Him and put Him back

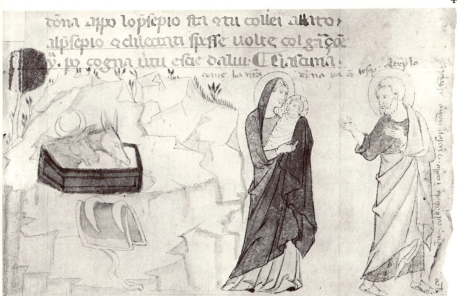

into the manger! With how much happiness, confidence, and motherly authority did she embrace, kiss, gently hug, and delight in Him whom she saw as her son! Oh, how often and how gently she looks at His face and all parts of His most holy body! How regularly and skillfully she placed the tender limbs while swathing them! As she was most humble so she was most prudent. In all offices and services, waking and sleeping, she continually ministered to Him, not only to the infant but also to the man. How readily she nursed Him, feeling a great and unknown sweetness in nursing this Child, such as could never be felt by other women! And of the saintly old Joseph the Blessed Bernard relates that he often held the child Jesus on his knees, laughing and playing with Him, and comforting Him.

Thus the Lady remains at the manger, and you stay with her at its side, delighting in the boy Jesus, for all virtue comes from Him. Every faithful soul and especially a religious should visit the Lady at the manger at least once daily in the period between the Nativity of the Lord and

the Purification, to adore the infant Jesus and His mother, thinking affectionately of their poverty, humility, and benignity.

(XI. *Of the Purification of the Blessed Virgin*)

When the forty days prescribed by the law were over, the Lady came out with the boy Jesus and Joseph and

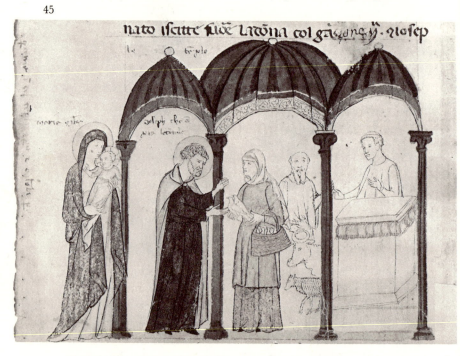

went from Bethlehem to Jerusalem, which was five miles, that they might offer Him to the Lord according to the law. You go with them and help to carry the Boy and observe attentively everything they say and do, because they are most pious. They bring the Lord of the temple to the temple of the Lord. Having entered the temple they bought (two) young doves or pigeons to offer, as befits the poor to do. Since they were destitute, it is more likely that they

chose young doves, that is, pigeons, for these are found more
easily and at a lower price and therefore are placed last in
the law; and the evangelist does not mention lambs, which
were offered by the wealthy. Behold Simeon the just, com-
ing by the Spirit into the temple so that, since he had re-
ceived the reply, he might see the Christ of God. He came
in haste and when he had seen Him he immediately recog-
nized Him by the spirit of prophecy and hurriedly knelt to
adore Him in His mother's arms. The Boy blessed him
and, looking at His mother, bowed to show that He wished
to go to Simeon. Realizing this, the mother marvelled and

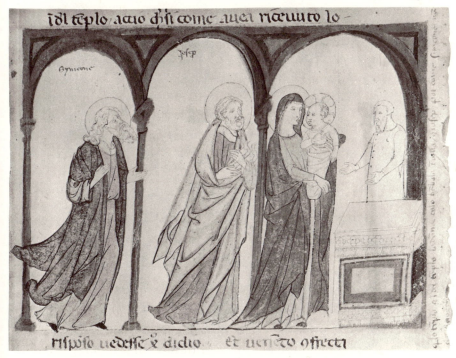

handed Him to Simeon. With joy and veneration he re-
ceived Him in his arms and rose to bless God, saying,
"Nunc dimittis servum tuum, Domine" etc. (Luke ii, 29);
and he prophesied His Passion. Anna the prophetess came

and also adored Him and spoke of Him in the same manner. The mother wondered at these things and kept them all in her heart. Then the boy Jesus stretched His arms

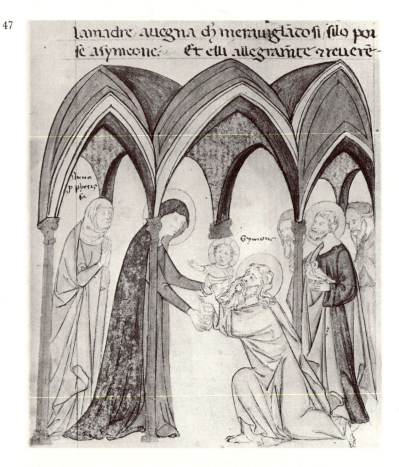

lamadre auegna dj meuuigtaco si silo por se asymeone: Et ell allegramte greuere

toward His mother and returned to her. After that they walked around the altar in a procession that is today performed in the whole world. First there came the two venerable old men, Joseph and Simeon, holding hands, exultant, and singing with great joy, "Confitemini Domino, quoniam bonus" etc. (I Chron. xvi, 34, etc.), "Praise God, for He is

good, for He gives His mercy eternally"; "Fidelis Dominus in omnibus verbis suis" etc. (Psalm cxliv, 13), "Faithful is the Lord in all His words"; "Quoniam hic est Dominus

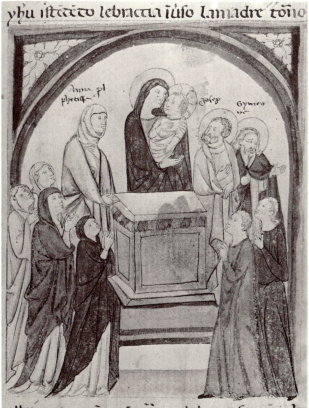

Deus noster in aeternum et in saeculum saeculi ipse reget nos in saecula" (Psalm xlvii, 15), "For this is the Lord God of ours in eternity and in the time of times He will rule us forever, that is, always"; "Suscepimus Deus misericordiam tuam, in medio templi tui" (Psalm xlvii, 10), "O God, we have received your mercy in the midst of your temple";

"Confitemini Domino, quoniam bonus" etc. There followed the virgin mother carrying King Jesus, accompanied by Anna walking at her side, jubilating with reverence and praising the Lord in great happiness. These comprised the procession, few but great people representing almost every kind, for among them there were men and women, old and young, virgins and widows. Turning to the altar, the mother knelt in veneration to offer her beloved Son to God His Father, saying, "Take Him, most excellent Father, your only Son, whom I present to you according to the commandment of your law, for He is the first-born of His mother; and I pray you, Father, to give Him back to me." Rising, she placed Him on the altar.

O God of truth, what an offering is this! Never in eternity was there one like this nor ever will there be one. Observe

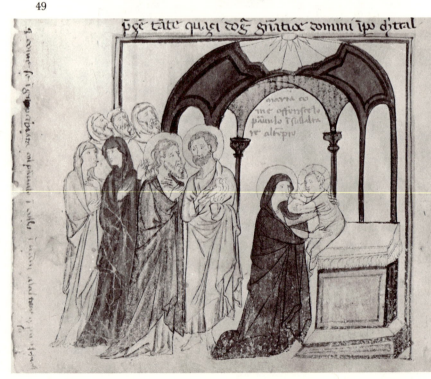

everything well: the infant Jesus on the altar, like any other child, gazing at His mother with mature face, meekly and patiently awaiting what He had to do next. There were priests in the temple, and the Lord of all was bought back like a slave for the price of five shekels, according to the custom of the others. When Joseph had paid the shekels, which are coins, to the priests, the mother joyfully took back the Son, and also taking the aforementioned birds from (the

50

29.

cu sauno altro bäbulo ẓo facea matura mura la
madre huilesitte ẹpaneteritte. ꝗllo dȝ da ite män
dbbia fait. Giano lispiti ʃ̃ol tẽplo. ꝑ eticõpato losi
g̃re di tutti come ſuo dꝩ. ſecli ſedol coſtume d̃lualt:

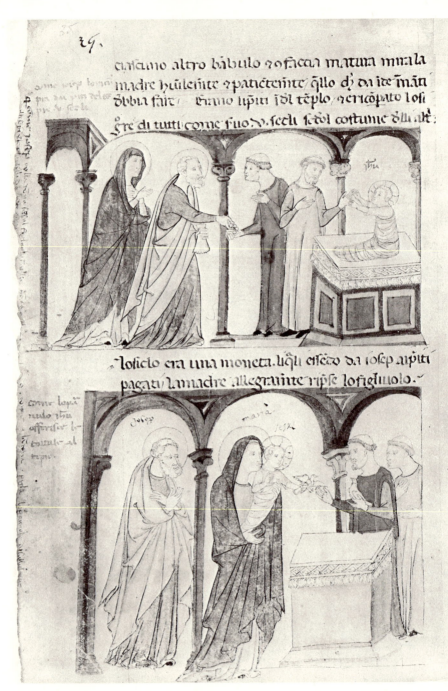

.Iosiclo era una moneta. liꝗ li eſſeēo da ioſep aꝑiti
pagati. La madre allegraurte riꝓſe loſigluiolo.

hand of) Joseph she knelt, holding them in her hand, and
with eyes raised to heaven, offered them and said, "Receive,
most merciful Father, this offering and small present, the

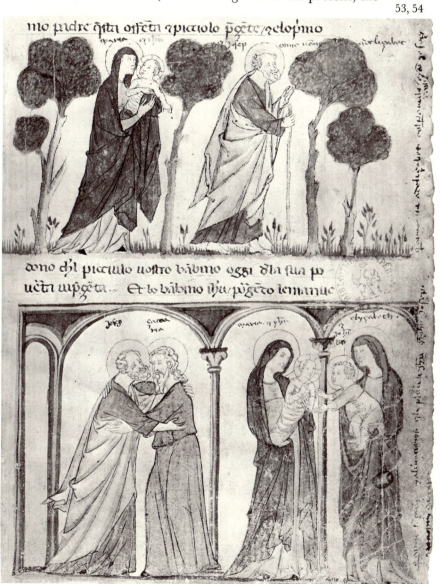

first gift which in His poverty your small Child today gives to you." And the infant Jesus reached out His hands to the birds and lifted His eyes up to heaven and, although He did not speak, by His gestures He offered them and together with His mother placed them on the altar. You have heard what donors are this mother and Son. Could it not be that this sacrifice, so very small, would be refused? No, God forbid, in fact it was presented by the hands of angels in the

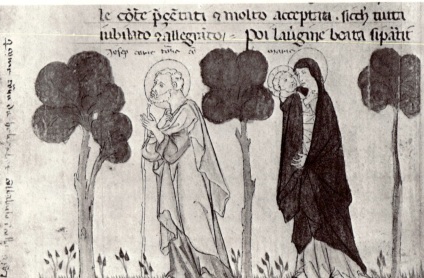

supernal court and readily accepted to the exultation and joy of all. Then the Blessed Virgin departed from Jerusalem and went to Elizabeth, wishing to see John before leaving that region. Go always with her wherever she goes and help to carry Jesus. When they arrived there was great festivity, especially about their children. The children made merry together; John, as though understanding, reverently approached Jesus. You also receive John with reverence, for the boy is great (in the sight) of God; perhaps he will bless

you. When they had stayed a few days in that district, they left, wishing to return to Nazareth. If you desire to learn about humility and poverty, consider in the aforementioned events the donation, the redemption, and the observation of the law and you can easily perceive them.

56

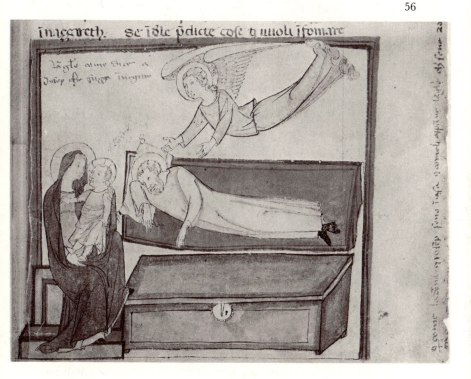

(XII. *Of the Flight of the Lord into Egypt*)

Since the plan of the Lord was not yet known to them on their return to Nazareth, the angel of God appeared in a dream to Joseph to say that the Boy and His mother should flee to Egypt, for Herod was preparing to take the life of the Child. Joseph woke up and aroused the Lady to tell her of the vision. She rose impetuously and without delay to start out, deeply shaken by this news and not

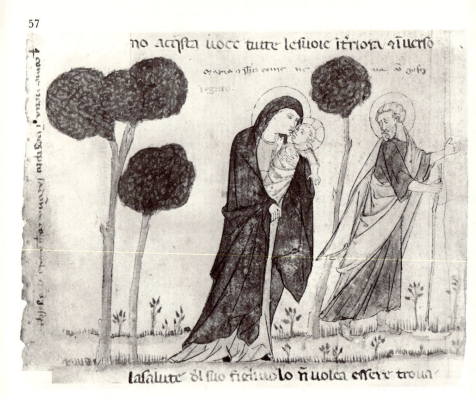

lafalute ōl fuo fieiiuolo ñ uolca effeŋe troua

wishing to neglect the well-being of her Son. Thus they
started toward Egypt during the night. Consider and medi-
tate on what is said above and written below, how they lift
the sleeping boy Jesus, and have pity on them. Listen atten-
tively, for there are many good things to examine here. First,
note how the Lord receives prosperity and adversity in His
person, so that when you are similarly visited you will not
be impatient. Beside the mountain you will find the valley.
Behold how at His Nativity Christ was extolled by the
shepherds as God and then shortly after circumcised as a
sinner. Then the Magi came to honor Him highly, and yet
He remained in the stable, among the animals, and crying,
like the son of any man. Later He was presented in the
temple, greatly exalted by Simeon and Anna, and now the
angel said that He should flee to Egypt. You can meditate
on many such events which are designed for our discipline.

Thus when you undergo tribulation, await consolation: we must neither rise to pride nor give way. The Lord gives consolations to raise hopes, that we may not falter under the weight of tribulations, and to keep us in humility, so that, knowing our distress, we live always in fear and love of Him. Thus it was to teach us that He did this and also to hide from the devil.

In the second place, meditate on the benefits and solace of God and that he who receives them should not consider himself superior to those who do not, and he who does not have them should not become indignant in his soul and envy those who have received them. I say this since the angel made the revelations to Joseph and not to the Lady, although he was much inferior to her. Even he who receives them does not do so through his own will and should not be ungrateful and complain, since even Joseph, who was so great before God, did not receive the messages in a manifestation but in a dream.

Third, consider how the Lord permits His friends to be tormented by persecution and tribulation. It was a great tribulation for the mother and Joseph to see the Child demanded and hunted to be killed. What more serious thing could they have heard? It was a greater tribulation in that they knew that He was the Son of God; nevertheless they might be deeply disturbed and say, "O Lord, almighty God, why is it necessary for your Son to flee? Could you not defend Him here?" It was also grievous that they had to go to a distant country of which they knew nothing, by rugged roads which were difficult for our Lady on account of her youth and for Joseph because of his age, and also because of the sweet Infant, not yet two months old, whom they had to carry. They had to wander in a strange land, poor, having almost nothing. Thus when you are suffering, remain patient: all these are causes for affliction. Do not think He will grant you a privilege He did not give to Himself or His mother.

Finally, reflect on the benignity of the Lord in having to sustain persecution so soon and in such a way. Fleeing, expelled from His native land, He yielded benignly to the wrath of him whom He could have destroyed in an instant. Deep is this humility and great this patience. He did not want to counter with force or offense, but avoided His abuse by flight. We must do likewise toward those who quarrel with us or reproach us or persecute us, by not resisting or wishing revenge but patiently bearing them and yielding to their anger, and moreover praying for them, as the Lord says elsewhere in the Gospels. Thus the Lord fled before the face of His servant, or rather the servant of the devil. He was carried to Egypt by the very young and tender mother and by the aged, saintly Joseph, along wild roads, obscure, rocky, and difficult, through woods and uninhabited places —a very long journey. It is said that couriers would take thirteen or fifteen days; for them it was perhaps two months or longer. They are also said to have gone by way of the desert, which the children of Israel traversed and in which they stayed forty years. How did they carry food with them? And where did they rest and spend the night? Very seldom did they find a house in that desert. Have pity on them, for it was a very difficult, great, and long exertion for them as well as for the child Jesus. Accompany them and help to carry the Child and serve them in every way you can. It should not seem such an effort to do penance for ourselves when we have received the labor of such as these, and so often. I shall not trouble to relate what happened to them in the desert and on the road, since few authentic things are known. When they entered Egypt all the idols of that province fell and broke, as was prophesied by Isaiah. They went to a city called Huiusmopolis (Heliopolis), rented a small house, and stayed there for seven years as pilgrims and strangers, poor and needy.

Here there comes a beautiful, pious, and compassionate meditation. Make careful note of the following things. How

did they live all this time, or did they beg? We read that she provided the necessities for herself and the Son with spindle and needle; the Lady of the world sewed and spun for money, for love of poverty. They loved poverty deeply and remained faithful to it till death. Did she not go from house to house asking for cloth or spinning-work? It was

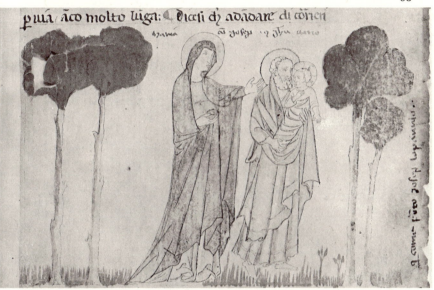

necessary to make it known in the neighborhood; otherwise she would remain without this work, since the other women could not guess. But when they found out, they gave her sewing and spinning to do. When the child Jesus was five, did He not become His mother's messenger, asking whether there was any work she could do? Yes, as she had no other servant. Did He not return the finished work and ask for payment for His mother? Is He not ashamed of this, the boy Jesus, Son of the exalted God? And also His mother, in sending Him? What shall we say if at times, when He had returned the work and asked for the price, some arrogant, quarrelsome, talkative, or scolding woman replied abusively,

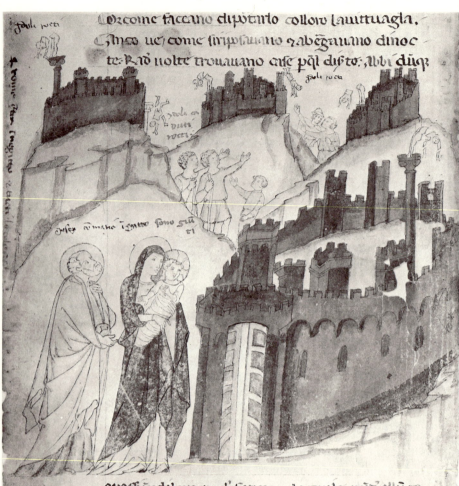

taking the finished work and driving Him away without pay-
ment, and He had to return home empty-handed? Oh, how
many different injuries were done these strangers! But the
Lord had come not to avoid them but to receive them.
What shall we say if sometimes He returned home hungry,
like other small children, and asked His mother for bread,
and she had none to give Him? She was deeply distressed

70

by this and similar things. She consoled her sweet Son by words and actions as best she could and perhaps went without food herself, that she might keep it for the Son.

uuno ñ auro oñ digtur: Et quato elli ïtrono
ïegypto / tutti litoli di glla puïaa crectено a piculo

ficcome p ysiya fu pfetato: Et atono a duina a
ti ch chiamata puuusmopolis aque accattono una

These and other things about the boy Jesus you can contemplate. I have given you the occasion and you can enlarge on it and follow it as you please. Be a child with the child Jesus! Do not disdain humble things and such as seem childlike in the contemplation of Jesus, for they yield devotion, increase love, excite fervor, induce compassion, allow purity and simplicity, nurture the vigor of humility

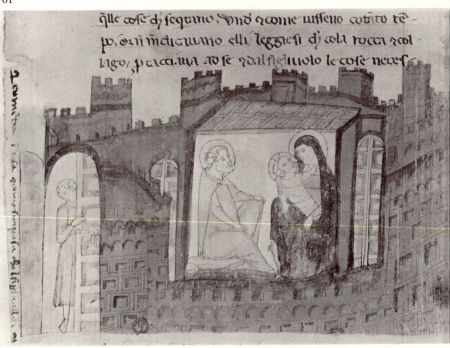

and poverty, preserve familiarity, and confirm and raise hope. We cannot rise to the highest things, because that which seems foolish to God is most wise to men, and what is weak to Him is most powerful to us (I Cor. i, 25). It appears that the contemplation of these things banishes pride, destroys cupidity, and confounds levity. You see how much good is born of it? Therefore, as I said, be a child with the Child, while with Him who begins to grow, you become older, ever maintaining humility. Follow Him wherever He goes, always watching His face. Have you not noticed in the things said above how full of difficulty and shame their poverty was? If it was necessary for her to earn food by the work of her hands, what shall we say about clothes, bedding, and other necessary household articles? They had no extra or superfluous or frivolous things. (These are against poverty and even if she could have them, the lover of poverty

72

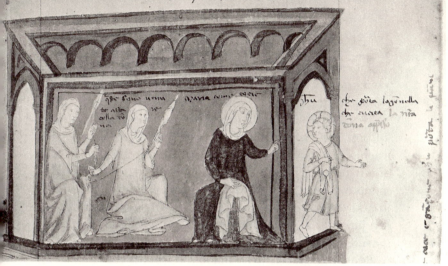

would not. Did the Lady, whatever she worked on, make for love some fancywork?[30] No!) These are done by people who do not mind losing time. But she was so poor that she could not and would not spend time in a vain occupation, nor would she have done such work. This is a very dangerous vice, especially for such as you. Do you wish to see why? Remember first that the time given for the praise of God is misappropriated in doing vain things, the frivolities that require much more time than necessary. And this is a great evil. Second, because it is a source of vainglory for him who makes it. How often does he consider it and ponder it in his mind, even when he is not at work and should be concerned with sacred things, so that when he does good work he considers himself great and wishes to be known for his work! Third, because it is a source of pride to him who makes the work and thus nourishes as with oil the fire of

pride and makes it burn brighter. As rough and coarse things are food for humility, so these are food for pride. Fourth, because it is a cause for withdrawing the soul from God, according to what the Blessed Gregory said: "Tanto quis a superno amore disiungitur, quanto inferius delectatur," "The further a man is removed from supernal love, the more he delights in base things." [31] Fifth, because it is concupiscence of the eyes, which is one of the three sins to which all the sins of the earth are reduced. These frivolous things are not useful for anything, for they offend the eyes of both him who made them and him who wears or uses them often. Sixth, because they are snares and the ruin of many others. Those who regard these things may offend in many ways, either by receiving a bad example, or by looking at them with delight, or by desiring similar things, or by judging, complaining, or detracting. Think then how often God can be offended before this curiousness or frivolity is destroyed. And he who made the work is the cause of all these things. Therefore if I asked you to do these things for me, or if you knew I wanted to use them, you should not make them, for there is no excuse for consenting to sin and one must refrain in every way from offending God. How much more do you offend if you do it of your own will, wishing to be more pleasing to the creature than to the Creator! Let those who live a secular life do this; these things are worldly ornaments and a blasphemy of God. But I am surprised to see that those who intend to live with a pure conscience should dare to do such things and wish to soil themselves. You see how many evils come from curiousness. And there is another even worse evil, that the curiousness is directly contrary to poverty, and this, aside from all previous reasons, is proof of a slight, vain, and inconstant spirit. I have said these things in a "curious" manner, so that you may avoid the "curious" things. Therefore avoid both doing and using them, as though they were poisonous serpents. This should not be taken to mean that

74

one cannot make beautiful things in some cases, especially
things destined for divine service, but in these all disorderly
desire, intention, and delight should be avoided studiously
and expelled with care far away from the soul. Of this
curiousness Bernard says this in chapter xiii (viii) of the
sermon to the priests: "I beg you to tell me what the sight
of vain things lends to the body and what it appears to
give to the soul. Here one should say that you will discover
that curiousness does not benefit anything in man, since it
is after all a vain and trifling consolation, and I do not know
anything harder to invoke on him than that he always
have everything that he requests: fleeing the joy of repose
he delights in a 'curious' tempest." [32]

After this digression on the accursed vice of curiousness
let us now return to the Lady in Egypt. Look at her as she
works at sewing and spinning with constancy, humility,
and promptness, and yet is not the less diligent in the care

63

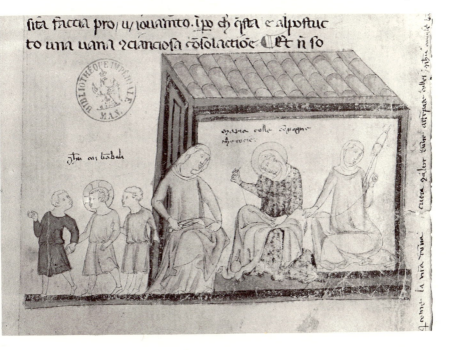

of her Son and the administration of the household and ever intent in vigils and prayers with all her power. Have pity on her with great affection and consider that after all the Lady of the world did not receive the world as a gift. It may have happened often that some good woman, noting her poverty, honesty, and holy conversation, sent her something that she received humbly with reverence and gratitude. The old Saint Joseph practiced the art of the carpenter. On every side is material for compassion. Finally, when you have stayed with her for some time, ask permission to leave, and receive first the blessing of the boy Jesus and of the mother and of Joseph, kneel before them, and take leave of them with tears and deep sympathy, for they were exiled and driven away from their country for no reason, remaining for seven years as pilgrims in that place and living by the sweat of their brows.

64

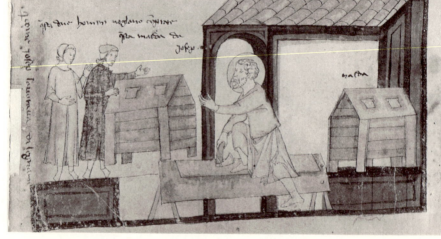

Of the Return of the Lord from Egypt— MATT. ii

When the seven years of the Lord's peregrination in Egypt were over, the angel appeared to Joseph in his sleep, saying, "Take the Child and His mother and go to the land of Israel, for those are dead who sought the life of the Child" (Matt. ii, 20). And he took the Child and His mother and returned to the land of Israel. When they arrived, hearing that Archelaus, son of Herod, reigned (in Judaea), he was afraid to go there and, again being warned by the angel, went to Galilee, to the city of Nazareth. We know from the martyrology that they arrived there at about the feast of the Epiphany, that is, on the second day.

You saw mentioned in the treatise above how the Lord gives consolation and revelation in parts and not as fully as desire demands. This is shown in two facts: that it was

65

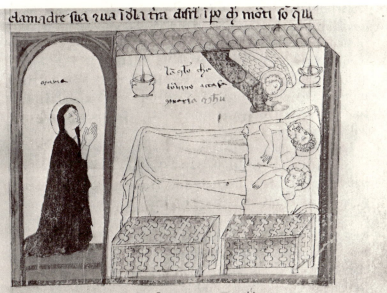

revealed in sleep and not publicly, as I said before; and that He told them where to go at two different times. The gloss explains that this was done by the Lord so that the man might become more certain through the repeated visitations. Whatever they are they must appear great to us and we must be thankful, for He always does what He believes to be most useful for us.

And now pay attention to the facts concerning the return of the Lord, for they lend themselves to very pious meditation. Go back to Egypt to visit the child Jesus. Perhaps you will find Him outside among boys, but when He sees you He will eagerly come to you, for He is benign, kind, and courteous. Kneel before Him and kiss His feet, then take Him in your arms and repose with Him. Then He will say to you, "We have been given permission to return to our land, and tomorrow we must leave here. You have come at the right time to return with us." To this you will answer cheerfully that you are very happy about it and wish to follow Him wherever He goes. In talk of this kind you will find pleasure with Him. I have already told you that these seemingly childish things are very valuable for meditation and lead to greater things. Then He will take you to His mother, who will honor you with courtesy. You will kneel to do reverence to her and the saintly old Joseph and you will rest with them.

Early the following morning you will see a few good women of the neighborhood, and also men, come to accompany them to the outside of the city-gate, to enjoy their pleasing and holy conversation. They had made their departure known to the neighbors a few days earlier, for it was not seemly to leave suddenly, almost furtively, since they did not have to fear the death of the Boy as when they came to Egypt. Thus they departed, the men ahead with Joseph holding the Boy by the hand, followed by the mother and the women. The Child walked in front of her, for she would not have let Him go behind. When they were out-

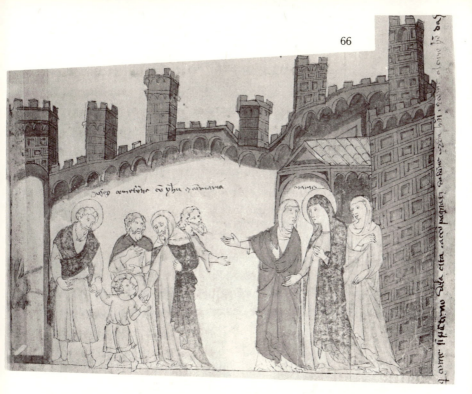

side the gates, Joseph would not suffer the others to accom-
pany them further. At that, some of them, sympathizing
with their poverty, called the Boy and gave Him some

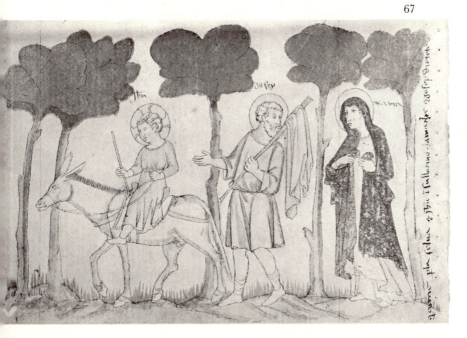

money for expenses. The Boy felt shame at taking it, but for love of poverty He extended His little hand to receive it shamefacedly, and gave thanks. Several men did this, and also the women called Him to do likewise. The mother was not less ashamed than the Son and thanked them humbly. You may truly have compassion for them, for He to whom the world and its fullness belong chose for Himself, His mother, and His foster father such severe poverty and a life of such distress. Saintly poverty shines in them, guiding us to love and follow it. Finally they bade grateful farewell to all and started on their journey. How will the child Jesus, still a tender boy, return? Their return appears to me more irksome than when they came to Egypt, for then He was so small that He could be carried. Now He is too big to be

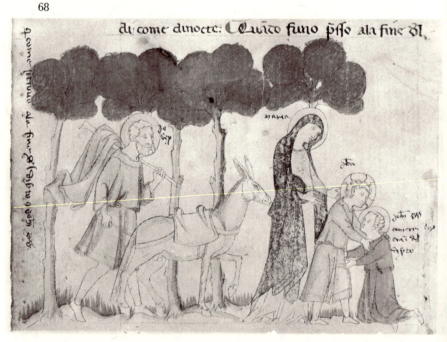

easily carried and yet too young to travel on His feet. But by chance one of those good men gave or lent Him a don-

key on which He might be carried. O noble and delicate Boy, King of heaven and earth, how much you endured for us and how early you began! This the prophet foretold about you: "Pauper sum ego, et in laboribus a juventute mea" (Psalm lxxxvii, 16), "Since youth I am poor and in distress." With firmness you bore great pain, difficult troubles, and corporal affliction. You held yourself in low esteem for love of us. This one effort alone, of which we now speak, should have been sufficient for complete redemption. Take, therefore, the child Jesus and place Him on the ass, leading Him faithfully; and when He wishes to dismount, receive Him cheerfully in your arms and hold Him at least until the arrival of His mother, who walks behind and more slowly. Then the Child will go to her and the mother will be greatly refreshed in receiving her Son. Thus they go, passing through the desert by which they had come. On that journey you will often pity them who have little rest, and see them weary and tired, by day as well as by night. When they came close to the edge of the desert they found

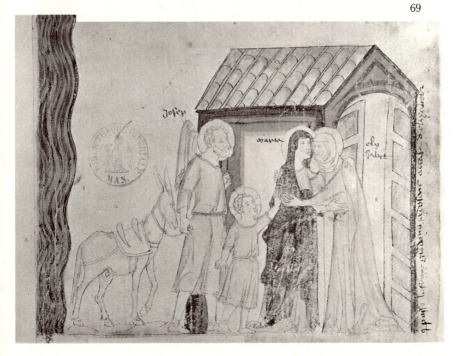

John the Baptist, who had already begun to do penance there, although he had not committed any sin. It is said that the site on the Jordan where John baptized is the same place where the children of Israel crossed when they came from Egypt through the desert, and that near this spot in that desert John did penance. Thus it is likely that the boy

70, 71 Jesus, passing it on His return, found him there. Meditate

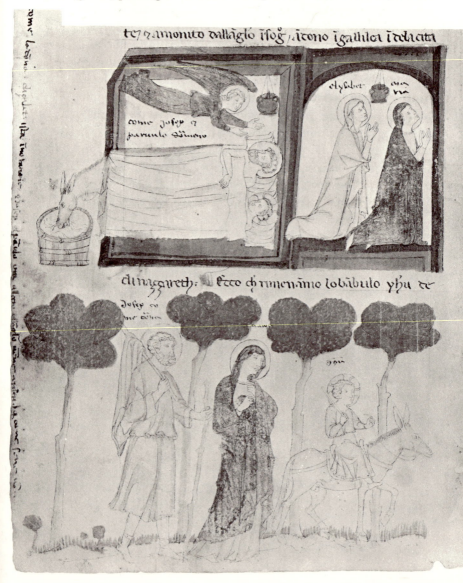

on how he received them joyfully and how, resting a little, they ate with John those raw foods that he usually ate. Finally, after enjoying great refreshment of the spirit to-

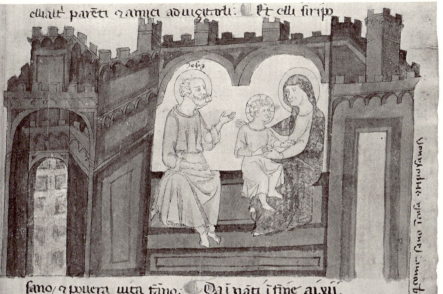

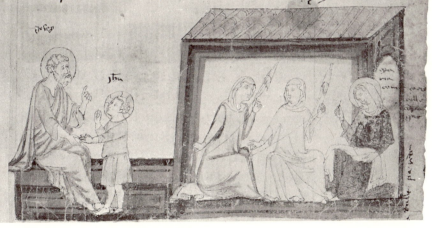

gether, they bade farewell to him. You, therefore, on greeting him and on departing, kneel before John to kiss his feet, ask for his blessing, and commend yourself to him. This boy was very excellent and marvelous, for he was the first hermit and the leader and path for those who wish to live religiously. He was a most pure virgin, a great preacher, more than a prophet, and also a glorious martyr. Then, crossing the Jordan, they came to the house of Elizabeth, where they rejoiced greatly together. On hearing that Archelaus, the son of Herod, reigned in Judaea, Joseph was afraid and, warned by the angel in his sleep, he went to Galilee, to the city of Nazareth.

Thus was the child Jesus taken from Egypt. When they had returned, the Lady's sisters and other relatives and friends came to visit them. Here they remained, leading a life of poverty. From this time until his twelfth year there is nothing written about Jesus; but it is said, and this seems probable, that there still exists the fountain from which the Boy brought water to His mother. The humble Lord rendered this and other services for His mother, as she had no other servant. You may consider also that John the Evange-

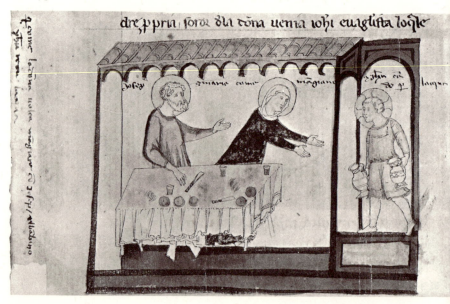

list, then five years old, came with his mother, the sister of the Lady. We read of him that he died in the year (67)[33] of the Passion of the Lord, in the ninety-eighth year of his life. Thus at the time of the Passion of the Lord he was thirty-one and the Lord thirty-three or a little older. Therefore at this time the Lord was seven and John five. Watch them as they stay and talk together, since the Lord will give you this grace. He was later to be the disciple whom Jesus loved most intimately.

(X I V.) *How the Boy Jesus Remained in Jerusalem*
—LUKE ii [34]

When He was twelve years old He went to Jerusalem with His father and mother, according to the custom and commandment of the day of the feast, which feast lasted eight days. At that time the boy Jesus already wearied Himself in long trips, and He went to honor His celestial Father at His feast, for there was supreme love between the

75

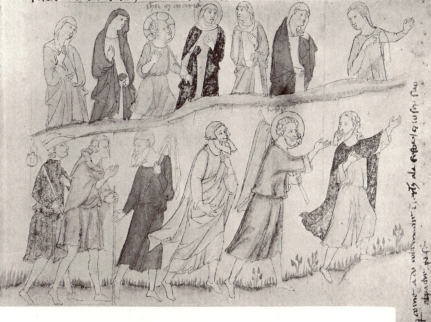

Father and the Son. But He felt greater pain and more acute sorrow of heart at the insults to the Father caused by many sins than joy at the honor shown Him and the outward pomp of the feast. Thus was the Lord of the law observing the law and conversing humbly with others like any other poor man. When the days of the feast were over, the father and mother returned home while Jesus remained in Jerusalem. Now heed this well and remember everything that is said and done, for it is a devout and beneficial matter. I told you before that from Nazareth, where the Lord

lived, to Jerusalem is a distance of about 74 (14 or 15) miles. Since the Lady and Joseph had travelled by different roads, they met in the evening at the place where they were to spend the night after the day's journey. Seeing Joseph without the Boy, who she thought had accompanied

him, the Lady asked, "Where is the Boy?" He replied, "I do not know, because He did not return with me, and I thought that He had come with you." And moved to tears by her strong sorrow, she said, "He did not come with me. Now I see that I did not take good care of my Son." That evening, wishing to go from house to house as opportunely as possible, she looked for Him, asking, "Have you seen my Son? And you, have you seen my Son?" And she was in pain from sorrow and ardor. Crying, the old Joseph

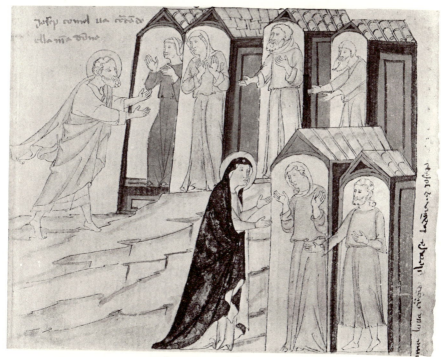

followed her. But they found nothing, and you yourself can imagine that they had no peace, especially the mother, who loved Him most intimately. Although she was comforted by the acquaintances, this could not console her. Was she then to lose Jesus? Watch her and pity her deeply, for her spirit is

anguished as never before since she was born. Thus we should not become agitated when we have tribulations, since the Lord did not spare the mother but permitted troubles to come to His own as a sign of His love. Therefore it is necessary for us to have them. Finally the Lady

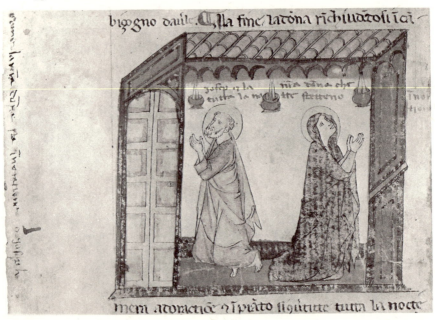

shut herself into her room, turning to prayers and tears all night, saying, "My God, eternal Father, most clement and benign, it pleased you to give me your Son, and now I have lost Him and do not know where He is. Give Him back to me, O Father. Relieve me of this grief for my Son. See, Father, the affliction in my heart, and not my negligence. I was incautious, but did not do it knowingly. In your great goodness you will return Him to me, for without Him I cannot live. O most beloved Son, where are you, what are you doing, with whom are you staying? Or have you returned to your Father in heaven? I know that you are

God and the Son of God, but would you not have told me? Or were you taken by someone with wicked intent? I know that you are a human being born of me, and once before, when Herod was looking for you, I carried you to Egypt. May your Father guard you from all evil, my Son. Tell me where you are, sweet Son, and I shall come to you or you to me. Forgive me this time, for never again will it happen that I be negligent in your care. Or did I offend you in any way, my Son, or why have you left me? I know that you realize the sorrow of my heart. Alas, my Son, do not delay to come to me, for, since you were born till now, I have never been without you, have not eaten or slept without you, except now. Now I am without you and I do not know how it happened. You know that you are my hope, my life, all my well-being, and without you I cannot be. Show me, therefore, where you are and how I can find you." The mother said these and similar things in her anguish about her beloved Son that night. Very early the next morning they left the house to look for Him in the neighborhood, for one could return by several roads; as he who returns from Siena to Pisa might travel by way of Poggibonsi or Colle or other places. Therefore they searched on other roads, asking acquaintances and friends. And on not finding Him the mother was anguished, hopeless, and disconsolate. On the third day, returning to Jerusalem, they found Him in the temple, seated among the doctors. On perceiving Him, she was cheered, almost restored, and knelt in tears to thank God. When the boy Jesus saw her, He came, and she received Him in her arms, clasping Him tightly, kissing Him gently, pressing Him to her cheek, and holding Him to her bosom. In this way she restored herself, for she could not have spoken while she was overcome with emotion. Then she looked at Him and said, "Son, why have you done this to us? Your father and I looked for you in sorrow." And He replied, "Why did you look for me? It was necessary for me to be about the things which are my Father's."

51 9

għi. Iosguēte ādauano cōcito paltre ue. addimādā
tolo rcēdatolo isfali cognoscēti elluamia: Et aco nō
trouātolo. lamadre quaçi sesa ispāsi sitribulaua zū sipo

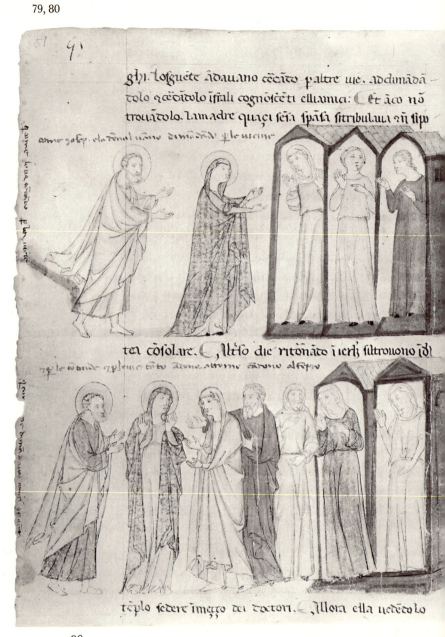

tea cōsolare. Altro die ritōnato i ierłs siltrouono īōl

tēplo sedere imeço dei dotori. Allora ella uedētolo

rallegrosi quaſi riſuſcitato ſilligmocchio aglagrime·
recete gře adio. Clogaçone ihu uedeto lamadre·
uene aller loquale ella iſtale braccia loricauette et

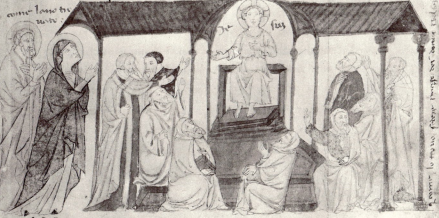

ſtriſelo ebaciolo dolcemite, etenerſelo accoſtato alagoti

ioſep

lanta nona ihu ƈ p gřeð · delaıſta damoıt

fabbricamano iſtemie

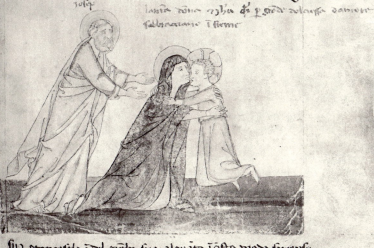

ſui. etenerſelo idel gřeto ſuo alquito iſſto moðo ſirepoſo

They did not understand these words, and the mother said to Him, "Son, I want us to return home. Will you not come back with us?" And He replied, "I shall do what pleases you." And He returned to Nazareth with them.

You have noted the affliction of the mother during this

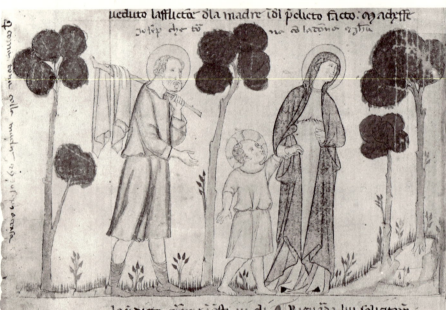

time. But what did the Boy do on those three days? Follow Him solicitously as He goes to a hospice for the poor and meekly asks for shelter. There the poor Jesus eats and sleeps with the poor. Now see Him as He sits among the doctors, with pleasant, wise, and reverent expression, listening and asking questions, almost as though ignorant. He did this for the sake of humility and also that they might not be ashamed by His marvelous responses.

These events will lead you to meditate on three very noble things. The first is that he who would approach God

must not stay among relatives, but must leave them. Therefore the boy Jesus departed from His sweet mother when He wished to attend to the work of His Father, and when inquiry was made to His relatives and friends He was not found there either. The second is that he who lives

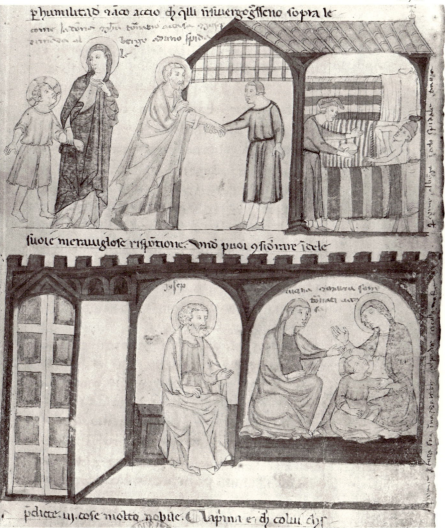

spiritually should not marvel if at times he seems abandoned by God, with arid mind, since this happened to the mother of God. But his mind should not become lukewarm, but should diligently look for God by persevering in holy meditation and good deeds, and thus he will find Him again. The third is that no one should act by his own judgment and will. Accordingly, when the Lord Jesus said He had to attend to His Father's work, He changed His intention and followed the wish of His mother to go with her and His foster father and was subject to them. In this you may marvel at His humility, on which we shall soon speak more fully.

(xv.) *What the Lord Jesus Did from His Twelfth to the Beginning of His Thirtieth Year*

When the Lord Jesus had returned from the temple and from Jerusalem to the city of Nazareth with His father and mother, He was submissive to them and lived with them till the end of His twenty-ninth year. That there is found nothing else in the Scriptures of what He did during this time seems very surprising. What do we think He did? Or did the Lord Jesus remain idle so long and not do anything worthy of being remembered and recorded? If He did anything, why should it not be written like all His other deeds? After all, this seems very strange. But heed this well, for you will clearly see that, by not doing anything, He did magnificent things, but none of His deeds is free from mystery. But as He spoke and acted with virtue, so He remained silent with virtue. The supreme Master, wishing to teach virtues and the way of life at some future time, began in His youth to do virtuous deeds, in a way that was wonderful, unknown, and unheard-of in former times. He rendered Himself abject and foolish in the eyes of men so that He would be thought of as devout and without any rash profession of understanding. These thoughts about His humiliation, which are not proved by the authority of the

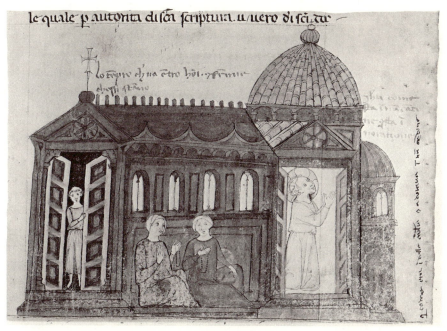

Holy Scriptures or by the saintly doctors, I affirm according to what I told you in the beginning. He avoided the company and the conversation of men and went to the synagogue, that is, the church, spending much time in prayer and staying in the lowest place. Returning home, He stayed with His mother and sometimes helped His foster father. He passed back and forth among men as though He did not notice anyone. All were surprised to see such a fine young man doing nothing worthy of praise. They waited for Him to do lofty deeds, befitting a capable man. As a child He was in advance of His years in wisdom before God and men. But now, growing up and passing His twentieth, His twenty-fifth year, and beyond, He did nothing to show any significance in prowess and valor. They were much surprised and they scoffed at Him, saying, "He is a useless man, an idiot, a good-for-nothing, foolish, bad." Nor was He literate, and among the people He was com-

monly known as big and bad. But He kept firmly to this way of life and continued what was thought base and displeasing by all. This was well said by the prophet: "Ego sum vermis et non homo" etc. (Psalm xxi, 7), "I am a worm and not a man."

Thus you see what He did by doing nothing. As I have said, He rendered Himself base and displeasing to all. Now, does this seem little to you? Certainly He did not need to do this, but I know of no greater or more difficult thing in our deeds. I think He reached the highest and most difficult degree, He who reached this out of His heart and a true, not false, soul. Thus did the Lord conquer Himself, His spirit, and the proud opposition of His flesh, which He did not wish to consider but despised as contemptuous and vile. This is a greater feat than conquering cities, according to the opinion of Solomon that says, "The patient man is better than the strong one, and he who rules his spirit better than the conqueror of a city" (Prov. xvi, 32). Before you have reached this degree, you do not seem to have done anything. But in truth we are all useless, even if we have done good according to the word of the Lord. Until we have reached this degree of contempt, we remain vain and not truthful. The apostle also demonstrated this, saying, "He who considers himself to be something, but is nothing, deceives himself" (Gal. vi, 3). If you ask why the Lord Jesus did this, I shall reply, "Not because He needed to, but to show us." And if we do not learn, we cannot excuse ourselves. For it is an abominable thing for the worm and for those who should be food for worms to rise in pride, when the Lord of majesty thus scorned and humiliated Himself.

But if to some it appears unsuitable that the Lord behaved so uselessly and that the evangelists left out many things, and if they say so, you can reply that it was not a useless deed to show or practice so much virtue; in fact, it was very valuable and a direct and firm foundation for all

virtues. We have the words of the Lord in the Gospel of Saint John: "But when the Holy Spirit will come, whom I shall send you from the Father, the Spirit of truth which proceeds from the Father, He shall testify for me, and you shall also bear witness, for you"—that is, the preachers—"have been with me since the beginning" (John xv, 26–27). And Peter, in the election of the apostle Saint Matthias, says, "These men should" etc., "from the time when the Lord Jesus was among you, beginning with the Baptism by Saint John" (Acts i, 21, 22). At that time He was almost thirty, but would John have been His precursor if the Lord Jesus had begun to preach before him? And if He had started earlier, would He not have been known otherwise to the neighbors who said, "Is He not the son of the craftsman?" (Matt. xiii, 55). For later, within a short time, He was called "Son of David," as by the blind men (Matt. ix, 27). Therefore, if He had begun or had done notable things, at least a few of them would have been recorded, and the evangelists would not all have remained silent. It seems that Bernard felt what I have said here, as you will see in the following treatise, in the last passage. But whatever the truth may be, I think that to consider it in this manner is very pious and valuable. In this way the Lord Jesus made the knife of humility, as the prophet had said of Him, "Gird your knife firmly to your body" (Psalm xliv, 4). Surely no other knife was suitable for killing the arrogant adversary than the one of humility. We do not read that He used the knife of power or grandeur, but rather the opposite. And for the time when He most needed it, that is, the time of the Passion, the same prophet complained to God the Father on behalf of the Son, saying, "You deprived Him of His weapon, the knife, and did not help Him in the battle" (Psalm lxxxviii, 44). Thus you see how the Lord Jesus trained Himself before teaching, and He said these words in the Gospel, "Learn from me, for I am mild and humble of heart" (Matt. xi, 29). He wanted to do this

first, and not with deception but with His heart; since He was in His heart truly mild and humble, He could not sink to simulation and falsely show one thing for another. Instead He penetrated so deeply into humility, inferiority, and subserviency, and had so reduced Himself in the eyes of all, that when He then began to preach and say exalted and divine things, and to perform miracles and great deeds, no one had regard for Him but saw Him as vile and contemptible, saying, "Who is this? Is He not the son of a craftsman?" and similar scornful and spiteful words. In this way are clarified the words of the apostle, who said, "He annihilated Himself, taking the position of a servant" (Phil. ii, 7), not just of any servant, by His Incarnation, but of a useless one, by humble and unworthy conversation.

But do you wish to see how powerfully He girds this knife? Consider all His deeds. In them, always, humility shines. You have seen it in the events told above; remember them well. We have it, even multiplied, in the events that follow. Up to His death He was faithful to it, and even beyond death and after the Ascension. Did He not at the end wash the disciples' feet? Did He not humiliate Himself beyond words in undergoing the torment of the cross? And after the Resurrection, when He was glorified, did He not call the disciples His brothers? "Go," He said to the Magdalen, "and tell my brothers that I am rising to my Father" etc. (John xx, 17). And after the Ascension did He not speak humbly to Paul, almost as to an equal: "Saul, Saul, why do you persecute me?" (Acts ix, 4). And He did not then call Himself God but Jesus. And when in the seat of majesty, does He not say on the day of judgment, "When you did this to one of the least of my brothers, you did it to me" (Matt. xxv, 45)?

He loved this virtue greatly, not without reason, for He knew that as the beginning of every sin is pride, so is humility the foundation of all good and all health. Without this foundation the edifice is built in vain. Therefore do not

trust in virginity or poverty or any virtue or deed without humility. He it was who made it, that is, showed how one may practice and acquire it, by despising and scorning oneself in the eyes of oneself and others and by continually doing humble actions. Go and do likewise if you wish to acquire humility, for it is necessary that this, that is, scorn for oneself and the exercise of low and humble actions, precede humility. On this Bernard speaks in the letter he sent to Oger, Canon Regular: "Indeed humiliation is the way to humility as patience is to peace and reading is to knowledge. Thus if you desire the virtue of humility, do not flee the path of humiliation. Therefore if you cannot be humiliated, you will not be able to attain humility." [35] And he also says in the 34th (sermon on the) canticles, "It is proper that he who ascends to the highest things should feel humble about himself, so that when he rises above himself he shall not fall below himself if he is made firm and steady by true humility. Since one cannot have great things without the merit of humility, he who wishes to advance must be humbled by correction and be deserving through humility. Thus when you see yourself humiliated, take it as a good sign and even as evidence of nearby grace. As the heart is exalted before destruction, thus it is humbled before exaltation. But both are the law of God, that is, to resist the proud and give grace to the humble (James iv, 6). . . . When God Himself humiliates one it is a small thing to receive it willingly, but if we are not experienced in bearing it when He permits others to do this likewise, then follow the marvelous instructions concerning it given by the holy David. Once a servant spoke ill of him, but he did not hear the great insult because he had felt grace previously, and he said, 'What have I to do with you, son of Zeruiah?' (II Kings xvi, 10). I declare that he is truly a man according to the heart of God who was vexed rather with him who wished to avenge him than with the one who insulted him. Thus he said with a quiet conscience, 'If

I have rendered evil to him who brought evil, I shall deservedly fall empty before my enemies' (Psalm vii, 5)."[36] For the present, these words about this virtue will suffice.

We return to the consideration of the acts and life of the Lord Jesus, our mirror, as is our principal purpose. Thus arrange and dispose all these things according to what I have often told you. Consider this family, blessed above all others, small but very excellent, leading a poor and humble life. The blessed old Joseph procured what he could from

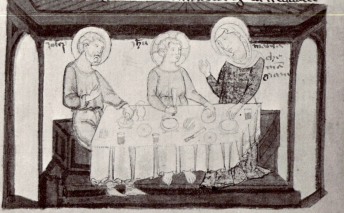

the practice of carpentry. And the Lady of the world worked for money with distaff and needle and did the other housework as was necessary, as you yourself know, and prepared food and drink for the husband and Son, for she had no servants. Have pity on her who thus had to work and toil with her hands. Feel compassion also for the Lord Jesus, who helped her faithfully in everything He could that was necessary, for He had come, according to His words, to serve and not to be served (Matt. xx, 28). Did He

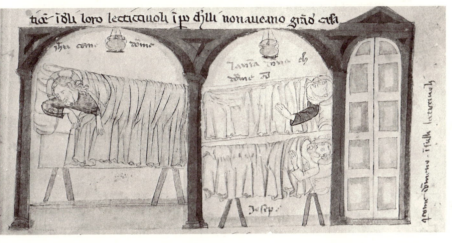

not help to set the table, put the beds in order, and do the other intimate things in the household? Regard Him well as He does humble services for the house, and see the Lady as well. Likewise consider the three of them eating at table every day, not delicate meals but scanty and sober ones. And afterwards they speak, not in vain and idle words, but all full of wisdom and the Holy Spirit, so that they nourish themselves not less in mind than in body. And after some revelation[37] they turn away and back to prayer in their beds. They had a small, not large, house. Reflect on the three beds in one small room, as humble and simple as that

of any poor man of the people, and see the Lord Jesus on one of them every evening after praying for such a long time and so persistently. Every evening you should see Him thus. O hidden Lord, why did you thus afflict your delicate and innocent body? Surely the pilgrimage of one night should suffice for the redemption of the whole world, but your immeasurable love compelled you to do this. You were deeply inflamed for the lost sheep and wished to carry it on your shoulders to celestial pasture. You, King of kings and eternal God, who bore the punishment of all, you prepare all things and for all abundantly, according to the requirements of each, but for yourself you kept so much poverty, misery, asperity, while waking, sleeping, fasting, eating, and in all your actions and deeds for such long periods of time. Where are those who look for repose of the body, who search for frivolous, ornate, and vain things? Have we not learned in the school of this Master, those of us who desire these things? But we are not wiser than He. He has taught us with words and the example of humility, poverty, affliction, and bodily exertion. Let us therefore follow the supreme Master who does not wish to deceive and cannot be deceived, and let us be content if we have food, drink, and clothing, according to the doctrine of the aspostle (I Tim. vi, 8), that is, having these things sufficiently for necessity and not in superabundance, persevering also in spiritual study and continuously and solicitously in other exercises of virtues.

(x v i.) *Of the Journey of the Lord Jesus to the Baptism* —MATT. iii, MARK i, LUKE iii, JOHN x

When He had spent twenty-nine years living in the difficult and lowly manner that I have described, the Lord said to His mother, "It is time for me to go to glorify and manifest my Father, to show myself to the world and fulfill the salvation of souls for which my Father sent me into this world. Take comfort, my sweet mother, for I shall re-

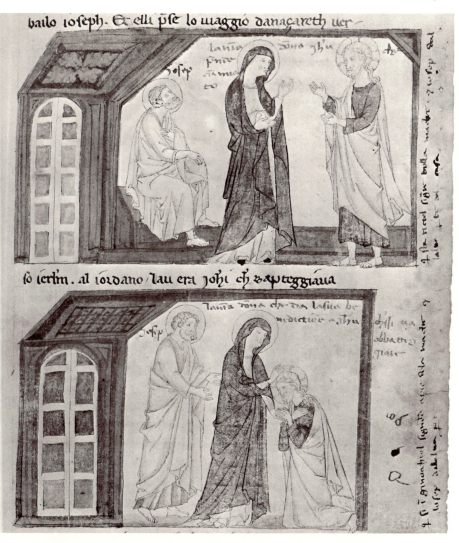

turn to you soon." And the Master of humility knelt, ask-
ing for her blessing. She also knelt and, in tears, embraced
Him tenderly, saying, "My blessed Son, go with your
father's and my blessing. Keep me in mind and remember
to return soon." Thus He departed reverently from her and
His foster father Joseph. He started on the road from

Nazareth toward Jerusalem to the Jordan where John was baptizing, which place was eighteen miles from Jerusalem. Alone He walks, the Lord of the world, for He does not yet have disciples. Observe Him therefore diligently for the sake of God as He goes alone, barefoot, on such a long journey, and have deep compassion for Him. What should

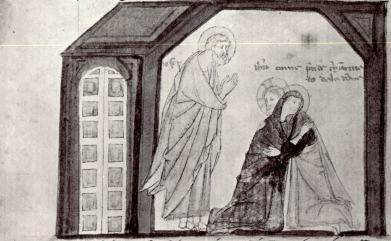

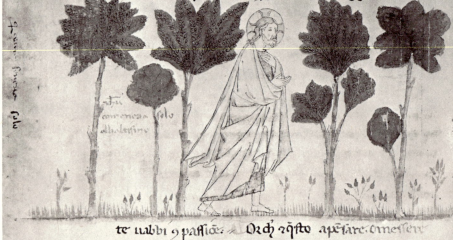

we think, O Lord, of your going? Are you not above all the kings of the earth? O Lord of lords, where are the barons and counts, the dukes and cavaliers, the horses and camels, the elephants, the wagon and train with beautiful and rich harness, and the multitude of companions? Where are those who stand around to defend you from the overwhelming crowds, as is the custom with other kings and great barons? Where are the triumphs of the trumpets, the sound of the instruments, and the royal gonfalons? Where are those who go ahead to arrange necessary matters at the inns? Where are the honors and the pomp to which we worms are accustomed? Lord, are not the heavens and the earth full of your glory? Therefore how can you go thus despised? Or are you not He whom a thousand thousands serve in your kingdom and before whom ten hundred thousands bow (Dan. vii, 10)? Then why do you tread the earth so, alone and barefoot? But you are (not) in your kingdom and I know well the reason why your kingdom is not of this world (John xviii, 36). You annihilated yourself by taking the form of a servant (Phil. ii, 7) and not of a king; that is, you became one of us, pilgrim and stranger like all our fathers (Psalm xxxviii, 13); you became a servant that we might become kings. Thus you came to lead us to your kingdom, opening before our eyes the path by which we can ascend. But why do we not heed it? Why do we not follow you? Why do we not humiliate ourselves? Why do we demand and grasp honors and pomp and vain and fleeting things with such longing? Surely because our kingdom is of this world and we do not consider ourselves pilgrims and therefore fall into all these evils. O vain sons of men, why do we accept empty for true things, perishable for certain, temporal for eternal, and embrace these so eagerly? Surely, O good Lord, if with fixed mind we would aspire to your kingdom and our conversion would be in heaven (cf. Phil. iii, 20) and we thought of ourselves as pilgrims and strangers, we would follow you easily, and selecting only the

necessary ones of these things we should not hesitate to run after you in the odors of your ointments. We shall be without a burden and without these transitory things, which we can consider as almost out-of-date and lightly scorn. Thus the days passed and God Jesus humbly continued walking until He reached the river Jordan, asking for alms along the way for love of poverty, since He did not carry money.

94

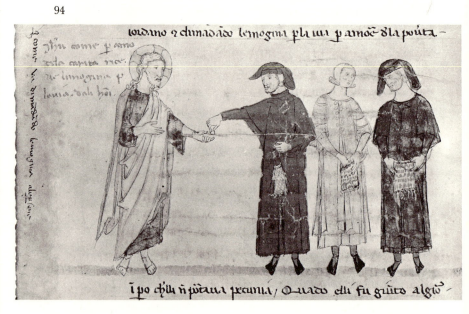

When He arrived at the Jordan He found John, who was baptizing sinners, and a multitude, which had come for his preaching and honored him almost as Christ. Then the Lord Jesus said to him, "I pray you to baptize me together with these." And John looking at Him immediately recognized Him by virtue of the Spirit, feared, and said reverently, "Lord, I should be baptized by you." And the Lord replied, "Remain quiet now; it is so we must fulfill every justice. Do not say this now and publicize me, for my time is not yet manifest or come, but baptize me. Now is the time for humility, and I wish to carry out every humility."

106

Here you will pay attention to humility, for this is the place to discuss it. And you must know that the gloss says at this point that humility has three degrees. The first is submission to a superior and not placing oneself before an equal. The second is submission to an equal and not placing oneself before an inferior. The third and highest is submission to the inferior. The third was reached at this time by Christ, who thus fulfilled every humility. See how His humility has grown since the previous chapter. Here He submitted Himself to His servant. He vilipends Himself and justifies and magnifies His servant. Consider how His humility grew in other ways. Up to now He lived as a humble, almost useless, and contemptible man; here He wished to appear as a sinner. John preached penance to sinners and baptized the Lord Jesus among them; and before them He wished to be baptized. On this Bernard speaks, that is in the sermon on the Epiphany: "Among the multitude of people He came to the baptism of John; He came like one of the people, He who alone was without sin. Who would have believed that He was the Son of God? Who would have thought that He was the Lord of majesty? Lord, how greatly you humiliated yourself; too much you hid yourself! But you could not conceal yourself from John." [38] Up to here you have what Bernard said. And although one could say the same thing about the Circumcision, for there too He wished to appear as a sinner, here it is more, for He is in front of the crowds, publicly, while there it was in secret. But was there not a danger here for Him who wished to preach, that He might be despised as a sinner? But the Master of humility did not want to go without humiliating Himself profoundly. Thus He wanted to appear what He was not, in His baseness and contemptibility, for our instruction. But we, on the other hand, wish to seem what we are not in our praise and glory. Therefore if something in us seems brave and good we show it, but the defects we hide, as we are sinners and guilty. What is our humility?

Listen not to me but to Bernard, who says in the 40th (42nd sermon on the) Canticles, "This is not humility that truth produces, and it has no warmth; that is humility that charity forms and inflames, and this is truly found in the affections, while the former is in knowledge. And verily if you examine yourself in the light of truth without simulation, and judge without flattery, I do not doubt that you humiliate yourself; and, although in your eyes even more ignoble to yourself by this true knowledge of yourself, we suppose that you still do not wish to be seen thus in the eyes of others. Therefore you will be humble, but at this time only in the working of truth and not yet in the infusion of love. But if you had been as illuminated by love and desire as by the splendor of that truth that shows you to yourself truthfully and healthfully, you would have wished in the end that all had the same opinion of you that you yourself believe true. In truth what is said of you is that often it is not suitable to manifest to all everything we know about ourselves, and we are prevented by that love of truth and by that truth of charity from making evident to an acquaintance that which is harmful. Otherwise, if you are restrained by private love of yourself, and also keep within yourself the judgment of truth, can one doubt that you love truth, to which you submit your own profit or honor, too much?" And further on he says, "If you are already humiliated before yourself by that necessary humility which truth looks for in hearts and reins by the senses of the watchful will, summon the will and make a virtue of necessity, for virtue is nothing without moderation by the will. So it will be done, if you do not wish to appear different on the outside from what you find yourself inside. Otherwise you fear that you read of yourself what is said: 'He is deceitful in his own eyes until his iniquity be found to be hateful' (Psalm xxxv, 3). And also, 'This weight and that weight are abomination to the Lord' (Prov. xx, 10, 23). Why? Do you despise yourself in secret after having weighed

yourself with the scales of truth and, having placed another price on the outside, sell yourself to us with greater weight than you took from that scale? Fear God and do not wish to do this very bad thing, for the will exalts him whom truth humiliates. Verily this is opposing truth. This is fighting God. Rather yield to God and let your will become subject to truth, not only subject but devoted. Does not David say, 'My soul shall be subject to God' (Psalm lxi, 2)? But it is little to be subject to God if you are not so to every creature for the sake of God, to the abbot as a superior or to the prior ordained by him. I say also, submit yourself to your equals and even to the inferior, for He says, 'It is proper that we fulfill every justice' (Matt. iii, 15). Go to the inferior if you wish to be perfect in justice. Render honor to the least, bowing to him who is younger." [39] This was said by Bernard. On the justice of humility Bernard also speaks in the 47th (sermon on the) Canticles: "Who, if not the humble man, is just? Surely when the Lord God bowed to the hands of His servant the Baptist, and the latter was stricken with awe of the majesty, He said, 'Remain quiet, for it is suitable to render every justice' (Matt. iii, 15), ordering the accomplishment of justice in order to perfect humility. Therefore the just man is humble." [40] So Bernard said. Thus this justice is revealed in the humble, for it renders to each his right. He does not rob another but gives honor to God, keeping meanness to himself. But this you will realize better if you consider the justice of the proud man who takes as his own the benefits of the Lord. In the 84th (sermon on the) Canticles Bernard says, "Since from great benefits evils are usually born, when we have been made great by the benefits of the Lord God, we use these gifts as though they were not presents and we do not render glory to Him. Thus in the end those who seemed greatest through the grace received are considered least before God because of the grace not returned. But I am too indulgent, for I have used weak terms for great and little. For the

latter I have not made clear what I feel. The difference I covered I myself will uncover. I should have said 'very good' and 'very bad,' for surely without (doubt) that thing (is very bad) that each one who is very good ascribes to himself. In truth this is a very bad thing. Although someone may say, 'Please God, I know that I am what I am by the grace of God,' suppose that he appropriate glory for the grace he received, is he not a thief and robber? Let him listen who is of this kind. 'O wicked servant, I judge you by your tongue' (Luke xix, 22). What is worse than a servant who steals and plunders the glory of his master?" [41] So Bernard said. You see how the perfection of justice lies in humility, which does not take honor from God or appropriate to itself what it should not. And certainly the humble person does not harm his neighbor, for he does not judge him or place himself above anyone else. He believes himself the least of all and elects for himself the last place. Of this Bernard says in the 27th (37th sermon on the) Canticles, "O man, how do you know that the one whom you consider the vilest of all and much more miserable because of the infamous and very ugly life that you regard with horror, and whom you deem despicable, not only in comparison to yourself, for perhaps you mistake yourself as living temperately, justly, and piously, but even in comparison to all criminals, as worst of all criminals; I say, how do you know whether he may not become better and more than you and the others, by the variation of the right hand of God, or whether he is not already in God? And therefore He wished to choose either a middle position or one beside the last or at least among the last. But He says, 'Rest in the last place that you may be alone as the last' (Luke xiv, 10). And I say that you should not raise yourself above anyone or attempt to equal anyone." [42] To here the words of Bernard. The virtue of humility is much commended by many passages in the same Blessed Bernard, who says in the 85th (sermon on the) Canticles, "O brothers, humility is a

great and most high virtue, which deserves that which is
not taught, worthy of obtaining (what is not in a condition
to be learned), worthy of receiving from the Son of God
that which it cannot explain with its words. Why is this?
Not because this is the merit but because thus it is pleasing
before the Father of the Son, Bridegroom of the soul, Jesus
Christ our Lord, who is God, blessed above all things, in
eternity. Amen." [43] But he speaks also of the degrees of hu-
mility: "Humility is a virtue for which man debases him-
self by true recognition of himself." [44] He says in the sermon
on the Nativity of the Lord, "Only the virtue of humility
is reparation for offended charity." [45] He says in the letter
he sent to Henry, "Surely only humility is not accustomed
to glorify itself, does not know presumption, and is not
wont to contend. . . . He who is truly humble does not ar-
gue with a judgment, does not demonstrate right." [46] Cer-
tainly humility reconciles God to us and pleases God in us.
And he also says (in the homily) on the words *Missus
est Gabriel,* etc., "The virtue of humility always tends to be
related to divine grace." [47] Truly mercy usually arranges
divine things that humility be preserved through grace, in
order that the more good you do, the less you deem to have
done. Therefore if someone has done good to the highest
degree of spiritual action, nothing remains but for him to
lower himself in perfection of degree until he believes that
he has acquired the first step. In the same place he says,
"Beautiful is the companionship of virginity and humility.
That soul is not at all displeasing to God in which humility
commends virginity and virginity adorns humility. But of
how much honor must you not think her worthy in whom
fecundity exalts humility and birth consecrates virginity?
Hear the Virgin, hear the humble one. If you are not able
to imitate the virginity of the humble one, follow the hu-
mility of the Virgin. Virginity is a laudable virtue but
humility is much more necessary. The former is counseled,
the latter is commanded; to the one you are invited, to the

111

other you are compelled; of the one it is said, 'He who is able to receive it, let him receive it' (Matt. xix, 12), of the other is said, 'If a man does not become as a child, he will not enter the kingdom of heaven' (Matt. xviii, 3). Therefore the former is rewarded and the latter demanded. Finally, you can be saved without virginity but not without humility. In truth, humility is pleasing that weeps for lost virginity. I dare say that without humility the virginity of the holy Mary would not have pleased God. Therefore Christ says in the Gospel, 'On whom shall my spirit rest if not on the humble and meek?' (Isa. lxvi, 2). . . . Thus if Mary had not been humble the Holy Spirit would not have rested upon her and she would not have conceived. How could she have conceived Him without Him? Therefore it is manifest that she conceived by the Holy Spirit, since she says, 'The Lord God perceived the humility of His hand-maiden' (Luke i, 48), rather than the virginity. . . . Thus it is revealed that while virginity was pleasing, in the end she made use of humility. . . . Proud virgin, what do you say? Mary forgets her virginity, is glorious in her humility, and you, not electing humility, flatter yourself on your virginity, while she said, 'He regarded the humility of His hand-maiden.' Who is she? Surely a holy virgin, a prudent and devout virgin. Are you more chaste, more devout, more gracious in your purity than Mary in her chastity, that your virginity suffices to please God without humility, when she could not please Him with virginity alone? Finally, the more you are honorable by the singular gift of chastity, the greater the injury you do to yourself by staining its beauty in mixing it with pride." [48] And again he says in the letter to Henry the Bishop, "Charity, chastity, and humility are of no color but of great beauty that may delight divine eyes. What is found to be more beautiful than chastity, which makes him clean who is conceived of un-clean seed, a friend of him who is an enemy, an angel of a man? The difference between a virtuous man and an an-

gel is but in beatitude, not in virtue. Now if the chastity of the angel be happier, that of man is said to be stronger. Alone is chastity, which in this place and time of mortality represents some state of immortality and glory. Alone among the ceremonies of the wedding it appropriates to itself the custom of that blessed region in which there is no marrying or being married, giving in some way an experience of that celestial life. By this means chastity holds in sanctity this frail body we carry, in which we often storm and are near danger, in likeness to the odoriferous balsam with which the bodies of the dead are preserved incorrupt. It contains and restrains our senses and our limbs that they may not be dissolved in leisure or corrupted in desires or become putrid by the desire of the flesh. . . . But though it may happen that of these things chastity appears to be superior to all things through its own beauty, without charity it has neither value nor merit. And it is not strange, for without it the benefit of faith is not received even though it were so great that it could move mountains, nor that knowledge that speaks with the tongues of angels, nor martyrdom if I were to give my body to be burned (I Cor. xiii, 3). And no small thing is refused with it. Chastity without charity is like a lamp without oil. Remove the oil and the lamp will not shine. Remove charity and chastity will not be pleasing. . . . Now of the three things we have proposed the only one that remains to be discussed is humility, which is so necessary to the two virtues mentioned above that without it these two do not seem to be virtues. Without doubt, in order that chastity or charity may be held in virtue, humility is merited, for God gives His grace to the humble (James iv, 6). Humility watches the virtues received, that the Holy Spirit may not rest on any but the peaceful and humble (Isa. lxvi, 2). And having preserved these two virtues, perfect them if you will, for virtue is accomplished in infirmity, that is, in humility (II Cor. xii, 9). And it vanquishes the enemy of all grace and the beginning

of every sin, that is, pride. Therefore it drives away from itself as well as from the other virtues the tyranny of pride. Although it is surely wont to take good from any other you wish as an addition to its strength, only this humility resists this pride, as some bulwark, that is a fortified castle and tower of all virtues, and opposes its malice and presumption." [49] Now you have heard many and beautiful things on humility from this treatise by the most truthful and humble Bernard. You see therefore that these, and what he says about other virtues, you must understand well in your mind and exercise in your work. Now let us return to the Baptism of the Lord Jesus. When John understood the desire of the Lord he obeyed and baptized Him.

Now see carefully how the Lord of majesty undressed like every other man and entered the Jordan, into the cold waters in this period of great cold, and all for love of us. To effect our salvation He instituted the sacrament of baptism to wash away our sins. He wedded to Himself the universal Church and all faithful souls individually. In faith in baptism we are wedded to the Lord Jesus Christ, as the prophet said in His person, "I shall wed you to me in faith" (Hos. ii, 20). Thus this festivity and this event are great and very beneficial. Today the Church sings, which is united to the celestial Bridegroom, for Christ washed our sins in the Jordan for us. In this excellent deed the whole Trinity was manifested in a singular way: the Holy Spirit descended and rested upon Him in the form of a dove and the voice of the Father intoned, "This is my beloved Son, in whom I am well pleased" (Matt. iii, 17; Mark i, 11). For this place Bernard says—hear what he has to say—: "Behold, O Lord Jesus, speak. Why have you been silent up to now, why have you concealed yourself for so long? Why have you been silent such a long time? Now speak, for now you have your Father's permission to speak. O what a long time have you, who are the virtue of God and the wisdom of God, been as though infirm in some way, foolish, hiding yourself

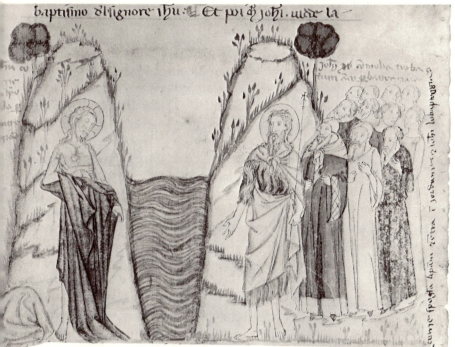

baptismo dl signore ihu. Et poi ch johi. ucdr la

among the people! For how long, noble King and King of
heaven, have you endured being called the son of a crafts-
man and being thought this! Saint Luke the Evangelist
testifies to this, that Jesus Christ was still believed to be the
son of Joseph (Luke iii, 23). O humility, virtue of Christ,
how you confound the pride of my vanity! I know little but
think that I know much and cannot remain silent but,
speaking without shame and foolishly intruding and dis-
playing myself, am prompt to speak, quick to teach, and
reluctant to listen. And Christ was silent so long, hid Him-
self, nor ever feared vainglory. How could He fear vain-
glory who was the true glory of the Father? Certainly He
feared, but not for Himself, nor does He who knows it is
to be feared fear vainglory. He protected us and taught us.
He was silent in speech and taught with His works; and

what He later taught with His holy word He already proclaimed with His example. 'Learn from me, for I am unsullied and humble of heart' (Matt. xi, 29). I hear little else

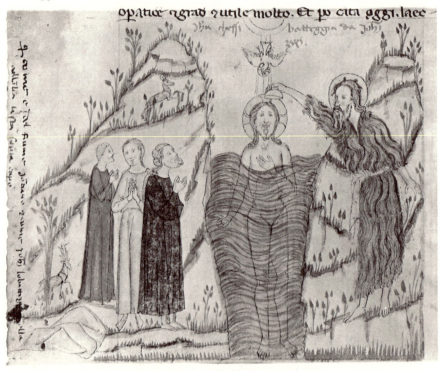

in the infancy of the Lord, from that time until His thirtieth year, but now He who is made manifest by the Father can no longer hide Himself." [50] Up to here Bernard spoke. This is the passage cited in the above treatise on that manner in which the Lord humbly remains silent for our instruction. Thus you see that in every place this humility is redolent. Of this I glady speak to you, for it is the greatest virtue and the one that is very necessary for us. Therefore it must be more studiously sought and loved with greater desire, since the Lord Jesus so carefully observed it in all His deeds.

116

(xvii.) *Of the Fast and the Temptations of the Lord Jesus and the Return to His Mother*—MATT. i, LUKE iv, JOHN i [51]

After the Lord Jesus was baptized He immediately went to the top of a mount in the desert, about four miles away, called Quarentana, where He fasted for forty days and nights. And according to what the Blessed Mark says in the Gospel, He was there with the beasts. Therefore consider and watch this well, which will show you examples of great virtue. Now He goes in solitude, fasting, praying, watching, lying and sleeping on the bare earth, and humbly conversing with the beasts. For this take pity on Him, for while His life was always and everywhere difficult and physically painful, here it was especially so. With this example learn from Him how to exercise yourself in these things. Here we are concerned with four things that are good for spiritual exercise and assist each other in a marvelous way, that is, solitude, fasting, prayer, and corporal suffering. Through these things we may truly arrive at purity of heart, which is greatly to be desired, for within itself in some way it comprises all the virtues. It includes charity, humility, patience, and all virtues, and the removal of all vices, for with vice and lack of virtue there can be no purity of heart. Therefore in the *Collationes patrum*[52] it is related that the whole effort of the monk is to have purity of heart. This is what makes man worthy of seeing God, as the Lord says in the Gospel, "Blessed are the pure in heart, for they shall see God" (Matt. v, 8). And according to Bernard, he who is purest is closest to God. Thus the purest has reached this beatitude: to obtain it, fervent and continuous prayer is most valuable. On this you will receive more instructions below. But prayer if taken together with overeating and a too full stomach, with its resulting softness and laziness, is worth little. Thus fasting and corporal affliction are necessary, but with discretion, otherwise it impedes all the good. Solitude appears to provide the fulfillment of all these things. One cannot pray

properly with noise and clamor. One can hardly see and hear many things without becoming impure; the offense, the death, enters by the windows of our soul (Jer. ix, 21). Therefore follow the example of the Lord and go in solitude, that is, part from company whenever you can, and remain alone if you wish to be joined to Him and see Him by virtue of purity of heart. Also avoid talk, especially that of laymen. Do not seek new affections and friendships. Do not fill the eyes and ears with vain fantasies and all the things that disturb the peace of the soul and the tranquillity of the mind; avoid and check them as poison and enemies of the soul. It was not without reason that the holy fathers sought the woods and places most remote from the conversation of all men. And not without reason did they command those who remained in a hermitage to be blind, deaf, and mute. But that you may better understand these things, hear what the Blessed Bernard in the 40th (sermon on the) Canticles has to say: "I say that if you are moved by the urgings of the Holy Spirit and are afire, then act. How can you wed your soul to God? . . . Sit alone, accord-

97

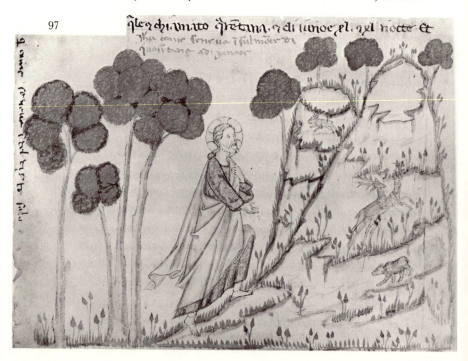

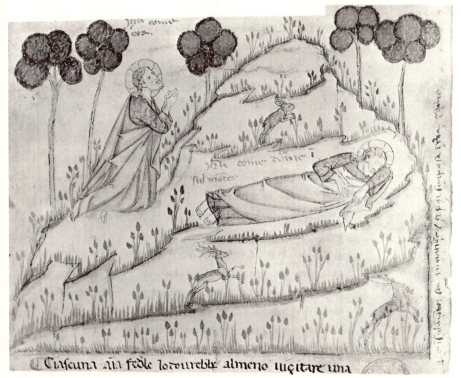

ing to the words of the prophet, that you may raise yourself above yourself (Lam. iii, 28). Finally, know that you are wedded to the Lord of the angels. Is it not above you to approach God and be one spirit with Him? Therefore sit solitary as the turtledove. Have nothing to do with crowds, nothing to do with the masses of mankind; forget your people and your father's house; and the King desires your beauty (Psalm xliv, 12). Holy soul, remain alone so that you may preserve yourself for Him alone of all, that is, above all, for you have elected Him above all. Flee from the public places, flee the familiar ones, withdraw from him and the friends and intimates and him who serves you. Do you not know that you have a modest Bridegroom, and that He never wishes to reveal His presence to you before everyone? Thus you must withdraw in the mind, not in the body, but in intent, devotion, and spirit. Let the spirit be-

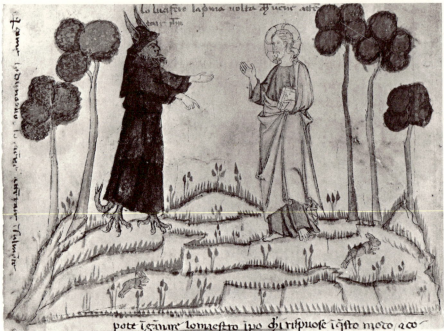

fore you be Christ the Lord, and the spirit does not require
solitude of the body but of the mind." And he also says,
"You are alone if you do not think common things, if you
do not desire present things, if you despise[53] what many
receive, if you are disdainful of what all desire, if you scorn
and flee troubles, if you do not feel damages, if you do not
remember injuries. Otherwise if you remain alone with
the body you are nevertheless not alone. You see that you
can be alone even when among crowds when you are self-
absorbed with your mind, and all alone only if, in spite of
conversing with any number of men, you take care not to
join in strange conversation or to be a curious investigator
or a foolish judge."[54] So Bernard said. You see how valu-
able solitude is and how physical solitude does not suffice
without mental. But in order to attain the mental, one
must have very strict corporal solitude, so that the mind
may not be dispersed in exterior things and may be joined
with its Bridegroom. Therefore with all your affection and

120

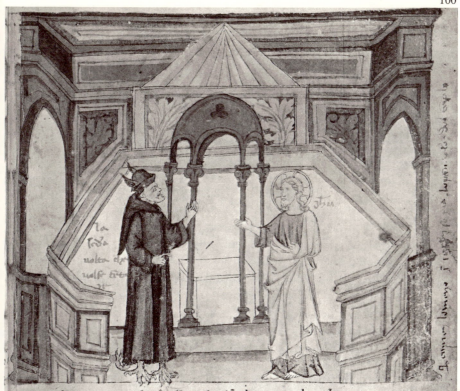

migha uqnuppreflo: Ouefte lughefze an luoghi

all your power endeavor to follow the Lord Jesus, your Bridegroom, in solitude, prayer, fasting, and moderate bodily suffering.

As He converses with the beasts, you also learn to dwell among others with humility, even calmly enduring those who sometimes seem to act irrationally. Visit the Lord often in this solitude to see Him as He converses and more so as He lies on the ground at night. Every faithful soul should visit Him at least once, especially on the day of the Epiphany, at the end of the forty days He stayed there. At the end of the forty days the Lord was hungry. Then the tempter came to find out whether He was the Son of God, and tempted Him to gluttony, saying, "If you are the Son of God, bid these stones become bread." But he could not

121

deceive the Master, who replied in such a way that He did not submit to the temptation of gluttony, and the enemy could not learn what he wished to. He did not deny or affirm that He was the Son of God, but defeated him by the victory of the Scriptures. And note here that, following the example of the Lord, one must resist gluttony, for here we must begin if we wish to conquer the vices. It seems that he who succumbs to gluttony becomes too weak to defeat other vices. And thus the gloss on Matthew says here, "If gluttony is not checked first, one fights in vain against the other vices." Then the devil came, lifted Him, and carried Him to Jerusalem, which was about 18 miles distant. The distances between places, as I have often quoted them in this little work, I heard from some who were in that region. Meditate here on the benignity and patience of the Lord, who permitted Himself to be carried and handled by this cruel beast who thirsted for His blood and that of all His friends. Placing Him on the top of the roof of the temple, he tempted Him to vainglory, again

101

wishing to discover Him, as before. But here he was defeated by the victory of the Scriptures, and his intention was disappointed. From that time on, according to what Bernard says on the psalm *Qui habitat,* etc.,[55] since the Lord had not revealed any divine qualities, the enemy thought that He was a man and tempted Him a third time as a man. Raising Him, he took Him to the top of a very high mountain two miles from the aforementioned Quarentana. There he tempted Him to avarice and this assassin was defeated. You have seen how the Lord Jesus was mishandled and tempted. Therefore why should you be surprised if we are tempted? He was also tempted at other times. Thus Bernard says, "He who does not read of the fourth temptation of the Lord does not know the Scriptures. And the apostle says He was tempted by all things in the same way without sin" (Heb. iv, 15).[56] When the victory was complete the angels came to serve Him. Be very attentive now as the Lord eats alone surrounded by the angels, and consider all those things that follow, for they are beautiful and very devout. And I ask what food the angels laid before Him after so long a fast. Scripture does not mention it, but we can suppose the victor to eat in any way we wish. And surely if we consider His power, the question arises of His obtaining anything He wished or of creating it according to the decision of His will. But we shall not discover that He made use of this power for Himself or His disciples, but for the multitude, whom He fed twice, with a few loaves for great numbers. Of the disciples we read that in His presence they gathered grain in their hunger and ate it. Similarly, when He was exhausted from walking and sat on the edge of the well talking to the Samaritan woman, it is not told that He created food but that He sent the disciples into the city to search for it. And it is not likely that He provided it through a miracle, for He performed miracles for the edification of others and in the presence of many, but here there were none but angels. How, there-

fore, shall we meditate on this? On this mount there were neither dwellings nor prepared food. But suppose the angels brought Him food that had been prepared elsewhere, as happened to Daniel. After the prophet Habakkuk had prepared a meal for his reapers, the angel of God carried him by the hair from Judaea into Babylon, to Daniel, that he might eat; and then in an instant carried him back. Let us therefore dwell on this, take it as an example, and rejoice with the Lord in His dinner. His mother felt this same joy and victory. But let us meditate with piety and devotion in this way. When Satan had been driven away, the angels came to the Lord Jesus Christ in great multitudes.

102

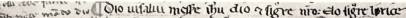

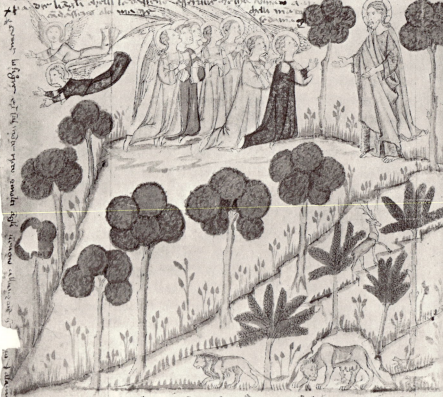

They bowed to the earth in adoration, saying, "May God save you, Lord Jesus, our God and Lord," and the Lord received them humbly and benignly, remaining with bowed head, thinking Himself a man somewhat below the angels. The angels said to Him, "Lord, you have fasted long. What do you wish us to prepare for you?" And He said, "Go to my beloved mother. If she has something at hand, let her send it, for I eat no food as gladly as hers." At this two of them went; in an instant they were before His mother. Reverently they greeted her and gave her the message. Then they carried away the modest food that she had prepared for herself and Joseph—bread, a tablecloth, and

other necessary things. And perhaps the Lady also obtained some small fish. When they had returned, they prepared everything on the ground, and the Lord blessed the meal. Watch Him well now in everything He does. He sits on the ground with composure and eats politely and soberly. The angels stand around Him to serve their Lord, one giving Him the bread, another the wine, a third preparing the small fish, and the rest singing canticles of Sion. They re-

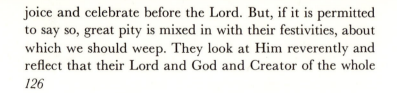

joice and celebrate before the Lord. But, if it is permitted to say so, great pity is mixed in with their festivities, about which we should weep. They look at Him reverently and reflect that their Lord and God and Creator of the whole

world, who gives food to all flesh, is thus humiliated and in need of sustenance with physical food, eating like other people: this moves them to compassion. Thus you yourself should correctly judge yourself; and I think that if your loving heart would teach you to see Him and love Him in this way you would cry, moved by great compassion, and say, "O Lord, how many things have you done for me! All your works are full of wonder! Help me that I may bear anything for you who have suffered so many and such

things for me." Surely this should inspire you to love Him. Finally, having eaten the food, He told the angels to carry the things back and to tell His mother that He would soon return to her. And when they had returned He said to all,

ti tonono alapadria loro / g prezo li suoi comitonmti . 23
la sua uictoria / a di queste buone nouelle ripietieno t

qcome lonro signor hmrato sia qdicea loro la sua
benedictione

tutta la corte celestiale. A lo signore yhu uoleto tona —
re alamadre / comitiae adusceeere. il monte. Riguardaui

106

"Go back to the Father and to your bliss, for I must still
wander, and I beg you to recommend me to the Father and
to the whole celestial court." They prostrated themselves
and all asked for His blessing. Having received it, they
returned to their Home following His commands and filled
the celestial court with the good news of His victory. Since
128

the Lord Jesus wished to return to His mother He started
to descend from the mount. Watch Him once more as He
goes alone, barefoot, He who is the Lord of all things, and
feel great pity for Him. When He came to the Jordan, John
saw Him approaching and pointed Him out, saying, "Be-
hold the Lamb of God! Behold Him who takes away

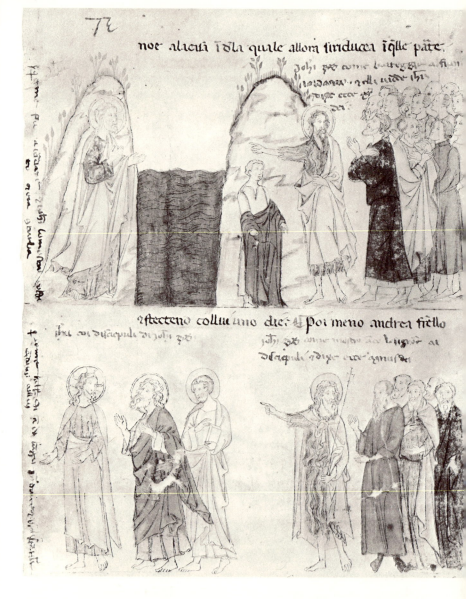

the sins of the world! He is the one upon whom I saw
the Holy Spirit rest when I baptized Him" (John i, 33).
And also on the next day, seeing Him walking beside
the Jordan, he spoke similarly: "Behold the Lamb of

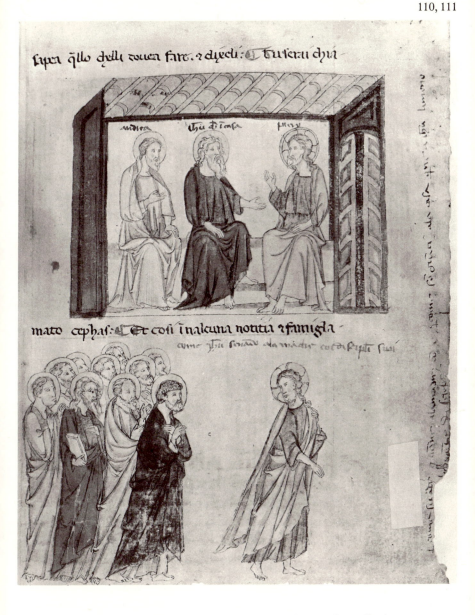

God!" (John i, 36). Then Andrew and another disciple of John followed Jesus. But the benign One, desiring their salvation, and everyone's, so as to give them confidence in Him, turned to them and said, "What do you desire?"

131

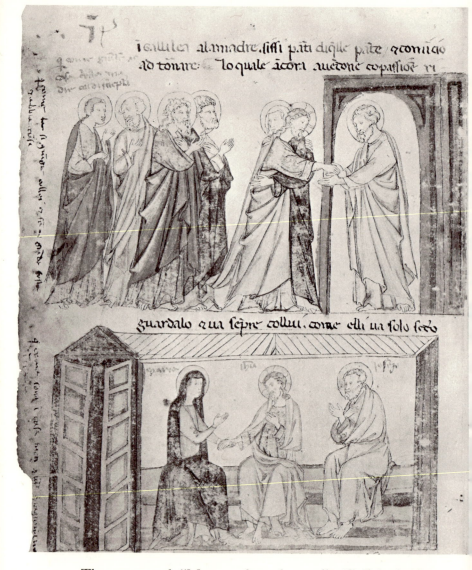

They answered, "Master, where do you live?" (John i, 38).
And He took them to the house in which He was staying
in that neighborhood, and they remained with Him one
day. Then Andrew led his brother Peter to Jesus, who re-
ceived him joyfully, for He knew what he was to do, and
said to him, "You will be called Cephas" (John i, 43). In

132

this way He made their acquaintance. When the Lord Jesus wished to return to Galilee to His mother, He took leave of that region and started on His way. Regard Him anew with pity and go always with Him as He walks alone and barefoot, according to custom, on this long road of 72 (14) miles. When the Lord reached home His mother was happy beyond words to see Him and rose impetuously to go toward Him and greet Him with a close embrace. He bowed reverently to her and to His foster father Joseph and stayed with them for several days according to custom.

(XVIII.) *Of the Opening of the Book in the Synagogue*
— LUKE iv

By the grace of God we have up to here traced the life of the Lord Jesus in orderly fashion, leaving out little or almost nothing of what happened to Him or what He did. But it is not my intention to do this from here on, for it would take too long to convert into meditations all the things He said and did. Rather it should be our concern to follow the custom of the Blessed Cecilia and carry the deeds of Christ always in the secret of our heart. Therefore we shall choose a few things, on which we intend to meditate continually, from here to the Passion, and beyond that we must not omit anything. We must also not completely forget the other things but meditate on them for a long time. But I do not intend to treat lengthily of meditations from now on, except a few times. It suffices that you place His deeds and words before your mind's eye and converse with Him and become familiar with Him. In this appears almost the whole fruit of these meditations, that there will be greater sweetness and more effective devotion. Always and everywhere regard Him devoutly in all His acts, that is, when He is among the disciples, among the sinners, when He speaks to them, when He speaks and preaches to the multitude, when He walks, when He sits, when He sleeps, when He wakes, when He eats, when He serves others,

133

when He heals the sick, and when He performs other miracles. In these and similar acts consider all His deeds and actions, especially contemplating His benign face, if you can picture it, for this seems to me the most difficult of all the aforementioned things. Watch Him attentively, that perhaps He will regard you benignly. Let this be a recourse and a lesson to you for all the things to follow, that wherever I shall narrate them, even when I do not express an individual meditation or leave it out, I shall return to this place and it should suffice for you. We shall turn to the narration of the events that follow.

When the Lord Jesus returned from the apostle,[57] the Master of humility conversed modestly as was His custom. Little by little He began to manifest Himself to some, by

114

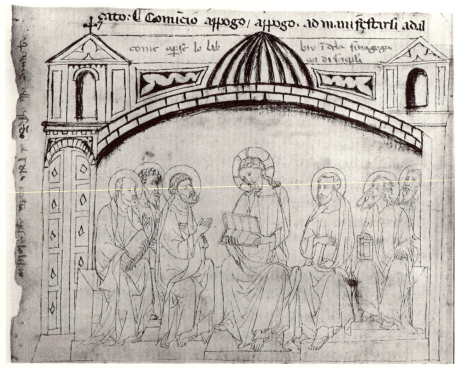

teaching and preaching in secret. It is not told that He publicly took the office of preacher during the whole following year, that is, up to the miracle of the marriage, which occurred on the same day as the Baptism the year before. While at times He preached and the disciples baptized, this was not continuously practiced before the imprisonment of John, as it was later, thus setting a marvelous example of humility, since He considered Himself a much less effective preacher than John. Meditate piously on this as above. So humble was He! Thus He did not begin with noise and pomp but humbly and little by little.

One Saturday when Jesus was in the synagogue, that is, the church of the Jews, with the others, He rose and read from the book of Isaiah the part saying, "Spiritus Domini super me, propter quod unxit me, evangelizare pauperibus misit me" etc. (Isa lxi, 1, 2, in Luke iv, 18), "The Spirit of the Lord is upon me; He has anointed me and sent me out to preach to the poor." When He had closed the book He said, "This Scripture is today fulfilled in your ears" (Luke iv, 21). See Him now as He humbly takes the office of reader, with benign and pleasing face, reading among them and explaining the Holy Scripture to them, and how He humbly begins to manifest Himself by saying, "Today this Scripture is fulfilled." And again He said, "I am He of whom it speaks." And all listened intently because of the virtue of His saintly and beautiful words and His humble and noble appearance, for He was very beautiful and very wise, as was foretold by the prophet, "Speciosus forma prae filiis hominum" etc. (Psalm xliv, 3), "You are beautiful in form above all the children of men: grace is poured into your lips."

(x i x .) *Of the Calling of the Disciples*— first JOHN i, second LUKE v, third MATT. (iv), and MARK (i); *Of the Calling of Matthew*—the same (MATT.) ix, LUKE v

The Lord Jesus began to call the disciples and to be con-

cerned with our salvation, always preserving humility. And
He called Peter and Andrew three times. The first time, as
narrated above, was when He was near the Jordan, and they
became acquainted; the second was when they were fishing
in the boat, as is told by Luke, and they followed Jesus with
the intent of returning to their own occupation but began
to listen to His teachings. The third was also from the boat,
according to the narration of Matthew, who says, " 'Come

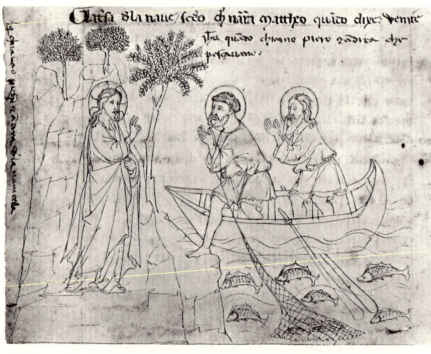

and follow me; I will make you fishers of men.' And they
abandoned everything and followed Him'' (Matt. iv, 19,
20). He also called James and John in the last two events,
and this is told in the same place as for Peter and Andrew.
He again called John at the wedding, as Jerome says,[58] but

this is not found in the text of the Gospel. He also called Philip, saying, "Follow me," and Matthew the publican; but the manner of calling the others is not told. Reflect thus 116, 117

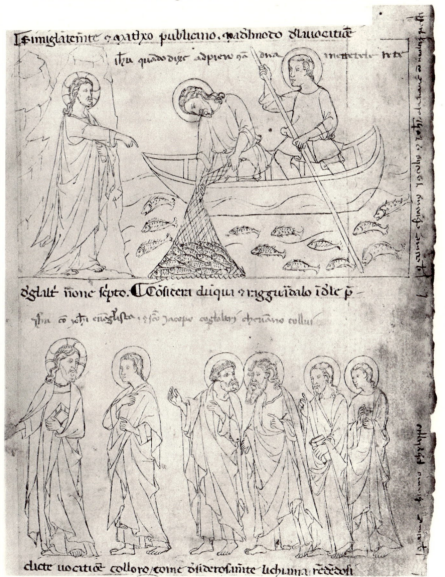

137

and see Him as He calls them with longing, being kind, fraternal, benign, and helpful, leading them outwardly and inwardly and even taking them home to His mother and familiarly going to their houses. He taught them, instructed

118, 119

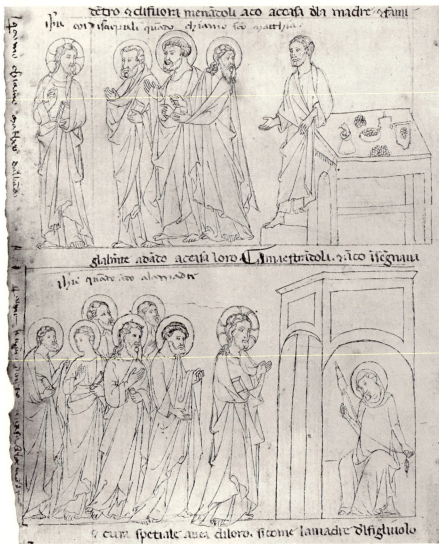

them, and cared for them as a mother for her son. It is said that the Blessed Peter told how, when they were asleep in one place, the Lord rose at night and covered them; for He loved them most tenderly. He knew what He

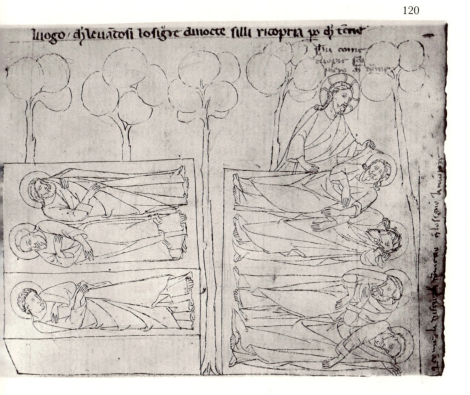

was to make of them. Although they were men of rude circumstances and obscure birth, nevertheless He had to make of them princes of the world and leaders for the spiritual battles of all the faithful. Meditate for God's sake on those from whom the Church took its beginnings. The Lord did not wish to choose the wise and powerful of this world, that the deeds they were to accomplish might not be ascribed to their strength, but reserved it for His goodness, power, and wisdom to redeem us.

(x x.) *Of the Holy Miracle at the Marriage; Of the Water Converted into Wine*— JOHN ii

Although there exists a doubt as to whose wedding was celebrated at Cana in Galilee, as the Master mentions in the *Historia Scholastica*,[59] we may meditate that it was John the Evangelist's, for thus it is said in the Prologue on John by Jerome, who seems to affirm it.[60] Our Lady was present at the marriage, not as a guest and an outsider but as the eldest and worthiest: first-born among the sisters, she was in her sister's house as in her own, as director and mistress of the wedding, as we may suppose for three reasons. The first is that the Gospel says that the mother of Jesus was present but

121

balluogo di cana p̄ migla᷑ia. iiij. dicēro ch̄ uolea fare le

q̄ come g̅ria maria · cola uita d̄na

noscie alfigliuol suo iōħi ella āco collei. ꝗ uene dināti p̄

q̄ come ua̅no
accusia di m᷑ia
p̄a cola uita
d̄na

alquan̄ di al᷑apar̄rch̄ uñto ficch᷑ q̄uēro gḣal᷑ fūno ī ui

141

79

tti elli gia era q̃ue: ꝃ la scda p ꝗllo lapossiuno ꝑpretere
p̃uenir lapparetchia lo nosse·

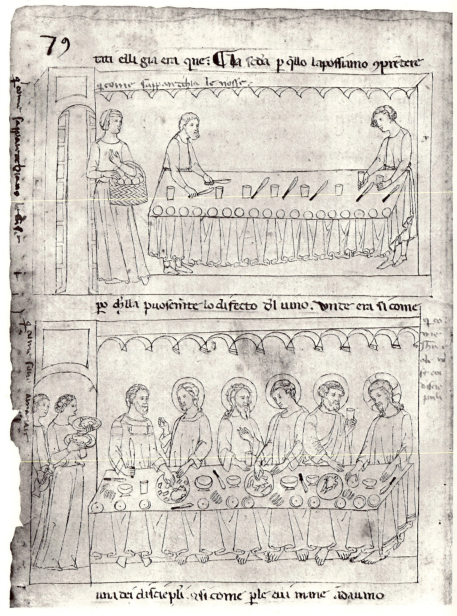

p̃ chella puosentite lo difecto ol uino· Onte era si come

uni oi oisciepli ꝗsi come ꝑle aui mane aōauino

that Jesus and the disciples were called, and one must believe the same for the others who were present. Therefore when her sister, Maria Salome, wife of Zebedee, went to her in Nazareth, which was four miles from Cana, to tell her that she wished to arrange the wedding of her son John, she returned with her. She was there several days in advance to make preparations; thus when the other guests were invited she was already there. The second we may deduce from the fact that she noticed the lack of wine; thus she was as one of the disciples,[61] and as one through whose hands things passed, and she saw the lack of wine. If she had been at the table, would not the mother have felt shame at being by the side of her Son among the men? And if she had been among the women, she would not have noticed the lack of wine earlier than the others. And had she noticed it, she would not have risen from the table to go to her Son. These things seem unbecoming, and it is more likely that she was not at the table; it is said that she was very busy. The third reason appears from the fact that she ordered the servants to go to her Son and do what He should command. Therefore it seems that she commanded them and that the wedding was under the direction of the Lady and that for this reason she took care that there should be no lack. In this way you must observe the Lord Jesus eating among the others as one of the people, seated in a humble place and not among the important people, as is understood from this same passage. He did not want the most important position, as is the custom of the haughty. He had to demonstrate what He says, "When you are invited to the wedding, sit at the most humble place at the table" (Luke xiv, 8–10). But He began by doing before teaching. Watch the Lady also as she works cheerfully and carefully, concerned with all the things to be done, directing, ordering, and showing the servants what and how they should serve those who were eating. As the end of the feast approached, the servants came to the Lady, saying, "My Lady, there is no more wine for

8°

cavero chi uoi narete aspectatini ipogo C Et uenedo
suoe alfigliuolo loquale humilemte comio dice seda

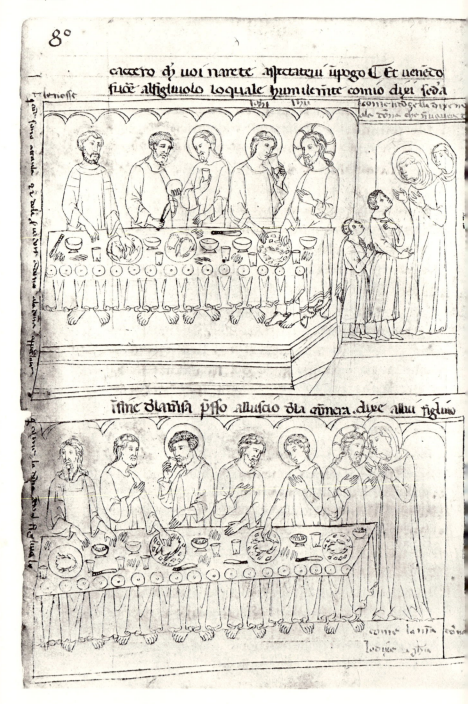

isine dealtiua pisso alluisio dela cena dice allui figliuo

us to set before them." The Lady replied and said, "I shall get more for you; wait a little." Going out to the Son, who was sitting humbly, as I said before, at the end of the table near the door of the room, she said to Him, "My Son, the supply of wine has failed, and since our sister is poor I do not know how we can have more." The Lord replied, "What is it to me or to you, woman?" (John ii, 4). This answer seems harsh, but it is to instruct us, according to what Bernard said, who speaks thus in the sixth sermon on the Epiphany: "What is it to you and to her, Lord? Wherefore is it not to the Son and to the mother? Do you ask her what concerns her, you who are the blessed fruit of her immaculate womb? Is not she the one who without corruption conceived you and as a pure virgin bore you? Is it not she in whose womb you stayed nine months? The virgin whose breasts nursed you? The one with whom you went to Jerusalem when you were twelve years old and to whom you submitted? Therefore, Lord, why do you now trouble her saying, 'What is it to me or to you?' It is a great deal. But I see clearly that you said, 'What is it to me or to you?' not in anger or wishing to disconcert the tender modesty of the virgin and mother, since when the servants came to you upon her order you did not fail to do what she had requested. Thus, brother, why had He first replied in this way? For us, surely, that we might be converted to God and not be anxious to care for our blood relatives, and that these necessities will not prevent spiritual exercise. As long as we are in the world it is clear that we are indebted to those persons who ask us. And when we have abandoned ourselves we are that much more free of their solicitations. Thus we read that a brother living in a hermitage was visited by his blood brother wishing for the grace of help. The former replied that he should go to another brother of theirs, who was already dead. The one who had come replied in surprise, saying that he was dead. And the hermit replied that he also was dead. Therefore the Lord

taught us very wisely that we should not be more concerned for those close to us by blood than religion requires when he replied, 'What is it to me or to you, woman?' to His mother, and to such a mother! In the same way He elsewhere turned against someone who said to Him that His mother and brothers were outside, asking and wishing to speak to Him, and He replied, 'Who is my mother and who are my brothers?' (Matt. xii, 48). Who are those who are so physically and vainly concerned with their blood relations as though they still lived with them?"[62] All this was said by Bernard. This reply did not cause the mother to doubt but,

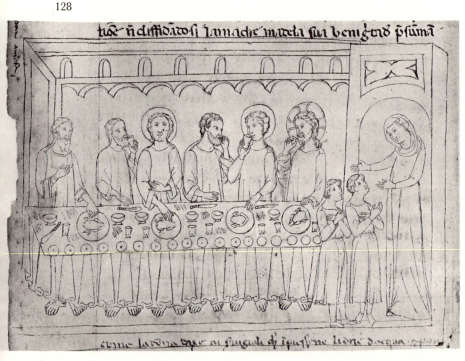

presuming his benignity, she called the servants and said, "Go to my Son and whatever He tells you, let it be done" (John ii, 5). They went to the Lord and did as He com-

manded, filling the hydrias with water. When they had finished, the Lord said to them, "Put some in the vessels and give it to the master of the feast" (John ii, 8). Here you may note two things. The first is the Lord's discretion, for He sent the drink first to the most honored man at the feast. The second is that He sat far from him, since He said, "Take it to him," as though he were remote. As the other

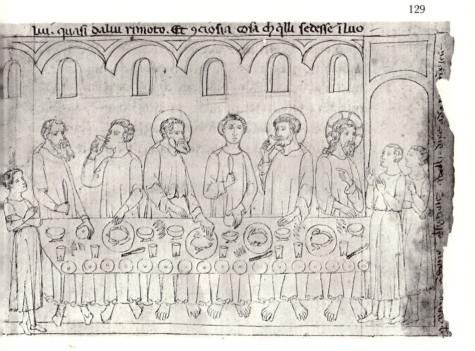

one was seated in the most honorable place, we realize that the Lord did not wish to sit there or near there but chose a humbler one for Himself. The servants poured the wine for him and the others, revealing the miracle, for they knew how it had been performed, and the disciples believed in Him. When the feast was over the Lord Jesus called John aside and said, "Leave this wife of yours and follow me, for

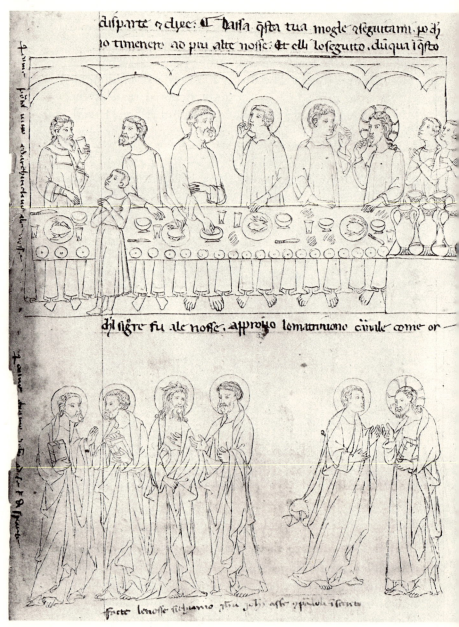

disparte. r ctyec: et taisa q̃sta tua mogle rseguitami. p̃ d̃j
io timerere ad piu alte nosse: Et elli loseguitto. diqui i q̃sto

djl sig̃re fu ale nosse. apresso lommatrimonio ciuile come or

facte lenosse filiuanio g̃tia polli asse g̃piuoli i santc

dinato da duo: C Ma iao d̄lli chiamoe iohi dale nos-
se aptainte die admetere ch̄ molto pio etegno loma

iohi glanta coia cō t̄hu ch̄
ste uano
arrasa lou

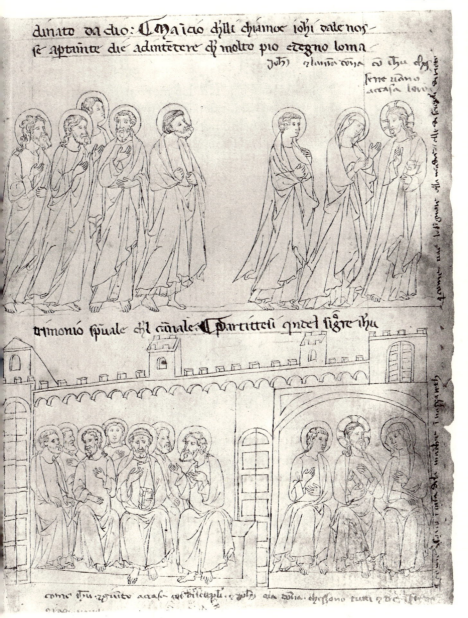

dimonio spuale ch̄l cōnale. C Sartitteli qndel siḡre t̄hu

come t̄hu yzuito aara... coi discepli. e poti aia coia. chessano tuti q̄ oc̄ ...

I shall lead you to a higher wedding." And he followed Him.
The presence of the Lord at the wedding shows that He
approved carnal marriage as instituted by God, but since
He called John from the wedding, you must clearly under-
stand that spiritual marriage is much more meritorious than
carnal. Thus the Lord Jesus departed, from then on wish-
ing to attend to the salvation of men publicly and openly.
First He desired to take His mother back to her home; for
such a woman such company is fitting. Thus He took her,
John, and the other disciples, and they went to Capernaum
near Nazareth and stayed several days, and then they went

134

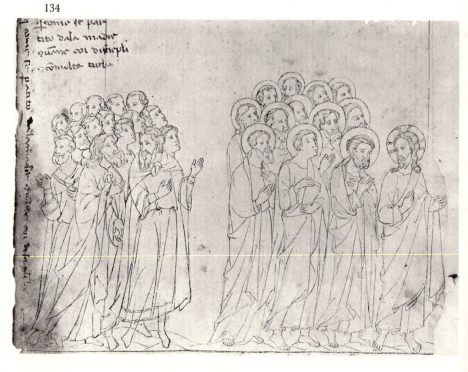

to Nazareth again with the mother. Watch them as they
walk together on the road, the loving mother and the Son
both going humbly on foot. What companions these are!
150

Never was the like of these two seen on earth. See also the disciples following reverently and listening to the words of the Lord, for He was not idle. Verily He was always doing and saying good, and therefore those who were with Him could never have cause for tedium in His company.

(xxi.) *Of the Sermon the Lord Preached to the Disciples on Mount Tabor*—MATT. V

The Lord called His disciples apart from the multitudes and led them with Him to Mount Tabor, two miles from Nazareth, to imbue them with His holy doctrine. He

instructed them before and above the others, for He was to dispose them as masters and leaders over the others. At that time He taught them many beautiful things. His sermon was very beautiful and generous, which is not surprising, for it was composed by the mouth of the Lord. He instructed them on the Beatitudes, prayer, fasting, almsgiving, and many other things belonging to virtue, which you can find in this sermon. Read it often and diligently and commit to memory the things said in it, for they are spiritual. But now I will not continue in this, for it would take too long and these expositions do not always seem to benefit meditations, although I shall intersperse such moral facts and sayings of saints for your instruction as occur to me. Here it is sufficient to mention how the Lord began. The beginning of the sermon is on poverty, which leads us to understand that poverty is the prime foundation of all spiritual exercise. He who bears the burden of worldly things cannot easily follow Christ, the mirror of poverty; he is not free, but a servant, subjecting the affection of the soul to these transitory things. Therefore He said, "Beati pauperes spiritu" etc. (Matt. v, 3). I spontaneously serve those things that I love affectionately. "Love is a weight of the soul, which carries it wherever it goes," as is said by Augustine in the 13th (book of his) Confessions.[63] Therefore nothing is to be loved except God alone or what is loved purely for God's sake. Therefore it is well said, "Blessed is the poor who does humble things for God, since he is in great part joined to his God." On this poverty Bernard says in the fourth sermon on Advent, "Poverty is a great wing with which one flies so quickly to heaven. In the other virtues that follow there are given promises for a future time. But as to poverty, it is not so much promised as it is given. Therefore at the present time it is announced that 'theirs is the kingdom of heaven'. . . . We see some poor people who, if they be truly poor, do not act cowardly and sad but as kings and kings of heaven, and some who want

to be poor on the understanding that they should lack for nothing, and love poverty while they do not suffer need." [64] He also says in the 21st sermon on the Canticles, " 'If I be lifted from the earth,' I boldly say, 'all things adhere to me' (John xii, 32) and therefore I have not foolishly borrowed the voice of my brother whose likeness I took. Thus it is that the rich of this world should not think that the brothers of Christ possess only celestial things when they hear Him say, 'Blessed are the poor in spirit, for theirs is the kingdom of heaven' (Matt. v, 3). . . . And they possess earthly things. And surely while having nothing but possessing everything, they do not beg like wretches but like masters possess, being surely the greater lords the less they desire. Finally to the man of faith the whole world is (a store) of riches; thus in adversity as well as in prosperity all alike serve him and work for his good. Thus the avaricious man always hungers for earthly goods like a beggar, while the faithful one despises them like a lord. The former, though possessing, begs; the latter, despising, maintains them. Ask whomever you wish whose heart is excessively insatiable for worldly gain what he thinks of those who, in selling their property and giving to the poor, exchange worldly goods for the kingdom of heaven, whether they act wisely or no. Undoubtedly he will answer, 'Wisely.' Ask him further why he does not do what he approves of. 'I cannot,' he will say. 'Why?' 'Surely because the Lady Avarice will not let me.' For those things which he seems to possess are not his, not even his right. If they are yours, spend them for gain; and for celestial things exchange earthly. If you cannot act according to your judgment, you confess that you are not the lord of your money but the servant; the guardian, not the owner." [65] All this was said by Bernard. But let us return to the meditations. Therefore look and reflect on the Lord Jesus humbly seated on the ground on the summit of that mount among the disciples surrounding Him; and see how He is among them almost

as if one of them. And consider how He speaks to them, with ardor, benignity, beauty, and power, to persuade them

136

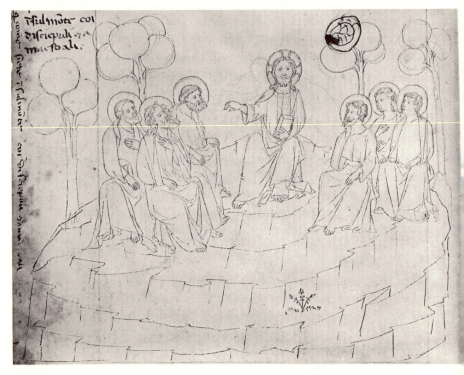

to all the deeds of virtue. And, as I said before in the general discourse, always try to look at the face of the Lord, and look also at the disciples as they gaze on Him with reverence, humility, and all intentness of mind, listening to those marvelous words and committing them to memory. Great happiness they derive from His words as well as His appearance. Take pleasure in these meditations, as though you could see Him speak, and approach Him; perhaps you will be called to stay with them at the Lord's bidding. When the sermon is finished, watch the Lord Jesus descend

154

together with the disciples, speaking familiarly with them; and as they walk on the road, see how this group of simple people follows, not in careful, orderly fashion, but like chickens following the hen, so that they might better hear Him, each one trying to come close to Him. And observe how the multitudes approach Him, wishfully presenting the infirm for Him to heal; and He healed them all.

(x x i i.) *Of the Servant of the Centurion and the Son of the Petty King, Liberated by the Lord*
—MATT. viii, LUKE vii, JOHN iv

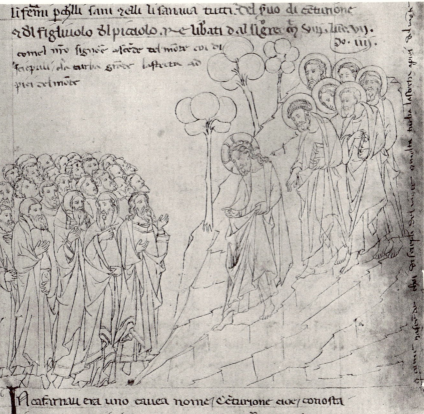

There was in Capernaum one who was called a centurion, that is, a constable of a hundred horsemen, who had a sick servant. Full of faith he sent to the Lord Jesus to have him cured. But the humble Lord replied, "I shall come to cure him" (Matt. viii, 7). When the centurion heard this, he immediately sent back to say, "Lord, I am not worthy that you enter under my roof, but if you only

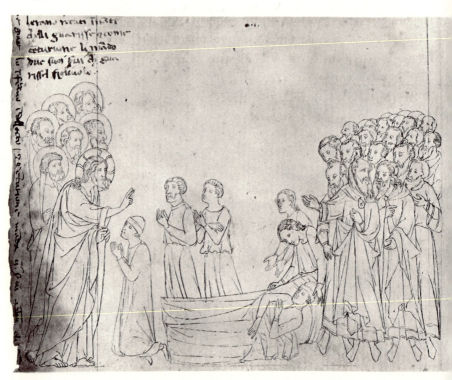

speak the word my boy will be healed" (Matt. viii, 8; Luke vii, 6). Then Jesus praised his faith and went no further, but healed the servant who was not in His presence. While He was in this city a petty king called Regulus came personally to Jesus to beg Him to go to his house and heal his

ailing son. The Lord Jesus did not wish to go, but nevertheless healed the son. In these matters you can reflect on the merit of faith, in the case of the centurion, and on the humility of the Lord, who wished to go to the servant but avoided the pomp of Regulus. Consider also that we must

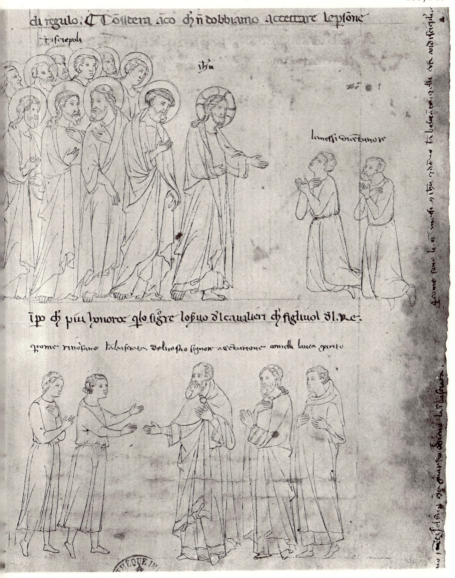

not accept persons, since here the Lord paid greater respect to the servant of the cavalier than to the son of the king.

141, 142

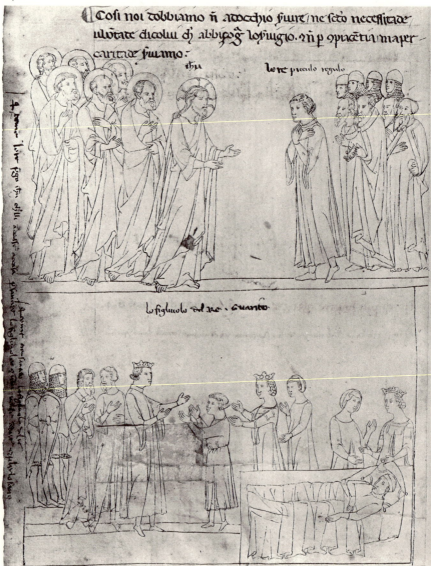

Therefore we should not attend people according to their appearance, or according to necessity or the excellence of him who needs the service, and not as a favor, but we must serve for the sake of charity.

(XXIII.) *Of the Paralytic, Lowered Through the Roof, and How He Was Liberated by the Lord*—MATT. ix, MARK ii, LUKE V

While the Lord Jesus was in the same city he was with many Pharisees and teachers of the law, from every citadel in Judaea and Jerusalem, gathered in a house; and (some people) wished to enter carrying a paralytic to be healed

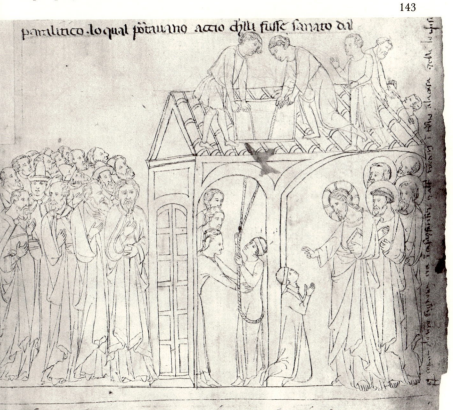

by the Lord. Since they could not reach Him because of the crowd of people, they climbed to the roof of the house and, lowering him inside, placed him before Jesus. Seeing their faith, the Lord Jesus said, "Your sins are forgiven you" (Mark ii, 9). Those Pharisees and teachers of the law, always prone to malice, said to themselves that He had blasphemed God, for only God can forgive sins and He whom they believed to be only a man had assumed this to Himself. The benign and humble Lord, who searches the

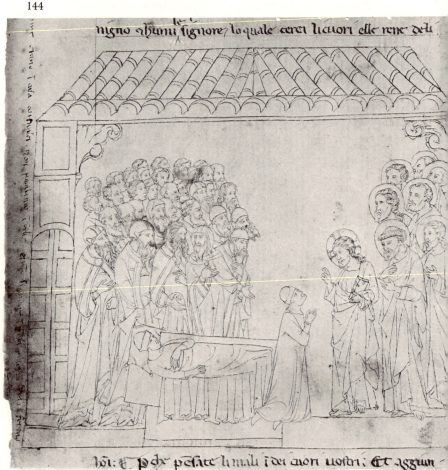

hearts and reins of men (Apoc. ii, 23), said, "Why do you think these evils in your hearts?" (Matt. ix, 4; Mark ii, 8). And He added, "That you may know that the Son of Man has authority on earth to forgive sins, I say to the paralytic, 'Arise and go'" (Matt. ix, 6; Mark ii, 10, 11). Impetuously the redeemed man rose, and everyone marvelled deeply.

Here you may meditate on many good and beautiful things. The first is how the blindness of the Jews was overcome, for thus they could clearly recognize the Lord Jesus to be God, who pardoned sins. The second is that disease is caused by sin and that through the absolution of sins there sometimes comes the liberation of the body. In this way it occurs later for him who was healed at the pool and told by the Lord not to sin again, that worse might not happen. Thirdly, consider how great is the value of faith, since the faith of one is of benefit also to others, as is seen above in the servant of the centurion and as you will see below in the Canaanite woman through whose faith the daughter was healed. This happens continually in the baptism of children, so that if they die before the years of reason they receive grace through the faith of others and are saved by the valor of Christ. This is the opposite of what the heretics wrongly say. To contemplate Him seated among them, benignly answering the malignant people and performing miracles, return to the general considerations I gave you before.

(x x i v.) *Of the Liberation of the Mother-in-Law of Simon* —MATT. viii, MARK i, LUKE iv [66]

It happened that in the same city the Lord Jesus rested at the house of Simon Peter, whose mother-in-law was in the grip of a violent fever. The humble Lord familiarly touched her hand and cured her, so that she immediately rose and ministered to Him and His disciples. Nothing is written about what she served. Reflect therefore that the Mother[67] of poverty was in the house of the poor. Some

coarse and easily prepared food was placed before them. Muse on this Lord Jesus who helps to serve, especially in the house of His disciple. Think as much as you can about humble things, how He placed the tablecloth and washed

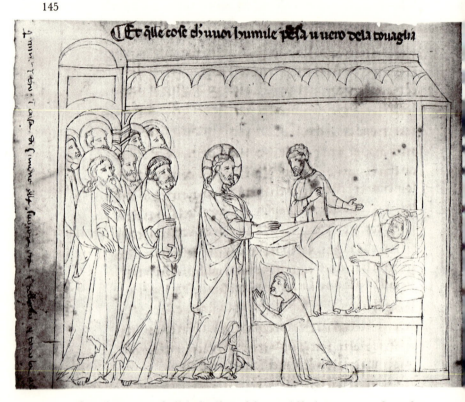

the glasses and did similar things. All these were done by the Master of humility, who had come to serve and not to be served and sat in a familiar way at the table. Cheerfully He ate, especially as the food was resplendent with poverty, which He so loved.

(xxv.) *How the Lord Slept in the Boat*—MATT. viii, MARK iv, LUKE viii

Once when the Lord Jesus entered a boat with His dis-

ciples He laid Himself to sleep, resting His head on a
wooden bolster, for He had often stayed awake all night to
pray and exhausted Himself in preaching by day. As He
slept, a tempest arose, and the disciples feared danger but

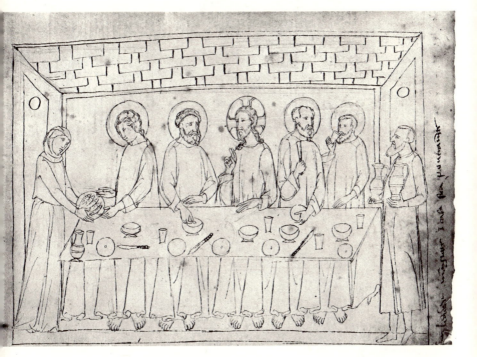

did not dare to wake the Lord. Finally, impelled by fear,
they woke Him, saying, "Lord, save us, for we are perish-
ing" (Matt. viii, 25; Luke viii, 24). He rose, rebuking them
for their little faith, and commanded the sea and the wind
to remain quiet; and immediately the tempest ceased. Ob-
serve Him in these deeds and consider them according to
the general rule or instruction given to you above. Here
you may meditate that when it appears to us that the Lord
is asleep in regard to us and our actions, especially when

we are in anxiety, He is nevertheless most solicitous in His care of us; and therefore we must be constant and strong in our faith and not doubt in anything.

147, 148

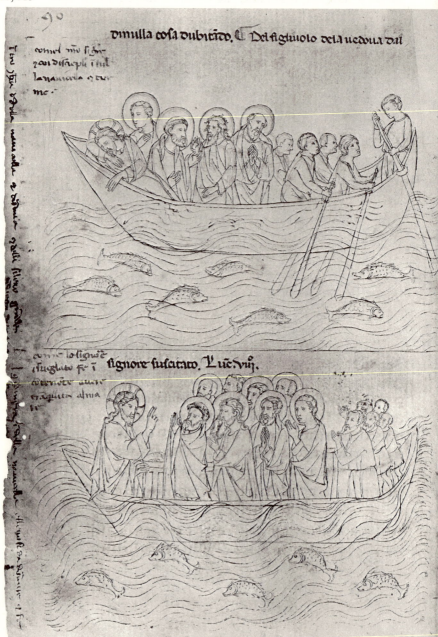

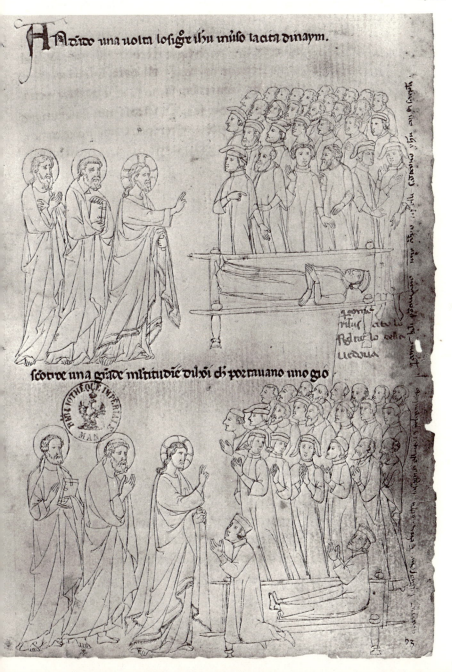

Once when the Lord Jesus was going toward the city of Nain He met a great multitude of men who were carrying the dead young son of a widow to the sepulcher. Moved to pity, the merciful Lord touched the bier, and those who were carrying it stopped. And He said, "Young man, I say to you, 'Arise'" (Luke vii, 14). And immediately he who had been dead arose and was given back to his mother. This caused everyone to marvel and praise God. In meditating, turn to what I have said above.

(XXVII.) *Of the Girl Who Was Resuscitated and Martha Who Was Cured*—MATT. ix, MARK V, LUKE viii

151

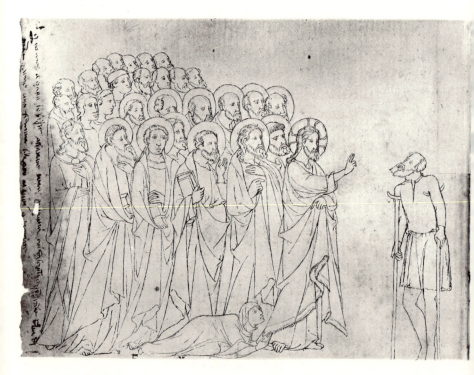

On the petition of a prince, the Lord Jesus went with him to heal his daughter. With Him went a great multitude, among whom was a woman, seriously ill, who is said to have been Martha, sister of Mary Magdalen. She said to herself, "If I touch the hem of His garment I shall be healed immediately" (Matt. ix, 21; Mark v, 28). Approaching with awe, she touched it and was liberated. The Lord Jesus said, "Who has touched me?" (Mark v, 30; Luke viii, 45). And Peter replied, "Lord, the crowds are hemming you in and pressing, and you say, 'Who has touched me?'" (Mark v, 31; Luke viii, 45). Here you can realize the patience of the Lord. Often He was pressed in the crowd when the people wished to approach Him. But Jesus knew what He said, and He repeated, "I felt that virtue went out of me" (Luke viii, 46). Then Martha made the deed public, and willingly the Lord cured her with whom He later had much familiarity. He said to her then, "Your faith has made you well" (Matt. ix, 22; Mark v, 34; Luke viii, 48). Therefore in this miracle you have the praise of faith, and also that the Lord wished the miracles to be manifested for the benefit of all. But He hid Himself behind His humility when, as here, what He had done by divine power He attributed to her faith. Here also there are notable things for the safeguarding of humility, as the Blessed Bernard says in this way: "Everyone who serves God perfectly may call himself the hem, the least part of the Lord's garment, because of his humble repute." [69] Thus he who has attained the state of knowing that he is granted by the Lord the healing of the infirm, and other miracles, should not for this rise in pride and claim it for himself, for it is not in him, but it is the Lord who performs it. Here it happened that Martha touched the hem, having faith in thus being liberated. This did not occur because of the hem, but the virtue of liberation came from the Lord. Therefore He said, "I felt virtue go out of me." Note this well and do not ever assert to yourself any good deed, for

everything comes from God. Finally the Lord Jesus went to the house of that prince and, on finding the daughter dead, resuscitated her.

152

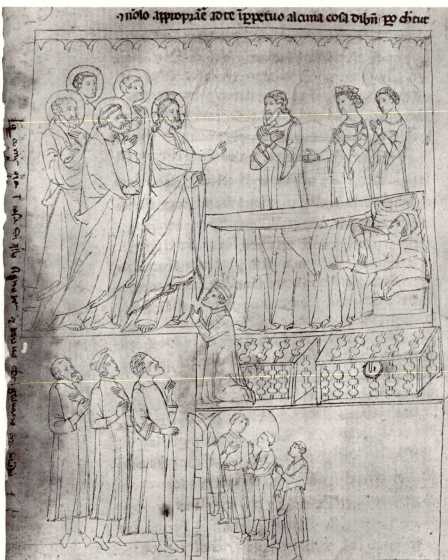

One day when the most courteous Lord was invited by

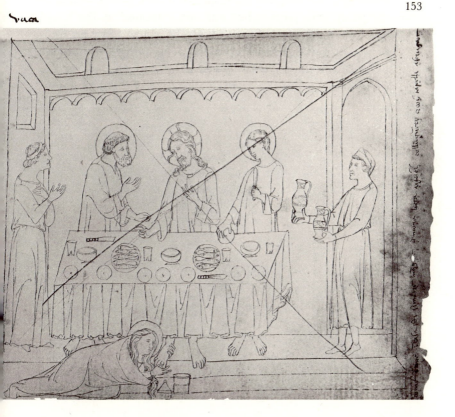

Simon the leper, He went to eat with him. It was His custom to do this out of politeness, as well as for the benignity and zeal He had in saving souls, for which He had come from heaven; while eating and conversing with men He drew them to love of Him. He did this also for love of poverty, for He was very poor and had kept none of the wealth of the world for Himself or His own. Therefore Jesus, the mirror of humility, when He was invited for any place and

time, humbly and gratefully accepted. Hearing that He was at the house of this Simon, the Magdalen, who perhaps had heard Him preach a few times and loved Him ardently, although she had not yet revealed it, but was touched to the heart with pain at her sins and inflamed by the fire of her love for Him, believing that she could have no well-being without Him and unable to delay longer, went to the place of the dinner with bowed head and eyes lowered to the ground before those at the feast, and did not stop until

154

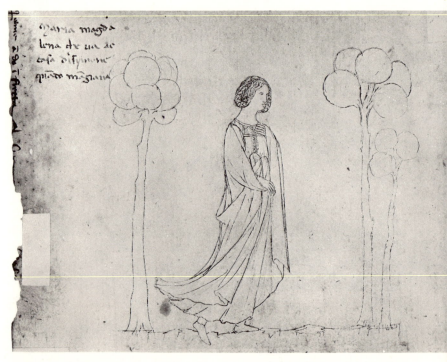

she reached the Lord, her Beloved. Then she instantly threw herself at His feet, her heart filled with both sorrow and shame at her sins. Prostrate, with her face above those holy feet, she felt somewhat confident, for already she loved Him

170

above all things. Then she began to cry loudly, with wails and sobs, and to say to herself, "O my Lord, I know, believe, and confess firmly that you are my God and my Lord. I have offended your Majesty in many and important ways. I have sinned against your every law and have multiplied my sins above the number of sands in the sea. But I, the wicked sinner, come for your mercy; I am grieved and afflicted; I beg for your pardon, prepared to make amends for my sins and never to depart from obedience to you. I

155

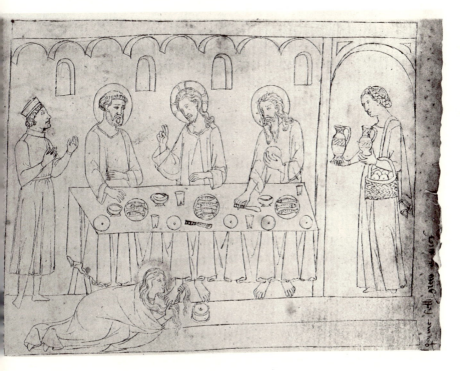

request you not to drive me away, for I know no other refuge, nor do I want any other, as I love you above all other things. Therefore do not drive me away but punish me for my offenses, and I beg for such mercy as pleases you." All

171

the time her tears flowed freely, bathing and washing the feet of the Lord. By this you can see clearly that the Lord Jesus walked barefoot. Finally she stopped crying and, judging it unsuitable that her tears had touched the feet of the Lord, she carefully wiped them with her hair. She did this with her hair because she had no more precious thing with her, and also because she had used it to satisfy her vanity and now wished to convert it to use, and also that she might not raise her face from the feet of the Lord. With increasing love she kissed them often and affectionately. And since the feet of the Lord were torn by His travels she anointed them with precious unguents. Watch her carefully and meditate particularly on her devotion, which was singularly loved by God, and also because this event was very solemn. See also how the Lord Jesus receives her benignly, and how patiently He endures what she does. He stops eating while this happens, and the others at the dinner also pause and marvel at this new event. Within his heart Simon judged Him harshly that He permitted such a woman to touch Him, as though He were not a prophet and did not know her. Replying to the thought in his heart, the Lord revealed Himself truly a prophet and convinced him by the example of the debtors. And wishing to show clearly that all things are brought about by love, He said, "Many sins are forgiven her, for she has loved much" (Luke vii, 47). And to her He said, "Go in peace" (Luke vii, 50). O delightful and gracious word, how willingly did the Magdalen hear it and how cheerfully she left! And completely converted to Him, from that time on, she lived in an honest and holy manner. She always remained close to Him and His mother. Meditate with diligence and make an effort to imitate so much charity, which is here praised highly in word and deed by the Lord. Here you have especially the fact that charity establishes peace between God and the sinner. In this way the Blessed Peter says that charity

covers the multitude of sins (I Peter iv, 8). Thus charity molds all virtues, and nothing pleases God without charity. To have it you must endeavor with all virtue to ingratiate yourself to your bridegroom Jesus Christ. I shall quote some passages on this. Thus the Blessed Bernard says of it in the 29th (sermon on the) Canticles, "O how dear[71] is charity, which is a quality that has no like and which the celestial Bridegroom took care to give continually to His new bride, saying, in truth, 'By this all will know you as my disciples, that you love one another. Now I give you a new commandment, that you love one another' (John xiii, 34, 35). And 'This is my commandment, that you love one another' (John xv, 12). Again I pray you all to be one together as He and His father are one. . . . Finally, what do we regard as comparable to this, which leads beyond martyrdom and the faith that moves mountains? Therefore this is what I say: let peace come to you and come from you, and everything that threatens from without will not frighten because it cannot harm."[72] And also in the 27th (sermon on the) Canticles he says, "Let the amplitude of each soul be estimated by the measure of charity that it contains, as I shall show you by this example. That soul which has much charity is great; that one which has little is small; that which has none is nothing, as the apostle says: 'If I have not charity I am nothing' (I Cor. xiii, 2). And if it has begun to have so much that at least it takes care to love those who love it and to greet its brothers and those who greet it, surely I shall not say that that soul has nothing, since it at least maintains a friendly charity in reason of God in give and take. But surely, according to the sermon of the Lord, 'What does it more?' (Matt. v, 47). I judge this soul to be neither broad nor great but clearly narrow and small, this soul that I know to possess so little charity. And if it grows and forges ahead, passing the limits of narrow and harmful love, let it fill to the wide edges of graceful goodness with

every freedom of the spirit so much until it extends itself as a large lap of good will, loving every neighbor as itself. Now one could not say directly, 'What more can you do?' Surely that which makes itself so broad. Moreover I say that he bears the bosom of charity who embraces all people, even those to whom he is not related by blood, of whom he does not expect to receive anything, to whom he does not owe anything in return for a service received, and to whom he is not bound by any debt except surely the one of which it is said, 'You are obliged to nothing except to love one another' (Rom. xiii, 8). And if you add that you wish to violate the kingdom of charity from all sides, so that you will include so much in its farthest limits, you, pious invader, will not think to close the bowels of mercy to the enemies but will do good to those who hate you, pray for those who persecute and calumniate you, and try to be pacific with those who hate peace. Then in the end the breadth and height of the sky and of your soul are not unequal and not of unequal beauty. In this is fulfilled what is said, 'The sky stretches like a skin' (Psalm ciii, 2), and in this heaven of marvelous breadth, height, and beauty, it, great, immense, and glorious, not only lives but moves freely."[73] This was said by Bernard. Thus you have seen how beneficial and how necessary is the virtue of charity, without which it is truly impossible to please God but with which everyone pleases without question. Therefore learn to have it with all your heart, mind, and virtue, for it will cause you to bear willingly all hard and harsh things for the sake of God and for your neighbor.

(XXIX.) *How John Sent the Disciples to Jesus Christ*
—MATT. ix, LUKE vii

When John the Baptist, the glorious cavalier and seconder of the Lord Jesus, was imprisoned by Herod for defending justice, for he had rebuked him for keeping the

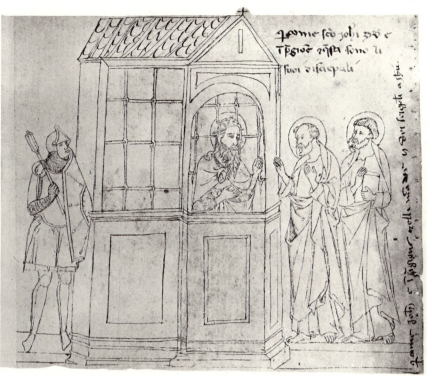

wife of his brother who was alive, he wished to induce his
disciples to follow the Lord Jesus. He thought of sending
them to Him that, after having heard His words and seen
His acts, they might be inflamed with love for Him and fol-
low Him. They went to Him as messengers of John and said,
"Are you the one who was to come, or are we waiting for
another?" (Luke vii, 20). The Lord Jesus was standing
before a great multitude. Observe Him carefully as He re-
ceives John's messages with pleasant countenance and see
how wisely He answers, first with deeds and then with
words. In their presence He healed deaf, mute, and blind
people and performed many other miracles and preached

96

jhu cōi discipli
qʼ olla ēba q̄ ueniē u aspᵗiamo noi altrui⁊ Et lo sigᵗie jhu auea grāde
come joh̄ iꝫ̄ tūba diuīsi dase. Piguādalo bñ come ᵱ piaceuīe uostᵒ
māꝺ· ii ōi sui discipli a signoꝛ·

riceuette li messaggi di joh̄i· ꝗ come sauiamēte uiꝺᵱma coꝛ

ꝗ come lo sᵱmō dolloꝛo labasoīt

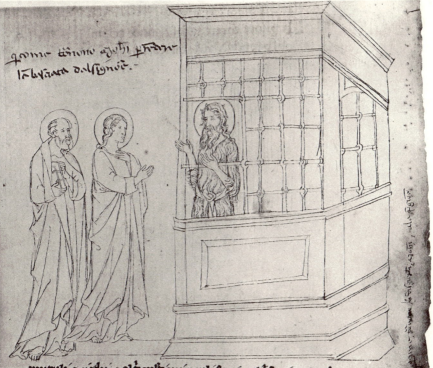

to the people. Then He said to them, among other things,
"Go and tell John of the things you have heard and seen"
(Luke vii, 22). They returned and related everything to
John, who listened most eagerly. After his death these dis-
ciples of John drew very close to Christ. After they had left,
the Lord Jesus commended John highly before the people,
saying that he was more than a prophet and that there was
none greater than he among the sons of women and other
things you can find in the Gospel. Thus you must always
keep the Lord Jesus in mind when He is preaching and also
when He does the miracles mentioned above.

(xxx.) *Of the Death of the Blessed John the Baptist*
— MATT. xiv, MARK vi [74]

Here you may consider the death of this Blessed John the
Baptist. It happened that the most evil Herod and that

47.

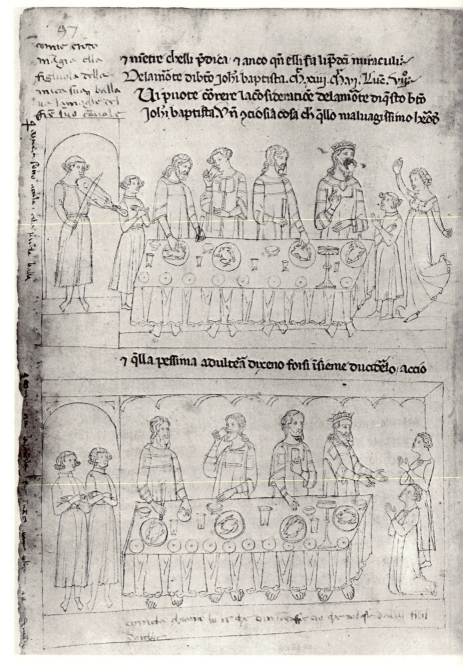

q̄nte che'll p̄dica. q̄ anco q̄n eſti fu lip̄ai miraculi
ſi che il miei ſua balla

Delamote dib̄o Joh̄i baptiſta. ch̄.xiiij. ch̄.xv. Luc.vij.

Ui puote cōrere la cōſideratice delamote diq̄ſto b̄o
Joh̄i baptiſta.V ñ q̄uoſia coſa ch̄ q̄llo maluagiſſimo lx̄oꝛ

q̄lla peſſima adultꝛea diꝛeno forſi ī ſieme ducadelo/acaio

delli nõ auesseno ripredimeto dellor peaõ. Ora itruie

qome oñaõa alamaõr
the uuole eft so oñaõ ziõ ho
al meetla dize locapo ziõ
Juli ʒeõ.

ne dì idel diē del quito ala missa figlíuola diqllo leõõaõ

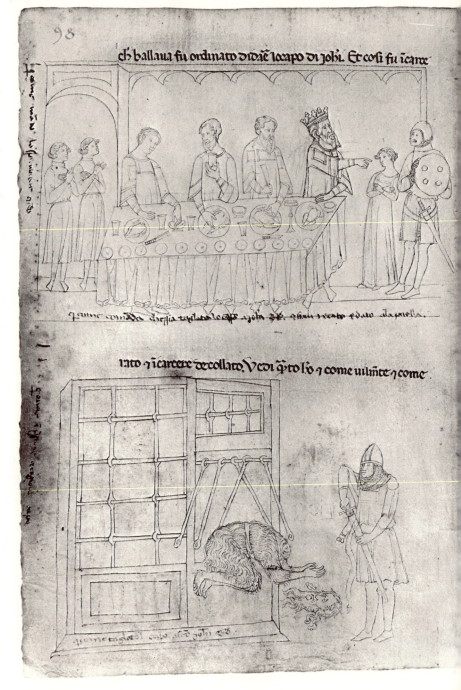

98

ch ballaua fu ordinato di dar locapo di Johi. Et cosi fu i carce

q anime connessa chressia tagliato locapo a Johi ﷽. et sui recato et dato alla puella.

rato i carcere decollato. V edi q̃to lo i come vilmẽte i come

q come tagliato capo al̃d Johi ﷽.

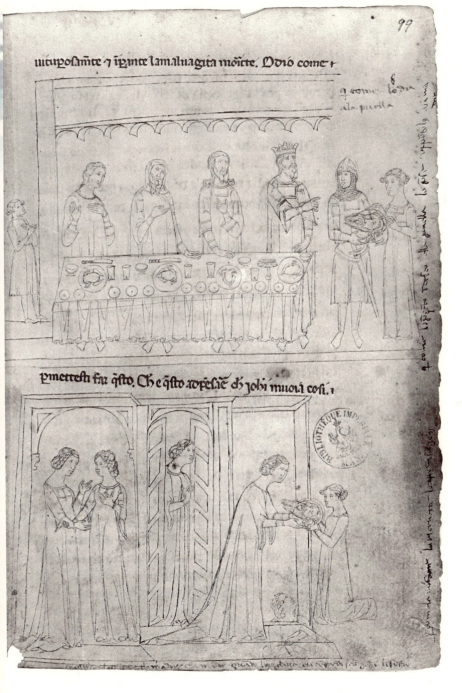

uitupofamte ꝗ iꝑinte lamaluagita moitte. Odio come ꞇ

pmetrefti far qsto. Ch e qsto aoꝑꝼefie dꝫ Johi muoiſ cosi. ꞇ

wicked adulteress together decided to kill him that they might not be reproved for their sin. Then it came about on a day of banqueting that the head of John was ordered to be given to the wretched daughter of that Herodias, who was dancing. In this way he was imprisoned and beheaded in prison. See how great a man he was and how miserably, abusively, with evil conquering, he died! O God, how could you permit this? How can we think that John, who was so perfect and holy that he was believed to be Christ, should die like this! Thus if you wish to reflect thoroughly on this fact, after the evil deed of those people, think of the greatness of John and his unique excellence, and then you may truly marvel. You have heard in the above treatise how he was praised in many ways by the Lord. Now listen to the many praises by Bernard in one of his sermons: "That mother and mistress of all churches, the Roman Church, of which it was said, 'I prayed for you, Peter, that your faith might not fail' (Luke xxii, 32), was consecrated and designated in honor of John the Baptist next after the name of the Savior. It was a worthy thing that he should give the singular Friend to the Bride, there where she started in the beginning. Peter was crucified and Paul executed by the sword, but the honors remain to the Precursor. Rome is empurpled by many martyrs, but the highest dignity is given to the blessed patriarch John. In all places he is the greatest, in all things unique, marvelous above all. Who is loved as gloriously? Who is he of whom we read that he was specially imbued with the Holy Spirit in his mother's womb? Of whom did you read that he leaped within his mother's womb? Whose birth have you heard the Church celebrate? Who is the child who desired to live like a hermit? Of whom do we read that he conversed on such a high level? Who was the first to show penance and the kingdom of heaven? Who baptized the King of glory? To whom was the Trinity first so openly revealed? Of whom did the Lord

182

Jesus Christ render such testimony? Who has been thus honored by the Church? . . . John the patriarch, indeed end and beginning of patriarchs; John the prophet, even more than prophet, for he proclaimed Him who was to come and pointed Him out; John the angel, but elect among angels, as was witnessed by the Savior when He said, 'Behold, I send you my angel' etc. (Matt. xi, 10, etc.); John the apostle, but of the apostles first and most important, for he was the man sent by God; John the evangelist, but of the Evangels the first initiator, preaching the Evangel of the kingdom; John the virgin, indeed the mirror of virginity, the title of purity, the example of chastity; John the martyr, but among martyrs the light, between the birth and death of Christ, most constant form of martyrdom. He is the voice in the desert, the crier, the precursor of the Judge, the herald of the Son of God. He is Elias to the end of the law of the prophets, the lamp alight and blazing. . . . I pass over in silence that he was incarnated in the ninth order of the angels, carried even to the height of the seraphim."[75] These are the words of Bernard. Hear now how Saint Peter Chrysologus[76] commends him in his sermon, saying, "John, school of virtue, master of life, model of sanctity, norm of justice," etc. Therefore if you compare the excellence and worth of John (and) the depth of the evil deed of those who killed him, you will have worthy cause for surprise and murmuring, if it is proper to speak thus against Christ. To such a one, so great, the executioner is sent, to behead him as though he were a very base and wicked assassin and robber. See him with reverence and sorrow as, at the command of a wicked and wretched one, the executioner draws the sword and calls John to come forth. When the wicket was opened and John put his head out to leave the prison, he gave him a blow between head and shoulders, cutting off his head.[77] This is what happened to John, intimate friend, relative of the Lord Jesus and greatest confidant[78]

of God. Truly it is shameful of us that we are not patient in every adversity. John, the innocent, patiently bore death, and such a death, while we, often weighed down by sins and worthy of the wrath of God, cannot bear minor affronts and hardships, indeed sometimes only hard words. At that time the Lord Jesus was in the same part of Judaea but not in the same place. When the news of John's death was given Him, the compassionate Lord mourned for His

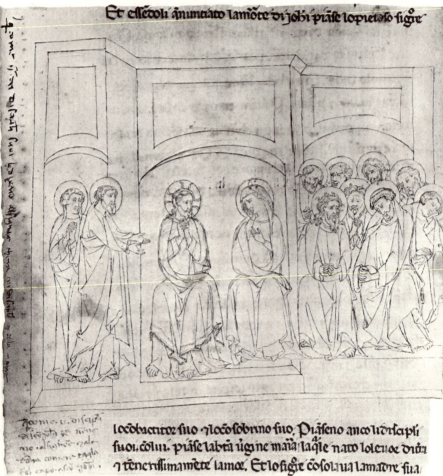

soldier and cousin. His disciples also wept with Him and with the blessed Virgin Mary, who had lifted him from the ground at his birth and loved him most tenderly. And the Lord consoled His mother when she said, "Son, why did you not defend him, that he might not have died in this manner?" The Lord replied, "O revered mother, he did not need that defense. He died for my Father and to protect His justice. Soon he will be in his glory. This Father does not wish to defend His own in such a way, because they should not live long, as their home is not here but in heaven. John is freed from the bonds of the body, and his manner of death is of no importance. The enemy was as fierce as possible toward him, but he reigns with my Father in eternity. Therefore be consoled, beloved mother, for John will always benefit." After a few days had passed, the Lord Jesus left that region and returned to Galilee. Keep all these things in your mind and meditate on them with devotion. Wherever the Lord goes, you will follow Him.

(XXXI.) *Of the Conversation of the Lord Jesus with the Samaritan Woman at the Well*— JOHN iv [79]

101

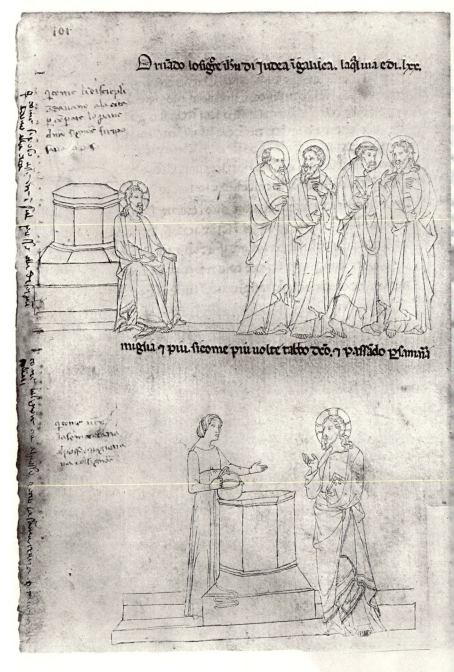

qcomr lieꝺıſoępꝉ
ꝫꝑauuauo ala ceta
p̄ d̄pare loꝯꝺum
duu ꝭꝑ̃oꝛ ſuꝛꝑo
ſꝫueꝛꝭao

muglia ꝫ puu. ſicome puu uoltе ta�̃o ꝺꝺo. ꝫ paſſãꝺo p̃ſamuã

qcomr uꝛa
laſemiueeꝺaua
ꝺpoꝭſeꝫmгuuua
ꝫꝗ colꝭꝑuꝺe

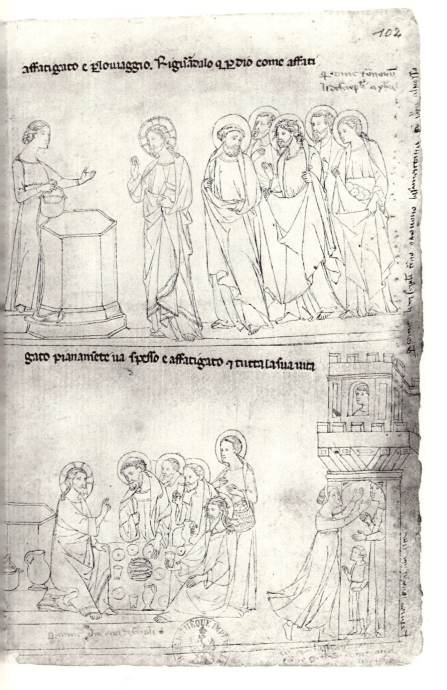

affatiguto e p̃louuaggio. Riguardalo q̃ p̃ dio come affati

gato pianamēte ua speffo e affatiguto 7 tutta la sua uita

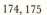

e affaticata. Puosesi ʒ asedere soṗ uno poʒo ʒ posauasi.

li discipuli andono alla cita ad ʒircare delcibo. Vēne una ·

femina

femina era chiama lucia pacħ ad q̄l posso: Elosigħe
comicio appalese collei ꝗdi grꝰd facti ad tractaē ꝗ
semedesmo allei manifestaē: ℣ Diqlle cose cħ collei
pꝶlaua ꝗtoe lidisciphi tonono, ꝗtoe ala parauln dla

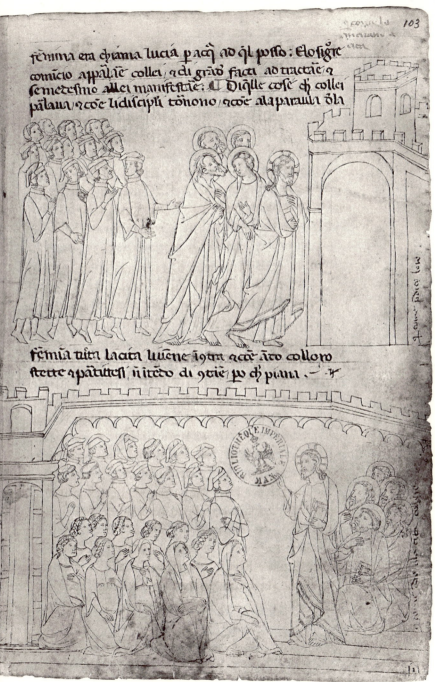

femia tuta lacata luuene iꝗtra ꝗtoe ꝶto colloro
stette ꝗpatitesi ꝟ itēdo di ꝗtiē po cħ piuui · ꝶ

When the Lord returned from Judaea to Galilee, which was a distance of 70 (17) miles and more, as I have often told you, He was exhausted by the journey as He was passing through Samaria. Observe Him with the help of God; how fatigued He is! He walks slowly; He is often tired; and His whole life is exhausting. He came to sit on the edge of a well to rest while the disciples went to the city to look for food. There came a woman, called Lucy, to get water from this well. And the Lord began to speak to her and to discourse on great things and to manifest Himself to her. I do not intend to relate the things He told her, or how the disciples returned, and how, at the words of the woman, the whole city approached, and how He went with them, stayed, and left, for here the story of the Gospel is clear. Read it and think of the Lord in all His deeds. Note several beautiful and beneficial aspects of this story: first, the humility of the Lord Jesus, for the humble Lord Jesus remained alone, while His disciples went to the city, and confided in her; and also that He discoursed humbly on such great things to that woman alone, and they talked together on equal terms. He did not disdain her, and said things to her that would have seemed very great if He had said them to many of the wisest of men. Haughty people do not act in this way, for they would consider it a waste to spread their pompous words among the few and would deem them unworthy of receiving their words. Second, consider His poverty and corporal suffering and the humility attending this. You see here how the disciples went to the city to seek food and, when they had it, returned and wished Him to eat it. Where would He have eaten? Surely near the well or at some stream or spring. You see thus how He was restored when He was tired and hungry. You must not think that it happened only once, accidentally; but this was His custom. You can clearly see that when the humble Lord and lover of poverty journeyed through the world He often ate outside the city and not in dwellings of men but at some stream or spring, however exhausted He was. He did not have pre-

pared food or delicacies or "curious" dishes. He did not drink fine wines but pure water from that spring or stream. He who rendered the vineyards fruitful and created the springs and all things that live in water, ate bread like a poor man, humbly seated on the ground. Third, reflect on His concern for spiritual study, for when the disciples invited Him to eat He said, "I have food to eat of which you know nothing. My food is to do the will of Him who sent me" (John iv, 32, 34). And he refused to eat, but waited for those who came from the city, so that He might first preach to them, wishing to perform insofar as necessary the things of the spirit before those of the body. Therefore observe Him in these things and try to imitate His virtues.

(XXXII.) *How the Lord Was Chased to the Top of a Hill to Be Thrown Over*—LUKE IV [80]

When the Lord Jesus returned to Nazareth, the inhabit-

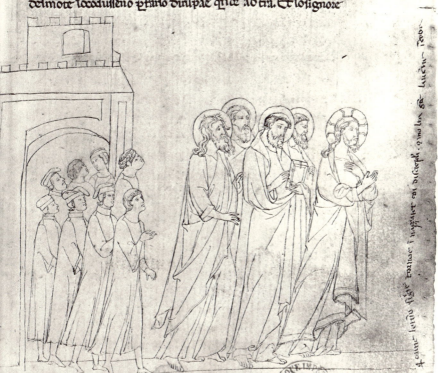

ants demanded miracles from Him. He showed them that they were unworthy of miracles, and, enraged, they chased Him out of the city and, with the benign Lord fleeing in front of them, pursued Him. What do you think of this?

179, 180

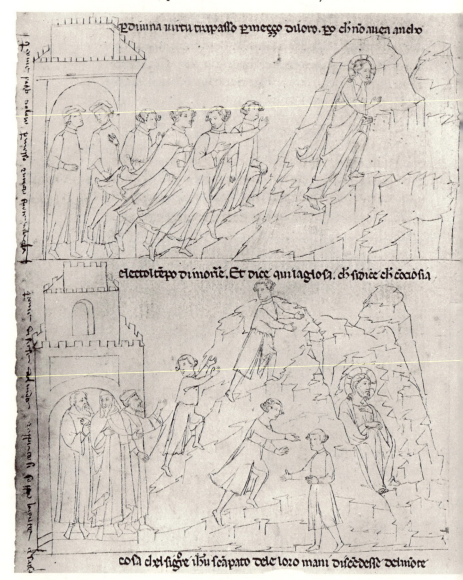

Their anger burned and continued to grow until they had lured Him to the top of a mountain from which they wished Him to fall to the ground. But by divine virtue the Lord passed through their midst, for He had not yet chosen His time of death. Here the gloss says that it is known that when the Lord Jesus escaped from their hands He descended and hid beneath a ledge; the stone yielded as if it were wax to give Him room to stay, and the folds of His clothing were imprinted on it as if carved. See Him flee before them and hide below the precipice, and pity Him for His afflictions and try to follow Him in humility and patience.

(XXXIII.) *Of the Man with the Withered Hand Healed by the Lord*—MATT. xii, MARK iii, LUKE vi

Once on a sabbath when the Lord Jesus was teaching in the synagogue, there was a man with a withered hand. The Lord Jesus drew him into the midst of those wise men and

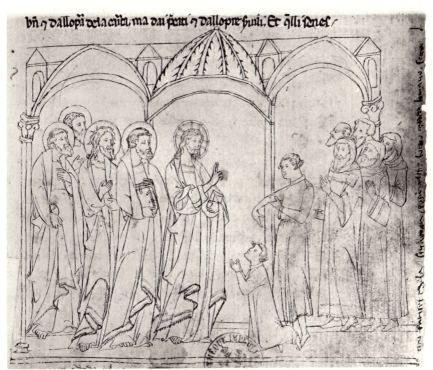

asked them if it were permissible to do good on the sabbath day. But they were silent. The Lord said to him with the withered hand, "Stretch out your hand" (Matt. xii, 13; Mark iii, 5; Luke vi, 10). And he was healed. Often (on the sabbath) He performed miracles, to confound the Jews who interpreted the laws materially, while God wished them to be observed spiritually. Thus one should not refrain from good and deeds of charity on the sabbath, but from sin and base actions. But the others were scandalized and murmured against Him, saying, "This is not a man of God, who does not keep the sabbath" (John ix, 16). But the Lord did not stop; indeed He purposely tried to remove their error. Reflect on Him in this work and follow His example in not ceasing from good deeds even if others raise unjust scandal. You must not cease from the good deed that is necessary to save the soul or encourage the growth of the spirit, regardless of scandal from anyone. But one must avoid adornment of the body, according to the requirement of perfect charity, upon the reproach of the brother. The apostle speaks of this in the 14th chapter of Romans,[81] "It is good not to eat meat or drink wine or do anything in which your brother can find an occasion for sin, cause for scandal, or weakness" (Rom. xiv, 21).

(XXXIV.) *Of the Multiplication of the Bread*
—MATT. xiv, xv, MARK vi, viii, JOHN vi

Though we read twice that the benign Lord multiplied a few loaves and satisfied many thousands of men with them, you will make this into one meditation and ponder on His words and actions. He said, "I am sorry for the multitude, for it is already three days that they have borne with me and they have nothing to eat, and if I let them fast they will grow faint on the road. Many of them have come from far off" (Mark viii, 2, 3). Then He multiplied the loaves, so that all might eat abundantly. Consider several good things here, especially how merciful the Lord Jesus

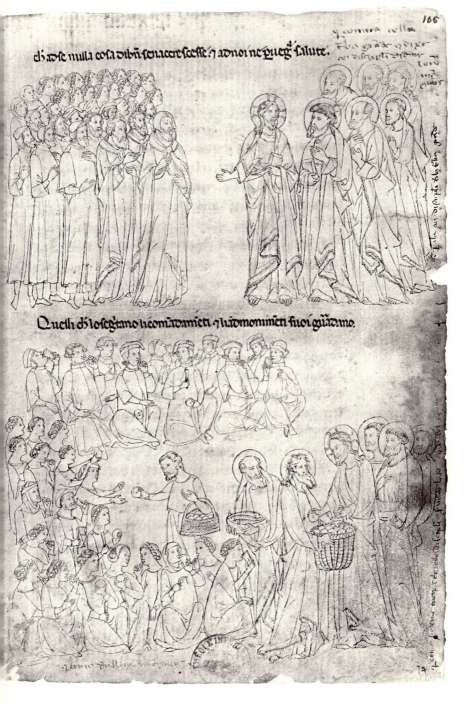

ch adse nulla cosa dubir sena cere scesse. q adnoi ne puege salute.

Quelli ch lo segtano li comandanieli q la doim meten suoi gua amo.

was, how gentle and pleasing, judicious and discerning. Meditate first on his mercy, for this led Him to help them. And also He said, "I have pity on the multitude," for the earth is full of His mercy (Psalm xxxii, 5).

Second, He was gentle and pleasing for the reason He designates when He says, "They have borne with me three days already." You see His great courtesy and acknowledgment, marvelous in that He speaks as of a benefit received from them, while in truth the benefit was theirs, not His. Thus, as He says elsewhere, it is a joy for Him to be with the sons of men (Prov. viii, 31), although no benefits derive to Him, and it is to us that salvation comes. The Lord loves those who follow His commandments and keep His counsel and does not close His hand to them, since He aids them fully in their need.

The third thing was His judgment and discernment, for He considered their need and their weakness, that they might faint, and that some had come from a great distance. See how full of flavor and mellifluence these words are. Thus He comes to us spiritually. We have no food unless He gives it to us; we faint on the road if He leaves us to fast; and without Him we cannot provide for ourselves in any spiritual event. Thus we have no reason for pride when we receive solace from the hand of God or when we feel any profit from spiritual exercise, for it is not ours but His. Therefore if you observe it well, you will see how much more perfect the servants of God will be, and how much closer to God and more excellent in their gifts, the more humble they become, for they claim nothing for themselves except their sins and defects. And the closer one comes the more he is illuminated and therefore he sees more clearly the magnificence of God and his own wretchedness. Therefore pride cannot enter into him, or vainglory, which are caused by blindness and ignorance. He who knows God and himself well and who examines himself cannot succumb to pride. And also it is a long road on which we

come to Him, and I speak especially of (myself and) those like me who through (our) sins have gone to a country so distant from Him. Thus those who return to Him are said to have come a long way. After these words Christ performed the deeds. See Him as He takes these loaves, giving thanks to the Father, and hands them to the disciples to distribute to the crowd. In their hands they are multiplied so that all can eat enough, and many pieces are left over. See also how He observes them eating and takes pleasure in their joy. And watch them as they marvel at this miracle, one recounting it to another in their jubilation. With gratitude they eat, not only physically; some of them perhaps are also fed mentally. Was not our Lady present to give the loaves freely to the women and to enjoy their refreshment? Scripture does not speak of this, but you should meditate as God gives you to do.

(x x x v.) *Of the Flight of the Lord When the Multitudes Wished to Make Him King*—JOHN vi

When the Lord had fed the crowds, as is related in the

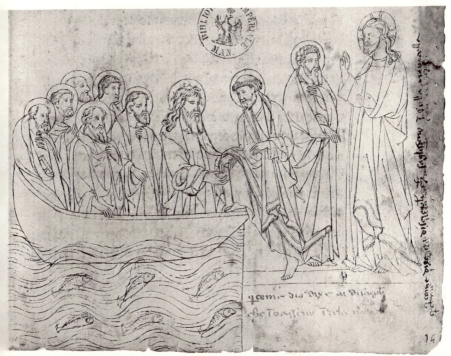

above chapter, they wished to make Him king, for they thought that He could provide for all their needs. But, knowing their intention, the Lord Jesus fled from them to the mount, so that they would not notice Him or find Him. He did not want to be honored in a temporal way. You see how He really fled this honor, and not in pretense, sending His disciples to sea while He climbed up the mount, so that those who looked for Him among the disciples would not find Him. The disciples did not want to leave Him, but He compelled them to enter a small boat and go across. Their

desire to stay always with their Lord was good, but He provided otherwise. Watch them now, for God's sake, as they leave by force, persuaded by the Lord, who showed that He wished them to get into the boat without Him. At

that they obeyed humbly, though it seemed hard and severe to them. In this way He continually deals with us spiritually. We would never want Him to leave us at any time, but His desire is different. He comes and goes at His will, but for our good. On this I want you to hear what Bernard says in this victory in the 32nd sermon on the Canticles: "After the Bridegroom has been urgently sought, with vigils and prayers and showers of tears, He slips away immediately when one thinks He is secured. And again returning to the one who weeps and rends himself He suffers Himself to be understood but not to be held, in that He immediately flies from one's hands. And if the devout soul continues in prayer and laments He will return anew and will not be deceived by the wish of the lips. But He will soon disappear again and not be seen unless entreated with all desire. Thus the presence of the Bridegroom may produce great pleasure in this body, but not in abundance, for while the visits bring cheer, the alternation troubles it. And this is its necessity: to bear the Beloved until, the weight of the corporal burden having been once laid down, it flies and is lifted by the wings of its desires, freely starting on a journey for the fields of contemplation and with a ready mind following the Beloved wherever He goes. And therefore He will not be present in passing in every soul, but in that soul that proves great devotion, strong desire, and sweet affection, and is worthy of the grace of a visit of the Son of God, who dresses it in beauty, taking the form of the Bridegroom." [82] And he also says in the 74th sermon on the Canticles, "Perhaps He withdrew that He might be recalled with more desire and held more closely. Sometimes He pretended to go further away, not because He wished to (but) to hear these words, 'Stay with us, for it is getting late' (Luke xxiv, 29). . . . Thus this holy pretense, or rather salutary dispensation, which the Son of God, then in the body, sometimes made material, does not cease to employ in a spiritual way with a soul devoted to Him. And when

leaving He wishes to be held back and when gone desires to be recalled His coming is a grace and His return is voluntary. And each of these is full of justice, and the reason for these things is His. Thus is manifested that in the saintly soul this coming and returning (of) the Son of God occurs as He says, 'I go and come to you' (John xiv, 28), and also 'In a little while you will not see me and again in a little while you will see me' (John xvi, 16). A little while is little; a little while is very long! Merciful Lord, you say, 'In a little while you will not see me.' Saving the word of my Lord, this little while is very long. But, for the love of God, each is true, for it is little in consideration of our merits and not little for our desires. The prophet says of both, 'If the Son of God delay, do not regret waiting, for He will come and will not delay long' (Hab. ii, 3). How is it that He will not delay if He tarry, except that it is much for our merit and little for our desire? The soul that surely loves is carried by desires and led by love, is said not to see its merits, closes its eyes to divine majesty and opens them to desire, placing love with desire in well-being and acting in God confidently. Finally it calls the Son of God again without fear and without shame and confidently requests His delights, and with habitual freedom it calls Him not Lord but Beloved, saying, "Revertere dilecte mi' etc. (Cant. ii, 17), "Return, my Beloved.' " [83] And he says in the 17th sermon on the Canticles, "The Son of God does not cease to change and cause these events in those who are spiritual or whom He intends to make spiritual. This He does by visiting them early and putting them to the test immediately." [84] This was said by Bernard. Thus you see how the Lord Jesus visits the soul spiritually and how He leaves it, and what the soul should do. It must call Him solicitously and continually, but in the meantime it must bear the departure of the Bridegroom patiently, following the example of the disciples who obeyed here and entered

the ship without Him, to endure the fortune of the sea and wait for liberation with His aid. But let us return to our Lord Jesus. When the disciples had embarked upon the sea, He climbed the hill alone and thus escaped from the hands of those who were searching for Him. See how studiously and cautiously He fled and scorned the royal honor. He set us an example for us to do likewise. He fled for us, not for Himself. He recognized what great folly it is for us to aspire to honors. Honor is one of the most dangerous snares and one of the heaviest burdens for the destruction of the soul that I know, whether it be honor of prelacy or of power or of knowledge. It is unlikely that he who delights in honor will not be in great danger of destruction, or rather, what is worse, is not already seared by ruin. This I shall show you with several reasons. The first because the spirit delights excessively in honor and urgently tries to conserve and increase it. But according to what the Blessed Gregory says, "The further one is removed from supernal love, the more one is pleased by the base things." [85] The second, because he intends to have friends, followers, and companions from whom, mediating and helping, he is safe and increases honor, for which reason many things happen in which he acts against God and against his own conscience, to please such friends, and makes them act for him. The third, because he envies those who have it, and disparages them, that he may remain more highly honored, and thus he slips into hate and envy. The fourth, because he thinks himself and desires to be reputed worthy of honor and consequently falls into pomp and pride. But, according to the apostle, "He who considers himself something while he is nothing deludes himself" (Gal. vi, 3). Therefore the Lords says in the Gospel, "When you have done everything well, you will say, 'We are worthless servants'" (Luke xvii, 10). But to whom does He say this? To him who wishes to be honored. The fifth, because he follows not the

spirit but the flesh. His spirit is not united and lifted to celestial things but vague and split into many things. The sixth and last, because he who has begun to delight in honor is then so greedy that he cannot satiate himself but continually solicits new and greater honors; and the more he receives the more he expects, for he considers himself ever more honorable than is customary, and more worthy in his and others' eyes. Thus he falls into ambition, which is a very bad vice and a cause and root for many other vices. On its malignity listen not to me but to Bernard, who says in the sixth[86] sermon on the Psalm *Qui habitat,* "The love of dominion, called ambition, is a very subtle evil and occult poison, a secret pestilence, a creator of deceit, mother of hypocrisy, relative of envy, beginning of vice, nurse of sins, rust of virtue, moth of sanctity, blinder of the heart; and of cures it creates infirmities and of medicine it generates fever. . . . How many men and women have been wickedly deceived by this pestilence and have been foully brought to a fall, so that all the others who have not known the hidden miner, the deceiver, should deeply fear the ruin they have seen others subjected to? But he who nourishes this worm nourishes only madness and forgetfulness of truth. Now who will show this worm, who will permit us to investigate this traitor, if not truth, which corrects the action of darkness? Surely this is what is referred to in 'What would a man gain if the whole world were his and he lost himself and harmed himself?' (Matt. xvi, 26). And it also says, 'The strong and powerful will be strongly tormented in Hell' (Wisd. vi, 7). This is what continually causes you suggestion, that is deception, of mind, as to how love of dominion is a vain consolation, a grave judgment, a brief utility, and an unknown end." And moreover he says, "The third temptation of the Lord was of this ambition, as we said before, when the devil showed to Jesus Christ all the kingdoms of the earth and said, 'I shall give you all

202

these things if falling, that is on your knees, you adore me' (Matt. iv, 9). Thus you see that the path of ambition is adoration of the devil, by which one arrives at the honors and glory of the world that he promises to his lovers." [87] He says in the fourth sermon on the Ascension, "Certainly we are all wishful; we all desire the exaltation of rising. We are noble creatures of great spirit and therefore possess a natural longing to desire the heights. But woe to us if we would follow him who says, 'I shall sit on the mount of the covenant, on the northern slopes' (Isa. xiv, 13). Woe to you, wretched one, who sit on the northern side, for that is a cold mount! We do not want to follow you. You desire might; you presume the height of power. How many to this day have followed your foul and unfortunate tracks! But how few escape who are not dominated by the ill wish to dominate! . . . Now whom do you follow, wretches, whom do you follow? . . . Was this not the mount climbed by the angel who became a devil? Remember that after his fall he was tormented by envy; and with evil intent, eager to overthrow man, . . . he showed him a similar mountain and said, 'You will be like gods, knowing good and evil'" (Gen. iii, 5). Further on he says, "The love of dominion, that is, the desire to be a lord, deprived the angel of angelic beatitude; and the appetite for knowledge, of wishing to know good and evil, despoiled our first parents of the glory of life. Suppose someone makes the effort to climb the hill of dominion, how many adversaries do you think he will find? How many aggressors, how many obstacles? And what a strenuous road? And suppose that in the end he has what he desires; remember what the Scripture says, 'The powerful will suffer great torment' (Wisd. vi, 7), and especially the many cares and anguish that this dominion creates. But let us leave everything else and say this. The other desire is the inflation of knowledge, which makes you proud. How much does the spirit exert and torment itself so as not to find an

203

equal! But in the end it will hear this: even if it were to study to the death it would always have an equal, and therefore its eye will always dwell in bitterness and envy. How often will it come about that you see someone who knows more than you or is thought by others to be better than you! And suppose that you have been raised very high, you will hear what the Scripture says, 'I will confound the wisdom of wise men and disappoint the calculations of the prudent' (I Cor, i, 19). Thus let us not delay in many things; you have seen that to my belief each one of these mounts is to be avoided if we fear the fall of the angel and the command of the man. And this is what the Scripture says, 'O mount Gelboe, neither dew nor rain visits you' (II Kings i, 21). Why therefore do we strive to climb if we do not need to? We are forced to climb by desire. But who will teach us a salutary ascent? Who if not the One of whom we read, 'He who ascends is the one who rises' (Eph. iv, 10)? He will show us the way to rise, that we may not follow the road advised by the wicked guide, the deceiver. And since there was none to rise, the highest One climbed down and with His descent dedicated to us a gentle and salutary ascent. He climbed down from the hill of power surrounded by disease of the flesh. He climbed down from the hill of knowledge, for it pleased God to save the believers by the folly of preaching (I Cor. i, 21). What seems more frail than the tender body and childish limbs? What thing appears more simple than the Infant who knows only His mother's breast? Who more impotent than He whose every limb was transfixed by nails and whose bones were numbered? Who seems more mad than He who surrendered His soul to death and paid for things He had not stolen? You see how low He descended from His power and how much He minimized Himself in knowledge. But He could not have climbed higher onto the hill of excellence or more expressly commended His charity. And it was not surprising that Christ rose in descending, when the one and

the other of the first parents fell in rising." [88] Again Bernard says, in the sermon on the Ascension, "Therefore, beloved ones, persevere in the discipline you have received, so that you may rise to the heights through humility, for this is the path and there is no other to be found. He who goes by another falls so low that he cannot get up, for here it is humility alone that raises and makes greater. This is the only way to life." And further he says, "Oh, the perversity, the contrariness of the sons of Adam! Although climbing is difficult, these sons of Adam rise lightly and descend with difficulty, prepared only for honors and greatness of ecclesiastical honors, which are fearful even for angelic force. But to follow you, Lord Jesus, there is scarcely found anyone who will bear to be drawn or who would wish to be led along the road of your commandments." [89] This was said by Bernard. By these words you see how you can attain the prime honor, evidently by humility, and how you must flee the temporal and false one. But it may be that someone ambitious, that is, eager for knowledge and honor, may be enticed under the pretense of gain for the soul, as though one might thus be better able to undertake the salvation of others. But listen to the reply of Bernard, in his sermon to the clerics, in the next to the last chapter: "My God grant that anyone who thus enters serve if possible as faithfully as he has faithfully offered himself. But it is difficult and perhaps impossible that the gentle fruit of charity grow from the bitter root of ambition." [90] These are Bernard's words. In order that you may suitably despise honors, the greatness of highest virtue is necessary. As Chrysostomus says on Matthew, "Such is the exercise of honor as though one were to converse with a beautiful young woman and keep the law and the doctrine so well as never to cast corrupt eyes on her." [91] Therefore it is undoubtedly necessary to employ with a very strong spirit the power and honor conceded to one.

(x x x v i.) *How the Lord Jesus Prayed on the Mount and Descended to Walk on the Waters Where Peter Was Submerged*—MATT. xiv, MARK vi, JOHN vi

As you read in the above chapter, the Lord Jesus urged the disciples to enter the boat while He climbed the mount. Let us follow the things the Lord effected after the miracle of the loaves, for this matter is continuous, and the events contained in these three chapters happened together. But hear them separately, so that you may better understand them and that their moral may be more clearly explained. After the disciples embarked, He climbed the hill and remained in prayer until the tenth (fourth) vigil of the night, that is, until three parts of the night had passed and the fourth was left. This shows how the Lord Jesus prayed during the night, and often one reads how intent He was in prayer. Watch Him therefore as He prays and humiliates Himself before the Father. He searches for solitary places and goes to them alone, mortifying Himself, keeping long vigils; thus the faithful Shepherd intercedes for His flock; not for Himself He prays, but for us, as our advocate and intermediary with the Father. He prays also to set us an example in prayer; often He thus admonished the disciples and now He confirmed it with His action. He told them that it was always good for them to pray and not to neglect it, and how the insistence on prayer will obtain what is requested, giving them the example of the judge and the widow, as you can see it in the 18th chapter of Luke. He encouraged them in the belief that they would receive their requests, by saying, "Petite, et dabitur vobis" (Matt. vii, 7; Luke xi, 9), "Ask, and it shall be given you." As another example He set forth the one of the friend who lent the necessary loaves on the insistent request of his friend, as is also to be found in Luke, (chapter) 11. This He told to commend to us the virtue of prayer. Surely its virtue is inestimable and effective in the request for beneficial

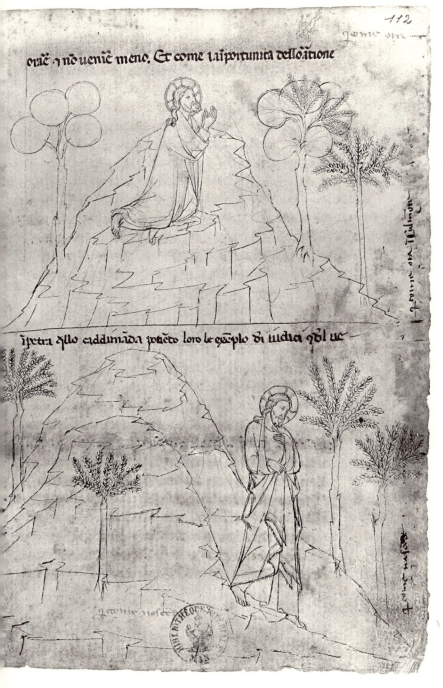

oraē ꝗ nõ ueniē meno. Et come laiportunita delloātione

ītra ꝗllo caddimāda ꝓuēto loro le exēplo di iudica ꝗōl uc

things and the removal of harmful ones. Therefore if you would bear adversity patiently, be prayerful. If you would

188

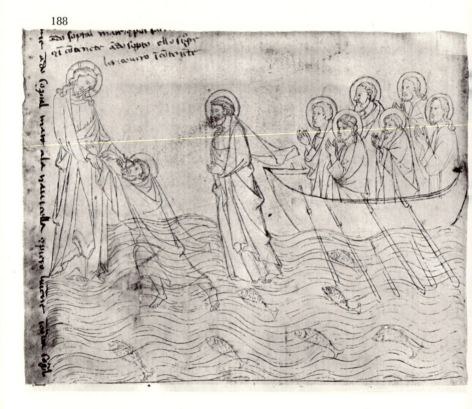

overcome and defeat temptation and trials, be prayerful. If you would drive away evil reflections, be prayerful. If you would know the stratagems of Satan, so as to avoid his tricks, be prayerful. If you would live happily in the works of God and not feel troubles and tribulations, be prayerful. If you would exercise a spiritual life and disregard the desires of the flesh, be prayerful. If you would drive away the flies of vain cogitation, be prayerful. If you would strength-

208

en your soul with good and saintly thoughts and fervent desire, and nourish your devotion, be prayerful. If you would establish your heart in the delight of God with strong spirit and steady purpose, be prayerful. Finally, if you would eradicate all vices and be full of virtues, be prayerful. In prayer you receive the advent of the Holy Spirit, which is the instructor of the mind in all things. Also, if you would rise to contemplation and enjoy the embrace of the Bridegroom, be prayerful. If you would taste celestial sweetness and the other great things of God that may be felt but cannot be said, be prayerful. To this contemplation and tasting of celestial things one arrives by the exercise of prayer. You see how full of power and virtue prayer is. To confirm these statements, leaving aside the proofs of the Scriptures, let this be effective evidence, which we continually see and hear through experience: unlettered and simple people have acquired these and many greater things by virtue of prayer. Thus all who desire to follow Christ must greatly stimulate themselves to prayer, and above all the religious, who should have more leisure, that is, more time for prayer. Therefore I exhort and order you as strongly as possible to take prayer as your principle exercise and delight in nothing other than prayer except the necessary things; for nothing can give you as much joy as to dwell with the Lord, and this is attained by prayer. But that you may hear a greater comforter, listen to the honeyed words of Bernard on this subject. Thus he says in the ninth sermon on the Canticles, "Those whose endeavor it is to pray often have felt what I say. Often we go to the altar with a lukewarm and dry heart and plunge into prayer. As we pray, divine grace immediately comes into our heart and nourishes our breast and fills us with the abundance of mercy. And if someone were to press, the milk of sweetness thus conceived would flow abundantly from our breasts." [92] And again Bernard in the fifth sermon on the beginning of

Lent says, "Whenever I speak of prayer I seem to hear in my heart words of human thoughts. . . . And it happens that we never cease praying, though there is hardly any one of us who seems to see the fruit of his prayer. As we go to prayer, thus do we seem to return, and no one answers a word and no one gives us anything. . . . Therefore you must follow the judgment of faith and not your experience, for faith is true and experience false. Then what is the truth of faith if not what was promised by the Son of God? What you ask for in prayer you will receive, if you have faith (Mark xi, 24). None of you beloved brothers should hold his praying in small esteem. I tell you that He to whom we pray does not regard it with contempt, but as soon as it issues from our mouths He orders it to be written in His book. And of two things we can know one thing without doubt, that He will give us what we request or what He knows to be most useful to us, since we do not know what it is necessary to ask for when we pray. But He has pity on us in our ignorance and, receiving our prayer benignantly, does not give us what will not be useful to us in the end or what is not necessary to be given so soon. (For love of this) our prayer is not fruitless if we do what is admonished in the Psalm, that is, delight in Him. The Psalm says, 'Delight in the Lord God and He will give you your heart's requests' (Psalm xxxvi, 4). . . . But consider what you said, 'requests of the heart,' which you prove by the judgment of reason. You do not have nor can you (plead) an excuse but rather you must turn it with great love into gratefulness to God for His great concern for you, since often, due to ignorance, you ask for something that is not useful to you; but He does not hear this and changes it to some better gift, in the same way as is done by a mortal father for his little son. When the latter asks for bread he gives it to him, but when he asks for a knife . . . he does not comply but rather breaks the bread he gave him himself. . . . I think

210

the petitions of the heart consist of three things, and that no elect person should demand anything besides these three for himself. Two are temporal, that is, the welfare of the body and of the soul; the third is the beatitude of eternal life. Do not marvel that I said that corporal welfare should be requested of God, for all temporal as well as spiritual things are His. From Him we must request and know for ourselves how we may be sustained in His service. But for love of this, for the necessity of our soul, we must pray more often and more fervently for the grace of God and the virtue of the soul. Thus we must pray with all piety and desire for eternal life . . . where surely beatitude may be full and perfect in body and soul. . . . Therefore let prayer for temporal things be restricted to our necessities, and prayer for the virtue of the soul be free of all impurity and intent only on pleasing God, and let prayer for eternal life be completely humble, claiming only divine mercy." [93] And also in the 86th sermon on the Canticles he says, "He who wishes to pray for himself needs to observe and keep not only place, but also time. Ferial, that is, festive, time is more convenient and free to be used for prayer, and especially the time when the sleep of night brings profound silence; that is, when everyone sleeps, then prayer issues softly from the lips of the faithful, more free and pure; as the prophet says, 'Rise at night, at the beginning of your vigils, and pour your heart like water before the face of the Lord your God' (Lam. ii, 19). At night prayer rises safely, with God as sole arbiter to see it, and the holy angel receives it for presentation on the divine altar in heaven. How gracious and clear, how modestly colored, how serene, pleasing, undisturbed by a single cry or noise! How unblemished and pure, free of the dust of earthly cares, not tempted by the praise or flattery of anyone who sees you! For this reason, the Bride, not less shamefaced than wise, requested the secrecy of her bed and of the night when she

211

wished to pray, that is, seek the Son of God." Thus says
Bernard. "You do not pray directly if you ask for anything
except the Son of God, . . . for all things are in Him (Rom.
xi, 36). In Him are the remedies of our wounds, the aid to
our needs, the reparation of our defects, the abundance of
profit. In Jesus Christ there is everything that it suits man
to receive and to have, that which is useful, that which is
necessary. Thus there is no reason to ask anything else of
Him, for He is all things. But it is for His sake that we ask
for these temporal things that we need, and since Christ is
our cause it is a worthy thing to ask not for temporal
things but for Him."[94] So Bernard said. Therefore you
have heard the most beautiful words of the loftiest medita-
tor and taster of the sweetness of prayer, Bernard. Muse on
them if you wish to taste their flavor. Gladly do I place and
add his words into this little work, for not only are they
spiritual but they reach the heart and are full of beauty
and encourage the service of God. He was a most wonder-
ful speaker and full of a spirit of wisdom and brightest with
sanctity. As I desire you to follow and exercise his teach-
ings in word and deed, I often place his words before you.

But let us return to the Lord Jesus. While the Lord
Jesus was praying on the mount, the disciples were on the
sea in deep affliction and anguish, for the wind was against
them and the ship was shaken by tempestuous rain and
hail. Observe them compassionately, for they are in grave
distress; it was night and they were without the Lord. In
the fourth vigil of the night, the Lord descended from the
hill and walked over the sea to approach them. Watch Him
carefully to see how, wearied by long vigil and protracted
prayer, He climbs down alone at night from the rigorous
and rocky mountain, barefoot, and how he walks on
the sea with firm step, just as if on land. The creature
recognized its Creator. When He neared the boat, the
disciples cried out in fear, thinking that He was a ghost.

But the benign Lord did not wish to excite them and reassured them, saying, "It is I; do not be afraid" (Matt. xiv,

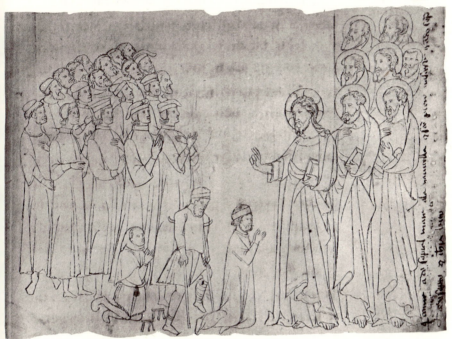

27; Mark vi, 51). Then Peter, confiding in the power of the Lord, also started to walk on the sea, at His command. But then, doubting, he started to go down into the water. Immediately the Lord stretched out His right hand and pulled him up so he would not drown. On this passage the gloss on Matthew says, "He makes him walk on the sea to show His divine power; He let him sink so that he would not forget his weakness, that he might not consider himself the equal of God and become proud." The Lord entered the boat and made the tempest cease, and everything be-

came peaceful. The disciples received Him reverently, joyfully, and remained in quiet and peace. Watch Him and the disciples during these events, which are very beautiful and devout; and you may consider the facts morally, for in this way the Lord acts toward us spiritually. He bears pain and suffers His elect to be afflicted in this world internally and externally, that is, in the soul and in the body, for He flagellates every son He receives. "Those who are left without discipline," as the apostle says to the Hebrews, "are not sons but bastards" (Heb. xii, 8). Therefore we must undergo trials and torment, for when we are disciplined we acquire virtue and, once it is acquired, keep it; moreover we await future and eternal rewards. Thus we must not be discouraged by tribulations or be impatient, but must desire and love them. Since the utility of tribulations is great and not known by many, it seems very difficult and unbearable to acquire. That you may be instructed in these things and learn to bear them patiently, I quote, according to the usual custom, the words of Bernard, who says in the 17th[95] sermon on the Psalm *Qui habitat,* "The tribulation suffered by the faithful Christian is very beneficial. And this causes approbation and leads to glory, as the prophet says, 'With Him I am in tribulation' (Psalm xc, 15). For this reason let us give thanks to the Father for His mercies; He is with us and consoles us in our every tribulation. According to what I said, tribulation is a necessary thing, which subsequently turns to glory, and sadness changes to a joy, truly lasting, that no one can take from us, a great joy, complete joy! A necessary thing is this necessity that produces a crown. Brothers, let us not disdain the seed, which is a small thing: great fruit is born of it.[96] Very insipid, very unripe is the mustard seed. Let us not consider the things that can be seen. They are temporal; but those that are unseen are eternal (II Cor. iv, 18)." Further he says, "'Let us glory in tribulation, for tribulation is surely

the hope of glory' (Rom. v, 3). . . . Even tribulation contains glory, just as the hope of the fruit is contained in the seed. . . . God says, 'With him I am in tribulation' (Psalm xc, 15); and must I ask for a merit beyond tribulation? It is good for me to approach God and not only this but place my hope in the Lord God, for He says, 'I will liberate and make him gracious; with him I am in tribulation' (Psalm xc, 15). And He also says, 'My delights, that is, joys, are to be with the sons of men' (Prov. viii, 31). . . . He came to this world to be close to those who are afflicted in heart, for He is with us in our tribulations. The time will come when we shall be lifted out of darkness to approach Christ in the air; and thus we shall always be with the Lord if we are concerned to keep Him in our midst. . . . It is good for me, Lord God, to be afflicted, as long as you are with me, better than to rule without you and have glory without you. . . . The furnace tests gold and the temptation of tribulations tests just men (Ecclus. xxvii, 6). . . . Therefore why do we fear, why do we doubt, and why do we flee this furnace? The fire burns very ferociously, and the Lord is with us in our tribulations. Thus if the Lord be with us, who is against us (Rom. viii, 31)? If He liberate us, who will take us from His hands? Finally, if He glorify us, who will abuse us? If He glorify us, who will hold us in contempt?"[97] Again Bernard speaks, in the 25th sermon on the Canticles: "Not only should we glory in hope, but also in tribulation. And the apostle says, 'Willingly shall I glory in my weaknesses, that the virtue of Christ may dwell in me' (II Cor. xii, 9). Greatly desirable is the weakness that is compensated by the virtue of Christ. Who will tell me to be not only infirm but abandoned and give up everything that I may be firmly established by the virtue of the Lord of virtue? The virtue of patience is fulfilled in weakness, that is, adversity. And at the end he says, 'When I am weak, I am stronger and more powerful' (II Cor. xii, 10), that is, in the mind."[98]

And in the 43rd sermon (on the Canticles) he says, "For the Bride does not call her Bridegroom 'bundle' but 'little bundle,' for to her what she carries seems light in weight or sorrows due to the greatness of the love she had for the commands of her Bridegroom. . . . It is well called 'a small bundle,' for the sufferings of this time are not worthy of the glory to be, which shall be manifested in us (Rom. viii, 18). That which in this world is a present and momentary and light weight of our tribulation secures for us an eternal weight of glory of exceeding loftiness (II Cor. iv, 17). Thus at times what is now a little burden of myrrh[99] will be a great load of glory for us. Does it not seem a little burden of myrrh that belongs to Him whose yoke is easy and whose burden is light (Matt. xi, 30)? Not that it is light in itself—the harshness of suffering and the bitterness of death—but because it is light only to him who loves it."[100] And again in the seventh[101] sermon on the Psalm *Qui habitat:* "If you wish to consider that great body of the holy Church, we may easily think that spiritual men are more seriously tried than worldly ones. . . . And truly pride, envious malady, always strikes perfect ones more, according to the words of the prophet, 'The food of the devil is the elect' (Hab. i, 16). . . . This He does not do without a certain dispensation of divine counsel, which will not let the imperfect be tempted before those who can bear it, making temptation an aid. And to the more perfect not only more gloriously but in greater number He prepares victories of the enemy. . . . Continually with greater care and greater cunning the opposite side tries to injure rather our right hand than our left. But it attempts to deprive us not only of the substance of the body but also of that of the heart." And further he says, "You must more assiduously resist where necessity weighs more heavily, where the whole weight of the battle overcomes, where the whole cause of the combat rests, whence is prepared for us either, captured

216

and bound, the ignominious prison or, as winners, triumphal and victorious glory. . . . Finally, this grace and mercy of God are for His servants, and His regard is for His elect, so that, while surely dissimulating as to their left, He is always present as a more zealous defender of their right. This is what the prophet affirms of himself: 'The Lord always provided for me, for He is on my right side, to make me stand firm' (Psalm xv, 8) May God grant that you, good Jesus, be always on my right side! May God grant that you always hold my right hand! I am sure that no adversary will harm me if no injustice rules. Meanwhile let the left side be shorn and cut, let it be struck with insults and bound with disgrace! Willingly do I set forth the word, while I am guarded by you, since you are my defense on my right hand."[102] And he also speaks in the 85th[103] sermon on the Canticles: "It is one thing for the soul to move by virtue, and another to let wisdom rule, and yet another to bear rule in virtue, and another to delight in sweetness. Although wisdom is powerful and virtue sweet, we may thus use appropriate words for the meaning: strength shows virtue, and wisdom pleasantness of soul with a special sweetness. This I believe was meant by the apostle when, after many exhortations relating to virtue, he adds that wisdom lies in the sweetness of the Holy Spirit (II Cor. vi, 6). Thus to resist, to expel force by force, which virtue causes in this way, is truly honorable, but laborious. It is not the same thing to defend your honor with difficulty and to possess it peacefully, nor is it the same thing to act virtuously and to enjoy virtue. Virtue is fatiguing, wisdom is possessive, and what wisdom orders and deliberates, virtue tempers and follows. Wisdom writes, 'They are merchandise and works' (Ecclus. xxxviii, 25). And the more leisurely wisdom is, the more industrious in its kind: virtue exercised by sanctity is more clear and approved the more it is in office. And if anyone would define wisdom as love

217

of virtue, I do not think he would depart from truth. But love is not an effort, but possesses savor. And perhaps wisdom—*sapientia*—is named from savor—*sapore*—, which approaches virtue like a condiment to give it flavor, where by itself it would seem in some way insipid and sharp. And I do not say that anyone who judges wisdom to have a savor of goodness should be reproved. . . . Thus it is for virtue to sustain tribulations with strength, but for wisdom to enjoy them; for virtue to comfort your heart and support the Lord, for wisdom to taste virtue and see how gentle the Lord is. And so that the good will shine more brightly by its own natural good, tranquillity of soul proves the wise man, and constancy shows us the man of virtue. And it is good for wisdom to come after virtue, so that virtue can be a stable foundation on which wisdom can build her house (Prov. ix, 1)."[104] He also says in the sermon on the Passion of the Lord, "Blessed is he whose cogitation—and this is our word—directs all his actions to justice, and whose intention is sound and action just. Blessed is he who orders the passions of his body with justice, so that what he suffers he suffers for the Son of God in such a way that his complaints be removed from the heart, and deeds of thanks and voices of praise be in his mouth. He who has risen in this way picks up his bed, called pallet in the Gospel, and goes home. Our pallet is the body in which we lay before, languidly serving our desires and lusts. Now, when we are urged to comply with the Spirit, we carry it."[105] And again Bernard, in the sermon on Pentecost: "Truly manifold is the Spirit, which is infused into the sons of men in so many ways that there is none who hides from His warmth. Surely He is given them to use, for miracles, salvation, and help, for solace and fervor; for the use, in truth, of life, giving the common good abundantly to the good and the evil, to the worthy as well as the unworthy, so much that it seems that He has no rule of distinction. Ungrateful is he who does not acknowledge in these things the benefits of the Spirit. He performs

miracles in signs and proofs, in various virtues, by means of anyone's hands. He is the one who revives the old miracles, so that, through the present ones, faith in the past ones grows. Since on some He does not lavish this grace without special utility, the third time is infused for our salvation when we return to the Lord our God with all our heart. Surely help is given when, in every battle, He aids our weakness. When He renders witness to our spirit that we are sons of God, that inspiration is a consolation. He also gives fervor, when, blowing more strongly in the hearts of the perfect, He lights a great fire of charity, so that we may rejoice not only in the hope of the glory of the sons of God but also in tribulation, deeming shame as glory, reproach as joy, contempt as exaltation. If I am not deceived, the Spirit is given to all of you for salvation, but not so for fervor.[106] Few are those who are full of this Spirit; few are those who strive to follow it. We are content with anxieties and do not wish to breathe in that liberty or even compel ourselves to aspire to it."[107] This was said by Bernard. Thus you see how the most eloquent Bernard has demonstrated by many and beautiful reasons that we need tribulations. Therefore do not wonder that the Lord permitted the disciples whom He loved to be thus tormented by the storms, knowing their benefit. One can read of several times when their little boat was buffeted by adverse winds and storms, but it never sank. With these warnings, try to establish and dispose your heart so that in the face of adversity and displeasure you will bear yourself cheerfully and patiently. And through the Spirit and full of its fervor, exert yourself to desire to receive pain for the sake of the love of the Lord Jesus, who followed and demonstrated this loftiest path for Himself and His.

(x x x v i i.) *Of the Canaanite Woman*
—MATT. xv, MARK vii

While the Lord Jesus was exerting Himself in preaching

and healing the infirm, there came to Him a Canaanite, that is, a woman from the city of Canaan, which belonged to the pagans and not to the Jews. She begged Him to liberate her daughter, who was greatly tormented by the demon. She had faith in His power to do this. Although the Lord did not reply, nevertheless she remained firm and persevered in crying and asking for mercy, so much that the disciples interceded with the Lord for her. And the Lord replied that one should not give the bread of the children to the dogs; but she humiliated herself and said, "Lord, at least grant me the crumbs that fall from the table, after the manner of the dogs." Thus she deserved to be heard. Contemplate the Lord and the disciples, and also the woman, in these events, according to the general considerations I gave you above. And consider none the less the virtues of this woman and convert them to your use. They were principally three. The first was the great faith that extended even to the daughter, and for this she was commended by the Lord. The second was her perseverance in prayer, and she was not only persevering but importunate, which importunity is accepted and invited by the Lord, according to what you saw in the above treatise on prayer. The third was her profound humility, in that she did not deny being a dog and did not consider herself worthy of being placed among the children and having the whole loaf, but was content to receive the crumbs. She greatly humbled herself and therefore had what she requested. In the same way, if you humiliate yourself before your God, persevering in prayer with your whole heart faithful and pure, deeming yourself unworthy of His benefits, I believe firmly that you will have what you ask. And in the same way as the apostles interceded for the Canaanite woman, your angel will pray for you and offer your prayer to God. On this, hear Bernard in the 31st (sermon on the) Canticles, who says the following: "At times the desired and longed-for object approaches

mercifully to the soul that often sighs, that prays without pause, and afflicts itself in desire. I think that it will happen to him by his own experience, so that he will say with Saint Jeremiah, 'O Lord, you are the Lord of those that hope in you and of the soul that asks for you' (Lam. iii, 25). But his angel, who is one of the companions of the Bridegroom, is commissioned minister in this affair and arbiter of the secret and alternating salutation. How that angel rejoices, turning to the Lord with gladness and delight, to say, 'I give you thanks, O Lord of majesty, for you gave him

190

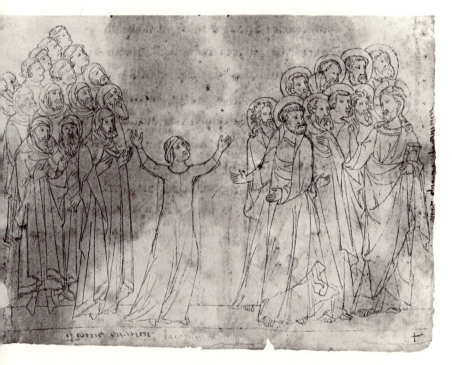

his heart's desire and have not cheated him of the will of his lips' (Psalm xx, 3). He is in every place and always an attendant of your soul and does not cease to entreat it and

admonish it with continual solace, saying, 'Delight in God, and He will grant you the wish of your heart' (Psalm xxxvi, 4). And also, 'Await the Lord and guard His road' (Psalm xxxvi, 34). Also, 'If He delay, wait for Him, for He will come and will not tarry' (Hab. ii, 3). To the Lord he says this: 'As the stag desires to reach the fount of water, so this soul desires to come to you, O God' (Psalm xli, 2). 'He has desired you in the night but your spirit is inside him. In the morning he wakes to you' (Isa. xxvi, 9). And also he says, 'All day long he stretches his hands to you' (Psalm lxxxvii, 10). 'Leave her for she cries for you' (Matt. xv, 23). 'Turn around and be benignant. Look down from heaven and see and visit the abandoned soul.' The faithful messenger, who knows and is aware of their love for each other but is not envious, does not ask his glory but that of the Lord. He goes back and forth between the Bridegroom and the beloved, offering devotion and giving back gifts. He arouses the one and assuages the other. And sometimes it may happen, rarely, that he presents them to each other in like manner, either carrying off the one or bringing the other to him. Surely he is familiar and known in the palace and does not fear to be driven away and continually sees the face of the Father."[108] So Bernard said.

You see how faithfully our angels wait on us: therefore we must now say something about them. I want you to know that we must render great reverence to them, continually praise and honor them, and give them thanks. And in their presence, for they are always with us, we must not say, think, or do any unlawful, vain, or foul things. The Blessed Bernard warns us again on this in the 12th[109] sermon on the Psalm *Qui habitat:* " 'Angelis suis mandavit de te, ut custodiant te in omnibus viis tuis' (Psalm xc, 11). 'He commanded His angels that they should guard you in all your (ways).' How much reverence, increase in devotion, and gift of confidence must this word give you! Reverence for the presence, devotion for the benevolence,

confidence for the vigilance. Go wisely where the angels are present in all your roads. In any place, in any corner, be reverent to your angel. Do not dare to do when he is present what you would not do when I can see you. . . . Thus they are present not only with you but also for you so they can defend you; they are here so that they may be of use. What will you render to God for everything He has given you? Surely it is meet for Him alone to have honor and glory. Why for Him alone? Because He has commanded it. And everything that is given is good only if it comes from Him (James i, 17). But if He has commanded it to those who thus serve Him and obey Him in so much charity and assist us in so much necessity, it is not for us to be ungrateful. Let us therefore be devoted, let us be grateful for so many guardians. Let us recall them and honor them with all our power."[110] So Bernard said. In the above treatise you have therefore the commendation of the service and help of the angels and the virtue of prayer. Make an effort to remember it and to render every honor to them that you can.

(x x x v i i i. *How Some Were Scandalized by the Words of the Lord*—MATT. xv, MARK vii, LUKE xi, JOHN vi)

Do not marvel if sometimes scandal arises from our words and deeds, however well and faithfully meant they may be, since it happened more than once to this Lord who could not err. Once the Pharisees asked the Lord why the disciples did not wash their hands when they ate. The Lord answered sharply and reproved them that they aimed for cleanliness on the exterior and not inside. They were scandalized about this and the Lord did not care. And also another time, when He was teaching and explaining spiritual words in the synagogue, some of His disciples who were carnal and did not understand Him left Him. And He said to the twelve disciples, "And you, do you not want to go away?" (John vi, 67). And Peter replied for himself and the

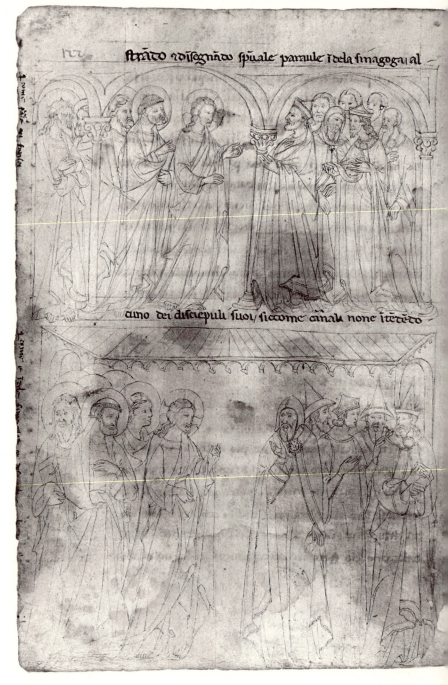

strato e disegnato spuale paraule idela sinagoga al

aimo dei discepuli suoi, siccome canali none iterecto

others, "Lord, to whom should we go? Yours are the words of eternal life" (John vi, 68). See Him therefore in this and similar events; see how He spoke with authority and taught the truth, not heeding the scandal of the wicked and the foolish. Note first that we should not depart from the virtue of justice because of the scandal of others. Second, we must take care rather of inward cleanliness than of outward purity, as God expressly said elsewhere, that is, in Luke 11. Third, we must live spiritually, so that the words of the Lord will not seem as strange to us as to those disciples who left. But above all let us recognize that they are of eternal life, that we may follow them perfectly, together with the twelve disciples.

(xxxix. *Of the Retribution for Relinquishing All*)

Once the faithful and judicious disciple Simon Peter wished to know the tribulation and the reward for himself and his companions from the Lord Jesus. In reply the Lord said, among other things, that "all those who left temporal things and followed me would receive a hundredfold reward in this world and eternal life in the world to come" (Matt. xix, 27–30). Make careful note of this reward and rejoice with great happiness and render thanks and praise to the Lord with your whole affection for having led you to such a bargain that you can earn a hundredfold in hand and, what is more, eternal life besides. This centuplication applies to spiritual, not material, things, that is, inner consolation and the virtues that we know by experience and not through learning. When the soul samples the odor of poverty, the splendor of chastity and patience, and the flavor of all the virtues, and delights in them, does it not seem that you have a hundred for one? And if it rises higher to receive the visit of the Bridegroom and is glorified by His presence, does it not receive more than a thousand for one of all those things, whatever they were and however much it had abandoned for His sake? You see how true is He (who) speaks the

truth. He does not fail to return a hundred for one in this world, not only once, but many times and often, to the soul

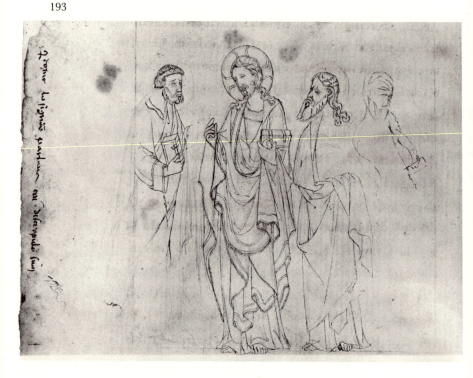

so devoted to Him that He strongly inflames it. It has not only abandoned these things but considers the whole world as dung and dregs so that it may earn its Bridegroom. And so that you may be more fully instructed on this centuple, hear what Bernard comments on this Gospel, chapters lvii and lviii: "It may happen that some layman might say, 'Show me this centuple you promise and I shall voluntarily abandon everything.' Why should I show it? The faith for which human reason offers proof has no merit. Would you rather believe the one that shows it than the Truth that promises it? Searching, he fails in the search. If you do not believe, you will not understand. That manna is hidden that

in the Apocalypse of John is promised to the winner, the new name that no one but he who takes it (knows). . . . And in the end does not he for whom all things operate to benefit possess everything? Does not he who is full of the Holy Spirit and has Christ in his breast have a hundredfold of everything? Is not the visitation of the Holy Spirit and the presence of Christ much more than a centuple? And he says this: 'O how great is the multitude of your sweetness, Lord, which you hide to those who fear you, fulfill for those who hope in you' (Psalm xxx, 20). You see that the memory of the abundance of this gentleness gives the Holy Spirit, desiring to propose that He multiply the words, for which reason he says, 'Great is the multitude.' This is the centuple: the adoption, that is, the acquisition, of the sons, and the liberty, the spirit, the first fruits, the wealth of charity, the glory of the conscience, the kingdom of God that is inside us. Surely it is not food or drink but justice and peace and joy in the Holy Spirit (Rom. xiv, 17); joy in reality, in hope not only of glory but of tribulations. This is the flame that Christ wished to have burning strongly. This is the virtue from above that caused Andrew to embrace the cross, Lawrence to laugh at those who tormented him, Stephen in death to kneel in prayer for those who were stoning him. This is the peace that Christ left to His own when He gave up His. Indeed this is a gift and a peace to the elect of God, peace of the present life and gift of that which is to come. It advances every sense, but what is shown under the sun and what is desired in the world cannot be compared. This is the grace of devotion and a suitable unction of men, which is known by those who have experienced it and not known by those who have not experienced it, for no one knows it except one who receives it." [111] This is what Bernard said. Be cheerful therefore and joyful, as I told you, and render thanks that you are called on to receive this centuple and enter often into this paradise that you can acquire by diligence in prayer.

(X L. *How the Lord Sought to Learn from the Disciples What Was Said of Him* — MATT. xvi, MARK viii, LUKE ix)

When the Lord Jesus came into the region of Caesarea Philippi, He wished to know from the disciples what was said of Him and what they thought of Him. And the others replied with what was said; but, for himself and these others, Peter said, "You are the Son of God" (Matt. xvi, 16). And the Lord said, "You are Peter, and upon this rock I shall build my church" (Matt. xvi, 18). Then He gave Peter, for himself and his successors, the keys to bind and loose on the earth. Consider this according to the general formula I gave you above and note here also that He who had so magnified Peter a short time later called him Satan, when Peter, because of the carnal love he bore Him, was distressed by the Passion and did not want it fulfilled. In this way you too should follow the example of the Lord and regard as enemies all those who wish to prevent you from spiritual exercise and good for the sake of corporal relief.

(X L I. *Of the Transfiguration of the Lord on the Mount* —MATT. xvii, MARK ix, LUKE ix)

The Lord Jesus took three disciples and climbed to the top of Mount Tabor, to transfigure Himself before them and show Himself in His glory. Moses and Elias came also, conversing with Him on the Passion He was to undergo and saying, "Lord, it is not necessary for you to die, for one drop of your blood would redeem the whole world." And the Lord said, "The good shepherd gives his life for his sheep, and I too must do this" (John x, 11). Here there was also the Holy Spirit in the form of a bright cloud, and the voice of the Father came from the cloud, saying, "This is my beloved Son, in whom I am well pleased; to Him listen" (Matt. xvii, 5). The disciples fell to the ground and when they rose, as from sleep, they saw only the Lord Jesus. Keep these things well in mind and set them before you, for they are most lofty.

(XLII. *Of the Casting Out of the False Buyers and Sellers from the Temple*—MATT. xxi, MARK xi, LUKE xix, JOHN ii)

Twice the Lord Jesus chased out those that were buying and selling in the temple, and this act was considered among His great miracles. Although at other times they scorned Him, now they fled before Him. And it came about that, although they were many, they did not defend themselves or make any resistance, but all fled with hardly time to collect and pick up their things, and He alone drove them out with some cords. This happened because He showed Himself terrible in His face. Kindled to wrath and to strong and good zeal because His Father was thus dishonored by them, especially in that place where He should be most highly respected, He drove them out. Watch Him well and feel compassion, for He is full of the sorrow of compassion; but, nevertheless, fear Him. If we who are in the temple of God, appointed by His great and special grace, concern ourselves with worldly things, as they did, instead of attending always to the praise of God, then we deserve and must fear expulsion and His indignation. Therefore if you do not wish to be tormented by this fear, never venture to involve yourself in worldly cares or deeds for any reason or cause. And do not do frivolous things that take the time that one should give to praising God, and leave those things that relate to worldly pomp and great vainglory.

(XLIII.) *Of the Sheep Pool*—JOHN v

There was a pool in Jerusalem in which the sheep destined for sacrifice were washed. It is said that the wood of the cross was there. Once a year it was stirred up by an angel, and the first to enter after the water was agitated by the angel was cured. Therefore many diseased people stayed continually at the edges of this pool. Among those there was a paralytic who had been lying on a pallet or little bed for thirty-eight years. Now it happened that Jesus

Christ healed this cripple on a sabbath. Look at Him as He goes humbly to the cripple and speaks according to custom. In this event note three things. The first is that the Lord asked the cripple if he wished to be cured, as He will not save us without our consent, and the sinners who do not consent to the will of the Lord and their salvation are not excusable: according to the words of Augustine, "The one who created you without you will not justify you without you." [112] The second is that we must be very careful not to fall back into sin, for, if we are healed by the Lord

198 and then fall back, our ingratitude will justly be punished more harshly, as the Lord said to this man: "Go and do not sin any more, that worse may not befall you" (John v, 14). The third is that malevolent ones lose in all things just as good ones gain in all. Therefore when the healed man was carrying his bed, he was asked by the Jews, "What are you doing? It is not proper to carry this bed on the sabbath." He replied, "He who cured me said to me, 'Take up your bed and walk.'" The others said, "Who said to you,

199 'Take up your bed and walk?'" (John v, 10–12). But they did not say, "Who healed you?" In this way they emphasized everything by which they could reproach Him and not what they could praise, as carnal men often judge in bad faith what they can see, and lose in everything; while those who live spiritually turn all things to the praise of God, whether prosperity or adversity, and do not doubt

200 that all things are done rightly or justly, since God acts in all things rightly or permits justice; and they interpret everything in good faith, according to the teachings of the Blessed Bernard, who says in the 40th (sermon on the) Canticles, "Avoid being in intercourse with others, and with the one who wishes to have familiarity with people, for we do not want him whether he be a loyal or a curious pryer and said to be he who wishes to see and hear secret things to which he is not called, an imprudent judge. Understand a false act and do not judge your neighbor thus,

but rather excuse him. Excuse the intention if you cannot excuse the deed. Suppose ignorance, suppose deceit, suppose chance. And if the certainty of the thing rejects any dissembling, persuade yourself nevertheless, and say to yourself, 'The temptation was excessively strong. What would it have done to me if it had taken a like mastery over me?' " [113] This was said by Bernard. How spiritual men gain in all things, both in their sins and in those of others, and of harmful things and the works of the devil, Bernard teaches in the fifth (sermon on the) Canticles: "The irrational and bestial spirit, even though it does not reach spiritual things but in order to acquire them for its corporal and temporal service, we know helps those who convert every use of temporal things to eternal fruits, using this world as though not using it. . . . And if any living things, as far as use is concerned, are found to be unsuitable . . . and harmful, and even shown to be fatal to the temporal salvation of men, still their bodies do not lack that which they use in doing good to those who are called saints, according to the purpose. And if they do not yield food or offer service, they surely exercise the intellect according to what is close to every man who reasons, and it is a common discipline of great use through which the invisible things of God can be seen and understood by the things that are made. And therefore the devil and all his ministers, although their intent is always evil, and always desiring to harm, cannot harm the good and perfect lovers of God . . . but rather do a service and, against their will, do good to man. . . . Some do good against their wish, the bad man as well as the bad angel. It is shown that this thing does not occur because of him, although it is done for him, therefore nothing turns to the good of him who does it against his wish. Thus to him is entrusted and given the dispensation, but I do not know in what more gracious and joyful way we feel that good that is administered by the evil minister. That is the reason why God does good to the good,

231

even through the evil, not because He needs their works in doing good." [114] Again in the 54th sermon on the Canticles: "Why are you proud, earth and ashes (Ecclus. x, 9)? Know that the Lord drove His angels from heaven to earth, refusing and hating their pride. Therefore for this reason we can see our advantage, as the expulsion of the angels becomes correction of men, and everything written for our improvement is for our advantage. The casting forth of the devil turns to our good and use. And we can wash our hands in the vengeance of the devil. In what way? Now hear. Surely the devil that was proud was given a terrible and fearful malediction If this happened to him, what will happen to me who am earth and ashes? He indulged in pride in heaven, and I in a dung hill. Who is he who does not hold pride more bearable in the rich man than in the poor? Woe to me; if such a great vengeance is done to such a powerful one in so severe a way . . . what will be done to me, wretched, small, and proud?" [115] And also in the 14th (sermon on the) Canticles, when speaking of the Bride, the Church, who after many sins comes to the Lord: "For the holy Church issued from the pagans who worshipped idols, about which the Synagogue was reproved. Thus she turns to her own benefit the things that were said. She is the one whom one pardons and she is the one who loves most. And the reproof of the envious one to her shame, the holy Church turned to her use. Therefore she was milder in correction, more patient in effort, and more ardent in love, and wiser in knowing how to protect herself, and more humble through knowledge, more acceptable in her shame, and more patient in obedience, and more solicitous and devoted in giving thanks." [116] These are the words of Bernard. You see how those who live spiritually interpret everything in good faith and make a gain of everything. Therefore be spiritual and everything will be turned to your good. This consideration is valid also in sustaining tribulations and temptations and for the

232

tranquillity of the spirit. By this exercise, others could come to such tranquillity of the spirit that they would hardly and seldom trouble themselves about anything; and that would take place which the wise man says: "The just will not be afflicted by what will happen to him" (Prov. xii, 21).

(X L I V.) *How the Disciples of the Lord Took the Ears of Corn When They Were Hungry*—MATT. xii, MARK ii, LUKE vi[117]

One sabbath, when the disciples of the Lord were hungry and had nothing to eat, they went through the cornfields and plucked the ears, rubbed them between their hands, and ate the grains. They were reproached by the Pharisees, who said, "It is unlawful to do what you are doing on the sabbath." But the Lord defended them and did many things on the sabbath day, as I said above about healing the man with the withered hand. Consider the apostles and feel pity for them who are in such need, although they bear it cheerfully for love of the poverty that their Lord and Master had commended to them above all virtues and beatitudes. What shall we think if the princes of the world, in the presence of the Creator of all things, reached such dire poverty that they had to sustain themselves on such food, like animals? The Lord noted it because He loved them tenderly. But nonetheless was He cheered both for their sake, for He knew they earned much, and for us, to whom this was an example. By following this example we may attain much virtue. Here poverty shines wonderfully and shows that the pomp of the world is to be scorned. Costly and savory preparation of foods is destroyed and the voracity of gluttony, with its loathsome virtuosity and insatiable appetite, is eradicated in all. You, therefore, who have grown in love by this example, embrace with all your strength the poverty that is so resplendent in the Lord and in the Lady His mother and in the princes of the world and in all those who wish to follow this example perfectly. Now listen to the kind of poverty you must understand. I

233

know that when you entered the monastery you swore poverty and nonetheless can have it, for which you may thank your Lord God and preserve it purely. But I want you to rise higher, which, however, does not discord with the profession; indeed if it were promised without this understanding it would be full of words and empty. I speak therefore of that poverty that is rooted and established in the heart. For virtues should be set into the soul, not the external parts. You can very easily place the profession of poverty there if you consent to with your heart. If you suffer outwardly because you do not have things in abundance, as your instincts desire, you have cupidity inside you; you must not desire more with resolute mind than is necessary; you do not live in poverty but in distress and necessity, for this is not virtuous and meritorious poverty but wearisome and worthless need. To lose merit and perform any sin, concupiscence with consent suffices. And do not think that in such poverty you may raise yourself to prayer or to contemplation or to receive a hundredfold return. How could the heart of earthly beings, burdened by the weight of desire for earthly things, rise up? And how could their desire, sullied by mire and scum, earthly and gross, be brought close to the purity of God and celestial things? Thus love poverty with your heart, take her as a mother, take pleasure in her beauty, delight in her and repose in her with joy and tranquillity of spirit. Never wish to abandon her for anything. Never have or wish to possess anything beyond your necessity. And if you ask what is your necessity, I will reply that the more intimately you love poverty the more subtly you will judge the necessity. Those things are necessary without which we cannot be. Therefore see those things without which you can easily do and do not wish to have them or desire them or procure them or even receive them from those who give them to you spontaneously. And with all this you will not be able to follow the Lord Jesus in poverty perfectly however much

you press, nor do I see how our poverty can be compared to His however much we observe it with all our might. And this I shall briefly demonstrate to you with a new and beautiful reason, leaving others that could be repeated— that He is the most wealthy God and that He is Lord of all and all things and that He is the most perfect in these things. But I mention this reason: that He assumed not only the pain of poverty but also its shame. When our poverty is taken voluntarily and for the love of God, it is considered virtuous, and it is, and therefore is considered not shameful but honorable, even with the wicked. But His was not so, for He was not recognized, and it was not known that He was voluntarily poor. But poverty from necessity produces shame and contempt. Since He was without a house and possessions or any goods, and everyone knew this, He was the more despised. Such poor people are driven away and trampled upon by all; and if they are wise no one will believe them; if noble, they are none the less scorned and despised; in fact, the greater their nobility, wisdom, valor, and every virtue, the more these seem to be extinguished in the opinion of men. They are rejected by almost all, so that neither old friendships nor ties of blood avail them, so that often all almost refuse to have such friends or relatives. You see clearly that you can neither compare your poverty to His nor follow Him in the abjection of such profound poverty and humility. Therefore the poor of the world, who represent our Lord, are not to be despised. This virtue of poverty is much to be desired, and especially by us who have pledged it, and therefore always take care to observe it with every reverence and devotion. And if you wish to hear Bernard also, listen to what he says of it in the fourth sermon on Advent: "Let us follow, as best we may, Him who so loved poverty that, although the ends of the earth were in His hands, He did not have a place to lay His head (Luke ix, 58), so that we read of the disciples who came to Him that, compelled by hunger, they rubbed

the ears of corn in their hands as they passed through the fields."[118] And Bernard also said, in the fourth sermon on the Nativity of the Lord, "Why does our Savior, who possesses gold as well as silver, consecrate holy poverty in His body? Or surely why is that poverty so solicitously expounded by the angel? . . . He said, 'I give you this sign: you will find the infant wrapped in cloths' (Luke ii, 12). Your cloths are placed as a sign, Lord Jesus, but a sign that many have contradicted up to the present. . . . You set an example that we might do thus. Surely in battle the iron helmet is more useful than linen vestments, although the one is a weight and the other honorable."[119] And again in the third sermon on the Resurrection he said, "It is a truly evil habit, too great, for the vile worm to wish to be rich, he for whom the God of majesty and the Lord of Sabaoth, that is, the Savior, wished to be poor."[120] And he also says in the letter to Duke Conrad,[121] "Not poverty but the love of poverty is considered virtue."[122] "The friendship of the poor has made friends of the king. The love of poverty has made the kings. And finally, the kingdom of heaven belongs to the poor. . . . Blessed is the one who does not pursue those things that, when possessed, are a burden; when loved, sully; when lost, torment."[123] This was said by Bernard. By the example of the apostles and the above passage from Bernard and the others quoted above for the Nativity of the Lord and His sermon on the mount, you see how you must desire poverty as a most excellent virtue. But what shall we say of abstinence and against greed, which likewise shine forth in this example? And surely it is tempting (to treat) these virtues without the principal one, and proposed especially because of the multiplicity of references. But since I consider your need, for you are not expert in these things, nor able to be taught, and you do not have books in which to read, therefore I shall write carefully on these things, that you may know in this way at least of those virtues in which you may follow their Master, whose

236

life we principally search. About gluttony: you must know that it is proper to resist it, to fight it continually, but above all to avoid it. In truth, the holy Fathers and those who have practised spiritual exercises study this. Hear what Bernard says against it in the sermon to the priests, chapter viii:[124] "From whence comes this great cowardice and baseness, so miserable that the noble creature capable of the glory of the great God, since it is created by inspiration, marked by likeness, redeemed by blood, endowed by faith, chosen by spirit, is not ashamed as a wretch beneath this putridity to bear the slavery of these corporal senses?[125] Surely it can be grasped in the battle that, after abandoning such a Bridegroom, one follows such lovers. . . . In truth, it is a loathsome effort to graze the sterile one that does not bear and not wish to do good to the widow; leaving the care of the heart and being concerned with the care of the flesh, in desire to fatten the fetid body that you know beyond doubt to be food for worms shortly after."[126] This was said by Bernard.

Thus you see how to avoid gluttony; but we may yield to the need and health of the body. The same Bernard says in the 134th short sermon,[127] "They are all goods of the body, and to Him only we owe health. And beyond that there is nothing to give him or to look for. But, in this limit, one should constrain and stop it, since its fruit is null and its end is death. . . . And if one is served by desire and not by health, this is not of nature but under nature, which the hands (give) to death, although he has made desire the teacher. Thus it is also that many descend to such bestial motion, so that I may say more truly that they put desire before health and very often involve themselves in such things that they follow evil and harsh passions. As the nature of the body is health, so the nature of the heart is purity, for with agitated eye one will not see God; and the human heart is made for this, to see its Creator. Therefore if one provides for the health of the body with solicitous care, one

should be so much more concerned for the purity of the heart, for this part is truly more worthy than the former."[128] And also in the 66th (sermon on the) Canticles he says, "This observation of food generates suspicion. . . . But if you offer us the rules of the doctors, we shall not condemn the care of the flesh, which no one ever hated."[129] This was said by Bernard. This is not to be done in a false or "curious" manner or more than is necessary. Therefore if we do not have a physical impediment because of which we desire or flee the observation of food, we must not continue and live physically. Of this Bernard speaks in the 30th (sermon on the) Canticles: "You see that the judgment of my Master should not be condemned by knowledge of flesh, by which desire is dissolved in luxury or the strength of the body desires those benefits more than is necessary. . . . What does it avail to be tempted by corrupt desire and that variety of constitution that can be found, and to spend continuous care in the variety of delicate foods. 'Beans cause wind; cheese burdens the stomach; milk harms the head; the chest does not bear the drinking of water; cabbages encourage melancholy; leeks excite anger; the fish of stagnant or muddy waters, that is, marshes, do not agree in any way with my constitution.' How is it that in all the rivers, fields, orchards, gardens, and cellars one can hardly find anything you will eat? I beg you to remember that you are a monk and not a physician and must not judge by the constitution but by the profession. I implore you first to spare your quiet; then have regard for the effort of the servants; spare the burdens of the house; have regard for the conscience, the conscience, I say, not yours but of others, that is, of him who, seated next to you and eating what is placed before him, murmurs about your singular fast. Surely it is a scandal to him, both your odious falsity and your hardness, which perhaps he attributes to the one who provides for you. . . . In truth, he deceives himself in vain with the example of Paul, who encourages the disciple that he should not drink

water but rather a little wine for the stomach and his many infirmities (I Tim. v, 23). He must note first that the apostle did not encourage and concede this thing to himself, and in the same way the disciple did not ask it for himself. Besides, this was not said to the monk but to the bishop, whose life was still very useful to the delicate and nascent church. This was Timothy. Give me another Timothy and I shall feed him even, if you wish, with gold, and balsam to drink. But you dispense it to yourself out of compassion for yourself. And I say to you that your dispensation to yourself is suspicious to me, and I am ashamed that you deceived yourself with prudence of the flesh under cover of and label of discretion. At least I want you to be warned of this, that if you like the authority of the apostle on drinking wine, do not ignore that he added 'little.' "[130] These are the words of Bernard. From these passages you have learned that one must resist greed and may attend to the health of the body but must beware of excessive observation of and attention to foods.

But what shall we say about abstinence? Listen not to me but to Bernard, who says this in the third sermon on the Ascension: "The spirit and the flesh . . . are not present in the same place, mainly because tepidity makes God vomit (Apoc. iii, 16). If even the apostles, who approached the flesh of the Lord Jesus Christ, which . . . was the holy of holies, could not be inspired by the Holy Spirit until He was removed from them, do you, with your flesh that is stained and full of the varied wickedness of fantasy, narrow, and glued together, think that you can receive that most pure Spirit if you do not determine in your heart on renouncing in all ways these carnal consolations? It is true that when you begin, sadness will fill your heart, but if you persevere, your sadness will change to joy. Then the impulse will be purged, the wish renewed or created anew so that all those things that first seemed irksome, even impossible, will come about with great sweetness and desire."[131]

And the same (Bernard) says in the 66th (sermon on the) Canticles, "Now why do we not reprove Paul, who chastises his body and leads it into servitude (I Cor. ix, 27), abstaining from wine, for luxury exists in wine, and if I am infirm I must use a little, in accordance with the counsel of the apostle. I shall abstain from meat so that I may not encourage the vices of the flesh by over-nourishment of the flesh. I shall strive to eat only bread, and this in moderation, so that it will not be wearisome for me to pray, with a heavy stomach, and also so that the prophet may not reproach me for having eaten my fill of bread (Ezek. xvi, 49). And also I must not fill my throat too much with plain water so that the stretching of the stomach will not lead to feelings of lust."[132] He also says in the letter to the monk Robert, "Wine and semolina, sweet drinks and fat things are cavaliers of the body, not of the spirit. Fried things do not fatten the soul but the flesh. Pepper, ginger, cumin, sage, a thousand kinds of such pickled things delight the palate but inflame luxury. . . . For him who lives judiciously and soberly it is enough to flavor his bread with salt and hunger, for if the latter alone is not awaited, then it is necessary to produce it with other and strange potions so as to remedy the palate, provoke gluttony, and rouse the appetite."[133] The same (Bernard) also says in the epistle to the brothers of the Mount of God,[134] "Where the spirit begins to be re-shaped into the image of its Creator, immediately the flesh, also flowering, begins the re-shaping of its will to conform to the spirit. And its sense begins to delight whatever delights the spirit. Also, from its many defects, from the pain of the sins, in a manifold way, thirsting for God, it also sometimes strives to precede its guide. We do not lose delights if we change from the body to the soul, from the senses to the conscience. Coarse bread, that is, of bran or one flour, and plain water, herbs or simple vegetables, are not delightful things, but can satisfy and please a stomach of good habits joyfully, for the love of Christ and the desire of

eternal delights. How many thousands of poor people pleasantly satisfy nature by means of these or some of these things! It would be a very convenient and pleasing thing to add the condiment of the love of God to living according to nature, if our madness would let us; nature being healed, one would immediately rejoice in natural things. In that way, the peasant acquires strong arms and strong shoulders from his labors, since exercise causes this: without it, he becomes soft, in time. The will generates habit; habit, exercise; in every effort it produces strength."[135] This is what was said by Bernard. In this passage it is clearly shown that abstinence is very praiseworthy and consequently should be practiced. In this way the old fathers, like the Blessed John the Baptist and the Blessed Francis and your leader, Saint Clara, serve it rigorously, as is shown in their lives. But it seems, according to Bernard, that one must moderate abstinence in three cases. The first is when it is done contrary to the will of the prelate: this should on no account be done. The second is when it would cause notable scandal among companions: it is more useful for spiritual exercise to live in common through charity than to do special abstinence above the common life and cause scandal to the brother. The third is when one practices beyond the possibility of the body, for immoderate abstinence is not considered a virtue but a vice. On this Bernard speaks in the 19th[136] (sermon on the) Canticles: "You do not wish to be satisfied with community life. It is not enough for you to follow the regular fast, the solemn vigils, and the imposed discipline, the measure we conceded you in vestments and food. You place private before common things. Why do you, who once placed your concern in our hands, again interfere? That with which you have so often offended God, as your conscience can testify, is your own will. And now you have a master, not myself, who teaches you not to be subject to nature, not to be content with reason, not to comply with the advice or the example of the saints, not to obey us. . . .

Do you not know that the angel Satan often transfigures himself into an angel of light (II Cor. xi, 14)? Wisdom is God and wishes to be loved not just sweetly but wisely. Therefore the apostle says, 'May your service be reasonable' (Rom. xii, 1), otherwise the spirit of error will easily deceive you by your zeal, if you are not concerned with knowledge. Nor has the wicked enemy a more effective corruption to remove love from the heart than to try as he may to make us act foolishly and without reason."[137] And he also says in the 33rd (sermon on the) Canticles, "It is very shameful that those who search importunately for superfluous things had before refused to satisfy their strictest needs, although some, persevering to their course, obstinately invincible, abstain more indiscreetly, and in all things particularly disturb those with whom they must live in a house under one rule. I do not know surely whether those believe they keep the rules in this way, but to me it seems that they have cast them far off. Those who believe themselves to be wise in their eyes and do not wish to obey advice or command— may they see that they respond not to me but to him who says, 'For to oppose is almost to sin in witchcraft and to wish to disobey is almost to sin in idolatry' (I Sam. xv, 23). He had first said that 'obedience is better than sacrifice, and listening is better than offering the lamb' (I Sam. xv, 22), that is, than the abstinence of contumacious people."[138] Bernard also says in the 64th (sermon on the) Canticles, "What is it that so seriously disturbs you in this, and so often, especially I speak of those among us who practice superfluous abstinence, for which reason they make themselves troublesome to themselves and to all and all to them? How is it that the general discord is not a marring of his own conscience and what is in him a great destruction of this great vineyard planted by our Lord, that is, the concord of all? 'Woe to the man by whom the scandal comes' (Matt. xviii, 7), says the Lord in the Gospel; 'Whoever will scandalize one of these little ones' (Mark ix, 41) . . . hard is what will

242

follow! How much harder things does he deserve who scandalizes so great and holy a multitude! In the end, a very hard judgment he will bear, whoever he is."[139] And he also says in the third sermon on the Circumcision, "To those who attain devotion of grace, there seems to remain a danger; and finally they must fear the meridian demon, for he, Satan, transforms himself into an angel of light (II Cor. xi, 14). This must be feared by him who does all things with great delight, so that while he follows desire he will not ruin the body by disorderly exercise and then need, not without great damage of spiritual exercise, to be occupied in the care of the body for its weakness. Therefore that he who hastens may not stumble, he needs to be illuminated by the light of discretion, which is the mother of all virtues and the fulfillment of perfection. This is the one that surely instructs that one should not do anything too much. . . . And this is the eighth day, on which the infant Jesus was circumcised, for true discretion circumcises, as it does the one who is lukewarm, so that neither more nor less is done. He who does less cuts the fruit of the good deed, he does not circumcise; as the one who is lukewarm does less. On this day the name is given, and the name is salvation. Nor will I hesitate to say of him who lives thus that he exercises his own salvation. Up to this day the angels may say they know the celestial secrets, but I now securely give Him the first name of salvation. But since indeed this bird is securely on the earth, O brothers, the place of this discretion fulfills the virtue of obedience, so that nothing less, nothing other than what is commanded should be done."[140] And he also says, in the letter to the brothers of the Mount of God, "These are exercises of the body in which one must exert oneself, such as vigils (and fasting) and such things, and these things do not impede spiritual things but help, if done with reason and discretion. But if these are done by the vice of indiscretion, so that the spirit is broken and the body weakened, spiritual things are hindered. He who is so cruel removes

the effect from his body, that is, the accomplishment of the good, the affection from the spirit, the example from the neighbor, honor from God; he is sacrilegious and offends God in all these things. Not that, according to the judgment of the apostle, this does not also seem a human thing and it is not suitable and it must not happen and it is not right for the head ever to ache in the service of God that often used to exert itself to the point of pain in secular vanity, to suffer hunger up to a rumbling in the belly that is often filled to the vomiting point. But one must have measure in all things. The body is sometimes to be afflicted but not consumed, and if corporal exercise is done with measure it is valuable, and piety is useful to all things, and therefore one must be concerned a little with the flesh, but not in concupiscence. But one must use sobriety and spiritual discipline in one's concern, so that nothing unsuitable to the servant of God either in measure or in quality or in quantity appears."[141] Thus spoke Bernard.

That you may better know the virtue of discretion, listen briefly to what Bernard says in praise of it in the 23rd (sermon on the) Canticles: "The virtue of discretion lies prone without the fervor of charity, and strong fervor runs ahead without the moderation of discretion. And therefore he is laudable who is not without either one, and whose fervor raises discretion and whose discretion directs fervor."[142] And in the 49th (sermon on the) Canticles he also says, "In truth discretion imposes order on every virtue; order gives measure and beauty and perpetuity. Finally it says, 'The day perseveres in your order' (Psalm cxviii, 91), calling the day virtue. And therefore discretion is not so much a virtue as a moderator and guide of virtue, and a regulator of desires, and a teacher of customs. Remove this and virtue will be vice, and that natural desire will be rather changed into agitation and destruction of nature."[143] These are the words of Bernard. Thus you see in these things how the example of the disciples destroys excess and greed. But how

the pomp of the world undoes itself I have not yet told you and I do not intend to proceed with this, yet not leave it altogether. I think this suffices for the present, that here the blessed simplicity of the primary state, in which men were content with the fruits of the trees and the roots of grass and plain water, seems renewed. If today we were to do thus, we would not need mills or ovens or material and equipment for many things or various and pompous goods, in which things the human race is intricately entangled.

(X L V. *Of the Ministry of Martha and Mary; Also of the Order of Contemplation and of How It Has Two Parts*
—LUKE X)

Once the Lord Jesus went to Bethany to the house of Martha and Mary, and they received Him with veneration and great joy, since they loved Him with deep affection. And Martha, who was the elder, immediately busied her- 204 self in preparing a respectable dinner for Him and the disciples. Mary placed herself at the feet of the Lord, and, 205 since the Lord never remained idle but, according to His custom, spoke words of eternal life, she listened intently, 206 delighting in His words more than one could say, and 207 thought of nothing else. But Martha was troubled by this and asked that she be compelled by the Lord to help her in 208 the preparations; however, she received a contrary judg- 209 ment and heard that Mary had elected the best part. Mary, who was resting in the words of the Lord, woke as from sleep at the clamor of her sister. She feared for her peace and, with her face bowed to the ground, remained quiet, but after the reply of the Lord she sat more securely and cheerfully. When the meal was arranged, the Lord stopped talking, and she rose forthwith, and the water was given for His hands, and she remained before Him serving Him faithfully from then on. Carefully watch the Lord, who is humble and benign at the table with His disciples; see those who gently serve Him, and the other beautiful deeds.

You must know that the saints say that these two sisters represent the two lives, the active and the contemplative, which would be a long matter to deal with. But since I believe that I shall later give you a long treatise, I shall now write something, as the Blessed Bernard treats of it copiously in various places, for it is most useful, spiritual, and necessary. According to this, we continually live two lives, and often we do not know which life is suitable for us, which is a great danger and not a light blow, especially for those who live a religious life. Thus the active life is designated by Martha; but, from what I gather from the sayings of Bernard, the active life is in two parts. The first is the one by which everyone acts to his advantage, principally correcting himself and cleansing himself of vices and infusing himself with virtues, and this is also secondarily done to the advantage of one's neighbor by deeds of justice and by the services of piety and charity. The second part is when someone principally converts his exercise to the use of his neighbor, even when this is to his greater merit, that is, when ruling and teaching and helping others with the salvation of souls, as is the case with prelates and preachers. And between these two parts of the active life is the contemplative life, so that this be the order maintained: first, everyone exercises himself and wearies himself in prayer and in the study of the holy writings and in the other good deeds and services in common conversation, rectifying vices and acquiring virtue; in the second step, he reposes in contemplation, searching for solitude of mind and attending only to God with all his might; in the third, by means of the above two exercises of virtue, he becomes fervent, full of and illuminated by true wisdom—he is concerned with the salvation of others. First, as I have mentioned, it is necessary that in the active, that is, the first part, the mind should be purged, purified, and fortified by the exercise of virtue. Then it should be formed in the contemplative and be

illuminated and instructed. Then it can securely turn to the profit and utility of others, and help them. That this be the right order is proved by this passage, and first, Bernard says, the first part of the active precedes the contemplative.

(X L V I. *The Active Precedes the Contemplative*)

Bernard says in the third sermon on the Assumption of the Lady, "When Jesus entered this castle, two sisters, Martha and Mary, that is, the deed and the intellect, received Him. . . . When He came, Jesus gave them two things, to each what was suitable to her: to all, virtue and wisdom; virtue to the deed and wisdom to the intellect. Thus it happened that the apostle preached the virtue of God (and the wisdom of God) (I Cor. i, 24). But how came it that, when He entered, Martha received Him and ran to make ready, but Mary, sitting at the feet of Him who had come, suspended her heart in His words, if it were not that first comes the deed and then the contemplation? Whoever wishes to attain intelligence should first diligently carry out good deeds, as is written, 'Son, do you desire wisdom? Serve justice, and God will grant it to you' (Ecclus. i, 33). And it also says, 'By your commandments I have understood' (Psalm cxviii, 104), and 'By faith their hearts are purged' (Acts xv, 9). What faith? Faith working through love."[144] And Bernard says in the 46th[145] (sermon on the) Canticles, "Behold, perhaps you desire the repose of contemplation, and you do well, but do not forget the flowers of which you read that they covered the bed of the bride. Therefore take heed to surround your own similarly with the flowers of good deeds, and put forward the exercise of virtues, as the flower comes before the fruit. Otherwise you will wish to sleep in too pleasant an idleness, if you desire to rest without having worked; and not taking heed of the fecundity of Leah, you desire to delight only in the embraces of Rachel. It is a distorted order to ask for the prize before the

247

merit and to take the food before the labor. As the apostle says, 'Qui non laboret nec manducet' (cf. II Thess. iii, 10), 'Who does not work does not eat.' And it says, 'By your commands I have understood' (Psalm cxviii, 104), that you may know that where there is no obedience of the commands it is not proper to taste contemplation completely. Thus you must in no way wish to prejudice the love of quiet itself, of the work of holy obedience, and of the commandments of greater ones. Otherwise the Bridegroom will not sleep with you in a little bed, especially in the one that you have covered with the flowers of obedience, . . . for which reason He will not fulfill your prayers and will not come when called and will not give abundance of Himself to the disobedient one, He who was so great a lover of obedience that He wished to die rather than disobey. He does not approve the vain idleness of your contemplation, saying with the prophet, 'I have wearied myself in sustaining' (Jer. vi, 11), meaning the time in which, an exile from heaven and home, of supreme quiet, He wrought salvation in the midst of the earth. . . . I marvel greatly at the shamelessness of some that are among us, who, having disturbed all of us by their singularity, having provoked us to anger by their impatience, defiled us by their disobedience, nevertheless venture to invite the God of all purity to such a foul bed of their conscience with all perseverance of prayer. 'But,' it says, 'where you stretch out your hands I shall turn my eyes away, and when you multiply your prayers I shall not listen to you' (Isa. i, 15). Why, since the bed is not covered with flowers but indeed foul, do you draw to it the King of glory? Do you do this to rest or to plead? . . . Proceed, therefore, to spread out your hands to God all day, you who molest the brothers all day, incite those that are of one mind together, separate yourself from unity. Now speak, what do you wish me to do? Surely you must first purify your conscience of every iniquity, anger, discord, and murmuring, and malice; and finally try to eradicate from dwelling in your heart every-

thing that might be opposed to the suffering of your brother or the obedience to greater ones. Then surround yourself with the flowers of good deeds and laudable efforts and odors of virtues, that is, with whatever things are true, whatever just, whatever holy, whatever lovable, whatever of good fame, whether any virtue or praise of discipline. Think of these things; try to exercise yourself in them. In this way you will safely call the Bridegroom, for when you have led Him in, you, even you, may truly say, because 'our little bed is covered with flowers' (Cant. i, 15), conscience is redolent, but of piety, peace, mildness, justice, obedience, cheerfulness, humility."[146] Up to here spoke Bernard. By these things is demonstrated how the part of the active that I called "first" comes before the contemplative.

(X L V I I.) *How the Contemplative Comes Before the Second Part of the Active*

It will now be seen how the contemplative precedes the second part of the active and therefore the contemplative remains between the two parts of the active. Bernard says in the 18th (sermon on the) Canticles, "Surely one must either keep or give that which we have taken to hold for distributing. Surely you keep to yourself what is your neighbor's by reason of the word full of virtue; although you may be none the less adorned on the exterior by gifts of learning and beautiful speech, perhaps out of fear or by grace or by less discreet humility, you restrain the good word, which might be of use to many, by a useless and even damnable silence. You are truly cursed if you hide the grain in your own belongings (Prov. xi, 26). You also spread and lose what is yours if you hurry to seminate it before you are completely infused; half full, you hasten to spread it, against the law, ploughing in the first-born of the ox and trimming the first-born of the sheep (Deut. xv, 19). Surely you deceive yourself in your life and your salvation, which

you give to others while empty of a sound intention; you are vainglory inflated by wind, infected by the poison of worldly cupidity, swelling with mortal imposthume. Therefore if you are wise you will make of yourself a basin and not a canal. The latter at the same time receives and pours back . . . but the former waits until it is full, and thus the superfluous communicates without loss to itself, knowing that he who makes his part worse is cursed." And further on he says, "In the end, you, brother, whose own salvation is not yet sufficiently secure, in whom charity is still null or so tender and so much like a reed that with each wind it moves, it believes in every spirit, at each wind of doctrine it turns around; in fact in whom there is so much charity that you clearly love your neighbor better than yourself, beyond the commandment; and again, if it is so much opposed to the commandment that it destroys itself with fervor, is broken by fear, is agitated by sadness, is contracted by avarice, is exposed by pride, is vexed by suspicion, is shaken by vices, is disemboweled and confused by cares and solicitude, is swollen by honors, is corrupted by blows; since you feel in your own matters with some pity . . . I pray you to have consideration for others, either that you exert yourself or that you rest. But listen to the advice of sagacious and solicitous charity: 'Not that pardon would come to others but tribulation to you, except by justice' (II Cor. viii, 13). Do not wish to be too righteous (Eccles. vii, 16). It suffices for you to love your neighbor as yourself. This is for justice. . . . But first fill yourself and then take care to disperse it. Benign and wise charity usually has in abundance but does not waste. 'Son, do not squander yourself' says Solomon (Prov. iii, 21). And the apostle says, 'Therefore we must attend to those things that are said, so that we may not forget much' (Heb. ii, 1). Who was then more saintly than Paul, more wise than Solomon? . . . But already you heard what things, how many,

one must infuse and gather before we can presume to spread out. . . . The physician comes to the wounds as the Spirit to the soul. The one He finds wounded by the knife of the devil . . . needs first to have the infection or ulcer that perhaps has grown in the wound cut before all other things. And thus the iron of sharp compunction cuts the ulcer of inveterate customs, but since the pain is bitter it is anointed with the ungent of devotion, which is none other than the conceived cheer of the hope of indulgence. The faculty of continence and the victory over sin produce this. Already he gives thanks and says, 'Dirupisti vincula mea; tibi sacrificabo hostiam laudis' (Psalm cxvi, 16), 'O Lord God, you have broken my bonds; to you I shall sacrifice hosts of praise.' Then there will be placed the medicament of the apostle, the plaster of penitence, that is, of fasting, vigils, prayer, and other exercises of penitents. When one is in affliction, one must feed on the sustenance of good deeds, so that one will not faint. Which deed is food you will learn then: 'My food,' He says, 'is that I do the will of my Father' (John iv, 34). Thus the labors of penitence are accompanied by those deeds of piety that suit them. He says that 'alms lend great confidence with the most high' (Tob. iv, 12). Since food induces thirst, one must also provide drink. To the food of good deeds is added the drink of prayer, forming in the stomach conscience, which is well borne, and commending it to God. While praying, one drinks the wine that gladdens the heart of man. The wine is the spirit that inebriates and instils forgetfulness of carnal desires, soaks the bowels of dry conscience, digests the food of good works, and leads by some members of the soul to the fortifying of faith, the consoling of hope, the composing and ordering of charity, the enriching of customs. Having taken food and drink, what is left but for the sick man to rest and lie in the quiet of contemplation after the sweat of action? Sleeping in contemplation, he dreams of the Lord through a mirror,

251

in image; not face to face is He considered meanwhile (cf. I Cor. xiii, 12). But it is not thus so much shown to him who waits as conjectured by him, for he sees Him rapidly, and almost under a splendor of passing sparks of fire, touched by force, and he burns in love and says, 'The soul has desired you in the night, even my spirit inside me' (Isa. xxvi, 9). Such love is zeal, thus it is worthy of the friend of the Bridegroom; he must glow, the faithful and wise servant, whom the Lord has placed above His family (Matt. xxiv, 45). This fills, this warms, this boils; this, now untroubled, spreads in abundance, bursting and saying, 'Who is weak, and I am not weak? Who is scandalized, and I burn not?' (II Cor. xi, 29). Let him preach, bear fruit, renew miracles, and transform marvels. Vanity does not mingle in, where charity occupies all. In truth, the fullness of the law and of the heart is charity (Rom. xiii, 10), and even if it be full. Finally, God is charity (I John iv, 16). And there is nothing in the things that may fill with charity the creature made in the image of God if not the charity of God, who alone is greater than that. But it is most dangerous for one to be advanced who has not yet acquired it, although it seems that he is resplendent with other virtues. Though he may have every knowledge, though he give all of his wealth to the poor, though he put his body to be burned, without charity he is empty (I Cor. xiii, 3). Oh, how many things must first be instilled and gathered in so that we may then spread out liberally, giving not out of penalty but out of plenitude! First surely comes compunction; then devotion; third, the effort of penitence; fourth, the deed of piety; fifth, the study of prayer; sixth, the repose of contemplation; seventh, the plenitude of love. All these things are worked by one and the same spirit according to the operation which gives us purely infusion; . . . surely it is already prepared for the praise and glory of our Lord Jesus Christ."[147] Also (Bernard) himself says in the 57th (sermon

on the) Canticles, "Indeed true and chaste contemplation has this quality, that at times it fills the mind, which is strongly kindled by divine fire, with the love and desire of acquiring God, who singularly loves him who willingly intermits the repose of contemplation for the study of preaching. And also, when he has made use of the desires to some extent, he returns to this part so much more ardently the more profitably he remembers to have intervened. And even after having assumed the taste of contemplation, the more valiantly he turns cheerfully to reacquiring the customary profits. In the end, the mind often battles between these alternating things, fearing and strongly exerting itself, so that by chance it may approach others more justly, while in its desires it is distracted here and there. And thus in the one and the other, little by little, it deviates from the divine will. Perhaps Saint Job endured such a thing when he said, 'If I sleep, I say, when shall I rise? and also, I shall await the end' (Job vii, 4), that is, when resting I reproach myself for abandoning work, and when occupied by worry I reprove myself nonetheless for resting. See the saintly man, earnestly fighting between the fruit of the deed and the sleep of contemplation, and, although he always works for the good, he always does penitence as for evil deeds, and with laments desires to find the will of God at all times. Certainly in this thing prayer and the continual cry to God are the remedy or refuge, so that He may deign to show us what, when, and how He wishes us to act always."[148] These are the words of Bernard. By these things it is demonstrated that there are two parts of active life, that between them there is the contemplative, and consequently their manner and order. There remains for us to examine them singly. But of the third member, that is, the second part of the active, how one must attend to the winning of souls and the benefit of the neighbor, I do not propose to treat, since your condition does not require this. It is enough for you to

place your whole effort in this, that, corrected in your vices and filled by virtues for the first part of the active, you may attend to your God in the contemplative.

(X L V I I I. *Of the Exercise of the Active Life*)

Although you have already heard about the active, especially in the 18th and 47th sermons on the Canticles, nevertheless I shall adduce other passages from the same Bernard, so that you may more wisely flee vices and more fully acquire virtues. He speaks thus in the 37th (sermon on the) Canticles: " 'Sow yourself to justice; reap hope of life' (cf. Hosea x, 12), and then in the end, 'Illuminate yourself in the light of knowledge,' he says. He placed knowledge last, like a painting that cannot stand above the void. Therefore he placed these two things first, and subjected to it, as if a solid thing were to support a painting. I shall attend securely indeed to knowledge if I first receive security of life through the benefit of hope. You would therefore sow yourself to justice if by your true knowledge you were awakened to fear of God, if you have humiliated yourself, shed tears, distributed alms, and given yourself to all works of piety, if you have afflicted your body in fasting and vigils, if you have beaten your breast and wearied the skies with laments. Certainly this is sowing to justice. The seeds are the good deeds, the good studies; the seeds are tears. The Psalm says, 'They went and wept, but going ahead and sowing their seed' " (Psalm cxxv, 6).[149] And again Bernard, in the ninth sermon on the Canticles, in the person of the Bride who was speaking to the companions of the Bridegroom and requesting the kiss, that is, the height of contemplation, says this: "If He has any concern for me, let Him kiss me with a kiss of His lips (Cant. i, 1). I am not ungrateful, but I love." And further he says, "Already it is many years that for His grace I have taken care to live chastely and soberly. I persevere in reading, resist vices, attend to prayer continually; I guard against temptations;

I consider my years in the bitterness of my soul; without complaint, I believe, I converse as best I may among the brothers; I am subject to the greatest powers, going and returning on the command of the greatest; I do not desire other people's possessions but rather I have given up myself and my things. In the sweat of my face I eat my bread." In the end he says of all these things, "And all is a manifestation of custom; but of sweetness, nothing. . . . Perhaps by coincidence I fulfil the commandments, but my soul is valueless, like earth without water. Therefore, that my sacrifice be enriched, I beg Him to kiss me with a kiss of His lips." [150] And Bernard also says in the 12th [151] (sermon on the) Canticles, "And if you have taken the gift mentioned above, give of it willingly to us, your companions, where, if you everywhere render offices toward us, making yourself obliging, pleasing, or reasonable, or humble, you will have the testimony of all that you are odoriferous of the best unguents. Each one among you who with fraternal delight patiently bears not only infirmity of the body as well as of the mind but also, if it suits him and he is able, helps by serving, comforts by speaking, informs by advising, if he cannot do this by discipline, should at least solicit with prayer and not cease to render joy to the infirm. Everyone among you who exercises these things in the end spreads a good odor among the brothers, the odor of the best unguents, carries balsam in his mouth. The brothers of the congregation point him out, and all say of him, 'This is the lover of the brothers and the people of Israel. He is the one who prays much for the people and the whole city'" (II Macc. xv, 14).[152] And Bernard also says in the first (sermon) on the feast of the apostles Peter and Paul, "These are the masters who have learned all the roads of life perfectly from the Master of all and who teach up to the present day. Now what have they taught us or what do the holy apostles teach us? Not the art of fishing or of deceiving people, or whatever is of this kind, not to read Plato or to

confound ourselves in the depths of Aristotle, not always to learn and at no time to arrive at the knowledge of truth. They teach me to live. Do you think that it is a small thing to know how to live? It is a great thing, and even the greatest. He does not live who is swollen with pride, soiled with luxury, disfigured by all the plagues, because this is not living but confounding life and approaching the doors of death. I think it is a good life to bear evil, do good, and persevere in this till death. It is said among the people, 'Who grazes well, lives well.' But they are deceived by sin, for one does not live well if one does no good. I consider that you who are in a congregation live well if you live in an orderly, sociable, and humble manner: orderly (for yourself), sociable toward your neighbor, and humble toward God. Orderly so that in your every conversation you may be careful to observe your roads and, in the sight both of God and your neighbor, keep yourself from sin and him from scandal. Sociable so that you will endeavor to be loved and to love and to make yourself pleasing and affable, to bear not only patiently but willingly the infirmities of your brother, those of character as well as those of the body. Humble so that as it is suitable you will do all these things. Strive to drive away the spirit of vanity that usually grows from these things and, whenever you feel it, deny it consent in everything. Thus it is in suffering evil, and since there are three manners, it is fitting that you have in yourself three ways of providence: that to which you are submitted by yourself; what you bear from your neighbor; what you bear from God. The first is the austerity of penitence. The second thing is the torment of the malice of others. The third is the scourge of divine correction. You must willingly undergo sacrifice when you cause yourself suffering. You must patiently bear what your neighbor causes you to suffer. Without complaint and rendering thanks, you must accept what you sustain from God." [153]

This was said by Bernard. At present these words on the exercise of the first part of the active will suffice.

(X L I X. *Of the Exercise of the Contemplative Life*)

The contemplative life is the next to be seen. On this Bernard says in the 52nd (sermon on the) Canticles, "For the most gentle Bridegroom placed His left hand under the head of the Bride . . . to let her rest and sleep on His breast. And now . . . as guardian of the worthy one, benevolently He watches over her so that, troubled by the frequent and small necessities of the adolescents, that is, of the young women, she may (not) be forced to wake up. . . . I cannot contain myself for joy that that Majesty, with such familiar and sweet association, does not disdain to stoop to our infirmity, and the supreme Deity does not shun giving its affection in a wonderful way, as in a marriage with the expelled soul, and taking it as bride with most ardent love. I do not doubt that it will come about in this way in heaven as I read it on earth, and that the soul will surely feel what the Scripture contains, except that it is not enough to explain completely what it then can take, nor what it can already. What do you think it will receive when it is up there, the one that is here given or endowed with so much familiarity that it feels itself embraced by the arms of God, nourished in the breast of God, guarded by the solicitude and study of God, so that perhaps sleeping sufficiently it not be awakened sooner? . . . The sleep of this Bride is not corporal dormition . . . but rather this is a vital and wakeful sleep illuminating the inner sentiment and, having chased away death, it gives everlasting life. Surely dormition is that which has not lulled the sentiment to sleep but leads it forth. It is death that I shall not call dubious. For the apostle, in praising some who still live in the flesh, speaks thus: 'You are dead and your life is hidden with Christ in God' (Coloss. iii, 3). For this reason I have not

improperly called the death of the Bride ecstasy that has not liberated her from life but from the snares of life, so that she may say, 'Anima nostra sicut passer erepta est de laqueo venantium' (Psalm cxxiii, 7), 'Our soul is liberated from the snares of the hunter like a sparrow.' She goes through this life in the midst of the snares, which she often does not fear, whenever by some holy and strong cogitation the soul is carried away out of itself, if it transcends the mind and flies so high that it passes beyond what is the custom and usage of thought; and therefore the net is thrown in vain before the eyes of the birds (Prov. i, 17). Now why shall luxury be feared where life is not felt? When the soul passes beyond the lifeless sense of the certain life, it is necessary for temptation of life not to be felt. And therefore the prophet says, 'Quis dabit mihi pennas sicut columbae, et volabo et requiescam?' (Psalm liv, 7), which means, 'Who will give me wings like a dove, and I will fly away and rest?' God willing, I may often fall into this death, so that I may escape the noose of death, that I may not feel the mortal enticements of the life of luxury and not be stupefied at the sentiment of lust, the heat of avarice, the stimuli of anger and impatience, the anguish of solicitudes,[154] and the troubles of cares. May the soul die the death of the just, so that it may not be ensnared by any unjust thing or delighted by any iniquity. It is a good death that does not remove life but carries it beyond and improves it. It is good, for now the body falls but the soul is lifted. But this is good, and my soul (dying), if one may say so, the death of the angels, so that it passes beyond the memory of present things, of infernal and corporal things, divests itself not only of desires but of similitudes and has pure conversation with those similar to it in purity. This thing, as I think, is called either excess or highest contemplation. And, while living, not to be bound to the cupidity of things is a human virtue and taking care not to be involved with material similitude is angelic purity. The one

258

and the other are divine gifts; you must pass beyond both the one and the other, but the one is far away and the other is not far away. Blessed is he who can say, 'Ecce elongavi fugiens et mansi in solitudine' (Psalm liv, 8), 'Behold, I go far away, fleeing, and I remain in solitude.' He was not content to leave unless he could go far, so that he might rest. You have passed beyond the delights of the flesh, so that already you do not obey its desires and are not bound by unlawful things; you have made progress in some way. You have separated yourself, but you have not yet gone far enough, unless you act so that you can with purity of mind pass well beyond the fantasies of corporal likeness coming in from every side. Up to here you cannot permit yourself repose. You err if you think to find sooner a place of quiet, secret of solitude, serene of light, habitation of peace. But give me him who has arrived there, and surely I confess that he is in repose and may justly say, 'Convertere, anima mea, in requiem tuam, quia Dominus benefecit tibi' (Psalm cxiv, 7), 'Return, my soul, in your repose, for the Lord has done well to you.' And this place is truly in solitude, its dwelling in light. . . . Think therefore that the Bride has withdrawn in this solitude and, through the delights of the place, has slept gently in the embraces of the Bridegroom; that is, she is lifted in the spirit, thus the young girls are forbidden to wake her until the dawn that she wishes. But how is this? Not simply, or with a gentle warning, as is customary, but they are finally forbidden by a new and unusual conviction, 'by the roes and the hinds of the fields' (Cant. ii, 7; iii, 5). For these wild animals appear to me sufficiently suitable expressly to the holy souls that have left the bodies and at the same time those angels that are especially with God, because of their acuteness of vision and lightness of leaping. Surely each one of these we know to be suitable to the one or the other spirit. Lightly they search for the highest things and penetrate the intimate. The conversation of those designated as 'of the fields'

signifies free and ready discourse. Why therefore does He want the entreaty for this made to Himself? Surely because the maidens do not dare to call the beloved for slight reasons from such revered company with which it undoubtedly mingles whenever it rises high in contemplation. They are thus excellently frightened by the authority of those from whose company it is clear that she is separated by their importunity. . . . Surely it is left to her will to be at leisure or attend to cares, according to what she considers necessary, although it is forbidden that she be awakened by them when she does not wish it. The Bridegroom knows how much the Bride is fragrant with love towards her neighbors, and, with much of her own charity, the mother is solicitous toward the needs of her daughters and is prepared not to withdraw and deny herself to them under any condition, however much and often required. For this reason He has securely committed to her discretion this dispensation to judge."[155] Up to here spoke Bernard.

(L. *Of the Three Kinds of Contemplation*)

You must know that there are three kinds of contemplation. The two principal ones are for those who are perfect; the third is added for the imperfect. Two are for the perfect: they are the contemplation of the majesty of God and the contemplation of the celestial court. The third is for the beginners, those who are not perfect in the contemplation of the humanity of Christ, on which I write for you in this little book. And therefore you must begin from this if you wish to climb to the highest; otherwise you could not rise so high, but would fall. You see thus how necessary the teachings of this little book are to you. You can never consider yourself able to rise to the highest things of God if you do not exercise yourself in this long and diligently. On this subject Bernard speaks in the 62nd (sermon on the) Canticles: "There are two kinds of contemplation: the one on the state, beatitude, and glory of the supernal city,

with which the host of celestial citizens is occupied, either in action or repose; the other on the majesty, eternity, and divinity of its King. The first state is as a wall of loose stones, that is, in weakness. The other state is in rock, that is, in strength. But of this state it is said that the harder one digs the more gratifying is the greater flavor that you get. . . . But since from every part of this world this rock is still to be dug, the Church cannot come, for it is not for everyone who is in the Church to be able to see the sacraments of divine will or to understand for himself the profundity of God as He is shown to live not only in the holes in the rock but in the clefts of the loose stone wall. Therefore those who are not perfect surely try to search for and understand the secrets of divine wisdom, which they can and dare do by purity of conscience and subtlety of intelligence. Thus they live in the holes of the rock and then in the clefts of the wall, so that those who either dig insufficiently or do not presume to dig in the rock for themselves may dig in the wall, being content to contemplate in their minds the glory of the saints. Now if this thing is not possible to someone, to him preach and propose Jesus Christ and Christ crucified, so that he may dwell without effort in the cleft of the rock in which he did not exert himself. The Jews exerted themselves in these things, and he will enter into the labors of the unfaithful so that he may be faithful. And do not let him who is invited to enter fear that he will suffer expulsion. 'Enter,' says the prophet, 'into the rock; hide yourself in the hollowed earth, in the face of fear of God and the glory of His majesty' (Isa. ii, 10). Also to the weak and indolent soul . . . there is shown the excavation where it may hide until it becomes strong and grows so that it may drill for itself holes in the rock by which it may enter to the things within the divine word, by vigor and purity of soul. And if we mean the Earth of which is said, 'Foderunt manus meas et pedes meos' (Psalm xxi, 17), 'They have dug my hands and my feet,' one can-

not doubt the health that the wounded soul that lives in the excavation will soon have. What is as effectual in caring for the wounds of conscience and purging the light of the mind as the continual meditation on the wounds of Christ? But until the time when it is purged and healed, I do not see how one can apply what is said: 'Show me your face; sound your voice in my ears' (Cant. ii, 14). How in the end is one who is commanded to hide his face so bold as to show it or to raise his voice? 'Hide yourself,' it says, 'in the hollowed earth' (Isa. ii, 10). Why? Because he is not beautiful in face or worthy of being seen. One is not worthy of being seen until one is worthy of seeing. But when, by living in the hollowed earth, he has accomplished so much in the healing of the inner eye that he may look on the glory of God with his face raised, then he who sees will speak confidently and with pleasing face of . . . those things that he can understand in the light of God. Nor could he see the same thing if he were not clear and pure and thus transformed into the same image of clarity that he sees. Otherwise, because of unlikeness, he would turn back, rejected by an unaccustomed splendor. Therefore when the pure can look on the pure truth, then the Bridegroom will desire to see the face and hear the voice." [156] Up to here spoke Bernard. You see how necessary is the meditation on the life of Christ, since by this authority it is shown that if you are not purified you will never be able to reach the most supreme things of God. Therefore be wakeful and exercise yourself in it solicitously and continually. You have also seen how there are three kinds of contemplation, that is, of the humanity of Christ, of the celestial court, and of the divine Majesty. You must know that in each of them there are two heights of the mind, that is, the intellectual and the affectual. On this Bernard says in the 49th (sermon on the Canticles), "There are two heights of blessed contemplation, the one in intellect and the other in affection; the one in light, the other in fervor; the one in

action, the other in devotion. The chief is surely affection; and a breast warm with love and the infusion of holy devotion and the great spirit filled with zeal, or great fervor, are reputed, not perfectly, however, to be from the winecellars." [157] Up to here spoke Bernard. You will not be introduced to these three kinds if you do not know how to enter, unless you first meditate on the humanity of Christ, which is given you in this little book. Therefore learn from Bernard in this and other things.

(L I. *Of the Contemplation of the Humanity of Christ*)

He speaks about this first in the sermon on the Ascension: "There are two things that we must purge within us, that is, the intellect and the affection: the intellect so that one may understand; the affection so that one may will. . . . Then the intellect is truly burdened and weighted when it thinks much, when it does not compose itself to a single meditation alone, which is conceived in that City whose participation is in itself. . . . The affections that are afflicted in the body corrupted by different passions can never be mitigated—and I do not say healed—until the will does not demand one thing and go to one thing. . . . But Christ illuminates the intellect; Christ purges the affection. The Son of God came and effected so many and such marvels in the world that not without reason our intellect was drawn forth from all worldly things, and we never think enough of what marvelous things He did. Truly He left us most ample fields of intelligence for expansion, and the stream of these thoughts is very deep. . . . Who is it who is satisfied with thinking how the Lord of everything came before us, came to us, supported us, and how that unique Majesty wished to die so that we might live, serve so that we might reign, be banished so that we might return to our Home, and bow Himself to the most servile acts in order to place us over all His possessions." [158] "How will

truth be in us in this obscurity? How was He charitable to us in this wicked life? In this world that is placed in evil, do you think there is anyone to illuminate the intellect, to inflame the affection? There will be if we are converted to Christ, that the veil may be driven from the heart." [159] Bernard also says, in the 43rd (sermon on the) Canticles, " 'The bundle of myrrh, my beloved to me, will dwell between my breasts' (Cant. i, 12). And, brothers, from the beginning of my conversation, in order to acquire the merits that I knew to be lacking, I took care to bind and place between my breasts this bundle of myrrh collected from all anxieties and bitterness of my God. The first are those needs of His infancy, then of the labors He bore in preaching, of the exertions in going to many places, of the vigils in praying, of temptations in fasting, of tears in having pity, of injuries in speaking, then of the dangers in false brothers, of the infamies of the spitting, of the nailing, and of similar things, which for the salvation of our race we know the evangelical forest has brought forth abundantly. . . . To meditate on these things I have called wisdom; in these things I placed the perfection of justice; in these things is plenitude of knowledge; in these things are riches of salvation; in these things, abundance of merit. From these things there is sometimes given me a drink of healthful bitterness. From these there still comes a gentle unction of consolation. These things raise me in adversity, repress me in prosperity, among the worldly mortal and sad things of this present life, going on the royal road, and they show you your judgment, each part on this side and that, driving away the evils that arise. These things assuage in my behalf the judge of the world, Him who causes fear to the powerful, make Him appear benign and humble, and represent Him who is incomprehensible to the princes and terrible to the kings of the earth, as not only benign but humble. Therefore all these things are always in my heart, as God knows, and, as is shown in my writings, they are

habitual to me. And, in short, this, my highest philosophy, is to know Jesus and Him crucified."[160] Up to here speaks Bernard. These things are sufficient on the contemplation of humanity, for you have it in this whole book. But you must know that it is not necessary for the active life to precede this contemplation, for it contains corporal matters, that is, the works of Christ according to humanity, as is proposed more easily, not to the most perfect, but to the vulgar, to look at, for in it, as in the active, we purge ourselves of vices and fill ourselves with virtues, and thus this converges with the active. Therefore when it is said that the active should precede the contemplative, it is true in its other, higher manifestations, that is, of the celestial court and the majesty of God, which are reserved only to the most perfect. For this reason, perhaps one should call this more directly and properly "meditation on humanity" rather than contemplation. But on the above two, let us look again at a passage from Bernard.

(LII. *Of the Contemplation of the Celestial Court*)

He says in the 62nd (sermon on the) Canticles that the celestial court should be contemplated in this way: "Each one of us is at liberty during this time of our mortality[161] . . . now to visit the patriarchs or then to greet the prophets or again to mingle in the college of the apostles or to join in the choir of the martyrs, to search with all cheerfulness of mind, according to how the devotion of each is borne, both the state and the abodes of the blessed virtues, passing from the least angel up to the cherubim and seraphim. Following those to whom he is the more affected, drawing the spirit to himself as it wishes, if he will pause and knock, immediately it will be opened."[162] And he also says, in the fourth sermon on the Ascension of the Lord, "Blessed is he whose meditation is always in the sight of the Lord, who by continuous reflection in his heart turns the delectation of the right hand of the Lord up to the end. What things could

seem serious to him who always deals with the mind in the passions of this time that cannot be compared with the glory that must be? What could he whose eye always sees the good things of the Lord on the earth of the living, he who always sees the eternal rewards, desire in this evil time? . . . Who is it who grants to me that all of you, rising, may stay on high and see the exaltation that is to come to you from God? . . . What thing is so good, in fact, what other thing does one seem to see, if not that the soul dwells in the good, since it certainly cannot in the body? . . . Which of you thinks to himself of that future life—what but happiness, but joy, but beatitude, but the glory of the children of God? Who is it who, turning these tranquil things in his mind, does not say impetuously, out of the plenitude of intimate sweetness, 'Lord, it is good that we are here' (Matt. xvii, 4)? Here, in truth, not in this miserable pilgrimage where we are held by the body, but in that gentle and salutary meditation in which one thinks with the heart. 'Who will give me wings like a dove, and I shall fly away and rest?' (Psalm liv, 7) . . . I beg you, my brothers, that our hearts be not burdened by worldly cares. . . . I entreat you to drive the tears, the burden of earthly cogitation, from your hearts. . . . Remove some thought from your hearts with your hands (Lam. iii, 41). . . . In your hearts raise not only tabernacles in the manner of the patriarchs and prophets (but also) all the many dwellings of that celestial house, according to him who went around offering hosts of cries in the tabernacle of God and saying that Psalm to the Lord, 'How delightful are your tabernacles, O Lord of virtues! My soul desires and faints in the houses of the Lord' (Psalm lxxxiii, 2, 3). Go around, brothers, with hosts of piety and devotion, visiting with the mind the supernal seats and many dwellings that are in the house of the Father, humbly bowing your hearts before the throne of God and of the angel of the Lamb, praying with reverence to all the orders of the angels, (the numbers) of the patriarchs, of the martyrs,

266

saluting the troops of the prophets, the college of the apostles, looking at the crowns of the martyrs resplendent with purple flowers, redolent with lilies, admiring the bed of virgins, and listening to the most sweet sound of the new psalm, as well as the infirmity of the heart may. 'Of these things I am reminded,' says the prophet, 'and I pour forth in me my soul.' Why? 'Because I shall pass into the place of the marvelous tabernacle, up to the house of God'" (Psalm xli, 5).[163] Up to here spoke Bernard. And these words on the contemplation of the celestial Home will suffice.

(L I I I. *Of the Contemplation of the Majesty of God; Also, Four Are the Kinds of Contemplation*)

Let us come to the highest, to which I think few arrive, that is, to the contemplation of God. But let us recount what Bernard says of this, so that in some way introduced by him, we may weigh whether the Lord sometimes deigns to receive one who is acceptable. He says thus in the 41st (sermon on the) Canticles, speaking of the companions of the Bridegroom, that is, the angels, saying to the Bride, " 'Let us make royal gold vestments inlaid with silver' (Cant. i, 10). . . . But note that royal vestments are offered, of gold, it says, inlaid with silver. Gold is the splendor of divinity; silver is the wisdom that one must have. Several signs, as of variety, are shown by this resplendent gold, which those who are to be goldsmiths of the supernal mystery must design and transplant within from the strength of the soul, which I do not believe to be anything but to weave some special similitudes and to relate the most pure sense of divine wisdom to the sight of the contemplating spirit, so that it may see at least in the mirror, in likeness, that which cannot yet be seen in any way face to face (I Cor. xiii, 12). These are divine things, and to those who have not tried it, in the end those things are unknown, as is seen in the mortal body, having faith in this state; and there is not yet revealed the substance of the subtle light, but already purely

sometimes the contemplation of truth presumes to operate its parts among us, or in part, so that it is possible for one of us, to whom it will be granted from above, to assume with the apostle, 'Now I know in part,' also, 'In part we know, in part we prophesy' (I Cor. xiii, 12, 9). But when, more divinely, something quickly and as with the speed of re-splendence of splendor has rendered light to the mind by a spirit raised to the heights, either to temper excessive splendor or in the service of teaching, immediately, I do not know from whence, there come from below some imagined similitudes of things that were given into custody by God to the infused senses, by which that most pure and splendid ray of truth is overshadowed in some way and made more bearable to that soul and more comprehensible to those to whom it wishes to communicate it. I think that they are formed in us by the suggestions of the holy angels, as, on the contrary, the contrary and bad admissions are un-doubtedly put in by the bad angel."[164] Bernard also says, in the 62nd (sermon on the) Canticles, "Blissful the mind that in this material, that is, in this soft stone that is like earth, has continually tried to dig; but the one who has dug in the rock is more blissful. And in truth it is permitted to dig in the rock, but for this it is necessary to work in the purer light of mind, and finally with a stronger intention and even with greater merits of sanctity. And who is suitable for these things? Surely he who said, 'In principio erat Verbum et Verbum erat apud Deum et Dominus erat Verbum' (John i, 1, 2), 'In the beginning was the Word, that is, the Son of God, and the Word was with God, and the Word was God.' Does it not seem to you that he plunged into the profound things of the Word and from the secret things of his breast drew a most holy marrow of intimate wisdom? ... And the more difficulty there is in digging in the rock the more gently does what is gained render savor. And do not fear that with which the Scripture threatens the searchers of majes-ty. Make use of your so pure and simple eye, that you may

268

not be troubled by glory but will be received, if you do not seek that the glory of God be yours. Otherwise each one is oppressed by his glory, not that of God; while you exert yourself for the former, you cannot lift your head to the latter. Without doubt, after having driven away this great cupidity, we surely search in the rock in which the treasures of wisdom and knowledge are hidden (Col. ii, 3). But if you still doubt, then listen to the Rock itself, which says, 'Those who work in me shall not sin' (Ecclus. xxiv, 30); 'Who will give me wings like a dove, and I shall fly away and rest?' (Psalm liv, 7). There the meek and the simple will find rest, where the wicked or the proud or the one desirous of vainglory is tormented. . . . One is not tormented because one is a searcher of the majesty but of the will. Surely sometimes one turns attention to the majesty and ventures to contemplate it, but as one marvelling, not as one searching. But if sometimes by ecstasy, that is, by elevation, one happens to be carried off to it on that finger of the Lord, it is He properly lifting man, not the madness of man foolishly searching (Him). As the apostle remembers having been carried away, so that he may excuse his daring, who is the other one who presumes to engage himself by his own efforts in the abominable search for mortal things and, as an importunate contemplator of the divine majesty, dares to open the secret things of God, which are greatly to be feared? And therefore the searchers of majesty may be called assailants, that is, they are not carried away by it but break in and thus are oppressed by glory. Thus the search for majesty is fearsome, but the search for the will is as safe as it is pious. Now why do I not remain firm in searching with all diligence for the sacrament of the glory of the will to which I know that I must obey in all things? Sweet glory, which does not proceed from anywhere but from the contemplation of its sweetness, from the abundance of goodness, and from the love of great mercy! In the end we saw this glory, glory almost as of the only Son of the Father (John i, 14). Everything

of glory that appeared in this part is truly benign, certainly paternal. This glory will not oppress me, though with all strength attending to it; I rather am committed to it. Therefore when regarding you with face revealed, we are transformed in that image . . . as we are conformed. But God forbid that we be confirmed in the glory of the majesty and not rather in the temperance of the will. My glory is this, if I ever hear of myself, 'I found the man, even my heart, the heart of the Bridegroom, the heart of His Father, surely Him.' He says, 'Be therefore merciful, as your Father who is in heaven is merciful' (Luke vi, 36). This is the form He desires to see when He says to the Church, 'Show me your face' (Exod. xxxiii, 13), a form of piety and of mildness. With every confidence it lifts it to the rock that it resembles. 'Attend to Him,' it says, 'and be enlightened, and your faces will not be confounded' (Psalm xxxiii, 6). For what reason would the humble be confounded by the humble? the saint by the pious? the modest by the meek? Surely the (pure) face of the bride will not be abhorrent to the purity of the rock, nor virtue to virtue, nor light to light."[165] He himself on this Gospel that says "Intravit Jesu in quoddam castellum" etc.: "These two sisters signify the two lives of the lovers of poverty. Some, with Martha, are solicitous in preparing for the God Jesus two dishes, that is, correction of work, with the savor of contrition, and work of piety, with the condiment of devotion. But those who with Mary attend only to God consider that God is contemplated to be in the world as well as in men and angels and Himself and in the damned. For God is the ruler and governor of the world, liberator and helper of men, flavor and beauty of angels, beginning and end in Himself, fear and dread of the damned. In the creatures, He is immutable; in men, lovable; in angels, desirable; in Himself, incomprehensible; in the damned, unbearable."[166] These are the words of Bernard. In this contemplation of majesty, we are reflected in four ways; on which Bernard says thus: "Four are the man-

ners of contemplation. The first and greatest contemplation is the admiration of the majesty. This contemplation requires a heart purged and free of vices and unburdened of sins, so that it may easily raise itself to supernal things; and sometimes, owing to delay, it keeps in suspense its wondering by surprise and ecstasy. The second is necessary to this and regarding the judgments of God, which firmly, with timorous aspect, while it strongly shakes the mind of the contemplator, chases the vices from the virtues, leads to wisdom, preserves humility. . . . The third contemplation is occupied, or rather is at leisure, with the memory of benefits, so that it will not leave him ungrateful, soliciting the commemorator to love of the benefactor. . . . The fourth is of those things that are behind us; forgetting them, one reposes alone on the expectation of promised things, which, although this be meditation of eternity, nevertheless are the things that are promised eternally to give strength to longanimity and perseverance."[167] Up to here spoke Bernard. And for the present this is enough on the contemplation of majesty.

(L I V. *Of the Manner of Living in the Active Life; Also the Good Authority of Bernard*)

After we have seen about the exercises of the one and the other life, that is, of the first part of the active and also the contemplative, and the kinds of the contemplative, there remains to be seen how we should act so that we may be introduced to them more easily and acquire them more effectively. You must know, therefore, that the first part of the active requires sociable conversation with others, while the contemplative requires solitude. Therefore in the active one converses with others, that one may better and sooner follow his purpose. When among others, one feels ashamed of the vices one has and the virtues one does not have. Therefore, in the one and the other, one improves, which does not thus occur in solitude, for then he would not be

concerned in it, and at times there would be no one to reprove him and no one before whom he feels shame. Therefore improvements and habits are furthered in the company of others. Let him endeavor to avoid the defects in which others are corrupted and displeasing; let him strive to acquire the virtues in which others are commended and pleasing. In this manner it befits you to act while you are in the active, that you may wisely watch and avoid your vices and those of others according to the way mentioned above in various places, especially in the exercise of the active. Diligently consider those things you are told about the virtues and vices and try to live in that way; you must examine yourself and pay attention to the virtues of others, follow them, and then humiliate yourself and always remain in fear that you do not have similar virtues.

Bernard teaches thus in the 54th (sermon on the) Canticles: "It is not without reason that (yesterday and the day before)[168] a faintness of spirit came over me, an unaccustomed dullness of mind, and some idleness of spirit. I was running well, but behold, I struck a stone on the road and fell; and (pride) was found in me, and the Lord turned away in wrath from His servant. Hence this sterility of my soul and the poverty of the devotion that I suffer. How is my heart thus dried out, coagulated like milk, become like earth without water? Nor can I be goaded to tears, so great is the hardness of the heart. The psalm has no savor, I do not like to read, I do not delight in prayer, I do not find the usual meditations. Where is that inebriation of the spirit? Where the clearness of mind and the peace and joy in the Holy Spirit? Thus I am lazy at working with the hands, full of sleep at the vigils, precipitating to anger, clinging to hatred, very indulgent toward the tongue and the palate, very sluggish and blunt at preaching. Alas, the Lord visits all the mountains in my circuit but He does not approach me. . . . In truth I see one of singular abstinence, another of marvelous patience, another of the highest

humility and meekness, yet another of great affliction and piety. I see one often rising to contemplation, another beating against and penetrating the heavens through continuation of prayer, and others shining in other virtues. All these I consider fervent, all devout, all unanimous in Christ, all abounding in celestial gifts and grace, as spirituals, that is, mountains, which are visited by the Lord and often receive the Bridegroom coming to them. But I, who do not find anything of this in myself, what shall I think myself to be other than one of the mounts of Gelboe that He passed over in His anger and indignation, that most benign of all visitors? Sons, this meditation removes the pride of the eyes, reconciles grace, with leapings prepares the way of the Bridegroom. . . . I want you not to pardon yourself but to accuse yourself whenever by chance you understand that in yourself grace becomes somewhat lukewarm and virtue weakened. . . . This the man must do who is a solicitous watcher of himself and searcher of his roads and of studies and always suspecting the vice of arrogance in all things, so that he will not submit to it. In truth I have learned that nothing is so directly effective in deserving and keeping grace as to be found before God at all times, not haughty but fearing. 'Blessed is the man who is always timorous'" (Prov. xxviii, 14).[169] He also says, in the letter to the monks of the Mount of God, "Learn . . . to be above yourself, order life and compose customs, judge yourself and judge yourself before yourself and often even condemn yourself and do not leave yourself unpunished. Justice sits in judgment; conscience stays upright accusing itself. Nor does any love you more or judge you more faithful. In the morning, question yourself on the night that has passed and demand security of yourself for the day that is to come. When vesper has passed, ask for the reason of the day and train for the one that is to come. Thus restricted, you will never meet with carnal desires. To all the hours of the day that are ordered by the ecclesiastical reason, distribute the

exercises to which they are suited; spiritual things to the spiritual, temporal to the temporal. In these things the spirit pays every debt to God, the body to the spirit, so that if anything is forgotten, or not cared for, or not perfect, it will not remain without punishment or compensation in its way, place, or time." [170] He himself in the 74th[171] sermon on the Time: "What Bernard thought then. I marvel at those, as much as I fear in my heart, as much as I embrace the affection of charity, who, as though not knowing those whom they continually see with them, see perhaps one or two or even more in greater furor, fervor of spirit, then elect them above all the others. And although they may be better, but nonetheless always before them, they propose and prefer the holy studies in God, and corporal or spiritual exercises. . . . 'Woe to me,' says one of us, 'for I will consider one of our monks in vigils, in whom I will list thirty virtues, of which I do not find even one in me,' and perhaps he did not have any as great as that humility of religious charity. And let this be the fruit of my sermon, so that you may ever attend to higher things, for in it is shown the fullness of humility. If by chance it seem to you that in anything you are given greater grace than your brother, then in many things, if you are a good lover, you will judge yourself lower. Now what is the use if perhaps you can work or fast more than he, and he surpasses you in patience, precedes by humility, and shines by charity? For which reason, all day, opposed to that which you seem to possess, you labor because of folly. Therefore be more solicitous in knowing what you lack, for this is the best." [172] Up to here spoke Bernard. You see what great benefit it is to pay attention and examine oneself and others, so that one may convert their customs to His use. In this you exercise yourself much while you are in the active, always keeping the services of charity, humility, and piety. But above all things observe the meditations on the life of Christ, and prayer, for in each you will be illuminated in a marvelous

way toward vices and virtues. And above all other exercises you will make use of these in acquiring purity of spirit, to which it will be profitable for you to attend with all your strength, because it contains all virtues, as I told you above in the fast of the Lord. If you have understood well the passages on contemplation mentioned above, the more must each one ornament himself with greater purity the higher he wishes to rise in contemplation. The soul purifies itself in meditations on the life of Christ and especially on His Passion, as you saw above in the kinds of contemplation and in the 62nd sermon on the Canticles. It is also purified in prayer, which is near and close to contemplation. And that which prayer beseeches with the sweat of fatigue, contemplation desires and tastes in delightful repose. And this suffices on the manner of active life.

(L V. *Of the Manner of Living in the Contemplative Life*)

In the contemplative, it is suitable for you to live in a very different way. The contemplator must devote himself only to God and remain in solitude, at least of the mind. Of this you have heard above, on the fast of the Lord. Nothing of common or selfish things must pertain to him during that time, nothing of corporal services to neighbors; only by prayer, devotion, and compassion must he attend to them. Nothing to him of himself; all things must shortly be thrown behind, and he must be as one without sentiment and dead, so that he may dedicate himself only to God, unless necessity constrain and force him. It is suitable that he learn this wisdom in idleness, as you saw above in the treatise on tribulations in the 85th sermon (on the Canticles). Therefore one must remain firm in action, and silent, following the example of Mary, however and how often one is beseeched, and by her example let the Lord reply and act, so that all things are committed to most worthy providence. But for these things listen to Bernard, who speaks eloquently, according to his custom. He says thus,

in the third sermon on the Assumption of the Lady:"While Martha acts, she has the form of good works; but Mary has a kind of contemplation while she sits, while she is silent. When she is called, she does not reply, but is absorbed with all concentration of mind in the words of God and, despising all things, hears intently only the grace of divine cognition, which she loves; and outwardly she becomes as if insensible while within she is rapt in contemplation of the joys of her God. . . . And let us not wonder if we see someone who exerts himself and does good, and he murmurs against the brother who sits and does not work, for in this Gospel we read that Martha did thus against Mary. But that Mary murmured against Martha because she did not want to engage in her actions is nowhere found. Nor could one easily do both the one and the other, that is, serve well one's outside concerns and attend within to the desires of wisdom. Certainly of this wisdom it is written, 'He who is lacking in action acquires it' (Ecclus. xxxviii, 25). Therefore Mary sits and stays still. She does not want to interrupt the repose of silence, that she may not lose the sweetness of contemplation, especially since she hears the Lord within saying, 'Vacate et videte quam suavis est Dominus' (Psalm xxxiii, 9; xlv, 11). Attend and see how gentle is the Lord." [173] Also in the third [174] sermon on her Assumption; "Do you think that in the house in which Christ is received there are heard murmuring voices? Blessed the house, blessed the congregation, where Martha complains of Mary. That Mary should be envious of Martha is after all unworthy and unlawful. Otherwise, where do you read that Mary complains that 'my sister left me alone to attend and rest'? God forbid, God forbid that he who attends and heeds God should have a longing for the fatiguing life of brothers in office. Martha always seems inadequate to herself, less fit, and more desirous that the work she prepares be placed before others. . . . Thus you see Mary's advantage, that she has an advocate in every

matter. The Pharisee was indignant, the sister complained, and even the disciples murmured. Everywhere Mary is silent, and Christ speaks for her. Thus see Mary, how she attends and sees how gentle is the Lord. She sees, I say, as with devout mind and tranquil spirit she sits beside the feet of Jesus, always caring for the soul in His sight and receiving the words that issue from the mouth of Him whose aspect is admirable and whose speech is sweet. For grace is poured in His lips, and He is most beautiful in form above all sons of men (Psalm xliv, 3) and also every glory of angels. Be joyful and render thanks, Mary, that you have elected the best part. Blessed the eyes that see those things you see and the ears that deserve to hear those things that you hear. Blessed surely are you who receive in silence the vein of the divine murmur in which it is truly good for man to await the Lord. Be simple, not only without deceit and malice but also without manifold occupations, so that the conversation of Him whose voice is gentle and whose face is beautiful may be with you. Of one thing beware, that you do not begin to abound in your sense and desire to know more than is necessary, so that, perhaps, when you follow the light, you fall into darkness, deceived by the meridian demon." [175] Up to here spoke Bernard. You have seen how the contemplator must abandon all things if he wishes to attend to God; but he must particularly leave corporal occupations and exercises, because occupation is directly opposed to freedom of thought and is one of the greatest impediments a contemplator can have. It hinders in many ways, and not only when he is at work but also afterwards, first rendering the mind solicitous and restless about what it has done or has to do and then leaving behind it imagination and fantasy, which greatly obstruct the contemplator.

(L V I. *Of the Four Impediments of Contemplation*)

Let us now see what things hinder contemplation. There are four impediments, on which Bernard says in the 23rd

(sermon on the) Canticles, "If by chance it happen that at some time one of us is rapt, and hides himself in this secret place of contemplation, in this sanctuary of God, so that he will not complain or be agitated either by the sense in want or by care stinging or by fault biting him or by those things that as they move with the more difficulty increase the fantasies of corporal images that come rushing in, certainly he can glory, and say, when he returns to us, 'Introduxit me rex in cubiculum suum' (Cant. i, 3), 'The king led me to his bed.'" [176] Up to here spoke Bernard. That you may better understand these intentions, let us regard them longer. The first impediment, he says, is poor health, that is, of the body. The soul is so closely joined to the body that if it be infirm in part, or notably suffering in the senses, it does not take delight in contemplation. Thus while it is infirm, there is no room for contemplation, unless the Lord gives it as a special grace. The same happens when there is great hunger, thirst, cold, or impediment of the body. The second impediment, he says, is pungent care, that is, attention to cares and occupations. This is clarified for you by the passages mentioned above. Bernard himself, with many more words, discoursing on the impediments to contemplation in the fourth sermon on the Assumption of the Lady,[177] says, among other things, that as dust scattered in the corporal eye hinders sight, in the same way care of earthly actions confounds the eye of intelligence and chases it from the contemplation of the true light. The third impediment, he says, is the biting blow, that is, sin, and this may occur in two ways. The first is when the sin is in the soul; the second, when it is extinguished by contrition and confession but is evoked in memory. Both obstruct contemplation, as he tells in the same sermon, saying, among other things, that as darkness impedes corporal vision, so the presence in the soul of sin, which is dark, hinders contemplation, for which purity and beauty of soul are required, and therefore there is no place for contem-
278

plation. Similarly, as blood or a congealed humor that runs in the eye impedes its sight, so sin, when it returns to memory, runs in the soul and impedes its sight. Therefore you must avoid thinking of sins during the time of contemplation. Certainly we must consider ourselves sinners at every time, but we must not set our thought particularly on anything and on any sins in the time during which we wish to contemplate. And on this the same Bernard says, in the 57th (sermon on the) Canticles, "We have a contemplative Mary in those who, after the passage of a very long time and with the exercise of the grace of God, benefit in some way when, better and more cheerfully presuming forgiveness, they are not as anxious to revolve in themselves the sadness, the sad reflection of sins, as they are surely to delight in meditating on the law of God day and night, insatiably. And sometimes, with face revealed, looking at the glory of the Bridegroom with the greatest joy, they are transformed into that image and grow in the divine spirit from clarity to clarity" (II Cor. iii 18).[178] Up to here spoke Bernard. The fourth impediment, he says, is the phantoms of corporal images. And this is more irksome than all the others named above. For this reason solitude is so highly praised in this state. Thus it is suitable for the contemplator to be mute, deaf, and blind, so that in seeing he does not see and in hearing he does not understand and in speaking does not delight; that is, in order to be abstracted from these transitory things and joined to God, in hearing, seeing, speaking, he does not abate his course; but he flees when he can. And if at times necessity impels him to this, he should not carry back with him the images that enter our soul through these windows. Thus the contemplative as well as the active must not look at the customs of others, so that he may not carry away fantasies. Much more carefully you must beware of the speech of secular people, although they are relatives, as I have often admonished you. Even if sometimes obedience or necessity

or service or restoration constrain you to work and labor, do it faithfully, but do not approach it willingly or with pleasure, that you may not bear away the images with you and that, when you devote yourself to God, you are not hindered. On this Bernard speaks in the chapters to the brothers of the Mount of God: "Manual work that is enjoined does not then keep the soul in delight as much as it is conserved and nourished by delight in spiritual studies, in which the soul is then restored and kept intact. Thus immediately and easily, when it seems to him that he must return, he hastens without contradicting the related will, without corrupting the contracted delight or the imagining memory. Man is not made for woman, but woman for man (I Cor. xi, 9). Spiritual exercises are not made for the corporal, but the corporal for the spiritual. And thus, as a helper was given or joined to man when created, similar to him, of the same substance as man, these are necessary in aid of spiritual study, but in this it seems not always rightly agreeing, yet some seem to have more relationship with the spiritual, as one meditates on what one writes, writes what one reads. But beneath the divine exercises and works, as they distract the senses, thus often empty the spirit, where, with a more serious study of the solicited works, there may be great contrition of body, up to contrition or unity of the heart, and the weight of its labor often shows affection of greater devotion. . . . The helpful and wise mind is disposed to every effort and does not dissolve in him, but rather for him retires into itself. He who always has before his eyes not only what he does but what he means by doing awaits the end of every fulfilment." [179] Up to here spoke Bernard. You see that it is advantageous for you studiously to avoid occupying the mind with manual labor. You will not stumble into this as much as into the impediment of contemplation by care and solicitude. These words suffice on the impediments of contemplation.

By this one can clearly show how harmful and entangled

is curiosity, which soils the whole mind and renders it turbulent and impure, how also the cupidity for, and the gathering of, things are dangerous, and on the contrary how very precious is blessed poverty, which continually presents a free and pure soul to God. Are you not moved by what I said above, that the contemplative does not attend to neighbors? It attends to God and exceeds the active in His delight. But the active exceeds the contemplative in love of the neighbor. On this Bernard says, in the 60th (sermon on the) Canticles, "I say, for the grace of God that is in us, that we have both fig-trees and vineyards. The fig-trees are more gentle in habit, but the vineyards are those that are more fervent in spirit. Everyone among us who acts in a joint and companionable way, and not only without complaint may he converse among brothers but also with much gentleness, gives himself to all, to be used in every office of charity. Surely I shall say that this one does the office of the fig most suitably. . . . But already those of the vineyards show themselves more cruel to us than gentle, acting in strong spirit, zealous for discipline, seizing vices harshly, adapting to them conveniently the voice of which the Psalm says, 'Nonne qui oderunt te, Domine, oderam, et (super) inimicos tuos tabescebam' (Psalm cxxxviii, 21), 'I hate those that hate you, Lord, and exert myself above your enemies.' It also says, 'Zelus domus tuae comedit me' (Psalm lxviii, 10),—zelus id est amor ut desiderium— 'The zeal of your house has consumed me.' Certainly it seems that these are resplendent in love of neighbors and those in love of God." [180] These are the words of Bernard. You see that the contemplative, to whom it especially pertains to be zealous for God, are placed before the active in love of God. But understand this discreetly, for the contemplative never abandons charity to the neighbor, but attends principally to God and secondarily to the neighbor, though he himself receive determination. It is proper, finally, for the coarse contemplator and beginner to devote himself

to God as strictly as possible and to remain in solitude of mind as well as body, if he can, so that he shows by his zeal that he does not care for the zeal of God and himself and his neighbor, for this nature of solitude requires it, and this especially when joyful because of the frequent visits of the Bridegroom; otherwise it could easily be eradicated. But when he is already perfect and exalted, that is, excellent, through long exercise of contemplation, then he fights vigorously for God and also for the salvation of souls, as you heard above in the 18th sermon on the Canticles in this treatise, that is, when the contemplative precedes the second part of the active. But when necessity overcomes, each contemplative, however he begins, leaves his repose for charity to the neighbor. Thus Bernard again says, in the 50th sermon on the Canticles, "It cannot be doubted by anyone that the man who prays speaks with God. But for the love of this how many times have we left prayer because of the commandment of charity and quickened by love of those who need our works or our words; and how often piously the pious replied, complying with the cries of need of the faithful Christians, and how often with easy conscience the book is put down in order to exert oneself with manual work, and how often, to operate earthly things justly for the benefit of the brothers, we omit to celebrate the solemnity of the masses. To do these things is an order, backwards but necessary because need has no law and charity conquers everything." [181] These are Bernard's words.

(L V I I. *The Contemplative Life is Placed Before the Active*)

As you have seen by the previous passage from Bernard, in the 60th sermon on the Canticles, the contemplative are placed before the active in love of God. It appears that the contemplative life is put before the active. On this Bernard, in the third [182] sermon on the Assumption of the Lady, also says the following: "O brother, what does the One who says that Mary elected the best part mean? Where then is

282

that which we are wont to bring forth against her, if by chance at some time she will wish to judge unjustly the confusion of Martha, the servant? It says, 'Better is an unjust man than a woman who does good' (Ecclus. xlii, 14). Where is that which says in the Gospel, 'Si quis mihi ministraverit, honorificabit eum Pater meus' (John xii, 26), 'If anyone serve me, my Father will do him honor'? And that which says, 'Qui major est vestrum, erit minister vester' (Matt. xx, 26), 'He who is greater among you will be your servant'? Finally, what consolation has the one who works when, as it were in contempt of her, she sees the part of the sister raised and commended? One thing I judge of the two, that either Mary is praised for electing the same part that, as it is in us, must be elected by all men, or that surely the one and the other part are said to have been, and on neither part whatsoever can one say that the choice has fallen, and both the one and the other are prepared to obey the commander. Who is it that was as faithful as David, who entered and left on the command of the king (I Kings xxii, 14)? Lastly, he said, 'My heart is prepared' (Psalm lvi, 8), and not only once but twice, to be devoted to you and to serve the neighbors. This is truly the best part, which is not taken away. This is the best mind, which is not changed whoever may have called her. Who shall have served well acquires a good degree (I Tim. iii, 13), and perhaps a better one he who devotes himself to God, but the best one he who is perfect in both. One thing more I say: if it be proper to suspect this of Martha, does it not seem that she almost reputed her as idle whom she asked to be given as helper? But it is carnal, and in the end does not receive the things that are of the spirit of God, if perhaps someone reproves her soul for emptiness, and he may hear that this is the best part, which remains in eternity. Does not the soul seem in some way rude that in the end has not felt divine contemplation and entered that place where one work is of all, one study, the same life?" [183] He also says, in the 40th

(sermon on the) Canticles, "Two things we have said that are in the intention of the soul, which we said to be its face, and these things are necessarily requested, that is, the thing and the cause, that which you mean and why. And from this is soundly demonstrated the beauty or the ugliness of the soul." And below: "Certainly to attend to things other than the Lord, except for God, is not the repose of Mary but the work of Martha. God forbid that the one who is of this manner I have mentioned has something ugly, but I have not affirmed that she has reached a perfection of beauty, since, to be sure, she who is solicitous and disturbed toward many things cannot but be sprinkled by the fine dust of earthly works. He who quickly and easily removes the chaste intention and the request of a good conscience discovers the request in God in the hour of holy dormition. Thus you must anxiously search for God, for Him alone. This surely is having the face of the intention beautiful on both sides, in two parts, the thing special and proper to the Bride of whom it is suitable to hear, by singular prerogative, 'Beautiful are your cheeks as doves'" (Cant. i. 19).[184] He also says, in the letter to the brothers of the Mount of God, "Solitude and reclusion are troubles. The cell must never become an imprisonment from necessity but a hostel of peace. The closed door must be not hidden but secret. He with whom God is is never less alone than when he is alone. Then he makes use of his joy freely; then it is for him to enjoy God for himself and himself in God. Then, in the light of truth, in the clearness of the pure heart, through his will, the conscience is shown him and freely instils the desirous memory of God, and the intellect is illuminated, and the affection enjoys His good, and freely the defect of human fragility weeps for itself. And, therefore, according to the form of your purpose you must live rather in heaven than in the cells; having shut out from yourself the whole world, you shut yourselves in with God." And again in the same letter he says, "Attending to God is not idleness but

284

the work of work." [185] So Bernard said. By these passages it appears that the contemplative life is put before the active, and you have also seen other passages in this treatise that discuss this same fact, and also above in the chapter on how the Lord fled when the multitudes wished to make Him king, in the 32nd sermon on the Canticles. But God knows what is of greater merit. I would think that what is borne with greater (love) is most deserved. But in the contemplative, it appears that man is more desirous of loving, and it is a greater thing to regard God, enjoy God, converse with God and know His will, all of which suit the contemplative. This is the savoring of the reward of the Home, which happens imperfectly and seldom. And this it seems that the saints affirm, that is, that the contemplative has greater merit than the active. But let it be that the Lord desires the one and the other. And, as many members of one body do not have the same action, in the same way many of us in the Church find it suitable to serve God in many ways, and not all of us are given the same spirit, but to another is given a sermon of wisdom (I Cor. xii, 8), etc. Thus let each persevere in that vocation to which he is called, and let him who is suited to contemplation live in it, and him who is adapted to the service of his neighbors exercise himself in it. As the Lord said here to Mary that she had elected the best part, so when He recommended His sheep to Peter, after examination of his love, three times He reaffirmed these things (John xxi, 15–17). And in this sense one must understand what Bernard writes in the third [186] sermon on the Assumption of the Lady, saying, "Let Martha receive the Lord in her house, for to her is surely entrusted the management of her house. . . . And let all her other assistants receive Christ for the quality of ministry, serve Christ, minister to Him in His members. The one serves the infirm brothers; the other, the guests and pilgrims. Since they are so solicitous in continuous ministry, let them see how Mary attends the Lord and how

gentle the Lord is." [187] Up to here spoke Bernard. You, therefore, as your state requires this, take the contemplative with all your strength, having sent the active before the actions through which it reaches it, and rejoice and render thanks to the Lord Jesus, who has called you to this part, which He calls perfect.

(L V I I I. *From Three Causes, the Contemplator Retires to the Active; Also of Why Faith Without Works Is Dead*)

Although several times before it has been touched upon that the contemplator must attend only to God and leave all other things, you must know that this is generally true, but not always. For three reasons one may depart at the right time from joyful contemplation and go to the active life. The first reason is to gain souls, as you saw above, that is, in how the contemplative goes before the second part of the active, in the 18th and 62nd sermons on the Canticles. The same Bernard also says, in the 61st (sermon on the) Canticles, " 'Arise, my friend, my Bride, and come' (Cant. ii, 13). The Bridegroom commends His great love, repeating the voices of love, for repetition is the expression of affection, and again, soliciting the beloved to the work of the vineyards, shows how solicitous He is for the health of the souls. You have already heard that the vineyards are souls. . . . But according to what I remember, never before in this work has He called her 'Bride' until now, when she goes to the vineyards when the wine of charity is approached." [188] These are the words of Bernard. Thus the Bride, knowing the wish of the Bridegroom, loving the salvation of souls, departs at the right time, that is, when it is necessary that she be employed, and then returns to contemplation. The other cause for leaving contemplation is by reason of the office that prevails. When the prelate must attend to the need of his subjects, he leaves contemplation by reason of his office. In this way, Bernard, speaking of himself to his monks, who at one time disturbed him too

286

much, says this, in the 52nd (sermon on the) Canticles: "A short hour is conceded me to rest from those who overtake me. . . . There I will refrain, so that I shall not seem to give rather an example of impatience to those who are infirm, for they are very small to the Lord who believe in Him. I will not suffer them to suffer scandal for my cause. I do not use this power but rather I want them to use me as they please, solely that they may be saved. They spare me if they have not spared me, and in Him I shall rest more if they do not fear to disquiet me for their needs. I shall bear their customs as I can and in them I shall serve my God as long as I shall be, in unfeigned charity. I shall not ask for the things that are mine or for what is useful to me, but what is useful to many I shall judge useful to me. This thing alone I pray for, that my service be pleasing to them, and for this perhaps to find great mercy in the eyes of their Father."[189] He also says this about both the aforementioned reasons, in the 51st (sermon on the) Canticles: "I tell you my proof that I have served. Every time when I have heard that I have given utility to one of you by my warnings, I confess that I have not then regretted having put concern for the sermon before my own repose and tranquillity. Therefore to demonstrate by an example: a wrathful man is found changed to meekness after a sermon, a proud one to humility, a weak one to strength. Surely the meek, humble, and strong, each one, is known to have grown in His grace and to have been made better than himself. But it seems that perhaps those who were becoming tepid and feeble, weakening in spiritual study and changing heart, at the fiery speech of God bloom again and awake; and those who, abandoning the font of wisdom and then digging cisterns of their own will that could not hold water and therefore at every imposition burdened with a heart dry or desiring evil, complain, not having in themselves any humor of devotion. And I say that those who are tested by the dew of words and the voluntary rain that God sent

to His heirs are proved to be reflowered in the work of obedience done in all voluntary and devoted things. I say it is not for you to submit the mind to any sadness through interrupted study of joyful contemplation, when I shall have been surrounded by such flowers and such fruits of piety. Patiently I was torn from the embraces of the sterile Rachel so that from Leah the fruits of your utilities may abound to me. In the end I shall not regret the quiet that was disturbed by care for the sermon, when I see my seed germinate in you and add to the growths of the oats of your justice, for the charity that does not ask for the things that belong to it has already exhorted me easily for a long time not to put any of my facts before your needs. To pray, read, write, meditate, even if there are some high gains that pertain to spiritual studies, for you I have considered these things to be evils." [190] Up to here spoke Bernard. The third reason for leaving contemplation occurs when the soul does not feel the usual consolation on the departure of the Bridegroom. The Bridegroom goes and comes according to His pleasure, as you saw in the chapter on the Lord's flight from the crowds when they wished to make Him king. Therefore when He leaves, the soul languishes in its desire for Him and with all its strength recalls Him, saying with the Bride of the Canticles, "Revertere, dilecte mi" (Cant. ii, 17), "O my beloved, return." And if He does not then come back, she calls the companions of the Bridegroom, the angels, to aid her, saying, "I beseech you, daughters of Jerusalem, if you see my beloved, tell Him that I languish for love" (Cant. v, 8). But if He does not deign to return in this way, the soul, knowing the wish of the Bridegroom, returns to the active, so that it may at least be fruitful for the Bridegroom. It is not suitable for the contemplator to be indolent. Consequently he says with the Bride, "Ornament me with flowers, surround me with apples, for I languish with love" (Cant. ii, 5). On this Bernard speaks in the 51st (sermon on the) Canticles: "The flower means

faith; the fruit, the act. Nor will it seem inconvenient to you, according to what I think, if you are concerned how, as the flower necessarily precedes the fruit, it is necessary for the good deed to proceed by faith. Otherwise, without faith, it is impossible to please God, as Paul testifies (Heb. xi, 6); and, moreover, as he himself teaches, saying, 'Omne quod, non est ex fide, etiam peccatum est' (Rom. xiv, 23), 'Everything that is not of faith is sin.' In this way there is no fruit without a flower and no good deed without faith. But faith without the deed is death (James ii, 20), and thus the flower that is not followed by the fruit appears uselessly. . . . Consequently, the mind accustomed to repose receives consolation from good deeds rooted in a faith that is not false every time the light of contemplation is concealed from it, as is usual. Who is it that—and I do not say continually, but for a long time—while inhabiting this body, enjoys and makes use of the light of contemplation? But as often, as I said, as he falls from the contemplative, so often he returns to the active. And also it must certainly receive him more familiarly, as a neighbor, for these two are comrades and live alike; certainly Martha is the sister of Mary. Although she fall from the light of contemplation, nevertheless she will not suffer in any case to fall into the darkness of sin or the inactivity of idleness, but remains in the light of good actions. And that you may know that the actions are light, 'Your light shines,' says Christ, 'before men' (Matt. v, 16). There is no doubt that this was said of the works that men may see."[191] Up to here speaks Bernard. These then are the three reasons for which the contemplator may depart from joyful contemplation and return to the active, although he returns by constraint in this last, yet by divine dispensation. And in each of them you were able to study through the words of Bernard, who does this at the right time and returns to contemplation. Therefore these very things are an argument that contemplation is put ahead of the active.

Now, thanks to God, we are released from the treatise

on contemplation. It is a copious and most useful matter, in which you may instruct yourself not only on contemplation itself but also on many other things, as it were on the whole study of spiritual exercise. Therefore learn it intently and diligently strive to make use of it in deeds. And do not think that I have given you everything in the above as Bernard treats it; but the things that are said will be enough for you.

(LIX. *How the Lord Said to the Jews That the Church Was to Devolve Upon the Gentiles, Under the Likeness of the Vine-Dressers Who Killed the Son of Their Master* —MATT. xxi, MARK xii, LUKE xx)

Our Lord and our Redeemer, desiring the salvation of the souls for which He had come to give His, tried to draw them to Him in all ways and to extricate them from the prisons of the enemies. Thus He sometimes used persuasive and humble sermons, sometimes reproving and harsh ones, sometimes examples and parables, sometimes signs and virtues, sometimes threats and frights. In this way He varied the means and remedies of salvation as He saw them and as was necessary according to the place and time and different people that were listening. But in this place He used against the chief priests and Pharisees hard words and a terrible example, so complete and true that they themselves passed sentence against themselves. He set forth before them the parable of the workers in the vineyard who killed the messengers of the lord, who had come for the fruits, and even his son. He asked them what punishment it was proper for that lord to deal out to them, and they replied, "Malos male perdet, et vineam suam locabit aliis agricolis" (Matt. xxi, 41), "The wicked will end badly, and he will let out his vineyard to other dressers." And the Lord Jesus approved this statement, adding, "In this way the kingdom of God, that is, the Church, will be taken

from you and given to people—*gente*—who will give Him His fruit" (Matt xxi, 43), that is, to the gentiles—*gentili*—of whom are we and the universal Church. He also related the example of the angle-stone, that is, of the corner, which signified Him, and that He was to destroy and crush the Jews. At that they understood that these words referred to them. They were not chastised but more angered, for their malice had blinded them. Now watch Him in the above as He sits humbly among the Pharisees, but speaking with authority and with power and vigor, and of virtue announcing their own fall in truth; and they did not understand.

(L X. *How They Wished to Catch Jesus in the Sermon*
—MATT. xxii, MARK xii, LUKE XX)

Just as the Lord Jesus strove in many ways to bring about the salvation of the Jews, so, in the opposite way, did they try with all their might to defame and confound Him. Thus they resorted to deceiving Him, but they lost out in their search. After resolved counsel, they sent two of their disciples with the familiars of Herod the King to ask Him whether it was right to pay the tribute to Caesar or not. They thought they could by this render Him odious either to Caesar or to the multitude of Jews, as He could not but contradict Himself. But He, the explorer of hearts, recognized their malice and replied that they should render to God what belonged to Him and give to Caesar what was Caesar's, calling "hypocrites" those who speak with sweet words and a deceitful soul. Those who were deluded in their intentions left in shame. Watch Him attentively here, as you were told in the general instructions. And also consider at this point that the Lord did not wish prelates and temporal lords to be defrauded of their due. Therefore it is a sin and a forbidden thing not to pay tolls and taxes that are duly, properly, and justly ordered and imposed by temporal lords.

210

211

212

213

214

291

(LXI. *Of the Blind Man Illuminated in Jericho, and Many Other Things*—MATT. XX, MARK X, LUKE xviii)

The most benign Lord, who descended from the bosom of His Father because of His great charity, for our salvation, knowing that the time of His Passion was approaching, prepared to go toward Jerusalem to receive it; and at that time He foretold it to His disciples, but they did not understand Him. As He neared Jericho, a blind man who sat beside the road, poor and begging, heard from the crowd that the Lord Jesus was passing by and began to cry loudly, "Mercy, mercy!" And although he was reproved by the multitude, he was not ashamed of shouting and did not stop. By his faith and fervor the Lord noticed him, had him led to Him, and asked, "What do you want me to do for you?" And the blind man said, "Lord, that I may see" (Mark x, 51; Luke xviii, 41). And the merciful Lord conceded it, saying, "See." And He illuminated him. Therefore watch the benign Lord Jesus and His courtesy diligently, and consider here the virtue of faith and prayer, and how the importunity of prayer does not displease God but, in fact, pleases Him. You saw this similarly above, with the Canaanite woman, and He teaches in this same chapter that it is always fitting to pray and not to fail, giving the parable of the judge from whom the widow, owing to her persistency, had what she wanted. He also gives the example of the man who lent bread in the middle of the night because of the importunity of the one that asked for it. In the same way, the Lord gives to those who persevere in supplication for that which they justly and properly request, so much so that He says to each, "What do you wish me to do for you?" and does it. In fact very often He does more than one asks and more than man dares to ask, as you see in the example of Zacchaeus, of whom we shall soon speak below. Consequently, know firmly that what you ask from God faithfully and persistently, you will re-

215
216

217

ceive. And you must not feel shame, since neither this blind man nor the Canaanite nor Zacchaeus was ashamed to ask for graces, and yet they had them. Therefore we must not be ashamed to serve God and abandon sin and ask for the graces needed. To have fear and shame at times pertains to great virtue and at other times to great vice. On this Bernard says in his book of praise to the new soldiers, "There is one shame that causes sin and another shame that brings glory (Ecclus. iv, 25). That shame is good by which you may be confounded for having sinned or for sinning. And although it may not be a thing for a human arbiter, the more you shamefully respect the divine aspect, the more humanly or more truly you believe man to be pure. And the more seriously he is offended by sin, the farther he sees sin removed from him. Without doubt this very shame puts opprobrium to flight and prepares glory, while, after all, it does not receive sin and surely punishes the one who committed it and repents and, confessing, expels it, if this, the testimony of our conscience, is our glory. But if someone is ashamed to confess, he feels remorse; this kind of shame leads to sin and destroys the glory of the conscience when compunction endeavors to expel evil from the depths of the heart, useless shame, having blocked the door, not letting anything leave." [192] "O shame devoid of reason, enemy of salvation, ignorant of all honor and honesty! . . . Thus it is not a shameful thing for a man to be conquered by God, and it is said to be valor to humiliate oneself under the powerful hand of the highest God. . . . The highest kind of victory is to yield to the divine Majesty, and not to resist the authority of the Mother Church, highest honor and glory. O perversity, you are not ashamed of defiling yourself but are ashamed of cleansing yourself! 'It is shame,' according to the wise man, 'that leads to glory' (Ecclus. iv, 25), that is, if you are ashamed of sinning or of having sinned; in this way there will not be a late

glory reducing the shame that guilt had expelled." [193] And Bernard also says, in the 86th (sermon on the) Canticles, "I do not know if one can see anything more gracious than shame in the customs of men. . . . This is surely an ornament of all ages, but the grace of shame shines more and most beautifully in those of most tender age. What can be loved more than a shamefaced youth? How beautiful and resplendent is this, the gem of habits, in the face and life of the young man! How true and undoubted a messenger of good hope, an indicator of good condition! A rod of discipline is it to him, which constrains the overwhelming impulses of an age perilous with shameful desires and light actions and suppresses the insolent ones. What is it that in this way flees before words of foul speech and every ugliness? Shame is the sister of continence. Nothing is as surely a manifest proof of dove-like simplicity and therefore a witness of innocence. It is a lamp of the pure mind, which is perpetually alight so that nothing ugly or shameful will attempt to remain in it that would not immediately show. In this way, it drives away evil and fights for innate purity and is the special glory of the conscience, guardian of (fame), beauty of life, seat of virtue, messenger of virtue, praise of nature, and nobility of all honesty, and that flush of the cheeks that perhaps shame has brought. How much of grace and beauty is shame accustomed to bring to the face! So much and so good a germ of the soul is shame that he who is not ashamed to do evil nevertheless is ashamed to be seen, . . . covering the deeds of the shadows and suitable for hiding. . . . What is so great a friend of the modest spirit as the secret? . . . Finally, if we wish to pray, we are entreated to enter the bed, that is, the secret of grace. It is securely on guard, so that while one is praying publicly, human praise will not pillage the fruit of prayer, deceptively frustrating desire. . . . But what is so particular to shame as to shun its own praises, avoid boasting? . . . What is so displeasing, especially in a youth, as the ostentation of sanctity?

. . . Good company[194] of praying must follow if you place shame first."[195] Up to here spoke Bernard.

Another meditation,[196] which brought me great devotion and consolation, came to me once at this point, but it has slipped my memory, although I touched it briefly while meditating on the life of the Lord Jesus that I am writing for you in this little book. It is almost like a circle: some weeks I completed it often; and this continued for many years. In this place there came to me—without hope or custom and without industry, as with most other things —there came to me a meditation that seemed most beautiful and cheered me greatly. When, according to my habit, the circle turned again, that is, when the round returned to this place last week, to my great distress I had forgotten it. Even looking again in this place last week I still did not find it. Therefore, since then, I have thought of committing such beautiful things to writing, especially for my memory. Up to then I had trusted that memory, and justly, because such forgetfulness had never yet come upon me in these matters. And although I had noted some things, seeing that this was an imperfect thing and out of order, I thought of beginning from the beginning and arranging them, not only for my memory but also for your use, and writing them to send to you. Thus perhaps that forgetfulness will avail you. Therefore, since your profit has had a great part in inducing me to do this, see that you do not receive this effort in vain but, by effectively studying it, restore me, so that I receive from you what I lost; although this writing itself has brought me not a little distraction.

The things that appear in the consideration of this blind man you may also meditate upon for the other two blind men illuminated by the Lord, that is, when He left Jericho. But this one was illuminated before He entered. Of the others there is mention in Matthew, chapter xx, and Mark x, where the name of one is given. In that manner they cried as this one, and received a reply and light from God.

(l x i i. *How the Lord Entered the House of Zacchaeus*
—luke xix)

When the Lord Jesus entered the city of Jericho and was passing through it, Zacchaeus, chief of the publicans, heard that Jesus was going by and strongly desired to see Him. As he was not able to see Him, because of the multitudes of the crowd and his small stature, he climbed into a sycamore tree, that he might see Him. Jesus, knowing and receiving his faith and desire, said to him, "O Zacchaeus, come down quickly, for today I wish to rest in your house" (Luke xix, 5). At that he climbed down and with great joy and reverence received Him and prepared a beautiful banquet for Him and His disciples. You see the courtesy of the Lord Jesus, who gave to Zacchaeus more than he desired

218 —He gave Himself, for which he would not have dared to
219 ask. Here you have the desire of prayer, for desire is a great
220 voice and a great prayer. Thus the prophet says, "The Lord
221 has granted the desire of the poor, and your ear has heard the preparations of their hearts" (Psalm x, 17). And to Moses the Lord said, "Why do you call me?" (Exod. xiv, 15), although at that time he was silent with his mouth but spoke with his heart. Watch Him sit and eat with those sinners. He placed Himself with Zacchaeus among those at the table, and one of the honored ones He placed at the head. In familiar and mild manner He conversed with them, in order to draw them to Him. See also the disciples, who converse willingly with these same sinners, speaking to them and encouraging them to good deeds, for they knew this to be the will of their Master and desired their salvation.

(l x i i i. *Of the Man, Blind from Birth, Illuminated*
—john ix)

When the Lord was going through Jerusalem, He saw a
222 man who had been born blind and whose name is said to have been Ce(li)donius. And when He was before him, the
223 Lord bowed humbly to make clay of spittle and, anointing
224 his eyes, sent him to the pool of Siloam, that he might wash

his eyes. The blind man immediately went, washed them, and saw the light. This miracle was earnestly examined by those malevolents and caused them confusion. But you may read the story in the Gospel, for it is very plain and beautiful. In these events, keep the Lord in mind, according to the general formula given you, and consider how great was the gratitude of this blind man, that he so constantly and bravely defended the side of the Lord Jesus before those chiefs and elders of the Jews and did not spare them even one word, though he had not yet seen Jesus. The virtue of gratitude is to be highly commended and is acceptable to God, and the vice of ingratitude is detestable and hateful. On this matter Bernard says, in the 51st (sermon on the) Canticles, "Learn to render thanks for all gifts. Diligently he considers 'those things that are placed before you' (Prov. xxiii, 1), so that no gifts of God will be received in vain, without due rendering of thanks—neither the big ones, nor the medium-sized ones, nor the small ones. In the end, we are compelled to collect the fragments, that is, the broken bread, so that they will not perish, that is, so as not to forget the smallest benefits. Now does not that thing that is given to the ungrateful one perish? Surely ingratitude is the enemy of the soul, the lessening of merits, the contempt of virtue, the loss of benefits. Ingratitude is a burning wind that dries up the font of piety, the dew of mercy, the fruits of grace." [197] These are Bernard's words.

(L X I V. *How the Lord Fled from the Temple and Hid Himself When the Jews Wished to Stone Him*—JOHN viii)

Here the mysteries of the Passion of the Lord begin. Rarely, from now on, will I adduce authorities, so that I may more properly dwell upon His Passion and the events preceding it. Once when the Lord Jesus was preaching in the temple and saying, among other things, ("If he keep my sermon, he shall never taste death,") to those who re- plied, "Are you greater than our father Abraham, who is

dead?" (John viii, 53), the Lord Jesus said, "Before Abraham was made, I existed" (John viii, 58). These words they took as reason for picking up stones to stone Him, as though He spoke an impossibility or a falsehood. But He hid Himself and left the temple, for the time of His Passion had not yet come. Watch carefully, with strong sorrow, how the Lord of all things was so despised by those most evil servants, and how the Lord, wishing to yield to their fury, hid Himself in some place outside the temple, behind some little wall or among some people. Watch Him and the disciples leaving the temple sorrowfully, with heads bowed, as though weak and simple-minded, leaving singly and softly and disappearing.

(L X V. *How at Another Time They Wished to Stone Jesus* —JOHN X)

Another time, when the Lord Jesus was in the portico of Solomon for the feast of the Encaenia, that is, of the consecration of the temple, those rapacious wolves surrounded Him with great anger, gnashing their teeth. They said, "Why do you take our souls? If you are Christ, say it clearly" (John x, 24). And the most benign Lamb answered humbly, saying, "I speak to you and you do not believe me; the deeds I perform in the name of my Father render witness to me" (John x, 25). Regard Him now for the sake of God and the whole deed. He spoke to them meekly, but they rioted with the fury of barking dogs, surrounding Him on all sides. Finally, since they were unable to hide the poison of their hearts, they picked up stones to throw, but the Lord Jesus spoke with a not less humble sermon, saying, "I have shown you much good: for which of these do you wish to stone me with stones?" (John x, 32). And the others said to Him, among other things, "Because you are a man and make yourself God" (John x, 33). You see the astonishing folly. They wished to know and recognize Christ, and they wanted to lapidate Him because He proved it with words

298

and deeds. But verily their malice had blinded them, and they can have no excuse that they could not and should not believe that the Lord Jesus was the son of God. But since His time had not yet come, He escaped from their hands and left to go beyond the Jordan to that place where John had baptized, which was 18 miles from Jerusalem; and here He stayed with His disciples. See Him, therefore, and the disciples as they go saddened, and have pity on them with all your might. 230

(L X V I. *Of the Resuscitation of Lazarus*— JOHN xi)

The present miracle is very devout and must be meditated solemnly, with devotion. Therefore be as attentive as though you had been present at what was said and done. And converse willingly not only with the Lord Jesus and His disciples, but also with the blessed family so devoted to God and beloved by the Lord Jesus, that is, Lazarus, Martha, and Mary. Since Lazarus was ill, his aforementioned sisters, who were most intimate with the Lord, sent to Him to the place where He had gone, that is, beyond the Jordan, as was stated in the preceding chapter. They said, "Lazarus, our brother, whom you love, is ill" (John xi, 3), and no more, for this was enough for Him who loved and understood; and also they feared to call Him, for they knew the elders of the Jews envied Him and desired His death. When the Lord Jesus had heard the message, He remained silent and delayed answering for two days. Then He said to the disciples, among other things, "Lazarus is dead; and I am joyful for you that I was not there" (John xi, 14, 15). You see the marvelous kindness and love of the Lord, and His discretion toward His disciples. They needed even greater strength and virtue, therefore He gladly worked for their benefit. Now they returned and approached Bethany. When Martha heard it, she immediately came to Him and, when she reached Him, impetuously threw herself at His feet, saying, "Lord, if you had been present, my 238

231

232
233

234
235

236
237

299

brother would not have died" (John xi, 21). The Lord replied, "I will resuscitate him," and they discussed the Resurrection together. And He said, "Go for Mary," for the Lord loved her particularly. And she immediately went to say, "The Lord wants you." Immediately she rose and swiftly

239
240
went to Him and threw herself at His feet, speaking words similar to Martha's. When the Lord saw His beloved in affliction, tearful and bereft of her brother, He also could

241
not restrain His tears, and cried. Watch Him and the sisters and also the disciples, and do you not suppose that they also cried? After a short time, during which all were weeping, the Lord Jesus said, "Where did you place him?" (John xi, 34). He well knew where, but He was speaking according to human usage. Then they said, "Lord, come and see" (John xi, 34), and led Him to the sepulcher. The Lord Jesus walks between the two sisters, consoling and comforting them, and they receive so much solace from His presence that they have almost forgotten all their sorrow and regard all things only in Him. As all three were going on their way in this manner, the precious Magdalen said, "Lord, what befell you when you left us? I was deeply grieved at your departure, but now, when I heard you had returned, I felt great cheer. But none the less did I fear,

242
and I fear much. You know how many evil things are being disposed against you by the chiefs and our elders. Therefore we did not dare to send for you. I am happy that you came, but I beg you to beware of their betrayal." The Lord replied, saying, "Do not fear, for my Father will provide for these matters." (Thus speaking to each other, they came to the monument.) Then the Lord Jesus commanded that the stone that was on top should be removed. But Martha said, "Do not, Lord; he is putrid, for he is already four

243
days dead" (John xi, 39). O God, see the wonderful love of these sisters for the Lord Jesus, for they did not wish the stench to reach His nostrils. Nevertheless He had the stone lifted. When this was done, our Lord Jesus raised His eyes

300

to heaven and said, "I thank you, Father, that you have heard me. I knew that you always hear me, but I say it for these, that they may know you have sent me" (John xi, 41, 42). Watch Him carefully as He prays thus, and consider His love for the salvation of souls. Then He cried in a loud voice, saying, "Lazarus, come forth" (John xi, 43). At that cry, he immediately rose and came out of the monument, but still bound as he had been buried. On the command of the Lord, the disciples loosed him. When he was free, he and also his sisters knelt, giving thanks to the Lord Jesus for such a benefaction, and took Him to their house. Those who were present and saw these things marvelled greatly. The miracle was divulged, so that a great multitude came from Jerusalem and other regions to see Lazarus, and the chiefs of the Jews were completely confounded and thought of how they could put Him to death.

244

245

(L X V I I. *Of the Cursing of the Fig Tree*
—MATT. xxi, MARK xi)

Although, according to the belief of history, the cursing of the fig tree and the appearance of the adulteress in the temple are thought to have occurred after the arrival of the Lord Jesus on the ass in Jerusalem, it seems more convenient not to meditate on anything after this arrival except the Supper and the Passion and their circumstances. Therefore I thought of placing these two events here. As the Lord was going toward Jerusalem and feeling hungry, He saw a fig tree, beautifully ornamented with foliage. When He came closer and did not find any figs on it, He cursed it. Immediately it withered, and the disciples marvelled at this. Therefore watch Him and the disciples in this, according to the general manner given you before. Consider also that this was done by the divine power of the Lord, for He knew that it was not the time for figs. But in place of this tree of green foliage, lacking fruit, one can regard those who are full of words, and story-tellers without

246

247

248

301

deeds, and also the hypocrites and deceivers who have an exterior appearance and are empty inside and without fruits.

(L X V I I I. *Of the Woman Taken in Adultery*—JOHN viii)

The evil chiefs and Pharisees in their malice watched against the Lord, solicitously plotting and studying how they might defeat Him by cunning and deceit and demonstrate this to the people, but their darts returned upon them. When a woman, taken in adultery, was to be stoned, according to the law, they took her to Him in the temple to ask what should be done with her, so as to calumniate Him; for if He should say that the law had to be observed, He might be rebuked for cruelty and lack of pity; and if He said it was not to be observed, He could be reproved for injustice. But the wise Lord, knowing their traps, and knowing how to avoid them, bowed humbly and wrote on the ground with His finger, as the gloss says, writing their sins. This writing was of such virtue that each one of them recognized his own sins in it. Then the Lord rose and said, "Let the one of you who is without sin be the first to throw a stone" (John viii, 7). And again the courteous Lord bowed, so that those who envied and opposed Him need not be ashamed. But all those departed, and their tricks were in vain. After He had admonished the woman not to sin again, the Lord dismissed her. Therefore watch Him well in all these deeds and words.

(L X I X. *Of the Conspiracy of the Jews Against Jesus; And of His Flight to the City of Ephraim*— JOHN xi)

When the time approached that the Lord Jesus had set for our redemption by the shedding of His own blood, the devil armed his followers and sharpened their hearts against Him, that is, against the Lord, to cause His death. They were more and more inflamed by the good deeds of the Lord, especially the resurrection of Lazarus, since they were

249

250
251

252

253

full of envy. Unable to protract their anger any longer, they began to gather the chiefs and the Pharisees in a council, in which Caiaphas prophesied, and they deliberated on killing that most innocent Lamb. O vicious council, most evil leaders of the people, and most wicked councillors! What are you doing, wretches? Why does so much fury move you? What order is this, what proposition? What reason do you have for killing the Lord your God? Is He not amongst you, He whom you do not know but who hears all your words and searches the reins and the hearts? But it must be done as you have deliberated. His Father placed 254 Him in your hands. By you He was killed, but not for you. He will die and rise in order to save His people, and you will all perish. This council was made known. But since the judicious Lord wished to give free vent to ire, and also because everything was not yet accomplished, He left and went to a region near a desert, into the city of Ephraim. In this way the humble Lord fled before the face of the most wicked servants. Watch these malefactors burning in their bad counsel. Similarly, watch the Lord Jesus and the disciples as they depart like feeble and poor men. What do you think the Magdalen said then? But in what spirits was the mother of the Lord Jesus when she saw Him thus depart and heard the reason why they wished to kill Him? Here you may meditate that the Lady and her sisters remained with the Madgalen, and that the Lord Jesus consoled them with His speedy return.

(L x x. *How the Lord Jesus Returned to Bethany, Where Mary Magdalen Anointed His Feet*—MATT. xxvi, MARK xiv, LUKE xxii, JOHN xii)

As in the above treatises the Lord Jesus exercised prudence by flight, for our instruction showing that in time and place we must judiciously stop the fury of those who persecute us, so He now used fortitude, for the proper time had arrived, and He returned spontaneously to offer Himself

for the Passion and to deliver Himself into the hands of those persecutors. As at other times He exercised temperance, in fleeing honor when the multitudes wished to make Him king, on the contrary He used justice when He wished to be honored as a king, when the people met Him bearing branches of trees. But He wished to receive this honor modestly enough and therefore mounted the ass, as Bernard relates in the sermon on the day of the olive.[198] These four virtues—prudence, fortitude, temperance, and justice—were exercised by the Lord of virtues for our instruction. It is said they are cardinal and principal because from them all the other moral virtues descend. One must therefore not think that He was as variable or inconstant as any other who exercises various virtues according to various cases. One sabbath before the day of the palms, the Lord returned to Bethany, which is almost two miles from Jerusalem. There He had supper in the house of Simon. Lazarus, Martha, and Mary were there, for perhaps they were relatives or very close to this Simon. At that supper, Mary poured a pound of precious unguent over His head and with it anointed His head and feet; and what at another time in that house she had done in contrition, she now did in devotion, for she loved Him above all things and could not serve Him enough. But Judas, the traitor, murmured at this, at which the Lord replied, defending her, according to His custom. Nevertheless the traitor remained indignant and took this as grounds for betrayal and on the following Wednesday sold the Lord Jesus for thirty denars of silver. Observe Him as He eats with these friends of His, conversing with them for those few days, that is, until His Passion. But, moreover, in the house of Lazarus—his and the sisters' house—there was His general refuge. Here He ate by day and slept at night with His disciples. There His mother, our Lady, rested with her sisters. All honored her very much, especially the Magdalen, who always accompanied her and never left her at any time. Watch the Lady

well as she is driven by fear for her most beloved Son and is not parted from Him for any time. When the Lord defended the Magdalen from the murmurings of the traitor, He said, "When she poured this unguent on my body, she did this for my burial" (Matt. xxvi, 12). Do you not think that the knife of these words pierced the soul of the mother? What could He have said more clearly about His death? Likewise all the others stood in shock, full of anguished thoughts, speaking together, one against another, here and there, in the manner of those who deal with hard and adverse matters. They were especially apprehensive when He went to Jerusalem, which He did every day. From the sabbath day until the day of the Supper, He said many things to the Jews and worked openly in Jerusalem, but I do not intend to say anything of these things except for His arrival on the ass, so that the meditation on His Passion will not be hindered, for we are at the door of the Passion. Therefore concentrate your spirit that it may not be distracted by other things and that you may attend to these mysteries that precede, and also to the Passion, with a mind free from cares and very diligent. Meanwhile converse gladly in Bethany with the aforementioned persons.

(LXXI. *Of the Arrival of the Lord in Jerusalem on the Ass; Also How Jesus Is Said to Have Shed Tears in Three Ways* —MATT. xxi, MARK xi, LUKE xix, JOHN xii, HEB. v)

The mysteries continued; the writings were fulfilled for the Lord; the time in which He desired to give relief to the world by the Passion of His body was approaching. Therefore, early in the morning of the following day, that is, Sunday, He prepared to go to Jerusalem in a new and unaccustomed way, but one that had been prophesied. As He wanted to leave, the mother stopped Him, with pious affection, saying, "My Son, where do you wish to go? You know the wicked counsel proposed against you. How can you go into their midst? I beg you, my sweet Son, not to

go." In the same way, it seemed unbearable to the disciples and the others that He should go, and they restrained Him as best they could. The Magdalen said, "Master, do not go, for God's sake; you know they desire your death. If you fall into their hands, they will take you immediately and do their will." O God, in what a way and how much did they love Him, and how bitter to them was anything that harmed Him! But He who thirsted for the salvation of all had disposed otherwise and replied thus: "The will of the Father is that I go. Let me go and do not fear, for He will defend me, and tonight we shall return safe and sound." And He took leave of His mother and the Magdalen and the other sisters and, having said farewell, went with His small but very faithful company. They followed Him until they came to Bethphage, that is, a hamlet that was halfway
256 on their road. Here He stopped and sent two disciples to
257 Jerusalem to bring Him an ass and its colt that were tied
258 in a public place, designated to serve the poor. When this
259 was done, the Lord humbly mounted the ass and rode
260 awhile, and then mounted the colt. On them, the disciples
261 had placed their clothing. In this way the Lord of the world
262 rode. And although it was a most just thing to honor Him,
263 in the time of honor He wished to use such mounts and
264 such trappings. Watch Him well and see how He shames
265 the honorable pomp of the world in this honor. These
animals were not decorated with reins and gold saddles and
266 silk ornaments, according to the custom of worldly folly,
267 but with wretched rags and two little cords, although He
was King of kings and Lord of lords. When the multitudes knew of it, they came towards Him and received Him as King, with praises and songs, with great joy, their garments spread on the ground, and branches of trees. But He mingled tears with this joy. When He was near Jerusalem, He wept for it, saying, "If you had known, you would cry."

You must know that we read that the Lord Jesus cried three times. Once on the death of Lazarus, that is, on

306

human misery. Once here, that is, on human blindness and ignorance. He cried thus because they did not recognize the time of His visitation. The third time He wept in His Passion, that is, on human guilt and malice, because He saw that His Passion was enough for all and yet did not profit all, for it was of no avail to the damned and hard-hearted and those that did not repent. This the apostle relates to the Hebrews, saying on the time of His Passion that He was heard with great cries and tears because of His fear (Heb. v, 7). Of these three times the Gospel tells, but the Church maintains that He cried at other times, that is, when He was an infant, and sings the following: "The Child placed in the narrow manger weeps." This He did to hide the mystery of the Incarnation from the devil. Therefore now observe Him carefully as He weeps, for you should weep with Him. He weeps long and hard; He grieves for them, not falsely but truly. Thus with bitter heart He wept for their eternal danger, and He also predicted their temporal danger. See also the disciples, who walk beside Him attentively, with fear and veneration. These are His barons, His counts, the pages and grooms. See also His mother, with the Magdalen and the other women, walking respectfully behind Him. And you must not believe that when He was crying the mother and the other intimates could restrain their tears. The Lord Jesus entered with triumph and honor from the crowds into the city, which was moved by this. He went to the temple and drove out all those who were selling and buying; and this was the second expulsion. The Lord remained in the temple, publicly preaching to the people and replying to the chiefs and Pharisees, until evening; and although He was thus honored by them He did not find anyone who invited Him even to drink. Therefore He and His companions fasted all day, and in the evening He returned with them to Bethany. Watch Him well now as He walks humbly through the city 268 with His few—He who had come so highly honored in the

morning! On this you may ponder that worldly honor is of very little consequence, since it ends in a short time. Consider also how the Magdalen and the others rejoice that He was thus esteemed by the multitudes, and much more that He returned to Bethany without difficulty.

(LXXII. *How the Lord Jesus Predicted His Death to the Mother*)

269 Here one may interpolate a very beautiful meditation of which the Scripture does not speak. On Wednesday, while the Lord was dining with His disciples in the house of Mary and Martha, and likewise the mother with her women in another part of the house, the Magdalen, who was serving, entreated the Lord, saying, "Master, bear in mind celebrating the Pasch with us. I pray you not to deny me this." But He would by no means consent but said that He would spend the Pasch in Jerusalem. On this she left weeping, and in tears came to the Lady, told her these things, and begged her to keep Him for the Pasch. After supper the Lord Jesus went to His mother and sat apart with her, talking to her and generously giving her His time, for in a short time He was to be removed from her. Observe them as they sit together, and how the Lady receives Him reverently and stays with Him eagerly, and how the Lord similarly leans reverently towards her. As they speak together, the Magdalen approaches and, seating herself at their feet, says, "I invited the Master to celebrate the Pasch

271 here with us, but it seems He wishes to go to Jerusalem to be captured. I beg you not to let Him go." At this the mother says, "My sweet Son, I beg you that this will not be so, but that we celebrate the Pasch here. You know they are directed to capture you." And the Lord said to her, "Most beloved mother, the will of my Father is that I spend the Pasch there, for the time of redemption is coming. Now all the things said of me will be fulfilled, and they will do to me what they wish." They heard these things in

308

great sorrow, for they well understood that He was speaking of His death. The mother spoke, hardly able to utter the words she formed: "My Son, I am as if dead to hear this, and my heart has abandoned me. May the Father provide, for I do not know what to say and I do not want to contradict Him. But, if it please Him, beg Him to delay now, and let us celebrate the Pasch with these friends of ours. If it please Him, He can provide for the redemption in a different way, without your death, for all things are possible with Him."

Oh, if you could see the Lady weeping between these words, but moderately and softly, and the Magdalen frantic about her Master and crying with deep sobs, perhaps you too would not restrain your tears!

Meditate on their condition as they spoke of these things. Said the Lord, gently consoling them, "Do not cry. You know that I am bound to obey the Father, but be surely confident that I shall soon return to you, and on the third day I shall rise safe and sound. Therefore I shall spend the Pasch on Mount Sion according to the wish of my Father." The Magdalen said, "Since we cannot keep Him here, let us be in our home in Jerusalem. But I think that He never had such a bitter Pasch." And the Lord consented that they should spend the Pasch in this house.

(L X X I I I. *Of the Supper of the Lord; Also of the Table and the Manner of Sitting at the Table; The Five Examples of Virtue of Christ at the Supper; Also Five Things from the Sermon of the Lord* —MATT. xxvi, MARK xiv, LUKE xxii, JOHN xiii)

Since the time was ripe for the mercies and compassions of the Lord, in which He had disposed to save His people and redeem them, not with corruptible things, not with gold or silver, but with His precious blood (I Peter i, 18, 19), He wished to have a remarkable Supper with His disciples before He left them by dying, as a commemorative memo-

rial and also to perform the mysteries that remained. It was a most excellent Supper, and excellent are the things the Lord Jesus did there. You must place these things for your consideration with the highest attention, for if you do this worthily and diligently, the courteous Lord will not permit you to return hungry. Among the things that were done, there are notably four on which one must principally meditate. The first is the corporal Supper. The second is the washing of the feet of the disciples by the Lord Jesus. The third is the leaving of His consecrated body. The fourth is the composition of the very beautiful sermon that was made by Him. We shall come to each in succession.

On the first event, learn that at the command of the Lord Jesus, Peter and John went to the house of a very dear friend on Mount Sion, where there was a large dining room arranged and set for the Pasch. On Thursday, late in the day, the Lord Jesus and the other disciples entered the city of Jerusalem. See Him, therefore, as He remains in some part of the house, saying salutary and good things to the disciples while some of the seventy prepared the dining room for the disciples. In the legend of the Blessed Martial[199] I have read that on that evening he and some of the seventy were there to serve the Lord Jesus and the twelve apostles; and they also helped to bring water to the Lord Jesus when He was washing the disciples' feet. When everything was ready in the dining room, the most beloved John, who went solicitously to see and help with the arrangements, went to the Lord Jesus when all was ready and said, "Lord, you can have supper when you please, for everything is prepared." Now meditate with discretion on everything that is said and done, for all should be deeply impressed on you, and not abbreviated but prolonged, like all other things concerning the Lord Jesus. In this is the great strength of all His meditations, but principally here, because of the great demonstration of love in this Supper. The Lord Jesus rose, and the disciples with Him. But John

drew close to Him and did not part from Him from that
moment: no one was drawn to Him as faithfully and famil-
iarly as John. When He was taken, he followed Him to the
palace of the high priest, nor did he leave Him at the
Crucifixion, or at His death, or after His death until He
was buried. At this Supper he sat at His side, although He
was younger than the others. They all entered the dining
room, washed their hands, and stood to bless the table.
Observe everything well. You must know that this table was
on the ground, and, according to the custom of the ancients,
they sat on the ground to eat. This table was, as we see,
square and consisted of several boards, as I saw in Rome,
in the Lateran church, where I measured it.[200] The one
square was of two *braccia* and three *dita* and the other square
of two *braccia* and one *palmo,* approximately. Thus they sat,
tightly, as one believes, three on each side, and the Lord
humbly in one corner, in such a manner that all could eat
from one dish. Therefore the disciples did not understand
when He said, "The one who has put his hand into the dish
with me shall betray me" (Matt. xxvi, 23), because all
placed their hands there. After the blessing was made by
the right hand of God, they sat on the floor at the table,
with John beside the Master; and then the Paschal lamb
was presented to them. But wait, for you can meditate in
two ways here. The one way is that they sat as I mentioned.
The other is that they stood, holding staves, eating the
lamb with wild lettuce and observing the other things as is
commanded in the law. As far as you can, meditate (that
they sat), eating other things, as one may gather from the
text in many places. Nor could John have remained on the
breast of the Lord while eating if they had not sat. When
the roast Paschal lamb was brought in, the true and immac-
ulate Lamb, that is, the Lord Jesus, took it: He who was
among them as if to serve them cut it into pieces and
cheerfully offered it to the disciples and exhorted them to
eat. They ate but could not become cheerful; they remained

ever in fear and trembling that a new injury might be done against their Lord. As they were eating, He revealed the facts more openly and, among other things, said, "I have greatly desired to eat with you this Pasch before I suffer the Passion (Luke xxii, 15). One of you is to betray me" (Matt. xxvi, 21; Mark xiv, 18). This word entered their hearts like a sharp knife, and they ceased to eat, looking at each other and saying, "Is it I, Master?" (Matt. xxvi, 22; Mark xiv, 19). Watch carefully now, and pity the Lord Jesus as well as them, for they are in great sorrow. As though this word did not apply to him, that traitor did not stop eating. But John, at the request of Peter, asked Him, saying, "Lord, who is the one who is to betray you?" (John xiii, 25). Since the Lord loved him most exceptionally, He told him privately. John, deeply stunned and stabbed to the heart, bowed towards Him and rested on His breast. But the Lord did not tell it to Peter, for, as Augustine says,[201] if he had known of that traitor he would have rent him with his teeth. Peter symbolizes the active and John the contemplative, as Augustine himself says in the homily on the Gospel that is read for the feast of Saint John. Therefore you have here the theme and the example that the contemplative does not intrude on the active from outside. Also it does not require vengeance for offenses to God, but weeps inwardly, turns to the Lord in prayer, and approaches Him more closely in contemplation. As He draws near, it puts everything at His disposition, and this is understood of the time of meditation when it has abundance of the Bridegroom; sometimes, through the zeal of God and the souls, this contemplation comes out, as you saw more fully above in the treatise on the contemplative life. Here you also see that John did (not) tell Peter, although he had asked at his request. By this you should understand that the contemplative must not reveal the secret of the Lord. We read of the Blessed Francis that he did not openly divulge the secret revelations unless compelled by the desire for fraternal[202]

salvation or dictated by the teaching of supernal revelation. Note now the benignity of God as He keeps His beloved on His breast. Oh, how tenderly they loved each other! See also the other disciples, who are very sad at the words of the Lord, not eating, looking at each other and not knowing what counsel to take. This is enough for now on the first item.

Attend diligently to these things on the second. As they were thus assembled at the table, the Lord Jesus rose, and immediately all the disciples rose, not knowing where He wished to go. He descended with them to a lower place in the same house, as is stated by those who saw the place, and had them all sit down. Then He commanded that hot water be brought, removed His garments and girded a towel about Himself, and poured water into a stone basin to wash their feet. Peter refused and, deeply shocked, exclaimed, according to his judgment, "This seems an unsuitable act." But, having heard the warning of Christ, he 280 wisely altered his opinion for the better. Consider all these acts well, and with wonder mark what they do. The supreme Majesty and Master of humility bent to the feet of the fishermen; He remains bowed and kneeling before those who sit, washing all their feet with His own hands, drying and kissing them. But it surpassed humility that He performed the same service for that traitor. O evil heart, harder than hardness, that does not soften at so much humility, that does not thus revere the Lord of majesty, that 281 does not thus recognize the excellence of Him that made you, and ever becomes more cruel in the death of the innocent! Woe to you, wretch, hard-hearted one! What you have conceived, you will bear; not He but you will perish! You must consequently marvel justly at such profundity of humility and benignity. When He had fulfilled this mystery,[203] He returned to the place of the Supper, and again placing Himself at the table He exhorted them to follow His example. Here you may meditate that the Lord Jesus

313

on this evening set us an example of five great virtues: that is, humility, as was said in the washing; charity, in the consecration of His body (and of His blood) and in the sermon, which is full of admonitions of charity; patience, in sustaining His betrayer and the great infamy of being captured and led like a thief; obedience, in going to the Passion and to death in obedience to the Father; and prayer, in praying in the garden three times. Let us endeavor to follow Him in these virtues. And this will suffice on the second item.

In meditating on the third, you will marvel at the most esteemed regard and most worthy charity that He gave us in leaving Himself as food for us. After He had washed the feet of the disciples and returned to the table, He wished to put an end to the sacrifices of the law and begin the new testament. Thus He made our (new) sacrifice; taking the bread, He raised His eyes to the Father and made the most lofty sacrament of His body. Giving it to the disciples, He said, "This is my body, which will be betrayed for you." Likewise He took the chalice, saying, "This is my blood, which will be shed for you." Now keep well in mind, for the sake of God, how diligently, faithfully, and devoutly He does these things and how with His own hands He communicates this beloved and blessed family of His. Finally, as a commemoration of love, He added, "This you will do in my memory" (Luke xxii, 19). This is the memorial that, when received as food and faithfully meditated upon by the knowing soul, should completely inflame and inebriate it and transform itself completely into Jesus Christ by the strength of love and devotion. He could not have left us anything greater, dearer, sweeter, or more useful than Himself. He is the one whom you take in the sacrament of the altar made by Him today. He is the same one who was marvelously incarnated and born of the Virgin; for you He suffered death. And He is the one who, resuscitated and gloriously rising to heaven, sits on the right side of God. He is the one who created heaven and earth and all things, and

the one who rules and tempers them. He is the one on whom your salvation depends, in whose will and power it is to give you (or not to give you) the glory of Paradise. He is thus offered and given you in this little host—He, the Lord Jesus of whom we speak, Son of the living and true God. This was on the third item.

On the fourth item, await the other demonstrations for every superabundant accumulation of love. He delivered a beautiful sermon to them, full of burning coals, gentleness and love. When the disciples and the wicked Judas were communicated, (according to Augustine,) although according to some he did not take part in the communion, the Lord Jesus said, "Judas, do what you must as quickly as you can" (John xiii, 27). That wretch immediately went to the chief of the priests, to whom he had sold Him for thirty silver denars on the Wednesday before, and asked for company to capture Him. Meanwhile the Lord Jesus preached the sermon to the disciples, and you may take five principal 283
things from its beautiful, useful, and revered greatness on which to meditate. First, predicting His death, He comforted them, saying, "I will still be with you only a short time, but I will not leave you as orphans (John xiv, 18, 19). I go and return to you. I will see you again and cheer your hearts." He told them this and similar things that I shall pass over briefly. It pierced their hearts, for they could not calmly bear to hear anything about His departure. Second, meditate how in this sermon He instructed them affectionately and solicitously, speaking of charity many times: "This is my commandment, that you love one another; and in this all will know you as my disciples, if you love each other" 284
(John xiii, 34, 35; xv, 12); and other things you can more fully see in the text. Third, meditate how He admonished them to observe His commandments, saying in the sermon, "If you love me, observe my commandments" (John xiv, 15), and, "If you observe my commandments, you will dwell in my love" (John xv, 10), and such things. Meditate,

315

fourth, on how He gives them confidence for their tribulations, which He predicted would come to them, in this way: "You will have tribulations in this world, but trust me, for I have defeated the world" (John xvi, 33). And He also says, "If the world hate you, know that it hated me before you (John xv, 18). The world will rejoice while you sorrow, but your sadness will turn to joy" (John xvi, 20); and similar things. Fifth, meditate on this sermon how finally this Lord Jesus, looking at the sky, said to His Father, "Father, preserve those whom you have given me (John xvii, 11). When I was with them, I shielded them; but now that I come to you, holy Father, I pray you for them, not for the world and not so much for them, but for the sake of all those who are to believe in me through them (John xvii, 9, 10, 20). Father, I want those whom you gave me to be where I am and with me so that they may see my charity," [204] and other similar things that must truly have torn their hearts. It is truly astounding that the disciples, who loved the Lord Jesus so deeply, were able to bear those words. Therefore, if you examine the things said in this sermon attentively, you will search them and diligently ruminate, meditating on them, reposing in their sweetness, that you may be properly kindled by so much regard, benignity, providence, (indulgence,) and charity, and by the other things He did on this evening. Watch Him well as He speaks—how, speaking effectively, devotedly, and pleasingly He entrusts the things He recounts to His disciples—and graze in the delight of His aspect and words. See also the disciples as they remain in sadness, with bowed heads, lamenting and sighing. They are full to the limit of sadness as He renders testimony to the truth of this by saying, "Since I said these things to you, sadness has filled your hearts" (John xvi, 6). But among them all, look at John as he approaches Him most familiarly. How attentively and earnestly he gazes at this, his beloved, and gathers His words in greater tender anguish! He alone left them to us by writing them down.

And among other things the Lord Jesus said this: "Rise up and let us go" (Mark xiv, 42). Oh, how much fear came upon them, not knowing where and how they should go and 285 greatly fearing His departure! Nevertheless He talked to them, completing His sermon in some other place or on the road. Now watch the disciples following Him, and how each tries to come as near to Him as possible, going in such an order as do chickens following the hen, pushing Him or crowding Him, now one, now the other, in the desire to approach Him and hear His words. But He bore this willingly. Finally, when the mysteries were fulfilled, He went with them to the garden beyond the river Cedron where His betrayer and the soldiers awaited Him. The events that follow are part of the Passion, and consequently we reserve them.

(LXXIV. *Meditation on the Passion of the Lord, in General*)

We must now treat of the Passion of our Lord Jesus. He who wishes to glory in the Cross and the Passion must dwell with continued meditation on the mysteries and events that occurred. If they were considered with complete regard of mind, they would, I think, lead the meditator to a (new) state. To him who searches for it from the bottom of the heart and with the marrow of his being, many unhoped-for steps would take place by which he would receive new compassion, new love, new solace, and then a new condition of sweetness that would seem to him a promise of glory. I, as an ignorant person and a stammerer, believe that in attaining this state it is therefore necessary to be directed by the whole light of the mind, by the eyes of the watchful heart, having left all the other extraneous cares that man keeps for himself for all those things that occur around this Passion and Crucifixion of the Lord, by desire, wisdom, and perseverance, not with slothful eyes or with omissions or with tedium of the soul. Therefore I exhort you that, if you have studiously considered the things said

above on His life, you much more diligently concentrate the whole spirit and all the virtues, for here is shown more especially this charity of His that should kindle all our hearts. Therefore take all the things, that is, what can be as piously meditated as I think I am telling you, with the accustomed meditation. I do not intend to affirm anything in this little book that is not asserted or said by Holy Scripture or the word of the saints or by approved opinion. It appears to me that one can say not improperly that not only that penal and mortal Crucifixion of the Lord, but also that suffering that went before, is cause for strong compassion, bitterness, and stupor. What should we think that our Lord, blessed God above all things, from the hour of His capture at night until the sixth hour of His Crucifixion, was in a continuous battle, in great pain, injury, scorn, and torment, that He was not given a little rest! But in what battle is He tormented? You will hear (and see). One of them seizes Him, (this sweet, mild, and pious Jesus,) another binds Him, another attacks Him, another scolds Him, another pushes Him, another blasphemes Him, another spits on Him, another beats Him, another walks around Him, another questions Him, another looks for false witnesses against Him, another accompanies the one that searches, another gives false testimony against Him, another accuses Him, another mocks Him, another blindfolds Him, another strikes His face, another goads Him, another leads Him to the column, another strips Him, another beats Him while He is being led, another screams, another begins furiously to torment Him, another binds Him to the column, another assaults Him, another scourges Him, another robes Him in purple to abuse Him, another places the crown of thorns, another gives Him the reed to hold, another madly takes it away to strike His thorn-covered head, another kneels mockingly, another salutes Him as king. These and many similar things were done to Him, not just by one but by many. He is led back and forth, scorned and reproved,

turned and shaken here and there like a fool and an imbecile; like a thief and a most evil malefactor He is led now to Annas, now to Caiaphas, now to Pilate, now to Herod, and again to Pilate, now in, now out. O my God, what is this? Does this not seem a most hard and bitter battle? But wait a while and you will hear harsher things.[205] The chiefs, the Pharisees, the greatest and best[206] of the people are strongly and ardently opposed to Him, and it is exclaimed by all in unison that He be crucified, which is agreed to by the judge, and it is sentenced that He be crucified and given to the horsemen to be crucified and led by them through the city like the crucified; the cross on which He is crucified is placed on His already broken and lacerated shoulders. From every side they draw citizens and strangers, the highest as well as any vile, scurrilous drunkard, not to pity Him but to mock Him. There is no one that recognizes Him, but they cover and afflict Him with mire and scum. And while He bears His abuse, the word is done. Those who sit at the gate spoke against Him and those who drink wine sang about Him (cf. Psalm lxviii, 12–14). He is pushed and anguished, afflicted and pulled, and exhausted, and scourged, and soaked, and completely sated by infamy; He is not given rest, not once, and hardly could His spirit rest until He reached the place of Calvary—a most ugly and evil-smelling place; and all these things were done with great noise and furor. In that place there is put an end to the battle we have described, and quiet comes. But what is that quiet? Crucifixion and a bed of sorrows. Behold, this is a repose more severe than the battle. You see thus that until the sixth hour He sustained a long, hard, and continuous battle. Truly the waters entered into His soul, and truly was He surrounded by many terrible and ferocious dogs, and verily was He besieged by the counsel and council of the malignants (Psalm xxi, 17), who cruelly cut Him by tongue and by hands, as with a knife with two blades. With these things that I have mentioned, the Passion

of the Lord seems summarily set forth and completed, so to speak, in the first three hours up to the sixth, that is, the first and third morning hours. But this is not so. One cannot so lightly treat so much bitterness and suffering of our Lord Jesus, for which reason you must again see (and attend). Great and much consideration is upon us, penetrating and pious, while, as is said, you are present at these things. These are generalized. Now we shall see each event individually, with great industry. We must not be repelled at the thought of those things that our Lord Jesus did not hesitate to bear to redeem us and rescue us from the hands of our old enemy.

(LXXV. *Meditation on the Passion of Christ Before the Morning*— MATT. xxvi, MARK xiv, LUKE xxii)

Therefore take up this meditation from the beginning of the Passion and follow it in order to the end, and I shall touch on matters as they seem to me and as our material requires. But delight yourself as you please in the greater and more beautiful and lofty things, and with so much effect and so much love as did our precious master, Saint Francis, and also as our Lord Jesus will give you the grace to do. Heed all these things as though you were present, and watch Him attentively as He rises from the Supper at the end of the sermon and goes to the garden with His disciples, to be accompanied by them on His last journey. How affectionately, comradely, and familiarly He speaks to them and exhorts them to prayer! How He departs from them a short way, that is, a stone's throw, and prays to the Father, kneeling humbly and reverently! Tarry here a little and examine the marvelous things of your Lord with pious mind.

286
287 Now the Lord Jesus remains in prayer. From here on, one reads that He prayed several times, but for us, as our advocate, while now He prays for Himself. Have compassion for
288 Him and marvel at His most profound humility. Although He
320

is God and equal to His Father and co-eternal, He appears to have forgotten that He is God and prays like a man. Like any other little man of the people He prays to God. Consider again His most perfect obedience, for to whom does He pray? Surely He prays to the Father that, if it please Him, He should not die, and He divulges this to the Father, and it is not granted, according to one will that I say was in Him. He possessed different kinds of will, as I already said. Here too have compassion. The Father wishes Him to die in the end and, although He is His own Son, He does not spare Him, but gives Him for all of us. So greatly did He love the world that He gave His only Son to it (John iii, 16). The Lord Jesus receives this obedience and reverently carries it out. Thus also in the third place is shown the unutterable charity of the Father as well as of the Son, most worthy of compassion, admiration, and veneration. This death is commanded and sustained for us by their great charity. The Lord Jesus addresses a long prayer to the Father, saying, "My Father, most merciful, I beg you to grant my prayer and not to scorn my request. Listen to me and answer my prayer (Psalm liv, 3), for I am saddened in my action and anguished is my spirit and agitated my heart. Incline your ear to me and listen to the voice of my prayer. It pleased you, Father, to send me into the world that I might give satisfaction for the injury done to us by man, and as you wished I immediately said, 'Behold, I go,' and as is written of me at the beginning of the book, that I do your will, so I desired and announced your truth and your salvation. I have been poor and in affliction from my youth (Psalm lxxxvii, 16) in complying with your wish and I have done everything you commanded. I am ready to fulfill what remains. But, O my Father, if it be possible, remove this great bitterness that is in store for me from my adversaries. See how many things are evilly planned against me. How many and what great falsehoods are attributed to me, for which they have counseled to take my soul! But,

holy Father, if I have done those things, if it be iniquity in my hands (Psalm vii, 4), yet always, always have I done what was to please you (John viii, 29). They have faced me with bad things for good, hate for love (Psalm cviii, 5). They have corrupted my disciple and made him the guide for betraying me and they took my price in thirty silver denars, for which I am valued by them (cf. Zech. xi, 12). I pray you, therefore, to lift this chalice, that is, this Passion, from me. But if it appear otherwise to you, then let not my but your will be done. But rise to help me; hasten, Father, to my aid. O most gentle Father, although they may not know that I am your Son, yet, since I have led an innocent life with them and have rendered them many benefits, they should not be so cruel to me. Remember that I have been in your sight to speak well for them, and you lifted your anger from them. Now they have returned evil for good. Certainly they have excavated a pit for my soul (Jer. xviii, 20) and have prepared a most foul death for me. O Lord, you see these things. Do not remain silent, do not leave me (Psalm xxxiv, 22), for I am near the trial and have no one to help me (Psalm xxi, 12). Those that torment me are close in your sight (Psalm lxviii, 21) and are looking for my soul. Disgrace and misery await my heart." When the Lord Jesus returned to His disciples, He awakened them and exhorted them to prayer. He returned to praying a second and a third time, that is, in three different places removed from each other the distance of a stone's throw, not as when the arm is violently agitated, but as when the stone is thrown without great force, (perhaps the length of our house). And as I have it from one of our brothers who was there, all these places still show the traces of the churches that were built there. When He returned to prayer, as I have said, a second and a third time, he repeated the same sermon and added, "Just Father, if you have thus judged that after all I am to undergo the suffering of the cross for mankind, may your will be done; but I recom-

289

322

mend my most beloved mother to you, and the beloved disciples whom I have up to now guarded when I was with them. My Father, keep them from evil." And meanwhile His most consecrated blood dripped copiously from all parts of His body in the manner of sweat abounding in this agony or battle; while He prays long, it flows abundantly to the ground.

Consider how anguished He is now in His soul. Also note here, in contrast to our impatience, that the Lord Jesus prayed three times before He received any answer.

As Jesus was thus praying and sweating blood, behold, there came the angel of God, the prince Michael, and stood before the Lord Jesus comforting Him and saying, "God save you, my Lord God, Jesus! I have taken your prayer and sweat of blood to your Father before the whole supernal court, and, all kneeling, we have prayed humbly that this chalice be lifted from you. The Father replied, 'My most beloved Son knows that the redemption of mankind, which we so desire, cannot be accomplished properly without the shedding of His blood; consequently, if He wishes the salvation of souls, He must die for them.' Therefore I would know what you have decided to do." Then the Lord Jesus replied to the angel, "I wish above all and finally the salvation of souls; and therefore I choose rather to die, that the souls of those whom my Father created in His image may be saved, than that I do not die and the souls not be redeemed. Therefore let the will of my Father be done." The angel said to Him, "Be comforted and act vigorously: it is suitable for the Highest to do the greatest things and for the man of great soul to sustain evil things powerfully. Painful things will pass quickly and glorious things will follow perpetually. The Father says that He is always with you and that He will protect your mother and the disciples and return them safe and sound." And the humble Lord reverently and simply received this comfort, even from His own creature, considering Himself to be lessened a little by

290

291

323

the angel as long as He was in this valley of tears. And since He was saddened as a human, so He was comforted by the words of the angel as a human. Then the angel bade farewell to the Lord Jesus, who prayed that he commend Him to the Father and the whole celestial court. He arose from the third time of prayer all bathed in blood. See Him carefully as He dries His face, or perhaps He washed it in the stream, and keep Him in mind, deeply afflicted, and intimately pity Him, for this could not happen without great bitterness of sorrow.

But the wise men and commentators say that the Lord Jesus prayed to the Father not so much in fear of undergoing the suffering as in pity for the first people, for He sympathized with the Jews that were lost by His death. They should not have killed Him, for He was one of them and had obeyed their law and had done them such great benefits. Therefore He prayed to the Father (for the salvation of the Jews), saying, "If one could make the multitude of people believe and yet save the Jews, I refuse and reject the Passion; but if the Jews are to be blinded that the others may see, then let not my will but yours be done." Thus there were four wills in Christ: the will of the flesh, and this by no means wished to suffer the pain; the will of the senses, and this complained and feared; the will of reason, and this obeyed and consented—according to Isaiah, He was offered because He wished (Isa. liii, 7); and there was in Him the will of divinity, and this commanded and dictated the sentence. Therefore, since He was a real man and placed in great anguish as a man, pity Him as intimately as possible. Consider and see with perseverance all the actions and afflictions of your Lord. Following these events, He goes to the disciples and says to them, "Sleep and rest yourselves" (Matt. xxvi, 45; Mark xiv, 41). They slept in that place, but the good Shepherd stayed awake to watch over His little flock. O great love!—He truly loved

them to the end, since He provided rest for them although He was in such agony. He saw His adversaries approaching from a distance with lighted torches and arms, but He did not wake the disciples until they were near and almost beside them. Then He said to them, "You have slept enough. Here comes the one who betrayed me."

Even as He spoke, that wicked man, Judas, most evil merchant, came before the others and kissed Him. It is said to have been the custom of the Lord Jesus to receive disciples He had sent out with a kiss on their return. Therefore the traitor gave the kiss as the sign. Preceding the others, he returned with a kiss, almost as though to say, "I have not come with these soldiers but, returning, I kiss you according to custom and say, 'Ave Rabbi, God save you, Master.' " O real traitor! Pay careful attention and follow the Lord as He patiently and benignly receives the treacherous embraces and kisses of that wretch whose feet He had washed but a short time before and to whom He had given the supreme food. How patiently He allows Himself to be captured, tied, beaten, and furiously driven, as though He were an evil-doer and indeed powerless to defend Himself! How He even pities His fleeing and errant disciples! And see also their grief as, unnerved, sorrowfully weeping and lamenting like orphans, and frightened by fear, they leave; and their sorrow grows greater as they see their Lord so miserably led away, (dragged by these dogs to the sacrifice, and almost like a lamb, unresistingly, following them. See) how He is led by those wicked ones from the stream toward Jerusalem, hastily and with anxiety, with hands tied behind His back, His mantle removed, His dress in disorder, head uncovered, bowed by the effort, and going at great speed. When He is presented to the chief (priests, Annas and Caiaphas,) and the (other) elders who were gathered together, they rejoice like lions that have taken their prey. Now they examine Him and procure false witnesses. . . .[207]

<div align="right">

292
293

294

295

296

</div>

... who condemn Him and spit on His most sacred face, blindfold Him, smite Him, strike Him, saying, "Prophesy, who is it that struck you?" (Luke xxii, 64) and afflict Him with many insults; and in everything He bore Himself patiently. See Him in each event and have compassion.

Then the elders departed, putting Him in a kind of prison there beneath the terrace, remains of which can still be seen. There they bound Him to a stone column, of which afterwards a part was broken away: it is preserved to this day, as I know from a brother of ours, who saw it. In addition, they left certain soldiers as a protective guard, who for the whole remaining night afflicted Him with scorn and empty curses. Observe, therefore, as He is reviled by these insolent and wicked men, who say, "Do you believe yourself to be better and wiser than our chief priests? What folly! You ought not to open your mouth against them. How can you do such things? Now your wisdom appears, so that you stand as is only suitable to you: you undoubtedly deserve death, and you shall have it." And thus for the whole night, sometimes one, sometimes another insulted Him in word and deed. Can you believe how much these mercenaries said and did? They insulted Him indiscriminately and irreverently with the vilest taunts. See the Lord shamefacedly and patiently remaining silent to all, as though captured in crime, with downcast eyes, and feel ardent compassion for Him. O Lord, into whose hands have you fallen! How great is your patience! Truly this is the hour of darkness.

And thus He stands erect bound to this column until the dawn. Meanwhile, however, John goes to the Lady and her companions gathered in the house of the Magdalen, where they had the Supper, and tells of everything that happened to the Lord and the disciples. Then there is unspeakable grief, lamentation, and crying. See them and have compassion on them, for they are in the greatest affliction and most violent sorrow for their beloved Lord, because they

now clearly see and believe that the Lord is to die. At length the Lady draws apart and turns to prayer, saying, "Most reverend Father, most pious Father, most merciful Father, I recommend to you my most beloved Son. You will not treat Him cruelly, for you are good to everyone. Eternal Father, is my Son Jesus to die? He has done no evil. But, just Father, if you wish the redemption of mankind, I implore you to effect it in another way, for all things are possible to you. I beg you, most holy Father, if it please you, let my Son Jesus not die. Free Him from the hands of sinners and give Him back to me. Out of obedience and reverence to you, He does not help Himself. He abandons Himself and seems feeble and helpless. Therefore, Lord, help Him!" The Lady prayed in these and similar words with all her feelings and mind and with great bitterness in her heart. Have compassion now for her whom you see thus afflicted.

L X X V I. *Meditation on the Passion of Christ at the First Hour*

Early in the morning, the chiefs and elders of the people returned and had His hands tied behind His back, saying, "Thief, come with us; come to judgment. Today your evil deeds are to be fulfilled; now your wisdom shall appear." And they led Him to Pilate; and He followed them as if He were a criminal, He who was the most innocent Lamb. When His mother, John, and her companions—for these had gone outside the walls at dawn in order to come to Him —met Him at the crossroads and saw Him thus vitupera-tively and outrageously led by such a multitude, they were filled with more sorrow than can be expressed. Moreover in this meeting there was the most vehement grief on both sides, for the Lord was deeply moved by His compassion for His own, and especially for His mother. He knew that they grieved on His account until their souls were torn from their bodies. Consider and contemplate each thing

diligently: there are certainly very many, indeed very great causes for compassion.

He is led, then, to Pilate; and these women who cannot draw near follow at a distance. At this time He was accused by them of many things; and Pilate sent Him to Herod. Herod, longing in truth to see miracles performed by Him, rejoiced; but was unable to obtain a miracle or even a word. Therefore, thinking Him a fool, in derision he had Him dressed in white, and sent Him back to Pilate. Thus you see how He was regarded by everyone not only as a criminal but as a fool; but He bore everything most patiently. Look at Him again while He is led hither and thither with downcast gaze and shamefaced walk, hearing all the shouts, insults, and mockeries, perchance struck by a stone or enduring indecencies and filth. See also His mother and the disciples standing apart in unspeakable sorrow and then following Him as He is brought back to Pilate. Those dogs prosecute their accusations with great audacity and constancy; but Pilate, not finding cause for death in Him, tried to release Him. Thus he said, "I will chastise Him and release Him." O Pilate! Do you castigate your Lord? You do not know what you are doing, for He deserves neither death nor scourges. You would act rightly if you chastised yourself at His bidding. However, he orders Him most harshly scourged.

The Lord is therefore stripped and bound to a column and scourged in various ways. He stands naked before them all, in youthful grace and shamefacedness, beautiful in form above the sons of men, and sustains the harsh and grievous scourges on His innocent, tender, pure, and lovely flesh. The Flower of all flesh and of all human nature is covered with bruises and cuts. The royal blood flows all about, from all parts of His body. Again and again, repeatedly, closer and closer, it is done, bruise upon bruise, and cut upon cut, until not only the torturers but also the

spectators are tired; then He is ordered untied. The *Historia* says that the column to which He was bound shows the traces of His bleeding.[208] Here, then, consider Him diligently for a long time; and if you do not feel compassion at this point, you may count yours a heart of stone. Now is fulfilled what Isaiah the prophet said. "We saw Him," he says, "and there was no beauty, and we thought of Him as a leper and one humiliated by God" (Isa. liii, 2, 4). O Lord Jesus! Who was so audacious and so bold as he who stripped you? And who was the more audacious one who bound you? But who was the most audacious one who scourged you so cruelly? But you, Sun of Justice, withheld your rays, and therefore the darkness came, and the power of darkness. All are more powerful than you. Your love and our sin made you feeble. Cursed be such sin, for which you are so afflicted!

Releasing the Lord from the column, they led Him thus naked and beaten through the house, seeking His clothes, which had been cast aside in the house by those who had despoiled Him. See Him thus harshly afflicted and trembling most severely, for it was very cold, as the Gospel says (John xviii, 18). When He wished to clothe Himself again, some most impious men contended with Him, saying to Pilate, "Lord, here He made Himself king. Let us clothe Him and crown Him with kingly honor." And taking a sort of robe of dirty red silk, they clothed Him; and they crowned Him with thorns. Look at Him in each of His actions and afflictions, for He does and endures all that they wish. He bears the purple; He wears the crown of thorns on His head; He carries the reed in His hand; and He holds His peace and most patiently remains silent before those who bow and salute Him as king. Look at Him now in bitterness of heart, especially at His head, full of thorns, often struck by the reed. And see how, with bent neck, He painfully receives the sharp and heavy blows. For those sharpest of thorns pierced His most sacred head until they

329

made it run with blood. O wretches! How terrible that royal head that you are striking now will appear to you yet! They mocked Him as though He wished to rule but did not have the power. He bore all things, for their cruelty was excessive. Indeed, not only did He endure their gathering together the whole company for great mockery, but also their leading Him before Pilate and all the people to mock Him publicly, wearing the crown of thorns and the purple robe. Behold Him now, for God's sake, how He stands with face bowed toward the ground before the multitude shouting and crying, "Crucify Him," and moreover deriding and insulting Him as though they were wiser than He; and how He seems to have acted foolishly toward the chiefs and Pharisees who had Him taken and who lead Him to such an end. Thus He received not only pain and punishment from them, but disgrace as well.

LXXVII. *Meditation on the Passion of Christ at the Third Hour*

Then the whole multitude of Jews demands that He be crucified; and thus He is condemned by Pilate, the miserable judge. His benefits and works are not remembered by them, nor are they moved by His innocence; and what is most cruel to see is that they are not drawn back by the afflictions they have already caused Him; but the chiefs and elders rejoice that their wicked intentions have been accomplished. They laugh and mock at Him who is the true and eternal God, and hasten His death. He is led back inside, stripped of the purple, and stands before them nude, not given leave to reclothe Himself. Pay diligent attention to this and consider His stature in every part. And to make yourself more deeply compassionate and nourish yourself at the same time, turn your eyes away from His divinity for a little while and consider Him purely as a man. You will see a fine youth, most noble and most innocent and most lovable, cruelly beaten and covered with blood and wounds,

gathering His garments from the ground where they were strewn and dressing Himself before them with shame, reverence, and blushes however much they jeer, as though He were the meanest of all, abandoned by God, and destitute of all help. Look at Him diligently, therefore, and be moved to pity and compassion: now He picks up one thing, now another, and dresses Himself before them. Next return to His divinity and consider the immense, eternal, incomprehensible, and imperial Majesty incarnate, humbly bowing down, bending to the ground to gather His garments together, dressing Himself with reverence and blushes as if He were the vilest of men, indeed the servant under their domination, corrected and punished by them for some crime. Look at Him diligently and admire His humility, again having compassion on Him for the considerations you held when He was tied to the column and beaten so excessively. When He is clothed they lead Him outside, so as not to postpone His death any longer, and then place on His shoulders the venerable wood of the long, wide, very heavy cross, which the most gentle Lamb patiently takes and carries. As it is told in the *Historia*, the cross of the Lord is supposed to have been fifteen feet high.[209] Then He is led and hurried and saturated with taunts, as told above at the beginning of the events of the morning. Moreover He was led outside with His companions, the two thieves. Behold, this is His company! O good Jesus! How much shame these friends of yours cause you! They associate you with thieves, yet make you their inferior, for they impose on you the carrying of the cross, which we do not read was done to the thieves. Thus you are not only "numbered with sinners," according to Isaiah (Isa. liii, 12), but as more sinful than sinners. Your patience, Lord, is indescribable.

Look at Him well, then, as He goes along bowed down by the cross and gasping aloud. Feel as much compassion for Him as you can, placed in such anguish, in renewed derision. And because His sorrowful mother could not

331

approach Him or even see Him, on account of the multitude of people, she went with John and her companions by another, shorter road, so that, preceding the others, she could draw near to Him. When, however, outside the gate of the city, at a crossroads, she encountered Him, for the first time seeing Him burdened by such a large cross, she was half dead of anguish and could not say a word to Him; nor could He speak to her, He was so hurried along by those who led Him to be crucified. But after going a little farther on, the Lord turned to the weeping women and said to them, "Daughters of Jerusalem, do not weep for me but for yourselves" etc., as is more fully related in the Gospel (Luke xxiii, 28). And in these two places there are the remains of churches that were built there within the memory of man, as I heard from a brother of ours who saw them. He also said that Mount Calvary, where Christ was crucified, was as far from the gate of the city as our place is from the Gate of Saint Germanus. Therefore the carrying of the cross took excessively long. When they had gone a bit farther, and He was so tired and broken that He could not carry it any longer, He laid down the cross. Those wicked ones, however, unwilling to defer His death, fearing that Pilate might revoke His sentence—for he had shown a wish to dismiss Him—had someone else carry the cross, thereby releasing Him; and they led Him bound, like a thief, to the place of Calvary. Do not the events that took place at matins and the first and third hours appear to you to be most vehement and bitter sorrows, and exceedingly shocking horrors, even without the Crucifixion? I certainly consider them as such, and as reasons for compassion and most intense feelings. This seems to complete what there is to say at the present time about these three hours. Let us now see what happened at His Crucifixion and death, that is to say, at the sixth and ninth hours; then we shall see what happened after His death, that is, at the hours of vespers and compline.

When the Lord Jesus, led by impious men, reached that foul place, Calvary, you may look everywhere at wicked people wretchedly at work. With your whole mind you must imagine yourself present and consider diligently everything done against your Lord and all that is said and done by Him and regarding Him. With your mind's eye, see some thrusting the cross into the earth, others equipped with nails and hammers, others with the ladder and other instruments, others giving orders about what should be done, and others stripping Him. Again He is stripped, and is now nude before all the multitude for the third time, His wounds reopened by the adhesion of His garments to His flesh. Now for the first time the Mother beholds her Son thus taken and prepared for the anguish of death. She is saddened and shamed beyond measure when she sees Him entirely nude: they did not leave Him even His loincloth. Therefore she hurries and approaches the Son, embraces Him, and girds Him with the veil from her head. Oh, what bitterness her soul is in now! I do not believe that she could say a word to Him: if she could have done more, she would have, but she could not help Him further. The Son was torn furiously from her hands to the foot of the cross.

Here pay diligent attention to the manner of the Crucifixion. Two ladders are set in place, one behind at the right arm, another at the left arm, which the evil-doers ascend holding nails and hammers. Another ladder is placed in front, reaching to the place where the feet are to be affixed. Look well now at each thing: the Lord Jesus is compelled to ascend the cross by this small ladder; without rebellion or contradiction He humbly does what they require. When He reaches the cross, at the upper part of this small ladder, He turns Himself around, opens those royal arms, and, extending His most beautiful hands, stretches them up to

His crucifiers. He looks toward heaven, saying to the Father, "Behold, I am here, my Father. For love and the salvation of mankind you wished me humbled as far as the cross. It pleases me; I accept; and I offer myself to you for those whom you gave to me, wishing them to be my brothers. Therefore, Father, accept, and for love of me be pleased to wipe away and remove all the old stains from them: I offer myself to you for them, Father." Then he who is behind the cross takes His right hand and affixes it firmly to the cross. This done, he who is on the left side takes His left hand and pulls and extends it as far as possible, puts in another nail, drives it through, and hammers it in. After this, they descend from the ladders, and all the ladders are removed. The Lord hangs with the weight of His body pulling Him down, supported only by the nails transfixing His hands. Nevertheless, another one comes and draws Him down by the feet as far as he can, and while He is thus extended, another most cruelly drives a nail through His feet. There are, however, those who believe that He was not crucified in this manner, but that the cross was laid on the ground and that they then raised it up and fixed it in the ground. If this suits you better, think how they take Him contemptuously, like the vilest wretch, and furiously cast Him onto the cross on the ground, taking His arms, violently extending them, and most cruelly fixing them to the cross. Similarly consider His feet, which they dragged down as violently as they could.

Behold, the Lord Jesus is crucified and extended on the cross so that each of His bones can be numbered, as He complained by the prophet (Psalm xxi, 18). On all sides, rivers of His most sacred blood flow from His terrible wounds. He is so tortured that He can move nothing except His head. Those three nails sustain the whole weight of His body. He bears the bitterest pain and is affected beyond anything that can possibly be said or thought. He hangs between two thieves. Everywhere are torments, everywhere injuries, everywhere abuses. For though He is in such

anguish, they do not refrain from abuse. Some blaspheme, saying, "Ah! You who destroy the temple of God," or "Himself He cannot save." Others make abusive remarks: "If He be the Son of God, let Him descend from the cross, that we may believe in Him" (Matt. xxvii, 40, 42). And the soldiers that crucified Him divided His clothing for themselves in His presence.

And all this is said and done in the presence of His most sorrowful mother, whose great compassion adds to the Passion of her Son, and conversely. She hung with her Son on the cross and wished to die with Him rather than live any longer. Everywhere are tortures and torments that can be sensed but in truth hardly described. The mother stood next to His cross, between the crosses of the thieves. She did not turn her eyes away from her Son; she was in anguish like His; and with her whole heart she prayed to the Father, saying, "Father and eternal God, it pleases you that my Son should be crucified: it is not the time to ask Him back from you. But you see what anguish His soul is in now: therefore I beg you to lessen His suffering, if it please you. Father, I recommend my Son to you." And the Son similarly prayed to the Father for her and silently said, "My Father, see how afflicted my mother is. I ought to be crucified, not she, but she is with me on the cross. It is enough that I, who bear the sins of all the people, am crucified; she does not deserve the same. See how desolate she is, consumed with sadness all the day. I recommend her to you: make her sorrow bearable." Near the cross, with the Lady, there were also John and the Magdalen, and the Lady's two sisters, that is, Mary Jacobi and Salome, and perhaps others as well, all of whom, especially the Magdalen, beloved disciple of Jesus, wept vehemently, nor could they be comforted for their beloved Lord and Master. They suffered for the Lord and the Lady, and for each other. Their sorrow was often renewed, for their compassion was renewed whenever abuses or deeds added anew to the Passion of their Lord.

LXXIX. *Meditation on the Passion of the Lord
at the Ninth Hour*

While He was hanging on the cross, however, until the departure of His spirit, the Lord was not idle, but did and taught useful things for us. From there He spoke the seven words that are found written in the Gospel.

The first was during the act of His Crucifixion, when He prayed for His crucifiers, saying, "Father, forgive them, for they do not know what they are doing" (Luke xxiii, 34), which word gives a token of great patience and great love, and indeed came of indescribable charity.

The second was to the mother, when He said, "Woman, behold your son," and to John, "Behold your mother" (John xix, 26, 27). He did not call her "mother," in order that the tenderness of vehement love might not grieve her the more.

The third was to the penitent thief, when He said, "To-day you shall be with me in Paradise" (Luke xxiii, 43).

The fourth was, "Eli, Eli, lamma sabacthani?" This is, "My God, my God, why have you forsaken me?" (Matt. xxvii, 46), as if He said, "Father, you loved the world so much that, while you delivered me up for it, you seem to have forsaken me."

The fifth was when He said, "I am thirsty" (John xix, 28), in which word there was the great compassion of the mother and her companions, and John, and the great pleasure of those wicked men. Now one could show that He was thirsty for the salvation of souls; yet in truth He thirsted because He was inwardly drained by loss of blood, and was dried out. And when those wretches were unable to think how they could injure Him further, they found a new manner of ill-treating Him and gave Him vinegar mixed with gall to drink. Cursed be their fury, for it was persistent; and they did as much harm as they could.

The sixth word was, "It is consummated" (John xix, 30), as if He said, "Father, I have completed perfectly the

336

obedience that you imposed on me. Yet, Father, whatever you still wish, command of me, your Son. I am ready for whatever remains to be fulfilled. 'For I am ready for the scourge' (Psalm xxxvii, 18). But all that is written about me is consummated. If it please you, Father, call me back to you now." And the Father said to Him, "Come, my most beloved Son. You have done everything well. I do not wish you to be troubled any further. Come, for I will receive you to my breast and embrace you." And from that time on, He began to weaken, in the manner of the dying, now closing His eyes, now opening them, and bowing His head, now to one side, now to the other, all His strength failing.

At length He added the seventh word, with a loud cry and tears, saying, "Father, into your hands I commend my spirit" (Luke xxiii, 46). And saying this, He sent forth His spirit: with His head bowed on His breast toward the Father, as though giving thanks that He had called Him back, He gave up His spirit. At this cry, the Centurion that was there was converted, and said, "Truly this was the Son of God" (Matt. xxvii, 54) on hearing that He expired with a loud cry; for other men, when dying, are not able to cry out; therefore he believed in Him. So great was that cry that it was heard even in Hell. Oh, what was the soul of the mother like, then, when she saw Him thus painfully weaken, faint, weep, and die! I believe that either she was so absorbed by the multitude of her sorrows as to be insensible or was half dead, now even more so than when she met Him carrying the cross. What did the faithful Magdalen, the beloved disciple, what did John, beloved above all, what did the other two sisters of the Lady, do now? What could they do, filled with bitterness, overwhelmed with sorrow, drunk with wormwood? Everyone wept unconsolably. Behold, then, the Lord hangs dead on the cross; the whole multitude departs; the most sorrowful mother remains with those four. They seat themselves near the cross, contemplating their Beloved, looking for help from

the Lord as to how they can take Him down and bury Him. But you, if you will contemplate your Lord well, will consider that from the sole of His foot to the crown of His head there is no health in Him: there is not one member or bodily sense that has not felt total affliction or passion. Therefore you have His Crucifixion and death, the events of the sixth and ninth hours that appear at the present time, written according to my modest means and your inexperience. Study devoutly, faithfully, and solicitously to meditate on all this. Now we shall speak of what happened after His death.

L X X X. *Of the Opening in the Side of Christ*

While our reverend Lady Mary, as well as John, the Magdalen, and the sisters of the mother of the Lord, remained, sitting to one side of the cross, unceasingly observing the Lord Jesus hanging thus on the cross between the thieves, naked, afflicted, dead, deserted by all, behold, many armed men came toward them from the city, sent to break the legs of the crucified, to kill and bury them, so that no body should remain hanging on a cross on the great day of the sabbath. Then the Lady and all of them rise and look up and see them, and they do not know what is happening. Their sorrow is renewed and their fear and trembling increase. Indeed, the mother is much afraid and does not know what might happen and, turning toward her dead Son, says, "My most beloved Son, why do these men return? What more do they wish to do to you? Have they not killed you? My Son, I believed them to be satisfied with you, but I see that you are persecuted even after death. My Son, I do not know what to do. I could not defend you from death, but I shall come and stand at your feet near your cross. My Son, beg your Father to make them gentle with you. I too shall do what I can." And then all five come weeping and place themselves before the cross of the Lord Jesus. The men approach with great fury and

noise and, seeing the thieves still alive, break their legs and kill them, and take them down and throw them hastily into some ditch. As they came back to the Lord Jesus, however, the mother, fearing that they would do the same to her Son, moved by the inward sorrow of her heart, thought of her usual weapon, that is, her innate humility. And down on her knees, arms crossed, with tear-stained face and hoarse voice, she addressed them, saying, "Men, brothers, I beg you in the name of God the most high, do not wish to injure me further in my most beloved Son. For I am His most sorrowful mother, and you know, brothers, that I have never offended you or injured anybody. And if my Son seemed to be opposed to you, you have killed Him; and I forgive you for all injuries and offenses and the death of my Son. Have mercy upon me and do not strike Him; let me at least bury Him whole. It is not necessary that His legs be broken, for you see that He is already dead and departed." For this was after He had gone. John, the Magdalen, and the sisters of the mother of the Lord stayed kneeling with her, and all wept most bitterly. O Lady, what are you doing? You stay at the feet of the most wicked of men; you pray to the inexorable. Do you think that pity will move the cruellest and most impious, and humble the proud? Humility is an abomination to the proud: you labor in vain. One, moreover, Longinus by name, then impious and proud, though later converted, a martyr and saint, extending his lance from a distance, scorning their prayers and entreaties, opened a great wound in the right side of the Lord Jesus; and blood and water came forth. Then the mother, half dead, fell into the arms of the Magdalen. John, urged on by sorrow, took action and rose against them, saying, "Most wicked men, why do you do these impious things? Can you not see that He is dead? Do you wish to kill His most sorrowful mother? Go away, for we shall bury Him." Then as it pleased God, the men departed. The Lady was aroused, getting up as if awakening,

asking what was done to her beloved Son. They answered, "Nothing was done to Him." After that, she sighed and was grieved, and, looking at the wounds of her Son, was weakened by the sorrow of death. Do you see how often she is near death today? Certainly as often as she saw new things done against her Son. In truth there was fulfilled in her what Simeon had said to her. "Your own soul," he said, "will be transfixed by a sword" (Luke ii, 35). For now, truly, the sword of that lance pierced the body of the Son and the soul of the mother. Then they all return and sit down near the cross, not knowing what they ought to do. For they cannot take the body down and bury it, because they do not have enough force, nor implements with which they might lower Him. Thus they remain, not daring to depart, yet unable to remain long, with night approaching. You see what perplexity they are in. O benign God, how do you permit your own, chosen of all women, mirror of the world and our resting-place, to be thus tried? However, it was time for a little relief.

LXXXI. *The Hour of Vespers; Meditation*

Again they see many others coming along the road. They were Joseph of Arimathea and Nicodemus, bringing others with them, and carrying implements with which to take down the body from the cross; and they brought about a hundred pounds of myrrh and aloes, for they were coming to bury the Lord. Then they all rise up in great fear. O God, how great is their affliction today! Looking around, however, John said, "I recognize Joseph and Nicodemus there." Then the Lady, recovering strength, says, "Blessed be our God, who sends us help; He was mindful of us and does not abandon us. Son, run to meet them." Therefore John went toward them quickly, and when he met them, they embraced each other with great weeping. For an hour they

were unable to speak to each other, from the tenderness of their compassion and the abundance of weeping and sorrow: afterwards they come before the cross. Joseph asks who are here with the Lady and what has become of the other disciples. John tells him who are here, but that he does not know about the others, because they have not been here today. He also asks what went on concerning the Lord, and John tells him each event. When they reached the place, they adored the Lord, genuflecting and weeping. Then, approaching, they were reverently received by the Lady and her companions, bending the knee and bowing to the ground. These too genuflecting, with great crying, they remained thus a long while. At length the Lady says, "You do well in keeping the memory of your Master, because He loved you very much; and I admit that the sight of your coming has brought new light to me. For we did not know what we should do. The Lord reward you!" And they say, "We grieve with our whole heart for all that was done against Him, for the impious prevailed against the Just. We would gladly have delivered Him from so much injustice had we been able to. At least we shall be responsible for this little service to our Lord and Master." Rising, therefore, they prepared to take down the body of Jesus.

You, however, as I have told you elsewhere, attend diligently and carefully to the manner of the Deposition. Two ladders are placed on opposite sides of the cross. Joseph ascends the ladder placed on the right side and tries to extract the nail from His hand. But this is difficult, because the long, heavy nail is fixed firmly into the wood; and it does not seem possible to do it without great pressure on the hand of the Lord. Yet it is not brutal, because he acts faithfully; and the Lord accepts everything. The nail pulled out, John makes a sign to Joseph to extend the said nail to him, that the Lady might not see it. Afterwards Nicodemus extracts the other nail from the left hand and similarly

gives it to John. Nicodemus descends and comes to the nail in the feet. Joseph supported the body of the Lord: happy indeed is this Joseph, who deserves thus to embrace the body of the Lord! Then the Lady reverently receives the hanging right hand and places it against her cheek, gazes upon it and kisses it with heavy tears and sorrowful sighs. The nail in the feet pulled out, Joseph descends part way, and all receive the body of the Lord and place it on the ground. The Lady supports the head and shoulders in her lap, the Magdalen the feet at which she had formerly found so much grace. The others stand about, all making a great bewailing over Him: all most bitterly bewail Him, as for a first-born son.

LXXXII. *The Hour of Compline*

After some little time, when night approached, Joseph begged the Lady to permit them to shroud Him in linen cloths and bury Him. She strove against this, saying, "My friends, do not wish to take my Son so soon; or else bury me with Him." She wept uncontrollable tears; she looked at the wounds in His hands and side, now one, now the other; she gazed at His face and head and saw the marks of the thorns, the tearing of His beard, His face filthy with spit and blood, His shorn head; and she could not cease from weeping and looking at Him. It is to be read in a certain writing that the Lord revealed to one of His devoted ones that His head was shorn and His beard torn; but the evangelists have not described everything. And indeed I do not know how to prove by the Scriptures whether or not He was shorn; but the plucking of His beard can be proved. For Isaiah in the person of the Lord says, "I give my body to persecutors and my cheeks to those who pluck them" (Isa. 1, 6). The mother gazed faithfully at all this and wished to look still longer. However, the hour growing late, John said, "Lady, let us bow to Joseph and Nicodemus and allow them to prepare and bury the body of our Lord; for as a

result of too much delay they might suffer calumny from the Jews." At these words, as she was grateful and discreet, and remembering that she was committed to John by the Son, she resisted no longer, but blessed Him and permitted Him to be prepared and shrouded. Then John and Nicodemus and the others began to shroud the body and prepare it with linen cloths according to Jewish custom. The Lady always held His head on her lap, because its preparation was reserved for her, and the Magdalen held His feet. When they came to the legs, near the feet, the Magdalen said, "I pray you to permit me to prepare the feet at which I obtained mercy." This was permitted, and she held the feet. She seemed to faint with sorrow, and what she once moistened with the tears of remorse she now washed with the much more copious tears of sorrow and compassion. She gazed at the feet, so wounded, pierced, dried out, and bloody: she wept with great bitterness. For as Truth itself testified, "She loved much" (Luke vii, 47); and therefore she wept much, and most of all in this last service to her Lord and Master, so afflicted, scourged, wounded, dead, and reduced to nothing. Her heart could hardly remain in her body for sorrow; and it can well be thought that she would gladly have died, if she could, at the feet of the Lord. There seemed no remedy for her sorrow; nor was she accustomed to serving Him in such a way. This service was new, and the last that she did for Him; and her soul was bitter in performing it, for she was not able to do as she strongly wished and as was fitting. She wished to wash, anoint, and prepare His whole body well; but there was neither time nor place. She could not do more; she could not do otherwise; she did what she could. At least she could wash His feet with tears, and at length devotedly wipe, embrace, kiss, wrap, and faithfully prepare them as best she knew and could. The body thus prepared, they looked for the Lady to make an end, and all turned again to lamentations. Then, seeing that it was not possible to delay

any longer, she placed her cheek against the face of her most beloved Son and said, "My Son, I hold you in my lap dead. Separation by your death is exceedingly hard, for the intercourse between us was joyful and delightful and we lived among others without quarreling or offence. In spite of this, you, my sweetest Son, have been killed as though a criminal. I served you faithfully, my Son, and you served me, but in this sad battle of yours the Father would not help you and I could not. You abandoned yourself for love of mankind, whom you wished to redeem. Hard and exceedingly painful is this redemption, in which I rejoice for the sake of the salvation of man. But in your sorrows and death I am much afflicted, for I know that you never sinned and that you are destroyed without cause in a bitter and disgraceful death. Therefore, my Son, our companionship is broken, and I must now be separated from you. I, your most sorrowful mother, shall bury you; but afterwards where shall I go? Where shall I then stay, my Son? How can I live without you? Willingly would I be buried with you, to be with you wherever you are. But if I cannot bury my body, I would be buried in mind. I shall bury my soul in the tomb with your body; I send it to you; I commend it to you. O my Son, how terrible this separation is!" And again, out of the abundance of her tears, she washed the face of her Son much more than the Magdalen did His feet. Then she wiped His face and, kissing His mouth and eyes, wrapped His head in a napkin, and diligently made Him ready. At last she blessed Him again. And then, all adoring Him on bended knees, and kissing His feet, they took Him and carried Him to the tomb. The Lady held His head and shoulders, the Magdalen His feet; the others were in between. The sepulcher was near the place of the Crucifixion, as far as the length of our church or thereabouts, and they buried Him in it reverently, with bended knees, amid great weeping and sobbing and repeated sighs. As He was buried, the mother again blessed and embraced Him, and stayed close to her

beloved Son; but, raising her, they placed a great stone at the portal of the monument. Bede[210] speaks of this monument, which was a circular house cut out of the underlying rock, of so great a height that a man could hardly reach the top with his hand, having its entrance to the east: in the northern part, the place for the body of the Lord, seven feet in length, was made in this same stone.

L X X X I I I. *Meditation After Compline*

Then Joseph, wishing to return to the city after the completion of this office, said to the Lady, "My Lady, I pray you for God's sake and for the sake of the love of your Son and my Master, if it please you, withdraw to my house, for I know that you do not have a house of your own. Use mine as yours, because everything of mine is yours." And Nicodemus said the same. Oh, what compassion! The queen of heaven has no place to rest her head; and on these days of her mourning and widowhood she will have to be taken under a strange roof. These are truly the days of her widowhood, for the Lord Jesus was her Son and her husband, her father and mother, and all her good; and in His death she has lost all. Truly she is abandoned and a widow and has nowhere to turn. Bowing humbly and giving thanks, she answered that she was entrusted to John. At their further entreaties to her, John answered that he wished to take her to Mount Sion, to the house where the Master had dined with the disciples on the evening before, and to stay with her there. Bowing to the Lady and adoring the sepulcher, they departed; and the others, as the Gospel says (Matt. xxvii, 61), remained seated near the sepulcher. As night was approaching, John said to the Lady, "It is not proper to remain here too long or return to the city by night. On that account, if it please you, Lady, let us withdraw." Then the Lady, rising and kneeling, embracing and blessing the sepulcher, said, "My Son, I cannot stay with you any longer: I recommend you to your Father." Then, with

eyes raised to heaven, she said tearfully, with great feeling, "Eternal Father, I recommend to you my Son and my soul, which I leave behind me." And then they began to withdraw. When they reached the cross, she knelt and adored it, saying, "Here my Son rested, and here is His most precious blood." And all did similarly. Think as well as you can that she was the first to adore the cross. After this they withdrew toward the city, and on the road she often turned around to look back. When they reached the last place from which they could see the sepulcher and the cross, she turned, bowed, and knelt in devout adoration. And all did similarly. When they approached the city, the sisters of the Lady veiled her as a widow, enveloping almost her whole face, and went on ahead. Thus veiled, the Lady followed most sorrowfully, between John and the Magdalen. Then the Magdalen, wishing on entering the city to take the road that led to her house and lead them there, looked ahead and said, "My Lady, I pray you, for love of my Master, to come to our house. There we shall be better off. You know how gladly He came to it. It is yours, and everything of mine is yours. I pray you to come." And they began to lament. But the Lady kept silent and indicated John, so the Magdalen went on pleading with him. He answered, "It is more fitting that we go to Mount Sion, mainly because we can meet our friends that way, and it is better for you to come with her." The Magdalen answered, "You know well that I will come with her wherever she goes and never leave her." At the entrance to the city, they met on all sides virgins and good matrons, who, as soon as they could reach her, accompanied her on the road for consolation; but great was the lamentation. And some good men felt compassion for her as they passed and were moved to grief, saying, "Surely a great injustice was done today by the rulers against the Son of this Lady, and God manifested great signs for Him. Let them beware of what they have done!" When they came to the house, she turned

toward the ladies, thanked them, and bowed most devotedly. They too bowed and knelt, all beginning to lament greatly. Thus the Lady entered the house with the Magdalen and her sisters. John, placing himself at the door, begged everyone to return home, for the hour was late; and thanking them he closed the door. Then the Lady, looking around the house, spoke thus: "My sweetest Son, where are you, that I do not see you here? O John, where is my Son? O Magdalen, where is your Father, who loved you so tenderly? O beloved sisters, where is our Son? Our joy, our sweetness, and the light of our eyes has gone; but He has gone, you know, in great anguish. And this is what adds greatly to my sorrow, that He went wholly lacerated, wholly straitened and athirst, goaded, oppressed, and outraged; nor could we help Him in any way. Everyone abandoned Him, and His Father, omnipotent God, did not wish to help Him. In what quick order this was done to Him, you saw. Whose condemnation, at any time, even that of the wickedest of men, was so hasty and fulminating? O Son, in this night you were captured, perfidiously betrayed; in the morning, at the third hour, condemned; and at the sixth hour crucified; and so you died. O Son, how bitter is the separation from you and the memory of your most shameful death!" At last John begged her to desist, and consoled her. If you will use your powers, you too will know how to obey, serve, console, and comfort her, so that she may eat a little, and comfort the others in doing so, for they have all fasted up to now. Afterwards you may receive a blessing from the Lady and each of the others, and withdraw.

L X X X I V. *Meditation on the Lady and her Companions; On the Sabbath*

On the morning of the sabbath, they remained at home with the doors closed, the Lady and the other companions one with John in affliction and sadness. They sat together

347

as if orphaned, full of sorrow, not speaking but remembering, looking quickly at each other, as happens in bearing great pressure and calamity. But then there was a knock at the door, and they were afraid, because everyone was fearful, for their security had left them. Nevertheless John went to the door, and looking out recognized Peter, and said, "It is Peter." And the Lady said, "Let him in." Thereupon Peter entered shamefacedly, with great sobbing and weeping; and then everyone began to cry, nor could they speak a word for sorrow. Afterwards the other disciples came in succession, also crying. At length, ceasing to weep, they began to speak of their Lord. Peter said, "I am ashamed of myself, and ought neither to speak in your presence nor appear before men, because I abandoned and denied my Lord, who loved me so much." Similarly all the rest, striking themselves with their hands and shedding tears, blamed themselves for abandoning their sweetest Lord. Then the Lady said, "Our good Master and faithful Shepherd has left us, and we remain as orphans; but I firmly hope that we shall have Him again soon. You know how good my Son is and how much He loved you. Do not doubt that He will be restored and that He will freely forgive every offense or fault. There was, however, so much fury against Him, by permission of the Father, that you could not have helped Him even if you had been with Him: therefore do not be troubled." Peter answered, "Truly, my Lady, it is as you say; for I, who saw so much at the beginning, was so weakened by fear in the courtyard of Caiaphas that I believed I could hardly escape, and I denied Him. Nor did I remember the words in which He had predicted this to me until He looked at me." Then the Magdalen asked what He had predicted to him, and he replied, "My denial," and told her everything and added that at the Last Supper He had said many other things about His Passion. Then the Lady said, "I should like to hear what He said and did at the Last Supper." Peter made a sign to John that

348

he should speak. John began and told everything; and he and the others told in turn what the Lord Jesus had done with them, first one, then another, and so they passed the whole day in conversing about Him. Oh, how attentively the Magdalen listened, and how much more attentively the Lady! Oh, how often on this day, during the telling of His deeds, she said, "Blessed be my Son Jesus!" Therefore pay diligent attention and have compassion, for they are in great affliction, nay rather the greatest, on this day. For what is it to see that the Lady of heaven and earth, and the prince of the church and of all the people, and the leaders of the whole divine army, thus fearfully staying secluded in such a little house, not knowing what they ought to do except comfort themselves, discussing the deeds and words of their sweetest Lord? Yet the Lady kept a tranquil and quiet mind, for she had the most certain hope of the Resurrection of her Son, and in her alone faith remained on this sabbath day: on that account the sabbath day is associated with her. Not, however, that the Lady was able to rejoice after the death of her sweetest Son, Jesus Christ. In the evening, when work was permitted, Mary Magdalen and the other Mary went to buy spices for making ointment. For on the preceding night, when they returned from the entombment of the Lord, they had prepared them until sunset, and afterwards had ceased. Now the sabbath was observed from sunset on Friday until the next sunset. Therefore they now went out to buy spices. Look at them diligently, walking with sad faces, in the manner of widows, and addressing some apothecary, perhaps one devoted to the Lord, who has compassion on them and freely gives them what they wish. They ask for spices and choose the best as much as they can. After paying the price, they return to make the ointment for their Lord. Observe diligently how humbly, devotedly, and faithfully they labor for their Lord, with great tears and deep sighs. The Lady and the apostles watch them, and perhaps help. When it is done,

349

they are quiet for the night. And this is the meditation for the sabbath day on the Lady, her companions, and the disciples.

Sabbath Day

L X X X V. *Meditation on the Lord Jesus Descending into Hell on the Sabbath Day*

Now there comes into consideration what the Lord did on the sabbath day. Immediately upon His death He descended to the holy fathers in Hell and stayed with them. And then they were in glory; for the sight of the Lord is perfect glory. Therefore consider and remark how much goodness there was in His descending into Hell, how much charity, how much humility. For He could have sent an angel to them, to free all His servants and bring them to Him wherever He wished; but His infinite love and humility would not allow this. Therefore He Himself descended: the Lord of all visited them as if they were friends and not servants, and stayed with them until dawn on Sunday morning. Reflect on this well, and admire and try to imitate it. The holy fathers rejoiced at His coming and were full of immense joy. All discontent was banished far away, and they remained praising Him and singing to Him. You can meditate on this by imagining them as if they were in the flesh, as they were to be after the resurrection, similarly imagining the most benign soul of our Lord Jesus Christ. When they perceived His most salutary coming, they joyfully hastened to meet Him, exhorting each other and saying, "Blessed is the Lord God of Israel, who has visited . . ." etc. (Luke i, 68). "Raise your heads, for behold, your redemption is coming" (Luke xxi, 28). "Rise up, rise up, Jerusalem, break the chains from your neck" (Isa. lii, 2). "Behold, the Savior comes to free us from our bonds." "Lift up your gates, Princes, and be lifted up, everlasting doors, and the King of Glory shall come in"

350

(Psalm xxiii, 7, 9). "We adore you, O Christ, and bless you, our most loving God." And falling down, they adored Him with great joy and pleasure. Look at them as they stand before Him with reverence and immense exultation, their faces joyful, and say the above in His presence; and thus with praises, singing, and jubilation they remained in limbo until near the dawn on Sunday, together with a multitude of angels in the same place, rejoicing with them. Then the Lord received them, leading them in exultation out of Hell; and proceeding before them gloriously, He placed them in the paradise of delights. After a little while spent agreeably with them, when Elias and Enoch recognized Him, He said, "It is time for me to resurrect my body: I shall go and reassume it." Whereupon all fell down and said, "Go, O Lord, King of Glory, and return quickly, if it please you, for we greatly desire to see your most glorious body."

Now you have the material concerning the Lord Jesus, His mother, the disciples, and the holy fathers to meditate upon on the sabbath day before the Resurrection. Indeed, as I have hastened over the whole Passion of the Lord for you without the interpolation of any quotations, that no soul should be diverted to anything other than this Passion, I thought I would now refer you to some of these passages, so that reading them may stir your mind to more fervent and devoted meditation. Therefore, in the usual way, hear certain sentences of Bernard, who says, "You owe Jesus Christ your whole life, because He gave His life for yours and suffered bitter torments so that you should not suffer eternally. . . . If there were gathered in me all the days of the sons of Adam and all the days of the ages and the work of all men who were and are and will be, it would be nothing by comparison with this Body, remarkable and amazing even to the supernal powers in its conception by the Holy Spirit, in its birth of a virgin, in the innocence of its life, in the richness of its doctrine, in the brightness of its miracles,

351

in its revelation of the sacraments. As exalted, then, as heaven is above earth, His life is exalted above our life, for which it was laid down. And as nothing bears no comparison to something, our life is not in proportion to His life, for His could not be worthier, ours could not be more miserable. . . . When I devote all that I can to Him, it is but a star to the sun, a water-drop to a river, a stone to a mountain, a grain to a great heap." [211] Again, "The emptying of Christ was not simple or moderate: He emptied Himself as far as the flesh, as death, as the cross. Who could properly weigh the humility, the meekness, the dignity, the majesty of God clothed in flesh, suffering death, disgraced on the cross? But someone says, 'Could the Creator not repair His work without such difficulty?' He could, but preferred to do it with His sufferings, so that no occasion should appear to man for that worst and most odious vice of ingratitude. Indeed He assumed many wearying things so that He might hold man His debtor in great love, and cause gratitude by the difficulty of the redemption, for man would have been less devout for an easy grant. For what did man, created and ungrateful, say? 'Indeed I was created freely, but without difficulty or work on the part of the Creator, for He spoke and I was made, like everything else.'" And below, "But the mouth that spoke evil was closed (Psalm lxii, 12). It appears more clearly than light, O man, how much loss was suffered for you. He did not refuse to be changed from the Lord to the servant, from rich man to poor, from the Word to the flesh, and from the Son of God to the Son of Man. Remember, although made from nothing, nevertheless you were not redeemed for nothing. In six days He created everything, including you. But for more than thirty years He worked on earth for our salvation. Oh, how much He bore in laboring! The necessities of the flesh, the temptations of the enemy, the shame of the cross—could He intensify these, or add to the horror of His death?" [212] Again, "Above all, there makes you lovable to

me, good Jesus, the cup of which you drank, the work of our redemption. This indisputably calls for all of our love. This, I say, is what draws forth our devotion more alluringly, requires it more justly, binds it more tightly, and affects it more vehemently. Certainly the Savior labored greatly in this; nor did the Creator take so much trouble in the making of the whole world. Then, indeed, He spoke and it was done; ordered, and it was created. But now He bore those who contradicted His speech, observed His actions, mocked His torments, insulted His death." [213] Again, "To the sum of His piety, Christ gave His soul in death, and from His own side He drew forth the price of satisfaction that appeased the Father. By this He took wholly to Himself this verse: 'Mercy is with the Lord, and with Him is plentiful redemption' (Psalm cxxix, 7). Truly plentiful, for not a drop but a wide wave of blood flowed from the five parts of His body. What should He have done for you that He did not do? He gave sight to the blind, released the captive, drew back the mistaken, reconciled the guilty. Who would not freely and willingly follow Him who frees us from error and conceals our faults, who living gives merits and dying wins awards? What excuse has one who does not run in the odor of His ointments, except perhaps one whom no odor reaches? But the odor of life went forth into the whole world, for the earth is full of the mercy of the Lord and His mercies are above all His works. Therefore he who does not feel this vital fragrance spread everywhere, and because of this does not run, is either dead or rotten." [214] Again, "The Bride is not ashamed of her blackness, which she knows the Bridegroom previously bore: how much glory there is in resembling Him! Nothing is more glorious for her than to bear the reproach of Christ. From this comes her voice of joy and salvation: 'God forbid that I should glory in anything except the cross of our Lord Jesus Christ' (Gal. vi, 14). The disgrace of the cross is welcome to him who is not ungrateful to the Crucified.

It is blackness, but in the form and likeness of the Lord. Go to the holy Isaiah, and he will describe to you how he saw Him in the spirit. For whom else did he call 'a man of sorrows, acquainted with infirmity, in whom there was neither beauty nor elegance?' And he added, 'We considered Him as a leper, struck down by God and humbled. But He was wounded for our iniquities, worn away for our wickedness, and we are healed by His bruises'" (Isa. liii, 3–5). And below, "In short, He even caused Himself to be made sin, and shall I be afraid to call Him black? Look at Him, then, in dirty clothing, livid with wounds, besmeared with spit, pallid with death."[215] Again, "What did the eyes of the spectators meet except deformity and blackness when, His hands outstretched on the cross, between the two criminals, He drew laughter from the malignant, weeping from the faithful, and alone was ridiculed who alone should have been feared and honored?"[216] Again, "The rock is the refuge of the hedgehogs (Psalm ciii, 18), and where is the safe and firm refuge of the weak except in the wounds of the Savior? I dwell there as much more securely as He is more powerful in salvation. The world rages, the body presses, the devil lies in ambush: I do not fall, for I am based on a firm Rock. I have sinned a great sin, my conscience is disturbed, but I am not alarmed, because I shall remember the wounds of the Lord. Truly He was wounded for our iniquities. What sin is so mortal that it may not be healed by the death of Christ?" And below, "The nail cries out, the wound cries out, that truly God is in Christ, reconciling the world to Himself. The iron pierced His soul and approached His heart, in order that He might know compassion for our infirmities. The secret of His heart is revealed through the holes in His body; the great sacrament is revealed; the bowels of the mercy of our God, in which the Dayspring visited us from on high (Luke i, 78), are revealed. Why should not His bowels be revealed through His wounds? For in what more clearly than in the

354

wounds could it have shone forth that you, O Lord, are sweet and mild and full of mercy? For no one shows greater mercy than in laying down his soul for those judged and condemned to death." [217]

In another place, Bernard says, "Meditate on the Passion of the crucified body and see if there is anything in it that does not plead a cause to the Father. For you that divine head was thickly pressed with a multiplicity of thorns, fixed to the tenderness of the brain when the thorn pierced through. 'The people,' says the Lord by the prophet, 'surrounded me with the thorns of their sins.' That your head might not suffer or your intention be wounded, His eyes have misted in death, and those lights that illuminate the world have been put out for a while. When they were overshadowed, did shadows not fall over the whole world; and with those two great lights, were other lights not removed? All this was done that your eyes might not be averted and not see vanity, or if they did, might not be attracted to it. Those ears that in heaven hear, 'Holy, holy, holy, Lord God of hosts' (Isa. vi, 3), on earth hear, 'You have a demon' (John viii, 48), and 'Crucify Him, crucify Him' (Luke xxiii, 21). Why is this? That your ears might be neither deaf to the cry of the poor, nor open to hear vanity, nor receptive to the poison of slander. That beautiful face, beautiful above the sons of men, was besmeared with spit, afflicted with blows, given up to mockeries. For thus it is written: 'They began to spit at Him and to strike His face and to mock Him, saying, "Prophesy, who is it that struck you?"' (Matt. xxvi, 67, 68, etc.). Why? That your face might be illuminated, and, being illuminated, might be confirmed in what is said of you; 'His face was no longer variously changed' (I Sam. i, 18). That mouth that teaches angels and instructs men, that spoke, and it was done, drank gall and vinegar; but this was done that your mouth might speak truth and judgment and confess the Lord your God. Those hands that founded the

heavens were extended on the cross and punished with most cruel nails, that your hands might be extended to the poor, and that you might say with the Psalmist, 'My soul is always in my hands' (Psalm cxviii, 109). What we hold in our hands is not easily lost sight of, and so he who applies his soul to good works does not bury it in oblivion. That breast in which are hidden all the treasures of the wisdom and knowledge of God was pierced by a soldier's lance that your breast might be cleansed of wicked thoughts, and, being cleansed, might be sanctified, and, being sanctified, might be maintained. Those feet whose footstool we ought to adore, for it is holy, were roughly pierced and fastened that your feet might not make haste toward evil but run on the road of the commandments of God. What more? 'They have made holes in my hands and my feet; they have numbered all my bones' (Psalm xxi, 16, 17). He laid down His flesh and His soul for you to claim your body and spirit for Him, and for all He regained all."[218] The same, "Awaken now, my soul, and shake away the dust, and contemplate this memorable Man, whom you may see in the mirror of the Gospel as if present. Consider, my soul, who is this who goes forth with the look of a king and nevertheless is full of the confusion of the most despised slave? He walks crowned, but His crown is a torment to Him, and His beautiful head is wounded with a thousand stabs. He is dressed in royal purple, but it is rather despised than honored on Him. He holds a scepter in His hand, but His revered head is attacked with it. Kneeling on the ground, they adore Him and proclaim Him king, but immediately afterwards they spring up to spit on His lovely cheeks. They strike Him with the palms of their hands and dishonor His honorable neck. See, my soul, how that Man is coerced and despised by all. He is ordered to bend His back under the weight of the cross, to carry this shame Himself to the place of punishment, to drink myrrh and gall. He is raised on the cross and says, 'Father, forgive

356

them, for they do not know what they are doing' (Luke xxiii, 34). What kind of Man is this that bore all His distress and never once opened His mouth to utter any complaints or excuses or threats or curses against those accursed dogs but whose last words shed such a blessing on His enemies as had never been heard before? Whom have you seen, my soul, who is meeker or kinder than this Man? Observe Him more intently and He will appear worthy of great admiration and tender compassion. See Him naked and lacerated by scourges between the thieves, shamefully fastened to the cross with iron nails, drinking vinegar on the cross, and after death wounded by a lance in His side and shedding copious streams of blood from the five wounds in His hands, feet, and side. Weep, my eyes, and melt, my soul, in a fire of compassion for the wounding of this lovable Man whom you see in so much meekness afflicted with so many sorrows." The same, "Look down, Lord and holy Father, from your sanctuary and your habitation in the height of heaven, and see this sacrosanct host that our great Pontifex, your holy Child, the Lord Jesus Christ, offers to you for the sins of His brothers; and be appeased for the multitude of our wickednesses. Behold, the voice of our brother Jesus cries to you from the cross. Behold Him crowned with glory and honor, standing before your face, at the right hand of your majesty, for us; for He is our flesh and our brother." The same, "Look, O Lord, at the face of your Christ, who was obedient to you unto death, and keep His scars perpetually before your eyes, so that you may remember how much satisfaction you received from Him for our sins. Would, O Lord, that the sins with which we earned your anger could be weighed in the balance with the calamity that your innocent Son endured for us! Certainly the calamity would appear heavier and worthier than the sins, so that because of it you would pour out your mercy on us rather than angrily restrain your mercy on account of our sins. O Lord and

Father, may all tongues give thanks to you for the abundance of your goodness, which did not spare the only Son of your heart but gave Him up to death for us that we may have Him as such a faithful advocate before you in heaven." The same, "And to you, Lord Jesus, strongest of zealots, what thanks may I give, what return worthy of you—I, a man, dust and ashes, a vile figment? What could you have done for my salvation that you did not do? From the sole of your foot to the crown of your head you plunged wholly into the waters of the Passion, in order to draw me out of them, and the waters entered your very soul; for you lost your soul in death to restore my lost one to me. Behold, you bind me with a double debt; for that which you gave and for that which you lost for my sake, I am your debtor; and I do not have anything better that I can give you than this life of mine, which you gave me twice, once in the creation, again in the redemption. For your precious soul, so troubled, I do not find anything worthy for a man to offer in return. For if I could repay you for it with heaven and earth and all their beauty, surely I would not reach the measure of my debt at all. That I give back what I owe and what I can pay of my debt to you, O Lord, is by your favor. You should be loved by me with my whole heart, whole mind, whole soul, whole strength, and your footsteps should be followed by me, for you deigned to die for me; but how can this be done in me except by you? My soul stays close to you, for all its strength depends on you." [219] Thus Bernard. There you have, then, the Blessed Bernard in his mellifluous way talking of the mellifluous and most beautiful Passion of the Lord. See that you do not receive it in vain. But with your whole heart and whole mind turn toward the Passion of the Lord, through the passages cited, for this meditation stands out above all others in His life. Let us now approach the Resurrection of the Lord Jesus.

L X X X V I. *Of the Resurrection of the Lord and How He First Appeared to His Mother on the Sunday*

On Sunday, very early in the morning, the Lord Jesus came to the tomb with an honorable multitude of angels, and reassuming His most sacred body, by His own strength He rose and came forth, the tomb being shut close. At the same hour, that is, very early in the morning, Mary Magdalen and Jacobi and Salome, after asking permission from the Lady, set out to go to the tomb with their ointments. The Lady, however, stayed in the house and prayed, saying, "Most clement Father, most merciful Father, you know that my Son is dead. He was nailed to the cross between two thieves, and I buried Him with my own hands; but you are powerful, Lord, and can restore Him to me uninjured. I beg your Majesty to send Him back to me. Why is He so long in coming to me? Send Him back to me, I pray, for my soul will not rest unless I see Him. O my sweetest Son, how are you? What are you doing? What causes your delay? I beg you not to wait any longer to come to me, for you said, 'On the third day I will rise again' (Matt. xxvii, 63). Is not today the third day, my Son? Not yesterday but the day preceding, that is, the day before yesterday, was the great but exceedingly bitter day, the day of calamity and death, of shadows and blackness, of separation and your death. Therefore, my Son, today is the third day. Rise up then, my glory and all my good, and return. More than anything else I long to see you. Let your return console me, as your departure so saddened me. Come back then, my Beloved; come, Lord Jesus; come, my only hope; come to me, my Son." While she was praying thus, and gently shedding tears, behold suddenly the Lord Jesus came, in the whitest garments, with serene face, beautiful, glorious, and rejoicing, and said to her, as if beside her, "Hail, saintly parent." She immediately turned around. "Are you," she said, "my Son Jesus?" And she knelt, adoring Him. Her Son said, "My sweetest mother, it

is I. I have risen and am with you." Then, rising, she embraced Him with tears of joy and, placing her cheek to His, drew Him close, resting wholly against Him; and He supported her willingly. Afterwards, when they were sitting down together, she looked intently and earnestly at His face and at the scars on His hands and asked whether all the pain had gone. He said, "Reverend mother, all pain has gone from me, and I have overcome death, and sorrow, and all hardships, nor could I feel anything of that kind now." And she said, "Blessed be your Father, who gave you back to me: may His name be praised and exalted and magnified forevermore." Thus they stayed and conversed together, mutually rejoicing and keeping the Pasch delightfully and lovingly. And the Lord Jesus told her how He had liberated His people from Hell and all that He had done in those three days. Now, therefore, behold a great Pasch!

LXXXVII. *How the Magdalen and the Other Two Marys Came to the Tomb and of the Running of Peter and John*

The Magdalen and the other two Marys, as I said, went to the tomb with the ointments. While they were outside the gates of the city, they recalled to memory the afflictions and pains of their Master, and in all the places where something notable had been done to Him, or had been done by Him, they halted for a little while and knelt, kissing the ground, uttering groans and sighs, and saying, "Here we met Him with the cross on His shoulders, when His mother was half dead; here He turned to the women; here, wearied, He laid down the cross and leaned for a little while on this stone; here they struck Him so cruelly and harshly to make Him walk faster, and forced Him almost to run; here they stripped Him and left Him totally naked; here they fastened Him to the cross." And then with great cries and floods of tears, prostrate on their faces, they adored and kissed the cross, still red with the precious blood of the

Lord. Then, rising and going toward the sepulcher, they said, "Who will roll the stone from the entrance of the tomb for us?" And looking, they see the stone rolled away, and sitting on it the angel of the Lord, who says to them, "Do not be afraid" etc., as is related in the Gospel (Matt. xxviii, 5). However, disappointed in their hopes, for they counted on finding the body of the Lord, not listening to the word of the angel, they go back in great fright to the disciples, announcing the body of the Lord to have been taken away. Then Peter and John run together to the tomb. Look at them well: they run, the Magdalen and her companions run after them, they all run seeking their Lord, their heart and their soul; they run very faithfully, and very fervently, and very anxiously. When they come to the tomb, looking in they do not see the body, but they see the linen cloths and the sudarium, and they withdraw. Feel for them, for they are in great affliction. They seek their Lord and do not find Him, and they do not know where else they ought to look: therefore, grieving and lamenting, they go away.

LXXXVIII. *How the Lord Appeared to the Three Marys*

But the Marys stay in the same place and, looking into the tomb, see two angels dressed in white, who say to them, "Whom do you seek, the living with the dead?" (Luke xxiv, 5). However, the women neither attend to their words nor accept any consolation from the angelic vision, for they are seeking not angels but the Lord of angels. The two Marys, in great fright, as if absorbed, went a little distance away and sat grieving. But the Magdalen, not knowing what else she should do, because she could not live without her Master and did not find Him there and did not know where to look for Him, stayed weeping outside of the tomb. Once more looking into the tomb, therefore, always hoping to see Him again there where she had buried Him, she saw the two seated angels, who said to her, "Woman, why do

you weep? Whom do you seek?" And she said, "They have taken my Lord away, and I do not know where they have laid Him." See the wonderful workings of love: a little while before she had heard from one angel that He was risen, and afterwards from the two that He was alive, and she did not remember, but said, "I do not know." Love made this happen, for, as Origen says, her soul was not here, where she was, but there, where her Master was.[220] She did not know how to think, speak, or hear anything except of Him. When she cried and paid no attention to the angels, her Master for love could not hold back any longer. Therefore the Lord Jesus turned to His mother and said that He wished to go to console her. She approved very much and said, "My blessed Son, go in peace and console her, for she loves you very much and grieves very much at your death; and remember to come back to me," and, embracing Him, she let Him go. He went to the tomb in the garden where the Magdalen was and said to her, "Woman, whom do you seek? Why do you weep?" And she, like an inebriate, not yet recognizing Him, said, "Lord, if you carried Him off, tell me where you have laid Him, and I will take Him away." Look at her well, how with tearstained face she entreats Him humbly and devoutly to lead her to Him whom she seeks; for she always hoped to hear something new about her Beloved. Then the Lord said to her, "Mary." It was truly as if she came back to life, and, recognizing Him by His voice, she said with indescribable joy, "Rabbi," that is, Master, "you are the Lord whom I sought: why did you hide from me so long?" And she ran towards His feet, wishing to kiss them. But the Lord, wishing to elevate her soul to the things of heaven, so that she should not seek Him from then on on earth, said, "Do not touch me, for I have not yet ascended to my Father. But tell my brothers: 'I ascend to my Father and your Father'" etc. And He added, "Did I not predict to you that on the third day I would rise? Why then did you seek me in the sepulcher?"

And she said, "I tell you, Master, that so much grief from the harshness of your Passion and death filled my heart that everything was obliterated. I could remember nothing except your dead body and the place where I buried it, and on that account I brought the ointment this morning. Blessed be your magnificence, that deigned to rise and come back to us!" Thereupon they stayed together lovingly with great joy and gladness. She looked at Him closely and asked about each thing, and He answered willingly. Now this is then a great Pasch! Although it seemed at first that the Lord held back from her, I can hardly believe that she did not touch Him familiarly before He departed, kissing His feet and His hands. But He acted thus, as His words at the beginning show, either because in this way He exposed Himself as He was in her heart, according to common exposition, or, as I said, because He wished to elevate her soul to the things of heaven, as Bernard seems to indicate. One can piously believe that He visited her thus lovingly and singularly, before all the others that are referred to in writing, for her pleasure, and not to distress her. Mysteriously, therefore, not pertinaciously, He spoke those words; for the most benign Lord is not pertinacious or harsh, especially not to those who love Him. After a little time the Lord departed, saying that He must visit the others. Then the Magdalen, as if changed, though just as unwilling ever to part from Him, says, "Lord, as I see, your relationship with us will not be as it used to be. I beg you not to forget me. Remember, Lord, the good things that you gave me, and the intimacy and love that you granted me, and remember me, O Lord my God." And the Lord says to her, "Do not be afraid: be confident and constant, for I shall always be with you." Then she receives a benediction from Him and, leaving Christ, joins her companions and tells this to them. Rejoicing in the Resurrection of the Lord, but saddened at not seeing Him, they depart with her. While the three Marys are going along together, before they reach the city, the

Lord Jesus appears to them, saying, "Hail." They are happier than I can say and, prostrating themselves, embrace His feet. Similarly questioning Him and gazing at Him, and receiving cheerful responses, they make a great Pasch. Then the Lord Jesus says to them, "Tell my brothers to come into Galilee: there they shall see me (Matt. xxviii, 10), as I predicted." You see that the Master of humility calls the disciples His brothers: does He ever abandon this virtue? And you, if you desire the understanding and consolation of these things, remember what I said to you before, that your soul should be in all places and deeds just as if you were present there in body. And the same applies to what is said below.

LXXXIX. *How the Lord Appeared to Joseph, James Minor, and Peter*

Departing from them, the Lord Jesus appeared to Joseph, who had buried Him. On that account he had been arrested by the Jews and shut up in a closely guarded cell, and after the Sabbath day they intended to kill him. But the Lord Jesus appeared to him and wiped his face and kissed him, and, without breaking the seal, took him back to his own house. The Lord Jesus also appeared to James Minor, who had sworn not to eat until he saw the resurrected Lord. Therefore He said to him, and to those who were with him, "Lay the table." Then, taking bread, He blessed it and gave it to him, saying, "Eat, my beloved brother, for the Son of Man has risen from the dead." This is mentioned by Jerome.[221] When the Magdalen and her companions returned to the house and told the disciples that the Lord had risen, Peter, unhappy at not having seen his Lord, unable to rest because of the vehemence of his love, left them and went alone towards the sepulcher, for he did not know where else to seek Him. As he was going on his way, the Lord Jesus appeared to him, saying, "Peace be with you, Simon." Then Peter, beating his breast and prostrating him-

self tearfully on the ground, said, "Lord, I confess my fault, for I abandoned you and denied you many times." And he kissed His feet. But the Lord raised him up and kissed him, saying, "Peace be with you; do not be afraid; all your sins are forgiven you. I knew it well and predicted it to you. Now go, then, and strengthen your brothers, and be confident, for I have overcome death and all your enemies and adversaries." Here too there was a great Pasch. They stayed and spoke together, and Peter observed Him diligently and noticed each thing. After receiving a benediction, he went back to the Lady and the disciples and told everything. You should know, however, that nothing is mentioned in the Gospel about the appearance to the Lady. I have included it and placed it first because the Church seems to hold to it, as it is more fully given in the legend of the Resurrection.[222]

x c. *Of the Lord's Return to the Holy Fathers After the Resurrection*

Because the Lord Jesus since His Resurrection had not visited the holy fathers whom He had placed in the paradise of delights, He returned to them when He left Peter, going forth in a white stole, with a multitude of angels. Seeing Him from a distance in so much glory, they welcomed Him with indescribable exultation and joy, songs and praises, saying, "Behold our King; come, let us meet our Savior. Great is His dominion, and His reign shall never end. The sanctified day is dawning for us; come all, and let us adore the Lord." And prostrating themselves on the ground they adored Him, and rising and standing with Him they reverently and joyfully concluded their praises, saying, "The Lion of the tribe of Judah is victorious; my flesh, Lord, flowers again; you will fill us with the pleasure of your face and the delights in your right hand forevermore. You have risen, our Glory; we shall exult and take pleasure in you. Your kingdom is an everlasting kingdom, and your domi-

365

nation is from generation to generation. And we do not depart from you: you will raise us up, and we shall exalt your name. The Precursor enters in for us; the Pontiff is made for eternity. This is the day that the Lord made: let us exult and take pleasure in it. Today there dawns for us the day of redemption, of reparation for the past, of felicity for eternity. Today the heavens are made mellifluous for the whole world, for the Lord has reigned from the tree. The Lord has reigned; He is clothed fittingly; the Lord is clothed in fortitude and has girded Himself. Sing a new song to Him who has worked miracles. His right hand saved Him, and His holy arm. We are His people and the sheep of His pasture: come, let us adore Him." The hour of vespers was drawing near, so the Lord Jesus said to them, "I feel compassion for my brothers, for because of my death they are sad and terror-stricken, scattered like errant sheep; and they greatly desire to see me. Therefore I shall go and show myself to them; I shall comfort and console them; soon I shall return to you." They prostrated themselves, saying, "Lord, let it be as you have said."

x c i. *How the Lord Appeared to the Two Disciples Going to Emmaus*

While two of His disciples were going towards the citadel of Emmaus, almost despairing of Him, going sadly and discussing what had happened, the Lord Jesus came and joined them in the guise of a pilgrim and walked along with them, questioning them, and answering, and exchanging salubrious words, as the Gospel says. At length, urged by them, He went in with them and manifested Himself to them. Attend diligently here, and consider the goodness and kindness of your Lord. First, because His fervent love could not leave His own thus errant and sad. Truly a trusty friend and faithful companion, the good Lord joins Himself to these, seeks the cause of their sadness, and expounds the Scriptures to them, inflaming their hearts and driving out

366

all rust. He does this spiritually with us every day. For if, weighed down by perplexity or acedia, we speak of Him, He is immediately there, comforting and illuminating our hearts and inflaming them with His love; for the greatest thing against such plagues is to speak of God. Wherefore the prophet says, "How sweet to my throat are your words, Lord, above honey and the honeycomb in my mouth!" (Psalm cxviii, 103). And again, "Your word is a violent fire, and your servant loved it" (Psalm cxviii, 140). Again, similarly thinking of God, the same prophet says, "My heart grew warm in me, and in meditation a fire flamed forth" (Psalm xxxviii, 4).

Secondly, consider His goodness, coming not only from love, as I have said, but also from profound humility. For observe how humbly He walks with them, walks along as if one of them, the Lord of all; is it not apparent to you that He has gone back to the basis of humility? It is an example to us that we should do similarly. But also attend to the humility of the Lord in another thing, that He did not disdain these disciples of lower degree. For these were not of the apostles, but were other, lesser disciples; and yet He joined them familiarly, walking and talking with them. Not thus do great men do; for they do not wish to converse and walk with anyone except important men of great wealth. His humility also shines forth in another thing. For if you consider great men, you will see that they do not wish to scatter their bombastic words among just a few people. But the Lord speaks of His secrets with two: He does not hold a few to be unworthy, nor even one, for earlier He addressed the Samaritan woman.

Thirdly, consider the goodness of the Lord on the present occasion, as He morally instructs, refreshes, and consoles His disciples. See how He pretends to be going farther on, in order to increase their desire and be invited and constrained by them, and how later on He kindly goes in with them, takes bread and, blessing it, with His most sacred

hands breaks and offers it, and reveals Himself to them. And every day, invisibly, He does this with us; for He wishes to be constrained and invited by our desires, orations, and holy meditations. And therefore we must always pray, and not fail, as He taught us, for this was done for our instruction, undoubtedly so that we should attend to works of piety and hospitality. And it is not sufficient to read or hear divine speech unless it is completed in deeds. You can learn more about this in the homilies of Gregory on the Gospel. Yet He did not give a great abundance of Himself to these disciples, but vanished before their eyes as soon as He had offered them the bread. For He wished to console others also, as He had consoled those.

XCII. *How the Lord Appeared on the Day of the Resurrection to Those Who Were Shut Up*

The two aforementioned disciples returned immediately to Jerusalem; and finding the other disciples, except for Thomas, gathered together, they told them of these events. Moreover, they in turn heard that the Lord had risen and appeared to Simon. Then the Lord Jesus went in to them, the doors being closed, stood in their midst, and said to them, "Peace be with you." The disciples prostrated themselves on the ground, acknowledging their fault, in that they had abandoned Him, and received Him eagerly. Thereupon the Lord said, "Rise, my brothers, for all your sins are forgiven you." He stayed familiarly among them, showing them His hands and side, and opening their minds to understand the Scriptures and know His Resurrection. He asked them if they had anything to eat; and in their presence He ate a piece of broiled fish and a honeycomb. He breathed on them and said to them, "Receive the Holy Spirit." You see how full these things are of joy and pleasure. The disciples rejoiced at the sight of the Lord; those who had been terrified earlier were joyful before Him. Oh, how willingly they offered Him these things to eat!

How faithfully they ministered to Him and how cheerfully stood by Him! Observe that the Lady is in the same place, for the disciples had gathered together near her. See her, therefore, looking around with indescribable joy, sitting familiarly next to her Son so as to be ready to serve Him speedily. For the Lord Jesus willingly receives all services from her hand and reverently honors her before the disciples. Do not omit the Magdalen, the beloved disciple and apostle of the apostles. Observe how she sits in her usual way at the feet of her Master, diligently listening to His words; and if there is anything that she can do, joyously, with her whole mind, she ministers to Him. Oh, what a little house this is, and how pleasant to live in it! Do you not now see this to be a great Pasch, if you have any devotion in you? I hold that it is. But the Lord stayed with them only a little while, for it was then almost evening. Perhaps they urge Him to stay with them a little longer, pleading that He should not depart so quickly. Do you not think that the Magdalen, sitting near Him at His feet, might confidently, with reverent audacity, have grasped His robe, so that He should not depart so soon? He was dressed in the whitest of garments, garb of His glory. But she may have held Him thus, not presumptuously but confidently doing so, so diligent, so beloved; nor was the Lord displeased. The Lord wishes to be held, as shown above in the two disciples on the way to Emmaus. At length the Lord, doing reverence to His mother and receiving leave from her, blessing everyone, departed from them; and they prostrated themselves, begging Him to return to them quickly. They remained in hunger and thirst for the Lord, of whom they were accustomed to have so much abundance, calling Him back often with sighs and longing. You have seen how many things you had on this day of Pasch; for all these appearances took place on the Paschal day. But perhaps you have heard but have not felt, for perhaps you did not have compassion at the Passion. I believe that if you felt compassion with

your whole mind at the Passion, and were not scattered on secular or superfluous or curious things, you would feel the Pasch everywhere. And this may happen on any Sunday, if with all your mind you prepare yourself on Friday and Saturday with the Passion of the Lord, for the apostle especially says, "If we were companions of the Passion, so shall we also be of the consolation" (II Cor. i, 7).

X C I I I. *How the Lord Appeared to the Disciples on the Octave of the Pasch, and Thomas Was with Them*

When the octave day of the Resurrection came, the Lord Jesus again appeared to the disciples, the doors being closed, and Thomas, who had not been with them the first time, was with them. And when the others had told him that they had seen the Lord, he had replied, "Unless I see in His hands the mark of the nails, and put my finger" etc., as is recorded in the Gospel, "I shall not believe" (John xx, 25). The Good Shepherd, solicitous for His little flock, said, "Peace be with you." Then He said to Thomas, "Put your finger here, and see my hands, and bring your hand and place it in my side, and do not be incredulous any more, but faithful." Then Thomas, prostrating himself, touched the wounds of the Lord and said, "My Lord and my God." For he saw the Man and believed in the God. He spoke of his fault in abandoning Him, as all had spoken. But the Lord, raising him, said, "Do not be afraid; all your sins are forgiven you." This doubt of Thomas' was permitted by dispensation, so that the Resurrection of the Lord might be proved by visible proofs. Therefore observe Him diligently and consider His customary goodness, humility, and fervent love as He shows Thomas and the other disciples His wounds in order to remove all doubt from their hearts, for their profit and ours. The Lord preserved the scars of the wounds for three reasons especially: that He might give the apostles faith in His Resurrection; that He might show them to the Father when He wishes to appease Him and

intercede for us, for He is our advocate; and that He might show them to the wicked on the day of judgment. The Lord Jesus then stayed with His mother and disciples for a little while, speaking of the kingdom of God; and they were with Him in great pleasure, hearing His lofty words and gazing on His joyful and beautiful face. Attend well to those all around, but the Lady familiarly nearest to Him: consider the Magdalen always at His feet. And stay reverently yourself, but at a distance, unless perhaps, moved by mercy, He should call you. At last He said to them that they should go into Galilee, to Mount Tabor, as it is called, and that He would appear to them there. After giving them a blessing, He left them. They remained as before, hungry and thirsty for Him, but very much comforted.

XCIV. *How the Lord Appeared to the Disciples in Galilee*

After the disciples had proceeded to the appointed place, the Lord Jesus again appeared to them, saying, "All power is given to me in heaven and on earth. Go, teach all nations, baptizing them in the name of the Father and the Son and the Holy Spirit, and teach them to observe whatever I have commanded you. And be comforted, for I am with you every day until the consummation of the world" (Matt. xxviii, 18–20). They adored Him in His coming and stayed with Him now in great happiness. Consider them well, and all that is said here, for it is exceedingly magnificent. He manifests to them that He is the Lord of all; gives them the command to preach; gives them the form of baptism; also gives them the greatest strength by saying that He will always be with them. See how much happiness He gives them and how many signs of charity He shows them. Having spoken, the Lord gave them a benediction and departed from them.

XCV. *How the Lord Appeared to the Disciples on the Sea of Tiberias*

The disciples still remained in Galilee. Once seven of

them went fishing on the sea of Tiberias and for the whole night caught nothing. When morning came, the Lord appeared to them a second time and stood on the shore of the sea. Pay attention to the things that were done here, because they are most delightful. When the Lord asked if they had caught anything, they answered, "No." He said, "Cast the net on the right side of the vessel and you will find something." They did this, and caught a great multitude. Wherefore John said to Peter, "It is the Lord" (John xxi, 5, 6). Then Peter, who was naked, put on his tunic and went quickly by way of the sea; the others went in the boat. And when they landed, they saw a fish placed on hot coals, and bread made ready, for the Lord had prepared this for them. He also had them take their fish and cook it, and eating together with them He made a great banquet and feast with them on the shore of the sea. Ministering to them with His customary humility, He handed them the bread and broke it into pieces, and similarly gave them the fish. They stayed reverently and with great willingness— these seven disciples—with their Lord: eating together with Him, they gaze into His desirable and joyful face and exult in their hearts. From His most sacred hands they take delectable food and are refreshed in spirit no less than in body. Oh, what a banquet this is! Observe each thing well and, if you can, feast with them. Attend none the less to the things that follow, for they are most lovely and most useful. The solemn banquet completed, the Lord said to Peter, "Do you love me more than these?" Peter answered, "Lord, you know that I love you." The Lord said to him, "Feed my lambs" etc. (John xxi, 15–17). Thus interrogating him three times, He recommended His flock to him. In which consider the usual goodness, charity, and humility of the Lord. For you can plainly see how diligently and affectionately He impresses upon and repeats to Peter that He recommends our souls to him. After this the Lord predicted Peter's death to him, saying, "When you were younger, you

girded yourself" etc. (John xxi, 18), signifying that by his passion on the cross God should be glorified. And when Peter asked about John, "What of this one?" the Lord answered, "I wish him to remain thus until I come," as if to say, "Not by the road of passion is he to follow me; but he will rest in old age and contemplation," by which the other disciples understood that he was not to die. But this would not be a great gift, because it is better to be dissolved and be with Christ. You have seen how many magnificent deeds and words there are in this appearance. After this, the Lord disappeared, and as usual went back to the holy fathers. But the disciples remained with great joy, and afterwards returned to Jerusalem, etc.

X C V I. *How the Lord Appeared to More Than Five Hundred Brothers at Once, and of His Appearances*

Again, the Lord appeared to more than five hundred brothers at once, as the apostle says (I Cor. xv, 6), but where or when is not mentioned. But the benign Lord standing among them, preaching and speaking of the kingdom of God, filled them with great gladness. Thus you have twelve appearances of the Lord from the Resurrection to the Ascension, without speaking of the two when the Ascension was near, which made fourteen. You must know, however, that only ten are mentioned in the Gospel. For how He appeared to His mother is not mentioned anywhere, but is piously believed. How He appeared to Joseph is told in the Gospel of Nicodemus. The apostle, in Corinthians, mentions the appearance to James, which the Blessed Jerome also refers to. The blessed apostle mentions the appearance to the five hundred brothers in the same place. The others are mentioned in the Gospel. You may meditate on many more, for it is probable that the most benign Lord often visited His mother and the disciples and the Magdalen, the beloved disciple, comforting and cheering those who had been so violently saddened and frightened by His Passion.

373

This the Blessed Augustine seems to feel, speaking of the time after the Resurrection. "Not everything," he says, "is written down. He had numerous meetings with them." And perhaps those holy fathers, especially Abraham and David, to whom promises had particularly been made by the Son of God, came with Him to see their most excellent daughter, the mother of the Lord, who brought about grace for them all and bore the Redeemer. Oh, how happily they looked at her and reverently bowed to her, and all as far as they could provided blessings, although unseen by her! Again in the usual way you may consider in this the benignity, charity, and humility of the Lord, which we have often mentioned and which shine forth in all His acts, in that even after He gloriously conquered and rose again, He wished to be a pilgrim for forty days in order to confirm and strengthen His disciples. For justly, after so many years, after so many labors and afflictions, after such an ignominious and bitter death, the Triumphator could have returned to His glory, and by His angels confirmed and comforted the apostles at His will; but because His charity would not permit this, He wished to converse with them personally, appearing to them for forty days with many proofs and speaking of the kingdom of God. For them and for us He did this; but we do not pay attention to it. He loved you vehemently, and is not beloved, yet near such a fire we should be not just warm but burning. Now let us turn to the Ascension.

x c v i i. *Of the Ascension of the Lord*

In respect to the Sunday of the Ascension you must be watchful, so that if at any time you were present at His words and deeds with your whole mind you are now even more so. For this solemnity surpasses all others, as I shall show you more clearly below. And this at least should animate your attention, that now the Lord is departing as to corporal presence, having completed the course of His pilgrimage. Wherefore His words and deeds are to be consid-

ered more attentively, for every faithful soul owes it to her
Bridegroom, her Lord, and her God to observe His depar-
ture more vigilantly, to embrace in mind what was said and
done by Him more intently, and to recommend herself to
Him more devoutly and humbly, wholly withdrawing her
soul from everything else. Thus the Lord Jesus, forty days
from the Resurrection, knowing that the hour had come
for Him to pass from this world to the Father, having loved
His own, now truly loved them to the end. Therefore, tak-
ing the holy fathers and other souls out of the earthly para-
dise, staying and blessing Elijah and Enoch, who still
remained there alive, He came to His disciples, who were
in the Cenacle on Mount Sion with His mother and the
others, appearing to them in order to eat with them before
His departure in memorial token of His love and joy.
While all were eating together with great pleasure at this
last banquet with their Lord, the Lord Jesus said to them,
"It is time for me to return to Him who sent me; but you
remain here in the city until you receive power from above,
for in a few days you will be filled with the Holy Spirit, as
I promised you. Afterwards you will go all over the world
preaching my Gospel and baptizing believers, and you will
be witnesses to me to the ends of the earth." Also, He re-
proached them for their incredulity in not believing those
who had seen Him rise, that is, His angels. This He partic-
ularly did now, when He spoke of preaching, as if He would
have them understand this: "Much more should you have
believed the angels, even before you had seen me, than
should the people, who will not see me, believe your preach-
ing." He does this also so that they should remain humble
in acknowledging His disappearance, showing them in His
departure how much humility pleased Him, as though
particularly recommending it to them. Asked about future
times, He did not wish to answer, because it was not ex-
pedient for them. Therefore they stayed, ate, and spoke,
and were joyful because of the presence of their Lord,

though nevertheless troubled on account of His departure. For they loved Him with so much tenderness that they could not bear with equanimity the word "departure."

What shall I say of the mother, eating near Him, who above everyone else loved Him so intensely? Do you not believe that at the idea of the departure of her Son, touched and moved sweetly by maternal love, she rested her head against her Son and reclined on His breast? For if John did this at the Supper, you may meditate that much more probably she did so here. Sighing tearfully, she besought Him, saying, "My Son, if you wish to depart, take me with you." The Lord consoled her and said, "I pray you, dearest mother, do not be grieved at my departure, for I am going to the Father. But it is expedient for you to remain here for a time, to confirm the believers. Afterwards I shall come to you and take you up into my glory." The mother answered, "My most beloved Son, let it be according to your will. For I am ready not only to remain but to die for the souls for whom you died; but remember me." Then the Lord consoled her, and the disciples, the Magdalen, and the others, saying, "Do not let your heart be disturbed or frightened. I will not leave you orphans. I go and I return to you, and I will always be with you." At length He told them that they should go to the Mount of Olives, because He wished to ascend from there, and then He disappeared from them. Therefore the mother and all the others went without delay to the aforesaid mount, which is about a mile from Jerusalem, and there the Lord again appeared to them. Behold how today you have two appearances. Now He embraces the mother, bidding her farewell, and the mother tenderly responds. The disciples and the Magdalen and all the others prostrate themselves weeping and kiss His feet, and He raises His apostles and benignly kisses them.

Now observe them well, and all that is done. Consider the holy fathers not any the less, in the same place, although invisible; how freely and reverently the Lady was regarded

and affectionately blessed, through whom they received so much of a benefit; how also those excellent champions and leaders of the divine army were regarded, whom the Lord selected among all to conquer and win the whole world. At last, all the mysteries completed, the Lord Jesus began to rise above them and ascend by His own strength. Then the mother and all the others prostrated themselves on the ground. The Lady said, "My blessed Son, remember me." And she could not restrain her tears at His departure, although she was very joyful that her Son thus gloriously showed the approach to heaven. His disciples also said to Him, "Lord, we gave up everything for you; remember us." He Himself, with hands raised, with face serene and joyful, regally crowned and adorned, was triumphantly raised into heaven. Blessing them, He said, "Be constant and act manfully, because I will always be with you." Then He ascended, leading that noble multitude with Him, making a way for them, as Micah the prophet said (Mic. ii, 13). And so the Lord, glorious, white, and rubicund, splendid and joyful, preceded them, showing them the way; and they, singing and jubilating, most happily followed Him, saying, "Let us sing to the Lord who ascends above death; the Lord is His name (Psalm lxvii, 5). May His mercies bless the Lord; and His wonders, the sons of man (Psalm cvi, 8, 15, 21). Blessed are you, O Lord our God, who grant salvation to those who trust in you (Psalm xvi, 7), leading forth your people in exultation and your elect in gladness (Psalm civ, 43). Be exalted above the heavens, O God, and let your glory be above the whole earth, that your Beloved may be liberated (Psalm cvii, 6, 7). Ascending on high, making the road favorable for us, leading us into refreshment, you draw forth your bound ones in fortitude (Psalm lxvii, 7), bestowing our desire upon us. We shall enter into your house and in the sight of your angels play and sing to you: 'Glory, praise, and honor be unto you, O King, Christ, Redeemer; kingdoms of the earth, sing to God, play to the Lord.'"

Meanwhile Michael, the prefect of Paradise, continuing towards the Home, announced that the Lord was ascending. Behold, all the orders of spirits in regular array went forth in succession to meet Him—not one of them remained that did not come before their Lord—and, bowing themselves with all possible reverence, with ineffable hymns and canticles they led Him in. Who can describe the songs and jubilo that were made? Then the princes came together with the singers and said, "Alleluia, alleluia, alleluia. O blessed King, who comes in the name of the Lord; to you who reign, behold, we make our song.

"Alleluia, alleluia, alleluia. Blessed are you, O Lord, who sit above the cherubim and contemplate the abyss (Dan. iii, 55), alleluia, alleluia, alleluia. You are worthy of the glorious victory you have won, alleluia. Let the heavens reveal your miracles, O Lord (Psalm lxxxviii, 6), alleluia, and your strength, alleluia. Behold now the tribes of the Lord ascend, alleluia, to confess and say to you, 'Alleluia,' to rejoice in the joy of your people, in order to praise your inheritance (Psalm cv, 5), alleluia, alleluia, alleluia." In such canticles and confessions they honored the Lord on all sides, exulting before Him and making a great festival, with all reverence. And who can describe this joy?

But who could say what the most blessed spirits and the most holy fathers did, when they met each other? The supernal spirits first did reverence before the Lord and finished their canticles, then with great happiness they said, "Princes of the people, we congratulate you, alleluia; you have met with your God, alleluia, and are greatly raised up, alleluia; sing to Him who ascends above the heaven of heavens, alleluia, alleluia." And the holy fathers quickly responded, "Princes of the people of the Lord, alleluia; our guardians and helpers, alleluia; joy and peace be with you, alleluia; sing to our King, alleluia. Exult in God our helper, alleluia, alleluia, alleluia." Adoring in turn they said, "We go into the house of the Lord rejoicing, alleluia, alleluia;

the venerable city of God will receive us, alleluia; we are sheep in the pasture of the Lord; let us enter its gates and courtyards, alleluia, with hymns and canticles, alleluia. For the Lord of Hosts is with us, alleluia; He is our protector, alleluia, alleluia." You see how everyone jubilated and sang. For according to the prophet, "God ascends in jubilation, and the Lord in the voice of the trumpet" (Psalm xlvi, 6). The Lord Jesus, then, ascended distinctly, for the consolation of the mother and the disciples, for as far as they could see Him. Then a cloud received Him from their sight, and in a moment He was with all the angels and aforementioned holy fathers in His Home. Thus the aforementioned prophet said, "In a cloud you make your ascent, you who walk on the wings of the winds" (Psalm ciii, 3). The wings of the winds are the summits of the winds, that is, the parts that go before and are the swiftest. And He ascended more quickly when the cloud intervened. There remained the mother and the disciples and the Magdalen and the others, kneeling, gazing after Him into heaven as far as they could.

Oh, what it was to see the Lord so gloriously ascending! And what if it had been possible to see and hear the most blessed spirits and holy souls entering together with Him! Perhaps the soul would have separated from the body for joy and ascended with them. While they raised their faces to gaze at Him, behold, two angels in white robes stood near them, saying, "O men of Galilee, why do you stand gazing into heaven? This Jesus who was taken up from you is in heaven: He will come in the same way as you saw Him go into Heaven. Go back to the city, then, and wait, as He told you" (Acts i, 11). Consider how solicitous the Lord was of them. For as soon as He vanished from their eyes, He sent His angels, that they might not be wearied by staying in the same place too long, and that the hearers might be comforted by the angelic testimony according with the Ascension of the Lord. Hearing these words, the

Lady humbly begged the angels to recommend her to her Son. They bowed to the ground and gladly accepted her message. The apostles, the Magdalen, and all the others spoke similarly. And so these disappeared, and those returned to the city, to Mount Sion, waiting at that place as the Lord Jesus had commanded them.

But the Lord Jesus, with the whole aforesaid happy and magnificent multitude, opening the gates of Paradise, until then closed to mankind, triumphantly entered and, kneeling joyfully to the Father, said, "Father, I thank you for giving me the victory over all our adversaries. Behold our souls that were held in captivity! I present them to you. But I promised to send the Holy Spirit to my brothers and disciples, whom I left in the world. I beg you, my Father, to fulfil the promise, and I recommend them to you." Then the Father, raising Him, made Him sit at His right hand and said, "My blessed Son, I gave you all power and judgment. Dispose as you will concerning these disciples and the mission of the Holy Spirit." Then all the holy fathers and most blessed spirits, who had adored before the Father prostrating themselves on their faces, rose and began their canticles and jubilated praises before God. For if Moses and the children of Israel, after the crossing of the Red Sea, sang a song to the Lord, saying, "Let us sing to the Lord, gloriously" etc. (Exod. xvi, 1); and Mary the prophetess, his sister, and the rest of the women following her, sang to the Lord God in timbrel and choir; how much more now that all the adversaries were overcome? Similarly when David led the ark of the covenant of the Lord to Jerusalem, the whole populace sang appropriately, and David played the harp with the singers, and everyone praised the Lord with their harps and timbrels, and David danced with all his might before the Lord, how much more would they that were truly with the Lord in so much joy do now? And if John, as it says in the Apocalypse (Apoc. xiv, 3), heard a voice in heaven of a hundred and

forty-four thousand harpers harping with their harps and singing as it were a new song before the seat of God and the Lamb, whatever joy that signified I suppose was very much greater in what happened on this day. All together there sing, all exult, all rejoice, all chant, all jubilate, all clap their hands, all chorus, all are gladdened, all dance. Truly now in the supernal Jerusalem is heard the canticle of gladness, and in all its streets everyone says "Alleluia." Never, from the origins of the world, was such a feast and such a solemn Pasch celebrated, nor perhaps will there be again until Judgment Day, when all the elect will be presented there in glorious bodies. And therefore I said to you at the beginning that this solemnity, all things considered, surpasses all others. Go through each thing separately and you will see if I speak the truth. A great Pasch and solemn feast is the Incarnation of the Lord, and the beginning of all our good; but that was for us, not for Him, for He was then enclosed in the virginal womb. Another great Pasch is His Nativity, but that is ours too. For He is to be pitied, because He was born to so much poverty, meanness, and penury. Similarly His Passion is a great feast on our account, for then all our sins were taken away. For nothing, so Gregory said, would it profit us to be born unless we received deliverance; but because of the most cruel torments and most shameful death that He suffered, it could not be a matter for joy and gladness either to Him or to us. Great and solemn, moreover, and a great Pasch, is the Resurrection of the Lord Jesus, as much for Him as for us, because He appeared gloriously as triumphator, and we were justified. Indeed it is very venerable, and therefore the Church sings of it particularly: "This is the day that the Lord has made" etc., according to the Blessed Augustine. This day is altogether holier than any of the preceding. But this day of the Ascension appears greater and holier, because although the Lord was resurrected, yet He still went as a pilgrim on earth, the gate of Paradise was still

closed, the holy fathers were still not gone to the Father. All this was completed in the Ascension. And if you examine well, whatever God did before, He did in order to gain this end, and without it all His works would be imperfect. For heaven and earth and all that are in them were made for man's sake, and man was made for glory. But after the Fall, until this day, no one, however just, could attain it. You see how magnificent and wonderful this day is. Similarly an exceedingly great Pasch is the day of Pentecost, and the Church greatly solemnizes it, and rightly, for then she received the highest gift, that is, the Holy Spirit. But this was for us, not for Him. But this day, the day of the Ascension, is particularly the most solemn feast of the Lord Jesus, because today He begins to sit at the right hand of the Father and rests from His pilgrimage. And this feast is also particularly for all the supernal spirits, because they receive new joy from their Lord, whom they did not see there previously in human form. And because today the ruins of these first begin to be restored in a great multitude of the blessed, it is particularly for the illustrious patriarchs, prophets, and holy souls that entered into the supernal Home for the first time. If, therefore, we celebrate a feast for some saint going to heaven, how much more so for so many thousands, and how much more so for the Saint of saints! It is also the feast of the Lady, who saw her Son regally diademed, raised as the true Lord, ascending above the heights. Nonetheless is it also properly our feast, for human nature today is exalted above the heavens, because if Christ had not ascended we could not have received that gift of the Holy Spirit that we so rightly solemnize. Wherefore He said to His disciples, "It is expedient that I go, for if I do not go the Paraclete will not come to you" (John xvi, 7). To strengthen my words, I adduce Bernard, who speaks thus of this day in the sermon on the Ascension of the Lord: "This solemnity, dearest ones, is glorious. For it is the consummation and completion of all the other solem-

nities and the happy ending to the whole journey of Jesus Christ, Son of the living God.[223] Rightly celebrated are the solemnity and joy of the day when the supercelestial Sun, the Sun of justice, presented Himself to be seen. Great joy was there indeed, and as great exultation, when, tearing off the sackcloth, He was girded with joy and dedicated the first fruits of our Resurrection. Nevertheless, what are these solemnities to me if my behavior binds me to the earth? . . . Therefore I say that the exile of this habitation seems to me not much more tolerable than Hell. In short, 'Unless I go, the Paraclete may not come to you.' . . . Do you not see that the solemnity that we celebrate today is the consummation of all the others, declaring the fruit and increasing grace? For as all the rest was done for us by Him who was born for us, so also His Ascension was done for our sakes, and He made it for us." [224] So Bernard says. Therefore you see clearly that this day is more solemn than all others. And the soul that truly loves the Lord Jesus should exult more today than on any other day of the year. Wherefore He said to the disciples, "If you loved me, you would rejoice, because I am going to the Father" (John xiv, 28). And on that account I believe I said rightly that never until then was such a day as this one solemnized in the Home; and the joy and exultation of so great a feast continued to the day of Pentecost. One can meditate in this manner: the Ascension of the Lord was at the sixth hour, for He first ate with His disciples at the third hour. Although everyone in the Home exulted more than I can say, yet on the first day, until sext on the following day, the angels particularly celebrated, and the Lord Jesus showed or made some special familiarity and consolation. On the second day the Archangels did so. On the third, the Principalities. On the fourth, the Powers. On the fifth, the Virtues. On the sixth, the Dominations. On the seventh, the Thrones. On the eighth, the Cherubim. On the ninth, the Seraphim; which are the nine orders of angels. They

continued thus until sext on the sabbath of the vigil of Pentecost. And then the holy fathers celebrated until the third hour on Sunday.

XCVIII. *Of the Mission of the Holy Spirit*

When all these things were completed, the Lord Jesus said to the Father, "My Father, remember the promise I made to my brothers about the Holy Spirit." The Father replied, "My Son, I am very pleased that you promised. It is time to fulfil your promise; therefore say to the Holy Spirit, 'We beg you to descend to our disciples and to fill them, console them, strengthen them, instruct them, and confer on them great virtues and joys.' And immediately It came and descended in tongues of fire upon the hundred and twenty disciples gathered together and filled them with all joy, by the strength of which the disciples were invigorated, taught, and enkindled, as well as illuminated, and they went all over the whole world and for the great part subdued it. Afterwards in the supernal city they praised and always praise the Lord none the less and keep the day in gladness, and never is there lacking there a solemnity, an act of grace, or a voice of praise. For it is written, "Blessed are those that dwell in your house, Lord: they will praise you forevermore" (Psalm lxxxiii, 5). Let us hasten, then, to enter into that rest where there is so much superabundance of indefectible joy, and let us sigh for the Home with all our might. Let us hate this poor, putrid bodily structure of ours, and let us not take care for its desires, which keep us imprisoned here, wanderers from so much good. Let us then say with the apostle, "Unhappy man that I am, who shall free me from the body of this death?" (Rom. vii, 24). And again, "While we are in this body, we are in pilgrimage away from the Lord" (II Cor. v, 6). And again, "I long to be dissolved, and to be with Christ" (Phil. i, 23). Let us desire this dissolution and continually ask it of the Lord, because we are not able to obtain

384

it safely by our own strength. And again, let us at least die to the world, to its pomps and concupiscences. Let us withdraw with strong and persevering hearts from these transitory things and from the poor, short, little consolations of visible things that corrupt and wound our souls. Let us then ascend in mind with the Lord, or rather to the Lord, and may our conversation with Him be in heaven. And doing thus, may we be not wholly pilgrims and strangers, so that in the time of visitation He of whom we speak may deign to take us to Him: our Lord Jesus Christ, who is blessed God over all, to whom be praise forever and ever. Amen.

XCIX. *Exciting the Desire for the Heavenly Home by the Wish for Death*

In the above, dearest daughter, you have had the life of the Lord Jesus given to you for the most part in meditations. Accept it reverently, willingly, and joyfully, and do not be lazy in using it with all devotion, cheerfulness, and solicitude, for this is your way and your life, the foundation on which you can construct a great edifice. You must begin from this if you wish to ascend to the more sublime, as you have read in many places above. For this meditation on the life of Christ not only nourishes sweetly, but leads on to better food. For these are what the Lord bore in the flesh; but it is far more sublime to consider those of the spirit, to which you can arrive by this ladder; but pause here for a while first. On this Bernard speaks thus: "I consider the principal cause for the invisible God to wish to be seen in the flesh, and converse with men, to be that those who could not love except carnally He might first draw to Him in the affection of carnal love, and so by degrees lead on to spiritual love." And again, "He showed the disciples the higher degree of love when He said, 'It is the Spirit that enlivens: the flesh does not profit anything'" (John vi, 64). And a little farther on, "In the devotion of the flesh, there-

fore, there is consolation for a while for him who has not the vivifying Spirit, in the same measure as for those who said, 'Christ the Lord is the Spirit before our face'" (Lam. iv, 20). And again, " 'If we knew Christ according to the flesh, now we know Him no more' (II Cor. v, 16). For surely Christ is not loved in the flesh without the Holy Spirit and without its fullness. Thus the measure of this devotion is that this sweetness fills his whole heart and replaces carnal love of the world and carnal allurements: this is to love with the whole heart. Otherwise, if I prefer my flesh and blood, or my pleasure, to the flesh of my Lord, less is fulfilled of what He taught me in word and example by becoming Man. Does it not show clearly that I by no means love with all my heart when, divided, I seem to give one part to His flesh and turn aside another part to my own? He even says, 'He that loves father or mother more than me is not worthy of me' (Matt. x, 37). Therefore, to speak briefly, to love with all one's heart is to esteem all that is pleasing to one's own flesh or another's less than the love of the sacrosanct Flesh. I comprehend in this equally the glory of the world, for the glory of the world is the glory of the flesh, and those who delight in it are undoubtedly carnal." [225] You see that this meditation is carnal but can be looked at spiritually. Do not receive it so that your devotion is lessened, but let your fervor increase to the greater part that you reach by passing through this, and may your feelings be enkindled, so that you immerse yourself wholly. That carnal meditation is good that excludes the carnal life and condemns and vanquishes the world. Exercising it, you will be steadied in mind, educated in virtue, and will receive strength of soul, as I told you in the prologue. Let meditating be your whole and only intent, your rest, your food, your study. From it you will have not only the aforementioned good consequences; it will be to you not only a step towards the heavenly Home and the contemplation of the Majesty; but it will continually and

perpetually be your consolation. Even those who ascend to greater contemplation ought not to renounce it, at the right place and time. Otherwise it will seem to be condemned as vile, which would show great pride. Remember what you have read above, in the treatise on contemplation, that is, on the humanity of Christ, that the Blessed Bernard, the highest contemplator, never renounced it. As appears in his sermons, he esteemed and praised it beyond measure.

c. *Of the Manner of Meditating on the Life of Christ,
and of the Conclusion of the Little Work*

I also wish to give you the manner that you should follow in meditating on the above, so that you do not try to include all that you find there and then neglect it because it is such a weighty mass, especially as I think that the above meditations should occupy the space of one week. Therefore you ought to know that it is enough to meditate only on what the Lord did or on what happened concerning Him or on what is told according to the Gospel stories, feeling yourself present in those places as if the things were done in your presence, as it comes directly to your soul in thinking of them. The moralities and authorities that I placed in this work for your instruction need not be used in the meditations, unless the virtue to be embraced or the vice to be avoided occurs of itself to your thoughts. Therefore, in this meditating, choose some quiet hour. Afterwards, later in the day, you can take the moralities and authorities and studiously commit them to memory. It is fitting to do so, for they are most beautiful and can instruct you on the whole spiritual life.

Divide the meditations thus: beginning on Monday, go on to the flight of the Lord into Egypt. Stop there, and on Tuesday, returning to it, meditate up to the opening of the book in the synagogue. On Wednesday, from there to the ministry of Mary and Martha; on Thursday, thence to the Passion; on Friday and Saturday, to the Resurrection; on

Sunday, from the Resurrection on to the end. Do the same thing every week, so that these meditations become familiar to you; because the more you do so, so much the more easily as well as cheerfully will they come to you. Converse freely with the Lord Jesus and, in imitation of the Blessed Cecilia, strive to place His life, as she did the Gospel, inseparably in your heart.

And so it is time to seal the book; but let this be not in my words but out of the richness of Father Bernard, from whom I have already picked so many beautiful flowers. Let the conclusion be in the name of Him who is the sealed book, our Lord Jesus Christ, to whose praise the book was made. Wherefore the Blessed Bernard, insofar as he looks at the present material, speaks thus on the words, "Your name is as oil poured out" (Song of Sol. i, 2): "Undoubtedly there is a similarity between oil and the name of the Bridegroom; not idly did the Holy Spirit compare them to each other. I also speak of the triple quality of oil, for it lights, feeds, and anoints; you need have nothing better. It sustains fire, nourishes flesh, soothes pain: it is light, food, medicine. See now the same things in the name of the Bridegroom: it gives light when it is preached; it nourishes when it is recognized; it soothes and anoints when it is invoked. Let us examine each of these. Whence do you think there came into the whole world so great and so sudden a light of faith, if not from the preaching of Jesus? Is it not in the light of this name that God called us into His admirable light? To those illuminated, who in the Light saw the light, Paul rightly said, 'You were once shadows, but now you are light in the Lord'" (Eph. v, 8). And below, "The name of Jesus is not only light but also food. Are you not wholly strengthened, as often as you remember it? What equally strikes the thinking mind, what so repairs the wearied sense, strengthens virtues, stirs up good and honorable habits, encourages chaste affections? All food for the soul is dry if oil is not poured over it: it is insipid if not

388

seasoned with this salt. If you write, it is not palatable to me unless I read Jesus therein. If you dispute or confer, it is not palatable to me unless Jesus sounds therein. Jesus is honey in the mouth, melody in the ear, jubilee in the heart; but it is also medicine. Is any of you sad? Let Jesus come to his heart and thence leap into his mouth. And behold, the dawn of the name that is light disperses all clouds, brings back serenity. Is someone falling into sin, running in desperation into the snare of death? If he invokes the name of Jesus, does it not immediately breathe him back to life? If someone has salvation by this name before his face, do not the usual hardness of heart, torpor of idleness, rancor of soul, and languor of acedia, flee? If someone whose fountain of tears is dried up calls upon Jesus, does it not break forth more copiously and flow more sweetly? If someone palpitates and trembles in peril, does not invoking the name of power immediately bring confidence, drive away fear? If, I ask, someone is excited and fluctuating in doubt, does there not suddenly, at the invocation of the splendid name, spring forth certainty? If someone despairs in adversity and sounds the name of help, does he not receive fortitude? These are undoubtedly diseases and weaknesses of the soul: that is their medicine. Finally, this can be proved, for He says, 'Call on me in the day of tribulation: I will deliver you, and you shall honor me' (Psalm xlix, 15). Nothing so well restrains anger, soothes the swelling of pride, heals the wound of envy, staunches the flow of luxury, extinguishes the flame of lust, tempers the thirst of avarice, and puts to flight the prurience of the disgraceful. For with the name of Jesus, I set before myself a Man of gentle and humble heart, benign, temperate, chaste, merciful, shining with all purity and sanctity, who is also omnipotent God, who heals me by His example and strengthens me by His help. All this is meant to me when Jesus is mentioned. I make myself an example of the Man and a help of the Potentate: these are, as it were, kinds of ingredients; and I

use them to make such a concoction as no doctor can make. You, O my soul, have an electuary hidden in the vessel of that name that is Jesus, the healthbearer, indeed, by which your diseases never fail to be cured. Let it be always in your breast, always in your hand, so that all your senses and actions may be directed towards Jesus. Finally, you are invited: 'Set me,' He says, 'as a seal upon your arm' (Song of Sol. viii, 6). But of this at another time. Now truly you have the means of curing your arm and your heart. You have, I say, in the name of Jesus, the means of correcting your actions and wickednesses, or of perfecting your imperfections, also of keeping your senses or slaves from corruption, or of healing them if corrupted."[226] Again, "How beautiful you are to your angels, Lord Jesus, in the form of God, in the day of your eternity, in the splendor of the saints, begotten before the morning-star, the splendor and figure of the substance of the Father, indeed the perpetual and utterly clear brightness of eternal life! How fair you are to me, my Lord, in the placing of your fairness! And even when you emptied yourself, when your unfailing light laid aside natural light, there great piety shone forth, there charity gleamed the more, there grace was more radiant. How dear to me as you arose, star of Jacob! How bright as you came forth, flower from the root of Jesse! In what a joyful light you visited me in the darkness, Dayspring from on high! How spectacular and stupendous in supernal powers, in conception of the Holy Spirit, in birth of the Virgin, in innocence of life, in eloquence of doctrine, in coruscations of miracles, in revelations of sacraments! How golden-red, after the sunset, O Sun of justice, you rise from the heart of the earth; how lovely in your apparel! At last, O King of glory, you betake yourself to the highest heaven; how could all my bones keep from saying to me for all this, 'O Lord, who is like you?' (Psalm xxxiv, 10). In a similar way I think of the Beloved as did the Bride, when she gazed at Him and

said, 'Behold, you are beautiful and fair' (Song of Sol. i, 15), and not only this but in addition something undoubtedly superior in the nature of fairness that wholly escapes our vision and flees our tests. The repetition designates the double beauty of the substance." [227] So Bernard says. Thanks be to the living God forevermore. Amen.

*NOTES
ON THE TEXT
AND ON THE PICTURES*

NOTES ON THE TEXT

1. Two phrases very similar to parts of this opening sentence have been found in a manuscript legend of St. Cecilia in Florence, Bibl. Riccardiana, 1443 (Q. I. 20), fol. 147ro. See C. Fischer, "Die 'Meditationes vitae Christi,' ihre handschriftliche Überlieferung und die Verfasserfrage," *Archivum franciscanum historicum,* xxv, 1932, p. 457. They are also included in the *Legenda aurea,* chap. clxix (ed. Graesse, 1890, p. 771).

2. Latin: ". . . with the organs singing, she with steadfast heart called to God only, saying. . . ." For the whole passage, from the wedding on, cf. *Legenda aurea, op.cit.,* pp. 771f. "Latin" above and hereafter refers to the Latin edition, *Meditationes vitae Christi,* in *Opera Bonaventura,* Venice, 1761, xii.

3. Bernard of Clairvaux, Sermon lxi in Cantica Canticorum (hereafter cited as Serm. in Cant.), ed. Mabillon, in J.–P. Migne, *Patrologia latina* (hereafter MPL), clxxxiii, col. 1074.

4. Bernard, Serm. xxii in Cant., *ibid.,* col. 884.

5. Latin: ". . . became almost His image."

6. Latin: "Jerome."

7. Bernard, Serm. i in festo annuntiationis beatae Virginis, MPL clxxxiii, cols. 387ff. C. Fischer, *op.cit.,* compares passages from this sermon with the *Meditations* in parallel columns to show the close relationships.

8. Cf. *Rivelazioni sulla vita della Madonna,* vi and viii, reprinted in *Prosatori minori del trecento,* i, 1954, pp. 1067ff., 1072, based on an earlier edition by Manni in *Vita di alcuni Santi,* Florence, 1735, pp. 355–370.

9. In the Pseudo–Matthew, or *Liber de ortu beatae Mariae,* the apocryphal Latin infancy gospel (attributed to Jerome in letters preceding the text proper). See Charles Michel, *Évangiles apocryphes,* i, Paris, 1911, pp. 74ff. L. Oliger, *Studi Francescani,* n.s., vii, 1921, p. 160 and n. 2, traced the source of the passage only as far as a manuscript in the Vatican, lat.4257, fols. 33ro.–44vo.

10. Ms. ital. 115, err.: "ninth year."

11. This may refer to the *Golden Legend;* cf. *Legenda aurea, op.cit.,* p. 589.

12. Latin: *"paranymphus."*

13. Ms. ital. 115 mistakenly adds "to the feast in Jerusalem."

14. Latin: "Since Joseph wished to go to his city, i.e., Bethlehem, and knew that the time of his wife's giving birth was approaching, he took her with him. Thus the Lady went on the long journey, for Bethlehem is five or six miles from Jerusalem. Therefore they took with them an ox and an ass."

15. Latin: "All sent her and her companion away, and thus they were pressed to turn aside to a covered alley where men were accustomed to take shelter in time of rain."

16. Bernard, Serm. I in vigilia nativitatis Domini, MPL CLXXXIII, col. 89.

17. *Idem,* Serm. V in nativitate Domini, *ibid.,* col. 130.

18. *Liber exhortationis, vulgo De salutaribus documentis,* chap. xviii, MPL XL, col. 1053. Not by Augustine.

19. Bernard, Serm. II pro dominica I novembris, MPL CLXXXIII, col. 348.

20. *Idem,* Serm. III in nativitate Domini, *ibid.,* cols. 123f.

21. "By His mother" not in Latin.

22. I Tim. vi, 8, paraphrased by Bernard, Serm. I in circumcisione Domini, MPL CLXXXIII, col. 134.

23. Gregory the Great, Hom. XI in Ezechielem, MPL LXXVI, col. 907. The second part differs: "Quasi enim quoddam nutrimentum verbi, est censura silentii."

24. *Idem,* Moralia, book V, MPL LXXV, col. 695.

25. Bernard, Serm. II in dominica prima post octavam epiphaniae, MPL CLXXXIII, col. 161.

26. *Idem,* De consideratione libri quinque ad Eugenium tertium, II, xiii, MPL CLXXXII, col. 756.

27. *"Gente"* here and twice later in this passage; *"gentiles"* in Latin. The interpretation as *"pagani,"* which follows, is not made in Latin in any of these three places.

28. Antiphon for Lauds on Epiphany.

29. Latin: *"purus."*

30. *"Opera curiosa";* later, in Italian, *"opera curiosa," "curiositade," "curiose cose,"* translated by the cognate word.

31. Gregory the Great, Hom. XXX in Evang., MPL LXXVI, col. 1221.

32. Bernard, Serm. de conversione ad clericos, viii, MPL CLXXXII, col. 842.

33. Ms. ital. 115, err.: "73."

34. *Ibid.,* err.: "iii."

35. Bernard, Epist. LXXXVII, ad Ogerium canonicum regularem, MPL CLXXXII, col. 217.

36. *Idem,* Serm. XXXIV in Cant., MPL CLXXXIII, col. 960.

37. Latin: *"recreationem."*

38. Bernard, Serm. I in epiphania Domini, MPL CLXXXIII, col. 145.

39. *Idem,* Serm. XLII in Cant., *ibid.,* col. 990.

40. *Idem,* Serm. XLVII in Cant., *ibid.,* col. 1011.

41. *Idem,* Serm. LXXXIV in Cant., *ibid.,* col. 1185.

42. *Idem,* Serm. XXXVII in Cant., *ibid.,* col. 974.

43. *Idem,* Serm. LXXXV in Cant., *ibid.,* col. 1194.

44. *Idem,* Tractatus de gradibus humilitatis et superbiae, MPL CLXXXII, col. 942.

45. *Idem,* Serm. II in nativitate Domini, MPL CLXXXIII, col. 122.

46. *Idem,* Tractatus de moribus et officio episcoporum, epist. XLII ad Henricum archiepiscopum Senonensem, V, MPL CLXXXII, col. 825.

47. *Idem,* Hom. IV super Missus est, MPL CLXXXIII, col. 84.

48. *Idem,* Hom. I super Missus est, *ibid.,* cols. 58f.

49. *Idem,* as note 46, iii and v, cols. 816f., 820f.

50. *Idem,* Serm. I in epiphania Domini, MPL CLXXXIII, cols. 146f.

51. Apparently err. for Matt. iv, Mark i, Luke iv.

52. John Cassian, Collationes patrum, I, vii, MPL XLIX, col. 489.

53. Error in Ms. ital. 115 makes this negative: "do not despise."

54. Bernard, Serm. XL in Cant., MPL CLXXXIII, col. 983.

55. *Idem,* Serm VI in Psalmum XC, Qui habitat, *ibid.,* col. 199.

56. *Idem,* Serm. XIV in Psalmum XC, *ibid.,* col. 240.

57. Latin: "from the Baptism."

58. In the preface to the Gospel of John; Wordsworth and White, *Nouum testamentum Domini nostri Iesu Christi latine,* I, iv, Oxford, 1895, p. 485.

59. Peter Comestor, Historia scholastica, MPL CXCVIII, col. 1559.

60. See above, n. 58.

61. Latin: "she was not herself one of those reclining (*discumbentibus*) at the table, but one through whose hands. . . ." Here and in the sentences following, Ms. ital. 115 omits "reclining" in the phrase "reclining at the table."

62. Bernard, Serm. II in dominica prima post octavam epiphaniae, MPL CLXXXIII, col. 160.

63. Augustine, Confessionum, XIII, ix, MPL XXXII, col. 849.

64. Bernard, Serm. IV de adventu Domini, MPL CLXXXIII, col. 49.

65. *Idem*, Serm. XXI in Cant., *ibid.*, cols. 875f.

66. Ms. ital. 115, err.: "iii."

67. Latin: "Lover."

68. Ms. ital. 115, err.: "viii."

69. Bernard?, passage not identified.

70. Ms. ital. 115, err.: "viii."

71. Latin: "Oh, what a gift. . . ."

72. Bernard, Serm. XXIX in Cant., MPL CLXXXIII, col. 930.

73. *Idem*, Serm. XXVII, *ibid.*, cols. 919f.

74. Ms. ital. 115 adds, err.: "Luke vii."

75. Sermo in nativitate S. Joannis Baptistae, MPL CLXXXIV, col. 1000. Not by Bernard.

76. Ms. ital. 115, err.: "John Chrysostomus." Peter Chrysologus, Serm. CXXVII, De decollatione D. Joannis Baptistae, MPL LII, col. 549.

77. Latin: ". . . prepares his neck, humbly kneels, and, thanking God, places his most consecrated head on some block or stone and patiently bears the blow by which it is completely cut off."

78. "*Secretario*."

79. Ms. ital. 115, err.: "iii."

80. *Ibid.*, err.: "vi."

81. *Ibid.*, err.: "of Corinthians."

82. Bernard, Serm. XXXII in Cant., MPL CLXXXIII, col. 946.

83. *Idem*, Serm. LXXIV, *ibid.*, col. 1140. "*Verbum*" in Latin in this passage and elsewhere; "*Figliuolo di Dio*" in Ms. ital. 115.

84. *Idem*, Serm. XVII, *ibid.*, col. 856.

85. Gregory the Great, Hom. XXX in Evang., MPL LXXVI, col. 1221, the same passage quoted once before (p. 74).

86. Ms. ital. 115, err.: "fifth."

87. Bernard, Serm. vi in Psalmum xc, Qui habitat, MPL clxxxiii, cols. 198f.

88. *Idem,* Serm. iv in ascensione Domini, *ibid.,* cols. 310ff.

89. *Idem,* Serm. ii, *ibid.,* col. 304.

90. *Idem,* Serm. seu Liber de conversione ad clericos, xxi, MPL clxxxii, col. 855.

91. John Chrysostomus, passage not identified.

92. Bernard, Serm. ix in Cant., MPL clxxxiii, col. 818.

93. *Idem,* Serm. v in capite jejuni, in quadregesima, *ibid.,* cols. 179f.

94. *Idem,* Serm. lxxxvi in Cant., *ibid.,* col. 1196.

95. Ms. ital. 115, err.: "16th."

96. *Ibid.,* err.: "Let us not disdain our brothers. The seed is a small thing and great fruit is born of it."

97. Bernard, Serm. xvii in Psalmum xc, Qui habitat, MPL clxxxiii, cols. 251f.

98. *Idem,* Serm. xxv in Cant., *ibid.,* col. 902.

99. Ms. ital. 115: "injury" (*iniuria,* possibly misread from Latin *murra*).

100. Bernard, Serm. xliii in Cant., MPL clxxxiii, cols. 993f.

101. Ms. ital. 115, err.: "sixth."

102. Bernard, Serm. vii in Psalmum xc, Qui habitat, MPL clxxxiii, cols. 205ff.

103. Ms. ital. 115, err.: "86th."

104. Bernard, Serm. lxxxv in Cant., MPL clxxxiii, cols. 1191f.

105. *Idem,* Serm. de passione Domini, in feria iv hebdomade sanctae, *ibid.,* col. 270.

106. Latin: *"non ita";* Ms. ital. 115, err.: *"nominato."*

107. Bernard, Serm. iii in festo pentecostes, MPL clxxxiii, cols. 333f.

108. *Idem,* Serm. xxxi in Cant., *ibid.,* cols. 942f. "Messenger" (*messaggio*) translates Latin *paranymphus.* Cf. n. 12 above.

109. Ms. ital. 115, err.: "11th."

110. Bernard, Serm. xii in Psalmum xc, Qui habitat, MPL clxxxiii, col. 233.

111. Declamationes de colloquio Simonis cum Jesu, lvii, lviii, MPL clxxxiv, cols. 473f. Not by Bernard.

397

112. Augustine, Serm. CLXIX, De verbis apostoli, Philipp. iii, 3–16, xi, 13, MPL XXXVIII, col. 923.

113. Bernard, Serm. XL in Cant., MPL CLXXXIII, col. 984.

114. *Idem*, Serm. V, *ibid.*, cols. 799ff.

115. *Idem*, Serm. LIV, *ibid.*, col. 1041.

116. *Idem*, Serm. XIV, *ibid.*, cols. 839, 842f.

117. Ms. ital. 115, err.: "v."

118. Bernard, Serm. IV de adventu Domini, MPL CLXXXIII, col. 50.

119. *Idem*, Serm. IV in nativitate Domini, *ibid.*, col. 126.

120. *Idem*, Serm. III in tempore resurrectionis ad abbates, *ibid.*, col. 289.

121. Actually to two others (cf. succeeding notes) and not to Duke Conrad.

122. Bernard, Epist. C, ad episcopum quemdam, MPL CLXXXII, col. 235.

123. *Idem*, Epist. CIII, ad fratrem Willelmi monachi Claraevallensis, *ibid.*, cols. 237f.

124. Ms. ital. 115, err.: "xiv."

125. Ms. ital 115 changes in mid-sentence to direct discourse: "Wretch, are you not ashamed . . . ?"

126. Bernard, Serm. de conversione ad clericos, viii, MPL CLXXXII, col. 843.

127. In MPL enumeration, Serm. de diversis XVI.

128. Bernard, De triplici genere bonorum, et vigilantia super cogitationibus, MPL CLXXXIII, col. 580.

129. *Idem*, Serm. LXVI in Cant., *ibid.*, col. 1097.

130. *Idem*, Serm. XXX, *ibid.*, cols. 939f.

131. *Idem*, Serm. III in ascensione Domini, *ibid.*, col. 308.

132. *Idem*, Serm. LXVI in Cant., *ibid.*, cols. 1096f.

133. *Idem*, Epist. I, ad Robertum nepotem suum . . . , MPL CLXXXII, col. 77.

134. Probably identical with the Chartreuse de Mont-Dieu (Ardennes); see L. H. Cottineau, *Répertoire topo-bibliographique des abbayes et prieurés*, Macon, II, 1937, col. 1894, with further bibliography, of which C.P., "La Chartreuse du Mont-Dieu," *Cabinet historique*, XXI, 1875, pp. 250ff., mentions the relationship with Bernard (on p. 254).

135. Epist. seu Tractatus ad fratres de Monte Dei, i, viii, MPL CLXXXIV, cols. 322f. Not by Bernard; formerly attributed to Guigo the Carthusian; now thought to be by William of Saint-Thierry (cf. J. M. Déchanet, *Guillaume de Saint-Thierry,* Bruges, 1942, pp. 110ff.).

136. Ms. ital. 115, err.: "18th."

137. Bernard, Serm. xix in Cant., MPL CLXXXIII, col. 866.

138. *Idem,* Serm. xxxiii, *ibid.,* col. 956.

139. *Idem,* Serm. lxiv, *ibid.,* col. 1085.

140. *Idem,* Serm. iii in circumcisione Domini, *ibid.,* col. 142.

141. MPL CLXXXIV, col. 328. See n. 135 above.

142. Bernard, Serm. xxiii in Cant., MPL CLXXXIII, col. 888.

143. *Idem,* Serm. xlix, *ibid.,* col. 1018.

144. Serm. in assumptione beatae Mariae Virginis, MPL CLXXXIV, cols. 1004f. Not by Bernard; formerly attributed to him as his fifth (not third, as cited in the first line of this paragraph in the text) sermon on the Assumption.

145. Ms. ital. 115, err.: "xvi."

146. Bernard, Serm. xlvi in Cant., MPL CLXXXIII, cols. 1005ff.

147. *Idem,* Serm. xviii, *ibid.,* cols. 859ff.

148. *Idem,* Serm. lvii, *ibid.,* col. 1054.

149. *Idem,* Serm. xxxvii, *ibid.,* cols. 971f.

150. *Idem,* Serm. ix, *ibid.,* cols. 815f.

151. Ms. ital. 115, err.: "xvii."

152. Bernard, Serm. xii in Cant., MPL CLXXXIII, col. 830.

153. *Idem,* Serm. i in festo SS. Petri et Pauli apostolorum, *ibid.,* col. 407.

154. Ms. ital. 115: "anguish of death of solicitudes."

155. Bernard, Serm. lii in Cant., MPL CLXXXIII, cols. 1029ff.

156. *Idem,* Serm. lxii, *ibid.,* cols. 1077ff.

157. *Idem,* Serm. xlix, *ibid.,* col. 1018.

158. *Idem,* Serm. iii in ascensione Domini, *ibid.,* col. 306.

159. *Idem,* Serm. v, *ibid.,* col. 319.

160. *Idem,* Serm. xliii in Cant., *ibid.,* cols. 994f.

161. Ms. ital. 115: "immortality."

162. Bernard, Serm. lxii in Cant., MPL CLXXXIII, col. 1076.

163. *Idem,* Serm. iv in ascensione Domini, *ibid.,* cols. 313f.

164. *Idem,* Serm. XLI in Cant., *ibid.,* cols. 985f.

165. *Idem,* Serm. LXII, *ibid.,* cols. 1076ff.

166. *Idem,* Serm. XLVIII de diversis, *ibid.,* col. 671.

167. *Idem,* De consideratione libri quinque ad Eugenium tertium, V, xiv, MPL CLXXXII, col. 806.

168. This phrase unintelligible in Ms. ital. 115.

169. Bernard, Serm. LIV in Cant., MPL CLXXXIII, cols. 1041f.

170. MPL CLXXXIV, cols. 325f. See n. 135 above.

171. In MPL enumeration, Serm. de diversis XXXVI.

172. Bernard, De altitudine et bassitudine cordis, MPL CLXXXIII, cols. 638f.

173. MPL CLXXXIV, col. 1005. See n. 144 above.

174. Ms. ital. 115: "fourth."

175. Bernard, Serm. III in assumptione beatae Mariae Virginis, MPL CLXXXIII, cols. 422, 424f.

176. *Idem,* Serm. XXIII in Cant., *ibid.,* col. 893.

177. MPL CLXXXIV, col. 1006. See n. 144 above. But here Ms. ital. 115 calls it the fourth sermon instead of the third.

178. Bernard, Serm. LVII in Cant., MPL CLXXXIII, col. 1055.

179. MPL CLXXXIV, col. 322. See n. 135 above.

180. Bernard, Serm. LX in Cant., MPL CLXXXIII, col. 1070.

181. *Idem,* Serm. L, *ibid.,* col. 1023.

182. Ms. ital. 115: "fourth."

183. Bernard, Serm. III in assumptione beatae Mariae Virginis, MPL CLXXXIII, cols. 422f.

184. *Idem,* Serm. XL in Cant., *ibid.,* cols. 982f.

185. MPL CLXXXIV, cols. 313f., 322. See n. 135 above.

186. Ms. ital. 115: "fourth."

187. Bernard, Serm. III in assumptione beatae Mariae Virginis, MPL CLXXXIII, col. 424.

188. *Idem,* Serm. LXI in Cant., *ibid.,* cols. 1070f.

189. *Idem,* Serm. LII, *ibid.,* col. 1033.

190. *Idem,* Serm. LI, *ibid.,* col. 1026.

191. *Ibid.,* cols. 1025f.

192. *Idem,* De laude novae militiae, ad milites templi liber, xii, MPL CLXXXII, col. 938.

193. *Idem,* Epist. CLXXXV, ad Eustachium occupatorem Valentinae sedis, *ibid.,* cols. 346f.

194. Latin: *"commendatio."*

195. Bernard, Serm. LXXXVI in Cant., MPL CLXXXIII, cols. 1195f.

196. This entire paragraph occurs only in the Italian manuscripts of the *Meditations*.

197. Bernard, Serm. LI in Cant., MPL CLXXXIII, col. 1027.

198. *Idem,* Serm. II in dominica palmarum, *ibid.,* cols. 257f.

199. Cf. *Acta Sanctorum Junii,* V, Venice, 1744, p. 539.

200. Possibly identical with a relic above the altar of the Chapel of the Sacrament in S. Giovanni in Laterano, inscribed as the table of the Last Supper. See H. M. and M. A. R. T(uker), *Handbook to Christian and Ecclesiastical Rome,* I, London, 1897, pp. 97f.; cf. *Mirabilia urbis Romae.*

201. Augustine?, passage not identified.

202. Ms. ital. 115, err.: "supernal."

203. Latin: *"ministerio."*

204. Latin (and John xvii, 24, the source of the quotation): "clarity."

205. At this point in Ms. ital. 115 there is an unintelligible note in the lower margin. It is unrelated to the text but written in a hand contemporary with it, probably that of one of the writers of the captions.

206. *"Miglori,"* misread from Latin *"millia."*

207. These are the last legible words of Ms. ital. 115, on fol. 206ro. Fol. 206vo., the conclusion of the manuscript, has space for an illustration, then six lines of unreadable text. Our translation continues from the printed Latin edition of the works of St. Bonaventura, XII, Paris, 1868, pp. 602ff.

208. Peter Comestor, Historia scholastica, MPL CXCVIII, col. 1628.

209. *Ibid.,* col. 1634.

210. Bede, In Matthaei Evangelium expositio, IV, XXVII, MPL XCII, col. 126.

211. Bernard, De quadruplici debito, MPL CLXXXIII, cols. 597f.

212. *Idem,* Serm. XI in Cant., *ibid.,* col. 827.

213. *Idem,* Serm. XX, *ibid.,* col. 867.

214. *Idem,* Serm. XXII, *ibid.,* col. 881.

215. *Idem,* Serm. XXV, *ibid.,* cols. 902f.

216. *Idem,* Serm. XXVIII, *ibid.,* col. 923.

217. *Idem,* Serm. LXI, *ibid.,* col. 1072.

218. *Idem?,* passage not identified.

219. Not Bernard, but Anselm of Canterbury, Liber meditationum et orationum, ix, MPL CLVIII, cols. 755ff. (from "Awaken now, my soul" to end of quotation).

220. Origen?, passage not identified.

221. In the preface to the Epistle of James; Wordsworth and White, *Nouum testamentum Domini nostri Iesu Christi latine,* III, 2, Oxford, 1949, p. 233. Cf. I Cor. xv, 7.

222. This may refer to the *Golden Legend;* cf. *Legenda aurea,* ed. Graesse, 1890, p. 241.

223. Bernard, Serm. III in ascensione Domini, MPL CLXXXIII, col. 301.

224. *Idem,* Serm. IV, *ibid.,* col. 309.

225. *Idem,* Serm. XX in Cant., *ibid.,* cols. 870f.

226. *Idem,* Serm. XV, *ibid.,* cols. 846f.

227. *Idem,* Serm. XLV, *ibid.,* col. 1003.

NOTES ON THE PICTURES

1 (p. 1).

Fol. lro. The Author and St. Cecilia.

Instructions:[1] lacking. Inscriptions:[2] *This is the brother who compiled the book; St. Cecilia.*

The author, a Franciscan monk, points to the saint. In the text he recommends her virtues to the Poor Clare for whom he is writing the book. This Poor Clare very probably was herself named Cecilia, as one manuscript of the *Meditations* seems to verify—Paris, Bibliothèque Nationale Ms. Nouv. Acq. Fr. 6194, of the fourteenth century, a Provençal translation, which begins, "Aquest libre compauset lo reverent payre en Christ frayre Bonaventura de l'orde dels frayres Menors e cardenal, loqual lo trames a una menoreta fort devota, laqual havie nom sorre Cecilia. . . ." (Henri Omont, *Catalogue général des manuscrits français,* v, *Nouvelles acquisitions françaises,* ii, Paris, 1900, p. 411). The saint in our manuscript bears some resemblance in costume to the Cecilia in the famous altar-frontal in the Uffizi (no. 449; Richard Offner, *A Critical and Historical Corpus of Florentine Painting,* iii, 1, New York, 1931, pl. vᵃ) except for being uncrowned. She differs from the other female figures represented in Ms. ital. 115.

2 (p. 4).

Fol. 2vo. St. Francis Receiving the Stigmata.

Instructions: *St. Francis with the stigmata.* Inscription: *St. Francis.*

The representation follows the "new type" invented in the late thirteenth or early fourteenth century within the circle of Duccio or Giotto. See Millard Meiss, *Painting in Florence and Siena After the Black Death,* Princeton, 1951, pp. 117ff.

3 (p. 7).

Fol. 4ro. The Dispute of the Virtues.

Instructions: *Here one will show the Majesty with four figures who are kneeling.* Inscriptions: *Justice and Truth; Mercy and Peace.*

Like many other illustrations in Ms. ital. 115, this picture is intimately related to the text and does not seem to have existed

[1] Refers to the notes, usually written along the length of the margin, that obviously give directions to the illustrator. Because of the poor condition of the manuscript, especially of its edges, these notes are often missing or illegible.

[2] Refers to explanatory words within the pictures.

separately. The episode is based on the sermon of Bernard cited in the note to the text: it became widely known by its incorporation into the *Meditations*. Psalm lxxxiv, the scriptural basis for the scene, had already achieved illustration, but only the reconciliation and not the dispute before God had been shown. (For an examination of the theme of reconciliation see Samuel C. Chew, *The Virtues Reconciled; an Iconographic Study*, Toronto, 1947.) When searching for a possible pictorial model for the dispute, the artist may have turned to the type of the *Aspiciens a longe*, where Christ (sometimes in a mandorla) appears above a group of prophets who gesture toward Him. One example appears in Ms. lxxxi in the Hoepli Collection (Pietro Toesca, *Monumenti e studi per la storia delle miniatura italiana, i, La collezione di Ulrico Hoepli*, Milan, 1930, pl. lxxiii). This correspondence may account for the representation of the virtues as men, for otherwise they are normally women (as also in the text). Isolated instances of the virtues as men do occur, as in the fresco in Brixen (Josef Garber, *Die romanischen Wandgemälde Tirols*, Vienna, 1928, pl. 71), and may possibly be traced to Greek origins, Mercy being of the male gender in Greek.

4 (p. 9).
Fol. 6ro. The Presentation of the Virgin.
Instructions: *Here one will show the temple, the father and the mother of our Mary, and Mary herself at the age of three as they enter the temple.* Inscriptions: *St. Anna; Joachim; Mary; the temple.*
A simplified representation of the scene as it is often shown in monumental art in the fourteenth century, differing mainly in the artist's faithful rendition of Mary as a young child.

5 (p. 10).
Fol. 6vo. The Virgin Praying in the Temple.
Instructions: *Here one will show how the little one stayed in prayer before the altar.* Inscription: *Our Lady as she prayed.*
Text illustration; no earlier examples known to us.

6 (p. 12).
Fol. 7vo. The Virgin and Her Companions Spinning.
Instructions: *How she spun with some companions.* Inscriptions: *Mary; and her companions.*
Text illustration; "from the third to the ninth hour she was busy spinning." Probably unconnected with the motif of the purple wool as shown in Byzantine art, where the act of spinning is not included.

7 (p. 13).
Fol. 8ro., 1. The Virgin Receiving Food from the Angel.
Instructions: *How the angel brought her food.* Inscriptions: *The angel bringing food; Mary; the temple.*
Text illustration. Although the theme has a previous history in Byzantine art, the iconography is different, for here the Virgin kneels, and the scene has no connection with her Presentation.

8 (p. 13).
Fol. 8ro., 2. The Virgin Receiving Temple Food.
Instructions: *Here how the priests give her food to her.* Inscriptions: *How he gives the food to Mary; the temple.*
No earlier examples known to us. According to the instructions and the text, the man bringing the food should be a priest, but he is not represented in clerical costume.

9 (p. 14).
Fol. 8vo. The Virgin Feeding the Poor.
Instructions: *Here how she gave the food of the priests to the poor.* Inscriptions: *How she gives the bread for the love of God; Mary.*
Text illustration; no earlier examples known to us.

10 (p. 15).
Fol. 9ro. The Marriage of the Virgin.
Instructions: *Here how she was married to Joseph.* Inscription: *Joseph as he marries Mary.*
Joseph, carrying the flowering rod (from the story common to several apocryphal Gospels but not mentioned in the text of the *Meditations*) holds a ring towards Mary, whose extended hand is supported by Zacharias. All the elements of the iconography can be found in contemporary painting, notably in the Arena Chapel: however, the usual addition of the breaking of the suitors' rods is not included. In Ms. ital. 115 the dove on the rod is particularly characterized by its nimbus as the Holy Spirit. Zacharias is given the nimbus but is not dressed as High Priest.

11 (p. 16).
Fol. 9vo. God Sending Gabriel to Mary.
Instructions: lacking. Inscription: *The angel who receives the message for Mary.*
The separation of the scene of the sending of Gabriel from the Annunciation proper occurs before the period of the *Medita-*

tions, but in monuments quite unrelated to it, for example, in the Byzantine *Homilies of the Monk James* (itself a lengthy cycle concerned with additions to the Gospels; see Cosimo Stornajolo, *Miniature delle omilie di Giacomo monaco,* Rome, 1910, pl. 48) and the twelfth century English Psalter, British Museum, Lansdowne 383 (see Farley and Wormald, "Three Related English Romanesque Manuscripts," *Art Bulletin,* xxii, 1940, p. 157, and for illustration O. Elfrida Saunders, *English Illumination,* Florence, 1928, i, pl. 42b). In both these examples the picture type is distinctly different from that in our manuscript. The representations that relate to ours are mainly fourteenth century Italian works always placed together with the Annunciation and possibly owing their inspiration to the text of the *Meditations.*

12 (p. 17).

Fol. 10ro. The Annunciation to the Virgin.

Instructions: *Here the house with the Lady and the angel who came to her in annunciation.* Inscriptions: *The angel who gives the message; Mary.*

This central picture in the Annunciation series follows Sienese tradition. It differs in its setting as well as its figure types from the textually based narrative scenes that follow. Unusual, however, is the motif of the dove of the Holy Spirit holding a branch. It is conceivable that the artist is trying to convey the presence of the Holy Trinity, emphasized in the text, by including the idea of Christ as the branch, the *flos* of Isa. xl, 1.

13 (p. 18).

Fol. 11vo. The Annunciation: the Virgin's Response.

Instructions: *Here she kneels before the angel.* Inscriptions: *The angel; how Mary accepts.*

Although here the picture with the Virgin kneeling is a text illustration, it also exists as a picture type in Trecento and later art. See Meiss, *op.cit.,* pp. 149, 150 n. 74.

14 (p. 19).

Fol. 12ro. The Annunciation: the Virgin Thanking God.

Instructions: *How our Lady kneels.* Inscription: *How Mary thanks God for the gift He gave to her.*

Text illustration; no earlier examples known to us.

15 (p. 22).

Fol. 13ro. The Journey to the House of Elizabeth.

Instructions: lacking. Inscription: *Joseph with the Lady as they go to Elizabeth.*

Text illustration, paralleled in the *Homilies of the Monk James* (Stornajolo, *op.cit.,* pl. 63), but a different picture type with no relationship.

16 (p. 22).
Fol. 13vo. The Visitation.
Instructions: lacking. Inscriptions: *Mary; Elizabeth; Zacharias; Joseph.*

The traditional embrace of Mary and Elizabeth is repeated by Zacharias and Joseph. The men's Visitation is not motivated by the text, but it possibly existed in the instructions, unfortunately destroyed: no earlier examples are known to us.

17 (p. 23).
Fol. 14ro. The Virgin and Elizabeth Conversing.
Instructions: lacking. Inscriptions: *Elizabeth; Mary.*
Text illustration; no earlier examples known to us.

18 (p. 24).
Fol. 14vo. The Birth of John the Baptist.
Instructions: *Here the birth of St. John and our Lady and another woman.* Inscriptions: *Mary; Elizabeth—how she bore John the Baptist.*

The presence of the Virgin at the Birth of John occurs in several texts other than the *Meditations,* and in pictures from the thirteenth century on. For the iconography of the scene see the bibliography in Marilyn Aronberg Lavin's article on the young Baptist in *Art Bulletin,* xxxvii, 1955, p. 90 n. 32. The Bathing, not motivated by the text, is a common motif in birth scenes generally.

19 (p. 25).
Fol. 15ro. The Circumcision of John the Baptist.
Instructions: *Here how they circumcised.* Inscriptions: *How they carried John the Baptist to Zacharias to be circumcised; Mary—how she stays behind the curtain.*

Text illustration including the unique representation of Mary behind the curtain. Although the Circumcision of John is represented elsewhere, it is never performed by Zacharias, as here, but usually at the altar, before or after the Naming. Our manuscript omits the more common picture of the Naming, which is only implied in this rarer scene.

20 (p. 26).

Fol. 15vo. The Return from the House of Elizabeth.

Instructions: *Here how our Lady and Joseph returned.* Inscription: *Joseph—how they return home—and Mary.*

See above, note to no. 15.

21 (p. 27).

Fol. 16ro. The Virgin Doubted by Joseph.

Instructions: *Here above how Joseph looks at the Lady.* Inscriptions: *Mary as she sews; Joseph as he is thinking about the Lady's pregnancy.*

Although never common, the Doubting (shown in two episodes in our manuscript) was represented occasionally from Early Christian times on. Our scenes do not follow any particular prototype but bring out the simple aspects of the life of the Virgin and Joseph in the spirit of the text, with the Virgin occupied in sewing and spinning.

22 (p. 28).

Fol. 16vo., 1. The Virgin Observing Joseph's Doubt.

Instructions: *How our Lady is watching Joseph.* Inscriptions: *Mary; Joseph thinking.*

See above, note to no. 21.

23 (p. 28).

Fol. 16vo., 2. The Dream of Joseph.

Instructions: *Here how the angel appeared to Joseph at night.* Inscriptions: *How the angel announced to Joseph how our Lady was pregnant by the Holy Spirit; Mary.*

The Dream is traditional. The Virgin at prayer is a text illustration; no earlier examples known to us in this context.

24 (p. 29).

Fol. 17ro. Joseph Giving Thanks.

Instructions: *Here how Joseph speaks with the Lady.* Inscriptions: *Joseph—how he thanks God for the gift to the Lady; Mary.*

In the final episode of the sequence, the artist is instructed to show Joseph and the Virgin speaking together. But instead he portrays Joseph giving thanks, a theme not motivated by the text.

25 (p. 31).

Fol. 18ro. The Journey to Bethlehem.

Instructions: *Here how our Lady and Joseph go with the ass and*

the ox. Inscription: *Joseph—how he goes with Mary to Jerusalem
to the feast.*

The inscription, obviously misunderstanding the scene, repeats an error of the text in mentioning the feast in Jerusalem. The scene itself is common from Early Christian times on. Its iconography here is normal except for the ox, which is never included before this time but obviously derives from the text. For one later example, almost certainly obligated to the *Meditations,* see the right wing of the Portinari altarpiece of Hugo van der Goes (Erwin Panofsky, *Early Netherlandish Painting,* Cambridge, 1953, ii, pl. 308).

26 (p. 32).

Fol. 18vo. The Nativity: the Virgin and Joseph Taking Shelter. Instructions: *Here how the Lady, Joseph, the ox and the ass are within the grotto.* Inscriptions: *How they have entered a grotto, not having found another shelter; Mary; Joseph.*

This and the succeeding illustrations present the most extensive cycle of the Nativity known to us, including many unparalleled scenes. Throughout, the setting is a landscape, usually with the cave or grotto of Ms. ital. 115, not the "covered alley" mentioned in the Latin version (see n. 15) or the place "under a roof" mentioned in other Italian ones (e.g., Florence, Bibl. Riccardiana, Ms. 1286, published in *Mistici del duecento e del trecento,* ed. Arrigo Levasti, Milan-Rome, 1935, p. 424). The sparse furniture of this setting consists, besides the manger, of the saddle and saddle-stuffing described in the text. Instances of the saddle in isolated later scenes from the Nativity cycle doubtless show the influence of the Meditations. Some examples are Botticelli, *Mystic Nativity,* and Piero della Francesca, *Nativity,* both in the National Gallery, London (National Gallery Catalogues, *Earlier Italian Schools,* London, 1953, i, pl. 71, ii, pl. 352); Masaccio, *Adoration of the Magi,* Berlin, Museum (Kurt Steinbart, *Masaccio,* Vienna, 1948, pls. 18, 19); and a manuscript in S. Verdiana, Castelfiorentino, Cod. A, fol. 8vo. (Offner, *A Critical and Historical Corpus of Florentine Painting,* iii, 7, 1957, pl. xxa).

Text illustration: to our knowledge the realistic portrayal of the pregnant Virgin is unique in the fourteenth century, and the moment chosen to be illustrated, *before* the Nativity, unprecedented.

27 (p. 33).

Fol. 19ro. The Nativity: the Birth of the Child.

Instructions: *Here how she gives birth.* Inscriptions: *Mary—how she has given birth; Joseph.*

Text illustration—"the Virgin rose and stood erect against the column. . . . But Joseph remained seated. . . ." The Child descends upon the hay taken out of the manger and spread at the Virgin's feet, just as described in the text. No other examples of the actual birth of the Child are known to us. The scene known under the title of the Nativity is always a later moment. This may also be the first instance of the peculiar role of the column. The architectural column, obviously incongruous in the rough-hewn cave, is included only in this one picture of the cycle. Like the saddle, it is a hallmark of the influence of the *Meditations* and reappears in later art, for example, in the Bladelin altarpiece of Roger van der Weyden (Panofsky, *op.cit.,* ii, pl. 197).

28 (p. 34).

Fol. 19vo., 1. The Nativity: the Virgin Embracing the Child.

Instructions: *Here how she picks Him up, embraces Him and kisses Him, then washes Him with her milk.* Inscriptions: none.

Probably meant as a text illustration, but the Virgin, who does not fulfil the requirements of the instructions, may possibly be interpreted as a picture type transferred, complete with her throne, from some more hieratic image.

29 (p. 34).

Fol. 19vo., 2. The Nativity: the Virgin and Joseph Adoring the Child.

Instructions: *Here how she put Him into the manger with the ox and the ass kneeling, and how John stays in adoration.* Inscriptions: none.

Text illustration, representing the Adoration by the Virgin and Joseph, the ass and the ox, but parallel to a type always known as the Nativity, showing a moment when the main figures are kneeling.

30 (p. 35).

Fol. 20ro. The Nativity: the Virgin Reclining and Gazing at the Child.

Instructions: *Here how Joseph placed the saddle and the stuffing— the saddle at the side of the manger, where she leaned her shoulder, and the stuffing (?) under her, with her eyes (?) on the face of the Child.* Inscriptions: none.

Text illustration, resulting in the conventional picture type
of the Nativity with the reclining Virgin. The artist here super-
imposes luxuriant foliage on the bare grotto, as he does also in
nos. 33 and 34.

s

31 (p. 39).
 Fol. 22ro. The Nativity: the Angels Adoring the Child.
 Instructions: *Here how the Lady and Joseph were in the grotto,
the Infant in the manger, the ass and the ox, and multitudes of angels
singing.* Inscriptions: none.
 Text illustration; a variation of the Adoration picture.

32 (p. 40).
 Fol. 22vo. The Annunciation to the Shepherds.
 Instructions: *Here how the angel came to the shepherds; here how
they started to go....* Inscriptions: none.
 Text illustration. The traditional picture type amended to
conform to the requirements of text and instructions in Ms.
ital. 115, which (in contrast to other versions) specifies a single
angel only as the bearer of the message. The motif of the tree
borne by the angel is unexplained by the text.

33 (p. 41).
 Fol. 23ro. The Adoration of the Shepherds.
 Instructions: lacking, except for a few letters. Inscriptions:
none.
 Not the Adoration of the Shepherds properly so-called, but
a narrative scene presumably preceding it, perhaps rather to
be identified as the journey or the approach of the shepherds
toward the manger, in illustration of the brief mention in the
text that "the shepherds also came to adore Him."

34 (p. 42).
 Fol. 24vo. The Circumcision of the Child.
 Instructions: *Here how our Lady circumcises.* Inscription: *Here
how our Lady circumcised the infant Jesus.*
 Text illustration (for Ms. ital. 115 only, as Latin does not
specify that the Virgin performed the Circumcision). No other
examples of the Virgin circumcising are known to us.

35 (p. 43).
 Fol. 25ro. The Child Comforting the Virgin After the Cir-
cumcision.
 Instructions: *Here how our Lady had the Child in her lap and
He touched her mouth and face that she should not cry.* Inscriptions:
none.

Text illustration; no other examples known to us in narrative context, although the type suggests the Madonna of Humility with the affectionate Child.

36 (p. 46).

Fol. 27vo. The Journey of the Magi.

Instructions: *Here how the Magi go with the cavalry and with the burden and the. . . .* Inscriptions: none.

The upper half of the scene is traditional, with Magi of three ages mounted and pointing out the star (on the next page); the lower half is less usual but conforms to the requirement of "a noble following" implicit in the text.

37 (p. 47).

Fol. 28ro. The Adoration of the Magi: the Holy Family Awaiting the Arrival of the Magi.

Instructions: *Here the cave with the Lady and with the Infant in her arms, Joseph at the entrance.* Inscription: *Joseph.*

Text illustration, but occasionally the conflation of the Journey and Nativity scenes gives a somewhat comparable effect.

38 (p. 48).

Fol. 28vo. The Adoration of the Magi: the Magi Adoring the Child.

Instructions: *Here how the Magi kneel before the Infant and converse with the Lady.* Inscriptions: none.

The first of two episodes into which the Adoration of the Magi is divided, with no portrayal of gifts. It is unusual but not unique for all three Magi to kneel. As is normal, however, the first and oldest has reverently removed his crown.

39 (p. 49).

Fol. 29ro. The Adoration of the Magi: the Magi Presenting Their Gifts.

Instructions: *. . . order rugs spread and offer gold, incense, and myrrh.* Inscriptions: none.

In its upper half the second Adoration picture is less of a text illustration than the first and is probably based on a monumental prototype. The setting is less specific; the dress of both Virgin and Child differs from that in the rest of the sequence; the accessories of ox, ass, and saddle disappear; Joseph is of a different physical type, is not nimbed, and is reduced in importance by being placed in the lower half of the picture. This

picture only in the sequence shows the Magi nimbed. They wear the polygonal nimbi usually employed for personifications of virtues but also given to miscellaneous lesser personages, possibly with some meaning of the sudden acquisition of grace, as in the case of the Centurion in the Crucifixion. The motif of the kissing of the Child's foot by the oldest Magus, frequently mentioned and always derived from the *Meditations,* is not portrayed in our manuscript.

40 (p. 50).
Fol. 29vo. The Departure of the Magi.
Instructions: *Here how they leave.* Inscription: *The Magi as they leave.*

Less frequently represented than the Journey, the Departure of the Magi still corresponds to traditional iconography. The artist does not try to make the costumes, crowns, or physical types conform to those in other scenes in the same series.

41 (p. 52).
Fol. 30vo. The Virgin Distributing the Gifts of the Magi.
Instructions: *How our Lady gives the money to the poor.* Inscription: *How our Lady distributes among the poor all the gold that had been offered to Jesus.*

Text illustration; no earlier examples known to us. For an unknown reason, the original sketch of a child beside the Virgin has been covered by a patch on which a smaller, more crudely drawn child is shown.

42 (p. 53).
Fol. 31ro. The Stay at the Manger: the Virgin Suckling the Child.
Instructions: *Here how the Lady is in the cave with the Child in her arms, and Joseph.* Inscriptions: none.

Text illustration resembling the Madonna del Latte, already a common type by this time; no earlier examples of scenes of the Holy Family after the departure of the Magi known to us.

43 (p. 54).
Fol. 31vo. The Stay at the Manger: Joseph Fondling the Child.
Instructions: *Here how the Lady is in her cave; the manger and the ass. . . .* Inscriptions: none.

Text illustration; see above, note to no. 42.

413

44 (p. 55).

Fol. 32ro. The Departure from the Manger.

Instructions: *Here how the Lady with the Child in her arms, and Joseph, go to the temple.* Inscription: *How our Lady goes with Joseph to the temple.*

Text illustration (to next chapter); no earlier examples known to us. The subsequent episode showing the Holy Family approaching Jerusalem is at least once depicted, however, in the tenth or eleventh century Sacramentary in Göttingen (Univ.-Bibliothek, Ms. theol. 231, fol. 17vo.; G. Richter and A. Schönfelder, *Sacramentarium fuldense . . . ,* Fulda, 1912, pl. 15).

45 (p. 56).

Fol. 32vo. The Presentation in the Temple: Joseph Buying Doves.

Instructions: *Here how he buys turtledoves in the temple.* Inscriptions: *Mary and Jesus; Joseph, who buys the turtledoves; the temple.*

The first of eight scenes, an unprecedented number for illustrating the Presentation, in a series of separate narrative moments beginning with the purchase of the doves. This rich sequence never includes the regular, hieratic iconography of the Presentation as so often shown in the life of Christ; but various elements of our sequence occur separately in this "normal" iconography.

The architecture of the temple shows wide variations on the theme of the sacred setting and does not strive for consistency.

Text illustration; no earlier examples known to us. Besides the doves the artist includes a lamb—the offering of the wealthy—and an ox, mentioned neither in the text nor in the scriptural account of the Presentation but understood (from John ii, 14, 15) as one of the sacrifices sold in the temple.

46 (p. 57).

Fol. 33ro. The Presentation in the Temple: Simeon Arriving.

Instructions: *Here the temple with the Lady holding the Child in her arms, and Joseph; then how Simeon hurries and then how he kneels down.* Inscriptions: *Simeon; Joseph.*

Text illustration; no earlier examples known to us.

47 (p. 58).

Fol. 33vo. The Presentation in the Temple: Simeon Receiving the Child.

Instructions: *Here how they are in the temple, with Simeon kneel-*
and receiving the Child in his arms, and Anna. Inscriptions: *Anna*
the prophetess; Simeon.
Text illustration; no earlier examples known to us.

48 (p. 59).
Fol. 34ro. The Presentation in the Temple: the Procession Around the Altar.
Instructions: *How the Lady holds the Infant in her arms—and how with Simeon and Joseph they go in procession.* Inscriptions: *Anna the prophetess; Joseph; Simeon.*
Text illustration; no earlier examples known to us.

49 (p. 60).
Fol. 34vo. The Presentation in the Temple: the Virgin Offering the Child.
Instructions: *Here how she kneels with the Infant in her arms in front of the altar and places Him on it.* Inscription: *Mary as she offers the Infant on the altar in the temple.*
Text illustration; for parallels to the kneeling Virgin see Dorothy C. Schorr, "The Iconographic Development of the Presentation in the Temple," *Art Bulletin,* xxviii, 1946, pp. 29f.

50 (p. 61).
Fol. 35ro. The Presentation in the Temple: the Child on the Altar.
Instructions: *Here how Jesus is lying on the altar, with Joseph, Simeon, Anna, and the others kneeling. . . .* Inscriptions: *Simeon; Joseph; Mary; Jesus offered in the temple.*
Text illustration; no earlier examples known to us. The third nimbed figure at the left ought to be Anna, according to the instructions, but is shown as a man. This unexplained confusion also occurs elsewhere, in the ordinary Presentation (cf. D. Schorr, *op.cit.,* p. 26).

51 (p. 62).
Fol. 35vo., 1. The Presentation in the Temple: Joseph Redeeming the Child.
Instructions: *Here how Joseph, with the Lady without the Son in her arms. . . .* Inscriptions: *How Joseph redeems Him from the priests of the temple with five shekels; Jesus.*
Text illustration; no earlier examples known to us. For later parallels to Joseph paying the ransom see D. Schorr, *op.cit.,* p. 30.

52 (p. 62).
Fol. 35vo., 2. The Presentation in the Temple: the Child Offering Doves.
Instructions: *Here how the Lady takes the Infant from the altar.*
Inscriptions: *How the infant Jesus offers the turtledoves in the temple; Joseph; Mary; Jesus.*
Text illustration; no earlier examples known to us.

53 (p. 63).
Fol. 36ro., 1. The Journey with the Child to the House of Elizabeth.
Instructions: *Here how she goes to Elizabeth with the infant Jesus in her arms and with Joseph.* Inscription: *Mary and Jesus and Joseph as they go to Elizabeth.*
Text illustration; no earlier examples known to us.

54 (p. 63).
Fol. 36ro., 2. The Greeting in the House of Elizabeth.
Instructions: *Here how . . . embrace, and the infants Jesus and John, Joseph and Zacharias.* Inscriptions: *Joseph; Zacharias; Mary and Jesus; Elizabeth and John the Baptist.*
The requirements of text and instructions are met by a repetition of the double Visitation of no. 16, to which is added the third element of the greeting between the children. The children's greeting is expressed elsewhere, but in a differing picture type, for example in a thirteenth century window in the cathedral of Tours (Bourassé and Manceau, *Verrières du choeur de l'église métropolitaine de Tours,* Paris, 1849, pl. II) and a painted altar frontal of the thirteenth century in the Pinacoteca of Siena (Phot. Alinari 36637).

55 (p. 64).
Fol. 36vo. The Return with the Child from the House of Elizabeth.
Instructions: *Here how she returns from Elizabeth with the Child in her arms, and Joseph.* Inscription: *Joseph as he returns with Mary.*
Text illustration; no earlier examples known to us.

56 (p. 65).
Fol. 37ro. Joseph Told in Dream to Flee to Egypt.
Instructions: *Here how the Lady and Joseph are at home and how the angel appears to them, that they should go.* Inscription: *The angel as he tells Joseph to flee to Egypt.*

The traditional representation of the second dream of Joseph, in a domestic setting with the Virgin and Child added.

57 (p. 66).

Fol. 37vo. The Flight into Egypt.

Instructions: *Here how the Lady goes to Egypt with the Infant and Joseph.* Inscription: *Mary and Jesus as they go with Joseph to Egypt.*

Text illustration, departing from the traditional picture type in showing the Holy Family on foot rather than with the Virgin riding the ass. There are a few other examples of this humble mode, e.g., the Carolingian ivory casket in the Louvre (Adolph Goldschmidt, *Die Elfenbeinskulpturen*, Berlin, I, 1914, pl. XLI, 95b); a fourteenth century manuscript in the Riches Collection, Shenley (*Speculum humanae salvationis*, ed. M. R. James, Oxford, 1926, pl. chap. xliv); and the stained glass panel in Assisi referred to below, no. 59).

58 (p. 69).

Fol. 39ro. The Flight into Egypt: Joseph Carrying the Child.

Instructions: *Here how Joseph carries the Infant.* Inscription: *Mary going with Joseph and Jesus.*

Text illustration. Few earlier examples are known to us of Joseph carrying the Child, except for the Byzantine type of the Child seated on the shoulders of Joseph. Some Western examples copy this motif; and a small number, like the Ingeburge Psalter in Chantilly (fol. 18vo.; Victor Leroquais, *Les psautiers manuscrits latins . . . ,* Macon, 1940–41, Atlas, pl. LVI), show a group a little more like ours, but with the Virgin riding.

59 (p. 70).

Fol. 39vo. The Flight into Egypt: the Fall of the Idols.

Instructions: *Here how He (?) enters Egypt and all the idols. . . .* Inscriptions: *Joseph and Mary have reached Egypt; broken idols; idols fallen and broken; broken idols.*

As in the preceding scenes, the Holy Family goes on foot instead of riding (or resting). The idols fall from their traditional columns, but the artist places them in an unusual deep landscape peopled with observers of the miracle. The example most nearly comparable to this in a general sense is a thirteenth century stained glass panel now in the Sacro Convento in Assisi, with the Holy Family walking (Beda Kleinschmidt, *Die Basilika San Francesco in Assisi*, Berlin, I, 1915, fig. 196).

60 (p. 71).

Fol. 40ro. The Holy Family in Egypt: Renting the House.
Instructions: *Here how he enters the city and rents the little house.*
Inscription: *Joseph as he rents the house.*
Text illustration; no earlier examples known to us.

61 (p. 72).

Fol. 40vo. The Holy Family in Egypt: Resting in the House.
Instructions: *Here she enters the house and rests holding the Son in
her arms.* Inscriptions: none.

An illustration of the instructions and not the text, which does
not mention the Holy Family's rest. No earlier examples are
known to us, for there appears to be no connection with the
theme of the Rest on the Flight into Egypt.

62 (p. 73).

Fol. 41ro. The Holy Family in Egypt: the Virgin Sewing and
the Child as Messenger.
Instructions: *How the boy Jesus leaves carrying the clothes.* In-
scriptions: *These have come to stay with the Lady; Mary as she sews;
Jesus carrying the tunic sewn by our Lady.*
Text illustration; no earlier examples known to us. The com-
panions of the Virgin here and in the next picture are not
specified in the text but are mentioned in the instructions.

63 (p. 75).

Fol. 43ro. The Holy Family in Egypt: the Virgin Sewing and
the Child Among Children.
Instructions: *Here how our Lady sews, and other elderly women with
her; Jesus with other children.* Inscriptions: *Jesus with the children;
Mary sewing with her companions.*
Text illustration; no earlier examples known to us. See also
above, note to no. 62.

64 (p. 76).

Fol. 43vo. The Holy Family in Egypt: Joseph as Carpenter.
Instructions: *Here how Joseph worked at carpentry.* Inscriptions:
These (are) *two men who wish to buy this kneading-trough from
Joseph; kneading-trough.*
Text illustration; no earlier examples known to us. The pic-
ture expands the bald mention of Joseph as a carpenter into a
little story that two men have come to buy a kneading-trough
from him.

65 (p. 77).
Fol. 44ro. Joseph Told in Dream to Return from Egypt.
Instructions: *Here how the angel appears to Joseph, that he should return home to the land of Israel.* Inscriptions: *Mary; the angel, that he should return home with Mary and Jesus.*
The traditional representation of the third dream of Joseph, with the addition of the praying Virgin, motivated by a passage towards the end of the preceding chapter where she is described as "ever intent in vigils and prayers with all her power," and— a touching genre motif—the sleeping Christ Child sharing Joseph's bed.

66 (p. 79).
Fol. 45ro. The Departure from Egypt.
Instructions: *Here how they left the city accompanied by men and women, and how some men give money to the child Jesus.* Inscription: *Joseph as he returns with Jesus and Mary.*
Text illustration; no earlier examples known to us.

67 (p. 79).
Fol. 46ro. The Return from Egypt.
Instructions: *Here how they go through the woods, Jesus on the ass, His mother and Joseph behind.* Inscriptions: *Jesus; Joseph; Mary.*
Text illustration. Another example of the rare motif of the Child riding can be found in the Holkham Bible, now British Museum Ms. Add. 47682 (W. O. Hassall, *The Holkham Bible Picture Book*, London, 1954, pl. fol. 17vo.).

68 (p. 80).
Fol. 46vo. The Return from Egypt: Meeting John the Baptist.
Instructions: *Here how He found Himself at the edge of the desert with John the Baptist.* Inscriptions: *Joseph; Mary; Jesus; John the Baptist . . . who was in the desert.*
Text illustration. For the history of the theme see pp. 89ff. of the article by M. A. Lavin cited above in the note to no. 18.

69 (p. 81).
Fol. 47ro. The Return from Egypt: Visiting Elizabeth.
Instructions: *Here He crossed the river Jordan, and they went to the house of Elizabeth.* Inscriptions: *Joseph; Mary; Elizabeth.*
Text illustration; no earlier examples known to us. The embracing women echo the picture type of the Visitation.

419

70 (p. 82).

Fol. 47vo., 1. Joseph Told in Dream to Go to Nazareth.
Instructions: *Here how the Lady and Elizabeth are praying, and Joseph and the Infant in bed, and the angel appears.* Inscriptions: *How Joseph and the Infant sleep; Elizabeth; Mary.*
Text illustration. For this unparalleled representation, the artist repeats the composition of no. 65, adding Elizabeth piously a prayer with the Virgin, and the ass. The text of Matthew (Matt. ii, 22) says that in Israel Joseph was warned in a dream: the setting of the scene in the house of Elizabeth results from the introduction of the new episode of the visit.

71 (p. 82).

Fol. 47vo., 2. The Journey to Nazareth.
Instructions: *Here how they go.* Inscriptions: *Joseph as he returns; Mary; Jesus.*
Text illustration; a variation on the composition of no. 67.

72 (p. 83).

Fol. 48ro., 1. The Holy Family at Home in Nazareth: Resting.
Instructions: *Here how they are at home and resting.* Inscription: *Joseph.*
Text illustration (although "rest" is mentioned only in the instructions and not in the text proper); no earlier examples known to us.

73 (p. 83).

Fol. 48ro., 2. The Holy Family at Home in Nazareth: Visited by Relatives.
Instructions: *Here how she is visited by relatives.* Inscriptions: *Joseph; Jesus; Mary as she sews with her companions.*
Text illustration. The occupation of the women does not stem from the text, but their industry is in its spirit (cf. nos. 62 and 63). No motivation appears in the text for the scene of Joseph instructing the Child: this may have been included in another line of instructions, now lost, of which a fragment seems to be visible.

74 (p. 84).

Fol. 48vo. The Holy Family at Home in Nazareth: the Child Bringing Water.
Instructions: *Here how the Lady wished to eat with Joseph and the Child Jesus brings the water.* Inscription: *Joseph and Mary eating and Jesus bringing water.*

Text illustration. It is characteristic that of the many apocryphal episodes in the life of the Christ Child (the clay birds; the bent beam; the broken pitcher; etc.) only the humble, domestic scene of drawing water for His parents and not any of the miraculous events should be selected, and only the second part, the bringing in of the water, shown. A number of the miracles are represented in the Holkham Picture Bible already mentioned. On fol. 18ro. the Child is depicted filling the pitcher and then serving at His parents' table (Hassall, *op.cit.*, pl. fol. 18ro.).

75 (p. 85).
Fol. 49ro. The Journey to Jerusalem for the Feast.
Instructions: *Here how he goes with the mother to the feast in Jerusalem, and Joseph His father separately.* Inscriptions: *Jesus and Mary; Joseph.*
Text illustration. This unique, complicated picture of the journey of the Virgin and Child and the women on a different road from that of Joseph and the men is motivated by the instructions and probably influenced by the description in the text of their separate return. The picture is the first of another extended sequence, playing on the emotional element of the story and adding pictures without parallel in earlier representational art for many episodes mentioned in the text.
For the picture type of the Virgin holding the Child by the hand see H. Wentzel, "Maria mit dem Jesusknaben an der Hand . . .," *Zeitschrift des deutschen Vereins für Kunstwissenschaft*, IX, 1942, pp. 203ff.

76 (p. 86).
Fol. 49vo. Joseph and the Virgin Discovering the Absence of the Child.
Instructions: *Here how they find themselves together in a house without the boy Jesus.* Inscriptions: *Joseph and Mary, who returned without the infant Jesus; how she asks for Him.*
Text illustration; no earlier examples known to us.

77 (p. 87).
Fol. 50ro. Joseph and the Virgin Searching for the Child.
Instructions: *Here how Joseph and our Lady searched for Him in the houses.* Inscription: *Joseph as he goes searching, and our Lady.*
Text illustration; no earlier examples known to us.

78 (p. 88).
Fol. 50vo. Joseph and the Virgin Praying for the Return of the Child.

421

Instructions: *Here how our Lady remains in prayer with Joseph.*
Inscription: *Joseph and our Lady, who remained in prayer all night.*
Text illustration; no earlier examples known to us.

79 (p. 90).
Fol. 51vo., 1. Joseph and the Virgin Asking the Neighbors About the Child.
Instructions: *Here how she searches for Him at the neighbors'.* Inscription: *How Joseph and the Lady go to ask at the neighbors'* (inscription continued in next illustration).
Text illustration; no earlier examples known to us.

80 (p. 90).
Fol. 51vo., 2. Joseph and the Virgin Asking Others About the Child.
Instructions: *Here how they ask friends and relatives.* Inscription (continued from preceding illustration): *and in the district and on the streets; they go around so much that they arrive at the temple.*
Text illustration; no earlier examples known to us.

81 (p. 91).
Fol. 52ro., 1. The Christ Child Among the Doctors: Found by Parents.
Instructions: *Here how they find Him seated among the doctors in the temple.* Inscriptions: *How they have found Him; Jesus.*
The common iconography, with central, elevated Christ Child and parents approaching from the side. Cf. (among many others) the enamel reliquary of the Corporale in the cathedral of Orvieto (*Diana*, IV, 1929, pl. 16 fol. p. 24) and the predella panel from Duccio's retable (Phot. Alinari 9910), where the gestures of the Child and mother and the types of the bearded doctors are especially similar.

82 (p. 91).
Fol. 52ro., 2. The Virgin and the Child Embracing.
Instructions: *Here how He runs to the mother and embraces her* (?).
Inscriptions: *Joseph; our Lady and Jesus embracing, moved by the great sweetness of love.*
Text illustration; no earlier examples known to us.

83 (p. 92).
Fol. 52vo. The Return from Jerusalem.
Instructions: *Here how He returns home with the mother and Joseph.*
Inscription: *Joseph returning with the mother and Jesus.*

Text illustration. The pose of the Virgin and Child is related
to that in no. 75 (q.v.) and is occasionally employed monumen- *Notes*
tally. A very close parallel is to be found in a fresco in Tolen- *on the*
Pictures

to that in no. 75 (q.v.) and is occasionally employed monumentally. A very close parallel is to be found in a fresco in Tolentino, S. Nicola, where the Virgin holding the Christ Child by the hand, followed by Joseph carrying drapery on a stick over his shoulder, moves away from a Christ Among the Doctors of the type of our no. 81 (Cesare Brandi, *Mostra della pittura riminese del trecento*, Rimini, 1934, fig. 97).

84 (p. 93).
Fol. 53ro., 1. The Stay at the Hospice.
Instructions: *How He stays at the hospice. . . .* Inscription: *How the Lady and Joseph return home and Joseph asks for shelter at a hospice.*

According to a "flashback" narration in the text, the Christ Child had stayed at a hospice for the poor while He was in Jerusalem. The instructions seem to require a picture for this episode. But the artist, perhaps unfamiliar with a narrative not strictly in chronological order, has reinterpreted as an episode on the return journey of the Holy Family and has shown *Joseph* asking for shelter at the door of a hospice.

85 (p. 93).
Fol. 53ro., 2. The Holy Family at Home in Nazareth.
Instructions: *Here how He is at home in Nazareth with His father and mother.* Inscriptions: *Joseph, Mary and another (?) have returned home.*

Illustration in the spirit of the text, following the instructions; no earlier examples known to us.

86 (p. 95).
Fol. 54ro. The Christ Child Praying in the Synagogue.
Instructions: *Here how He was in a corner (?) and adores in a corner (?).* Inscriptions: *The temple entered by men and women who were there; how Jesus stays in a corner praying.*

Text illustration; no earlier examples known to us. The Child kneels in a cross-topped cathedral standing for the synagogue.

87 (p. 100).
Fol. 57vo., 1. The Holy Family at Home in Nazareth: Eating.
Instructions: *Here how Joseph, Mary, and Jesus are in their little house and eat at a little table.* Inscription: *Joseph, Jesus, Mary, who are eating.*

Text illustration; no earlier examples known to us.

423

88 (p. 100).
Fol. 57vo., 2. The Holy Family at Home in Nazareth: Praying.
Instructions: *Here how they are in the little room with three small beds, and Jesus and the Lady in prayer, Joseph in his bed.* Inscriptions: *Our Lady as she stays in prayer; Joseph, who sleeps; Jesus as He stays in prayer.*
Text illustration; no earlier examples known to us.

89 (p. 101).
Fol. 58ro. The Holy Family at Home in Nazareth: Sleeping.
Instructions: *Here how they sleep in their little beds.* Inscriptions: *Jesus as He sleeps; our Lady, who sleeps; Joseph.*
Text illustration; no earlier examples known to us. The first representation in Ms. ital. 115 of Christ as a man.

90 (p. 103).
Fol. 59ro., 1. Christ Taking Leave of His Parents.
Instructions: *Here the Lord is standing with the mother and Joseph in His part of the house.* Inscriptions: *Joseph; our Lady; Jesus taking leave.*
Text illustration; no earlier examples known to us.

91 (p. 103).
Fol. 59ro., 2. Christ Blessed by the Virgin.
Instructions: *Here the Lord kneels at the feet of the mother and Joseph in His part.* Inscriptions: *Joseph; our Lady giving her blessing to Jesus, who is going to the Baptism.*
Text illustration; no earlier examples known to us.

92 (p. 104).
Fol. 59vo., 1. Christ and the Virgin Embracing.
Instructions: *Here the Lord and the Lady are kneeling . . . and embracing.* Inscriptions: *Joseph; Jesus taking leave of the Lady.*
Text illustration; no earlier examples known to us.

93 (p. 104).
Fol. 59vo., 2. Christ Departing from Nazareth.
Instructions: *Here how He goes away alone.* Inscription: *Jesus as He goes alone to the Baptism.*
Text illustration; no earlier examples known to us.

94 (p. 106).
Fol. 60vo. Christ Receiving Alms.
Instructions: *Here how He begs alms from people.* Inscription: *How for love of charity Jesus receives alms from men on the road.*
Text illustration; no earlier examples known to us.

95 (p. 115).
Fol. 65ro. The Baptism of Christ: Christ Undressing.
Instructions: *Here how He removed His clothes and entered the Jordan and John baptized Him.* Inscriptions: *Jesus as He undresses for the Baptism; John the Baptist with a great crowd, all also for baptism.*
Text illustration, possibly influenced by the picture type of John baptizing the multitude, where one figure is often shown undressing. (Cf. the silver altar frontal in Florence, *Pantheon*, v, 1930, fig. 2, p. 223, and our own no. 108.) The Baptism proper seems never to include this preliminary scene of Christ disrobing.

96 (p. 116).
Fol. 65vo. The Baptism of Christ.
Instructions: *Here how He is in the river Jordan and how John baptized Him, and the dove is above His head.* Inscription: *Jesus, who is baptized by John.*
The traditional Baptism, with the dove of the Holy Spirit above Christ almost submerged in the Jordan and baptized by John on the shore, but with the usual group of angels replaced by three praying figures.

97 (p. 118).
Fol. 66vo. Christ Going into the Desert.
Instructions: *Here how He went alone into the desert.* Inscription: *Jesus as He goes to Mount Quarentana to fast.*
Text illustration, also separately represented at least once, in the Pacino di Bonaguida Tree of Life in the Accademia in Florence (Richard Offner, *A Critical and Historical Corpus of Florentine Painting*, iii, 2, New York, 1930, pt. 1, pl. ii, 8).

98 (p. 119).
Fol. 68ro. Christ Praying and Sleeping in the Desert.
Instructions: *Here how He is on the mountain, stays in prayer, and then rests on the ground and sleeps.* Inscriptions: *Jesus as He prays; Jesus as He sleeps on the mountain.*
Text illustration combining two rare scenes in one picture.

99 (p. 120).
Fol. 68vo. Christ Tempted for the First Time.
Instructions: *Here how the demon comes to tempt Him on the mountain.* Inscription: *Lucifer tempting Jesus for the first time.*
The representation of the Temptation in three scenes, two in landscape settings, one architectural, is traditional. Unusual features in Ms. ital. 115 are the lack of such accessories as the

425

stones by which Christ was tempted to gluttony and the riches by which He was tempted to avarice, and the rare type of monkish devil (in one inscription identified as Lucifer) with ass's ears. This type differs greatly from that in the few examples of the scene known to us in Italian art of the same period, such as in Duccio's panel in the Frick Collection, New York, where the emaciated winged devil follows Byzantine prototypes (Curt H. Weigelt, *Duccio di Buoninsegna,* Leipzig, 1911, Plates, pl. 18).

100 (p. 121).

Fol. 69ro. Christ Tempted for the Second Time.

Instructions: *Here how he led Him to Jerusalem to the pinnacle* (?) *of a temple.* Inscriptions: *The second time he wished to tempt Him; Jesus.*

See above, note to no. 99. The protagonists are shown within the church, before the altar canopy, rather than on the pinnacle.

101 (p. 122).

Fol. 69vo. Christ Tempted for the Third Time.

Instructions: *Here how he took Him to the very high mountain.* Inscriptions: *The third time he wished to tempt Him; Jesus.*

See above, note to no. 99.

102 (p. 124).

Fol. 70vo. Christ Ministered to by Angels.

Instructions: *Here how the Lord is on the mountain and many angels came to Him and how . . . message to the mother of Jesus.* Inscription: *When the Lord Jesus had fasted forty days He was hungry, and immediately God the Father sent the angels to go to serve Him, and He sent two to His mother, that she should send something to eat.*

There are six pictures illustrating Christ Ministered to by Angels, usually a single scene that is often associated with the last of the Temptations. The narrative elements of our extended treatment of the subject are obviously of absorbing pleasure to the artist, who follows each detail of the story in the text.

The first picture most nearly conforms to the usual picture type, with angels, landscape, and wild beasts (including a suckling lion cub) but also begins the narration, with the two angels who go on the mission to Mary twice represented, first receiving their orders from Christ and then starting on their flight.

103 (p. 125).
 Fol. 71ro. The Virgin Sending Food to Christ in the Desert. Instructions: *Here how the Lady and Joseph are at home, and the two angels come to her to carry food to the Lord.* Inscriptions: *The angels who come to the mother for food; here how she gives it to them; Joseph; the angels who carry it to Jesus.*
 Text illustration; no earlier examples known to us.

104 (p. 126).
 Fol. 71vo. Christ Receiving Food Sent by the Virgin. Instructions: *Here how the angels return with the food and set the table; how Jesus sits on the ground with the angels around Him.* Inscription: *Here how the Lord eats and the angels serve Him.*
 Text illustration. The picnic meal is paralleled only by the Holkham Picture Bible, where the artist's imagination has led him to depict a similar moment (Hassall, *op.cit.,* pl. fol. 19vo.).

105 (p. 127).
 Fol. 72ro. The Virgin Receiving the Message from Christ. Instructions: *Here how the angels return to the mother with the things.* Inscriptions: *This angel gives the message to the mother; here how the angels give the things to Joseph.*
 Text illustration; no earlier examples known to us. The whole scene is motivated by the text, but it seems to be the artist's own idea to divide the mission so that Mary receives the message and Joseph the "things."

106 (p. 128).
 Fol. 72vo. Christ Blessing the Angels. Instructions: *Here how the Lord is on the mount, and the angels kneeling around Him.* Inscription: *Here how the Lord sends them away and gives them His blessing.*
 Text illustration; no earlier examples known to us.

107 (p. 129).
 Fol. 73ro. Christ Descending from the Mount. Instructions: *Here how He descends the mount alone.* Inscription: *Here how He descends the mount.*
 Text illustration; no earlier examples known to us.

108 (p. 130).
 Fol. 73vo., 1. John the Baptist Recognizing Christ. Instructions: *Here how He was at the Jordan, and John points to Him with his finger.* Inscription: *John the Baptist, as he baptizes at the river Jordan, sees Jesus and says, "Behold the Lamb of God."*

427

A known picture type enlivened by such narrative elements as the youth undressing (see note to no. 95) and the prominent Jordan river, both relating the scene to representations of John baptizing.

109 (p. 130).

Fol. 73vo., 2. Christ Followed by Disciples of John, and Again Recognized by John.

Instructions: *Here how the next day He went along the Jordan, and two disciples go with Him.* Inscriptions: *Jesus with the disciples of John the Baptist; John the Baptist as he again shows the Lord to the disciples and says, "Behold the Lamb of God."*

For the first part of the picture, some parallels exist (e.g., on p. 4 of the fourteenth century Passional in the Vatican, Ms. lat. 8541; Index of Christian Art phot. no. 83575), but the type is so simple that no connection can be made. The disciple following Christ is distinguished by his physical type as Andrew, although he is not identified in instructions or inscription. The second part repeats the main motif of no. 108.

110 (p. 131).

Fol. 74ro., 1. Christ with Andrew and Peter.

Instructions: *Here how they are inside (?) the house where Jesus taught them (?).* Inscriptions: *Andrew; Jesus in the house; Peter.*

Perhaps because Peter is not mentioned in the instructions, he is not represented in his usual physical type, with short beard and wig-like hair, as he appears in the next picture and traditionally. But general confusion reigns in this picture—the doubtful Peter is inscribed Andrew, Andrew is inscribed Jesus, and Christ is inscribed Peter.

111 (p. 131).

Fol. 74ro., 2. Christ Taking Disciples to the Virgin.

Instructions: *Here how . . . He went to the mother . . . disciples.* Inscription: *How Jesus went to the mother with His disciples.*

The identification of this scene as Christ taking the disciples to His mother depends on the inscription and on the succeeding picture. Perhaps it should rather have been designed to show Christ departing alone in order to return to Galilee, as the text specifies. It is not clear whether the ten nimbed figures (including Andrew and Peter; reduced to four figures in no. 112) all represent apostles, for the apostles have not yet been formally called to follow Him.

112 (p. 132).
Fol. 74vo., 1. Christ and Disciples Visiting the Virgin.
Instructions: *Here how He comes to her and they rejoice and embrace.* Inscription: *Here how He arrives at His mother's house with the disciples.*
Text illustration; no earlier examples known to us. For the representation of the apostles, see note to no. 111.

113 (p. 132).
Fol. 74vo., 2. Christ Conversing with His Parents.
Instructions: *Here how they are all in the house, speaking together.* Inscriptions: *Mary; Jesus; Joseph.*
Text illustration; no earlier examples known to us.

114 (p. 134).
Fol. 75vo. Christ Opening the Book in the Synagogue.
Instructions: *Here how when He was in the church He opened the book.* Inscription: *How He opened the book in the synagogue with the disciples.*
This infrequently represented scene is sometimes a central composition, as here and in the Holkham Bible (Hassall, *op.cit.,* pl. fol. 22vo.), but elsewhere it does not seem to include the apostles. (See again note to no. 111 for the unmotivated presence of the apostles.) The coloring of the illustrations is abandoned with this picture. From here on Ms. ital. 115 uses line drawing only.

115 (p. 136).
Fol. 76vo. Christ Calling Peter and Andrew.
Instructions: *Here He called Peter and Andrew from the boat.* Inscription: *Jesus, when He called Peter and Andrew, who were fishing.*
The lively action of Peter in stepping forth, and the praying gestures, are the artist's variation on the traditional iconography of Christ standing on the ground at the left side, His hand raised toward the two apostles in the boat.

116 (p. 137).
Fol. 77ro., 1. Christ Calling James and John.
Instructions: *Here how He called James and John to the boat . . . fish.* Inscription: *Jesus, when He said to Peter and Andrew, "Let down the net."*
A representation similar to the preceding. In the gesture of Christ toward the full net of fishes, it is possibly influenced (not

429

for the first time) by the scene of the miraculous draught of fishes, mentioned in Luke just before the calling of James and John. The writer of the inscriptions wrongly identifies the figures as Peter and Andrew, quoting Luke v, 4.

117 (p. 137).
>Fol. 77ro., 2. Christ Calling Philip.
>Instructions: *Here how He called Philip.* Inscription: *Jesus with John the Evangelist and St. James and the others who go with Him.*

Although represented a few times elsewhere, no set picture type exists for this scene. The apostles following Philip can be identified by their physiognomies—Peter, Andrew, James, and John: only the latter two are named in the inscription.

118 (p. 138).
>Fol. 77vo., 1. Christ Calling Matthew.
>Instructions: *Here how He called Matthew from the counter.* Inscription: *Jesus with the disciples when He called St. Matthew.*

A rearrangement of elements traditional at least since Ottonian times—the apostles, especially Peter, and Christ with Matthew, who is shown near a table on which are coins, scales, and vessels.

119 (p. 138).
>Fol. 77vo., 2. Christ and Disciples Visiting the Virgin.
>Instructions: *Here how He takes them straight (?) to His mother's house.* Inscription: *Jesus, when He went to His mother.*

Text illustration; no earlier examples known to us.

120 (p. 139).
>Fol. 78ro. Christ Covering Sleeping Disciples.
>Instructions: *Here how the disciples sleep and the Lord covers them.* Inscription: *Jesus as He covers St. Peter, who sleeps.*

Text illustration; no earlier examples known to us. The Lord draws the cover over one of the seven sleeping figures, not Peter as the inscription says. The underdrawing, especially on the left side, shows that the artist worked over the composition, for which he probably had no prototype, and changed the direction of the sleepers.

121 (p. 140).
>Fol. 78vo. Maria Salome Going to the Virgin.
>Instructions: *Here how Maria goes to our Lady.* Inscription: *This is Maria Salome, who goes to our Lady that she should come to the wedding of John the Evangelist.*

Text illustration; no earlier examples known to us. Maria Salome is accompanied by an attendant who is not mentioned in text or instructions. This is the first of three pictures made in illustration of a single sentence in the narrative.

122 (p. 141).
Fol. 79ro., 1. The Virgin Greeting Maria Salome.
Instructions: *Here how she arrives at the house of the Lady.*
Inscription: *Here how Maria arrives at the house of our Lady.*

Text illustration; no earlier examples known to us. Here the artist imagines the tender greeting between Maria Salome and the Virgin and adds a domestic detail in the industrious woman within the house, although these features are not specified in the text.

123 (p. 141).
Fol. 79ro., 2. The Virgin and Maria Salome Going to Cana.
Instructions: *Here how they return to the house (?) of Maria.* Inscription: *Here how they go to the house of Maria with our Lady.*
Text illustration; no earlier examples known to us.

124 (p. 142).
Fol. 79vo., 1. The Marriage at Cana: Preparation.
Instructions: *Here how they prepare the wedding.* Inscription: *Here how the wedding is prepared.*

Text illustration: the first of seven scenes of the marriage feast, obviously considered one of the most important sequences in the book and possibly elaborated in order to emphasize the merits of the celibate life. The established iconography of the scenes gives in a single picture, very frequently represented, many of the elements here extended into a detailed narrative sequence. However, here, in accordance with the text, Christ is always seated in a corner, no women are included, and the Virgin when she appears stands off to the side. Perhaps the closest parallel in these special features is the panel from the Duccio retable in Siena (Weigelt, *op.cit.,* pl. 19). In the seven scenes of our sequence, the participants are not always the same, nor are the nimbi consistently given.

125 (p. 142).
Fol. 79vo., 2. The Marriage at Cana: the Feast.
Instructions: *Here how they are eating.* Inscription: *Here how Jesus is at the wedding with the disciples.*
Text illustration. See above, note to no. 124.

126 (p. 144).

Fol. 80vo., 1. The Marriage at Cana: Servants Informing the Virgin.

Instructions: *Here how they are at the table and two of the servants go to the Lady to speak* (?). Inscriptions: *The wedding; John; Jesus; how the servants tell her there is no more wine.*

Text illustration. See above, note to no. 124. John, in this text the presumed bridegroom, specifically identified by name in the inscription, now appears beside Christ in place of the Peter of the preceding picture.

127 (p. 144).

Fol. 80vo., 2. The Marriage at Cana: the Virgin Informing Christ.

Instructions: *Here how the Lady goes to her Son.* Inscription: *How our Lady tells it to Jesus.*

Text illustration. See above, note to no. 124.

128 (p. 146).

Fol. 81vo. The Marriage at Cana: the Virgin Instructing the Servants.

Instructions: *Here how the Lady calls the servants who were at the table* (?). Inscription: *How the Lady tells the servants to fill the hydrias with water and take them to the Lord.*

Text illustration. See above, note to no. 124.

129 (p. 147).

Fol. 82ro. The Marriage at Cana: Servants Going to Christ.

Instructions: *Here how they went to the Lord and He said, "Go and fill them."* Inscription: *Here how the order of the Lady was carried out.*

Text illustration. See above, note to no. 124.

130 (p. 148).

Fol. 82vo., 1. The Marriage at Cana: Christ Sending Wine to the Master of the Feast.

Instructions: *Here how he brings the wine to the master of the feast at the wedding.* Inscriptions: none.

Text illustration. See above, note to no. 124. The only picture in the series where the hydrias, necessary in the regular iconography of the scene, appear.

131 (p. 148).

Fol. 82vo., 2. The Marriage at Cana: the Calling of John.

Instructions: *Here how He calls John aside.* Inscription: *When the wedding is over Jesus calls John and speaks to him in secret.*

Text illustration; no earlier examples known to us. Perhaps the picture type is based on that of the calling of Philip.

132 (p. 149).
 Fol. 83ro., 1. The Departure from the Marriage at Cana.
 Instructions: *Here how the Lord and the mother and the disciples go straight on* (?). Inscription: *John and our Lady with Jesus go to their home.*
 Text illustration; no earlier examples known to us.

133 (p. 149).
 Fol. 83ro., 2. Christ and Disciples Visiting the Virgin.
 Instructions: *Here how they are in the house of the mother in Nazareth.* Inscriptions: *How Jesus has arrived home with the disciples; John and the Lady and Jesus are all three together.*
 Text illustration; no earlier examples known to us.

134 (p. 150).
 Fol. 83vo. Christ and Disciples Departing from Nazareth.
 Instructions: *Here how He left His mother and went with His disciples.* Inscription: *Here how He left His mother and goes with the disciples and a great crowd.*
 Text illustration; no earlier examples known to us. For the first time all of the twelve are shown.

135 (p. 151).
 Fol. 84ro. The Sermon on the Mount: Ascent.
 Instructions: *Here is how they left the crowd and He climbed the mount with the disciples.* Inscriptions: none.
 Text illustration; no earlier examples known to us.

136 (p. 154).
 Fol. 85vo. The Sermon on the Mount.
 Instructions: *Here how He sits on the mount with the disciples and teaches them.* Inscription: *Here how He sits on the mount with the disciples and teaches them.*
 The conventional, central composition, not common but fairly consistent when it does occur. One should perhaps understand that the audience waits below the visible scene.

137 (p. 155).
 Fol. 86ro. The Sermon on the Mount: Descent.
 Instructions: *Here how He climbs down from the mount with the*

433

disciples and a great crowd awaits Him at the foot of the mount. In-
scription: *How our Lord descends from the mount with the disciples
and the great crowd awaits at the foot of the mount.*
Text illustration; no earlier examples known to us.

138 (p. 156).
> Fol. 86vo. Christ Healing the Centurion's Servant.
> Instructions: *Here how the infirm man lies in bed and the centurion
> sends two servants to Jesus that he may be healed.* Inscription: *Here
> how Jesus is with the disciples and the infirm are brought before them
> for Him to heal, and how the centurion sends two of his servants to have
> his son healed.*

This scene, rather rare in Western art, especially at the period
of our manuscript, is developed in a sequence of three pictures.
These follow the narrative, except that the first shows both the
messenger sent and a healing scene. The latter must represent
either the servant who is healed or another infirm person. One
would expect the healing to be shown with the final scene (cf.
no. 144).

139 (p. 157).
> Fol. 87ro., 1. Christ Healing the Centurion's Servant: the
> Arrival of the Messengers.
> Instructions: *Here how the messengers are before Jesus and give
> Him the message, and He was with the disciples and some others.* In-
> scriptions: *disciples; Jesus; the messengers of the centurion.*
> Text illustration. See note to no. 138.

140 (p. 157).
> Fol. 87ro., 2. Christ Healing the Centurion's Servant: the
> Return of the Messengers.
> Instructions: *Here how they are are before him, and the servant was
> healed, listening to the message.* Inscriptions: *Here how they repeat
> the message of our Lord to the centurion; of how He healed him.*
> Text illustration. See note to no. 138.

141 (p. 158).
> Fol. 87vo., 1. Christ Healing the Son of the Petty King: the
> Appeal.
> Instructions: *Here how the king prayed Jesus to go to his house to
> heal his son, and He did not want to go, yet healed him.* Inscriptions:
> *Jesus; the petty king, Regulus.*

This scene is known from Early Christian times on and is
often given in two episodes, but here is treated as a text illustra-
tion. The nearest parallel to be found is on fols. 3ro. and 4ro.

of Ms. 360 in the Morgan Library, New York (Meta Harrsen, *The Nekcsei-Lipócz Bible,* Washington, 1949, fig. 11). In this first scene the king has humbly removed his crown, now held by a member of his imposing following.

142 (p. 158).
Fol. 87vo., 2. Christ Healing the Son of the Petty King: the Cure.
Instructions: *Here is how the son of the king was healed.* Inscription: *The son of the king healed.*
The second scene includes two episodes. In the first the king, now again properly crowned, greets the boy. To the right one may understand a separate picture of an earlier moment in the sickroom (the boy a different and older type). The drawing is uninterrupted over an original patch serving to mend a tear in the paper.

143 (p. 159).
Fol. 88ro. Christ Healing the Paralytic: the Paralytic Lowered through the Roof.
Instructions: *Here how our Lord was in a house with Pharisees, and a great crowd around, and they put him through the roof.* Inscription: *Here how our Lord was shut in a house with some Pharisees, and a great crowd was outside, and some mounted to the roof and put a sick man through the smoke flue to be healed, and thus it was done.*
Although often illustrated, from Early Christian times on, the story as treated here departs from tradition. Normally the paralytic is lowered through the roof on a bed or a pallet: here he is held vertically in a loop of the rope (as in the Holkham Bible; Hassall, *op.cit.,* pl. fol. 24vo.). The crowd outside is faithfully depicted, and the moment of healing is combined with the lowering through the roof.

144 (p. 160).
Fol. 88vo. Christ Healing the Paralytic: the Cure.
Instructions: *Here how they were in the house of the Pharisees with the paralytic in bed* (?) *and our Lord. . . .* Inscription: *Jesus as He healed the paralytic.*
This is not an episode subsequent to the first but seemingly a repetition of the moment of healing, the Pharisees in the house (different in types and costumes from the crowd) being included. Possibly the result of the existence of a prototype showing the paralytic on his bed. The formula for the healing miracle is identical with that in the problematical scene in no. 138.

145 (p. 162).

Fol. 89vo. Christ Healing Peter's Mother-in-Law: the Cure.
Instructions: *Here how He entered the house of Simon and the mother-in-law was in bed, and He touched her with His hand and she was healed.* Inscription: *How He healed the mother-in-law of Simon.*

A conventional healing scene that disregards text and instructions by not showing Christ touching the woman. The servant behind the bed was originally drawn in an attitude of prayer.

146 (p. 163).

Fol. 90ro. Christ Healing Peter's Mother-in-Law: the Meal.
Instructions: *Here how she gave Him to eat at his house with poverty.* Inscription: *Here how He eats with the disciples in the house of Simon.*

The not uncommon sequel to the preceding is given as another ordinary dining scene, failing to make use of the pathetic incident of Christ's service at table, mentioned in the text.

147 (p. 164).

Fol. 90vo., 1. Christ Stilling the Storm: Christ Asleep.
Instructions: *Jesus entered the boat and went to sleep and a great storm arose.* Inscription: *How our Lord is in the boat with the disciples and sleeps.*

The story is traditionally represented by two episodes combined in one picture. Here the episodes are separated, with the first showing Christ asleep in the bow.

148 (p. 164).

Fol. 90vo., 2. Christ Stilling the Storm: Christ Awake.
Instructions: *Here how He was in the boat and awoke. . . .* Inscription: *How the Lord awakened and immediately made the sea quiet.*

The second part of the story shows Christ awake, the sea not noticeably calmer.

149 (p. 165).

Fol. 91ro., 1. Christ Raising the Widow's Son: the Funeral.
Instructions: *Here how men carry a body and . . . Jesus and the disciples.* Inscription: *Here is how He resuscitated the son of the widow.*

Normal iconography for this scene except in the omission of the widow herself and any indication of the city.

150 (p. 165).

Fol. 91ro., 2. Christ Raising the Widow's Son: the Miracle.

Instructions: *Here they place him on the ground and Jesus . . . rise from the bier.* Inscriptions: none.

Here again is the healing formula (cf. no. 144), with the kneeling, praying figure of the resuscitated. The widow is again omitted.

151 (p. 166).

Fol. 91vo. Christ Healing a Cripple and a Woman.

Instructions: *Here how the Lord walked to heal the sick* (?) *. . . the disciples and a great crowd . . . a woman threw herself at His feet. . . .* Inscription: *Here how He healed the cripple on the road.*

In a curious compression, the healing of the woman identified as Martha (mention of whose "issue of blood" is delicately withheld) is not expanded into a series, as one might expect it to be from the importance of Mary and Martha in this manuscript, and is even combined with the healing of a cripple who is not singled out in the text but only identified in the inscription. A tradition for this conflation may have existed, however: cf. the destroyed eighth century mosaics of the Chapel of John VII in the Old Basilica of St. Peter in Rome, where the woman with the issue is represented together with the healing of a blind man (Raffaele Garrucci, *Storia della arte cristiana. . . ,* Prato, IV, 1877, pl. 279, 1).

152 (p. 168).

Fol. 92vo. Christ Raising a Youth.

Instructions: *Here how He was in the house of that gentleman and found that the youth was dead. . . .* Inscription: *Here is how He entered the house of a gentleman for his son and found him dead and resuscitated him.*

The healing formula (cf. no. 144) is applied here to a scene that should be the raising of the daughter of Jairus but is represented, and described in the instructions and inscription, as the raising of a young man. The composition may have been planned rather differently—see the pentimenti of the upper part—and the split-level architecture introduced as a space-filling motif.

153 (p. 169).

Fol. 93ro. Christ Anointed by Mary Magdalen (cancelled illustration).

Instructions: *Here is how He (?) entered the house of Simon (and) ate, and Mary washed His feet with unguents and dried them with her hair.* Inscription: *Cancel.*

This scene, which possibly (the instructions to the contrary) may have been meant to show Christ dining with Simon, was drawn to include the Magdalen at His feet. After its completion, and perhaps after the completion of the next two related pictures, it must have been noticed that it was out-of-sequence (the Magdalen included before her arrival) and repetitious (almost identical with no. 155). The illustration was then cancelled by scoring out.

In composition, both no. 153 and no. 155 follow not the more traditional iconography in which Christ sits at the end of a table but the less familiar central type. The nearest parallel occurs in a fresco in the refectory of S. Croce in Florence in one of the series of dining scenes by Taddeo Gaddi (Photo Alinari 3945). In both no. 153 and no. 155 Christ is accompanied by Peter and another person, in one case a young man, in the other a graybeard. It is unclear which, if either, represents Simon.

154 (p. 170).
Fol. 93vo. The Journey of Mary Magdalen to Simon's House.
Instructions: *Here how she went in the forest to. . . .* Inscription: *Mary Magdalen, who goes to the house of Simon when he was dining.*
Text illustration; no earlier examples known to us.

155 (p. 171).
Fol. 94ro. Christ Anointed by Mary Magdalen.
Instructions: *Here how she threw herself at His feet.* Inscription: *Here is how the Magdalen threw herself at the feet of the Lord.*
See above, note to no. 153.

156 (p. 175).
Fol. 96ro. John the Baptist Sending Disciples to Christ.
Instructions: *Here how John is in prison and sends two disciples to Jesus.* Inscription: *Here how St. John the Baptist is in prison and these are his disciples.*

Although it is not very frequent, there is a set picture type for this scene: John the Baptist in a prison in the form of a tower or edicule addressing the two disciples from a window or opening that is often barred. A strange similarity links our picture with the mosaic in the Florentine Baptistery. In both the upper part of the figure of the Baptist is shown in front of

the rectangular bars of the prison, but the bars overlay the saint's nimbus. (For the mosaic, see Antony de Witt, *I mosaici del battistero di Firenze.* . . , Florence, 1954, pls. x, xxvii.) One of the two disciples, here and in the next picture, is erroneously represented with the features of the Apostle Peter.

157 (p. 176).
Fol. 96vo., 1. Christ Meeting Disciples of John the Baptist.
Instructions: *Here how Jesus was among a great multitude and those two disciples of John were before Him.* Inscription: *Jesus with the disciples and the multitude and how John the Baptist sent two of his disciples to the Lord.*
A known picture type, also faithful to the text.

158 (p. 176).
Fol. 96vo., 2. Christ Answering Disciples of John the Baptist.
Instructions: *Here how He performed many miracles in their presence.* Inscription: *Here how the Lord gave them the message.*
This scene is also known separately as a picture type. The multitude of the infirm is represented by a single cripple. Cripples are also shown in the Pisano south door of the Florentine Baptistery (Ilaria Toesca, *Andrea e Nino Pisani*, Florence, 1950, fig. 33) and in fresco in the Parma Baptistery (Laudedeo Testi, *Le baptistère de Parme.* . . , Florence, 1916, fig. 169): the type is related to such Byzantine examples as Ms. Plut. vi, 23, fol. 21vo., in the Biblioteca Laurenziana, Florence (Photo Millet C 380). The disciples in our picture have changed their types and lost their nimbi.

159 (p. 177).
Fol. 97ro. Disciples Returning to John the Baptist.
Instructions: *Here how the disciples returned to John in prison.* Inscription: *Here how they returned to John to give the message of the Lord.*
Text illustration; no earlier examples known to us. The types of the disciples are again different.

160 (p. 178).
Fol. 97vo., 1. The Feast of Herod: Salome Dancing.
Instructions: *Here how they are at the table and the girl dances.* Inscription: *How Herod eats and the daughter of his friend, the wife of his carnal brother, danced.*
Seven scenes, five before the Beheading of John and two after, represent the Feast of Herod, described in a single sen-

439

tence of only a few lines in the text. (More is said in the in-structions and inscriptions than in the text itself.) These seven scenes break up the story into even more episodes than usual (three or four are not uncommon) partly because the artist's unwillingness to show the women sharing the table of the men makes it necessary to add separate scenes for the Herodias incidents. It is possible to connect particular motifs (like the musician at the left) with other examples in the period, but in general it seems that we have here an individual, episodic treat-ment leaving no part of the story unillustrated.

161 (p. 178).
Fol. 97vo., 2. The Feast of Herod: Salome Questioned.
Instructions: *Here how the girl is before him and asks. . . .* In-scription: *How the king called her and asked what she wanted him to give her.*
See above, note to no. 160.

162 (p. 179).
Fol. 98ro., 1. The Feast of Herod: Salome Instructed by Herodias.
Instructions: *Here how she went to the mother and returned to ask for the head.* Inscription: *Here how she asked the mother, "What do you wish me to ask of the king as a gift?" and she said, "The head of John the Baptist."*
See above, note to no. 160. Two episodes are combined into one scene.

163 (p. 179).
Fol. 98ro., 2. The Feast of Herod: Salome Demanding the Head of John.
Instructions: *Here how she returned and asked for the head of John the Baptist.* Inscription: *Here how she asked the king for the head of John the Baptist.*
See above, note to no. 160.

164 (p. 180).
Fol. 98vo., 1. The Feast of Herod: Herod Commanding the Beheading of John.
Instructions: *Here how he sends the. . . .* Inscription: *Here how he commanded the head of John the Baptist to be cut off . . . and the head given to the girl.*
See above, note to no. 160. The pose of Herod is substan-tially altered from the underdrawing.

165 (p. 180).
 Fol. 98vo., 2. The Beheading of John the Baptist.
 Instructions: *Here how the head is cut off in prison.* Inscription:
 Here how the head of St. John the Baptist is cut off.
 The method of the beheading follows the text of Ms. ital.
115 and not that of the Latin version (cf. n.77). But the picture
type is traditional.

166 (p. 181).
 Fol. 99ro., 1. The Feast of Herod: Salome Receiving the Head
 of John.
 Instructions: *Here how it is presented on a dish and the girl took
 it and carried it to her mother.* Inscription: *Here how he gives it to
 the girl.*
 See above, note to no. 160.

167 (p. 181).
 Fol. 99ro., 2. The Feast of Herod: Herodias Receiving the
 Head of John.
 Instructions: *Here how the mother received the head of St. John.*
 Inscription: . . . *received (?) the head of St. John.* . . .
 See above, note to no. 160.

168 (p. 184).
 Fol. 100vo. Christ and the Virgin Told of the Death of John.
 Instructions: *Here how two of his disciples told the Lord, who was
 with the disciples and the mother.* Inscription: *Here how two disciples
 of St. John the Baptist came to the Lord and the Lady after John was
 beheaded.*
 Text illustration; no earlier examples known to us. This is
one of the most imaginatively touching inventions of our manu-
script, very expressive of the distress at the news of the death
of John.

169 (p. 185).
 Fol. 101ro. Christ on the Way to Galilee.
 Instructions: *Here how . . . with the disciples.* Inscription: *Here
 is how He went with His disciples to Galilee.*
 Text illustration making use of the regular picture type of
journeying.

170 (p. 186).
 Fol. 101vo., 1. Christ and the Samaritan Woman: Christ
 Resting at the Well.

Instructions: *Here how He sat down on the well and the disciples went to the city.* Inscription: *Here is how the disciples went to the city to buy bread and our Lord rested at the well.*

There are eight scenes for this story, normally told in one or two, the first with the woman and Christ at the well, the second and rarer with Christ besought by the Samaritans. As with the series of the Feast of Herod (nos. 160–167), a few lines motivate the whole extended treatment. The story is used didactically to praise the simple life and to emphasize the part that a woman might play in the religious world; and each succeeding moment is narrated in detail. This first episode illustrates the text: it is paralleled in the Holkham Bible (Hassall, *op.cit.*, pl. fol. 24vo.).

171 (p. 186).
Fol. 101vo., 2. Christ and the Samaritan Woman: the Arrival of the Woman.
Instructions: *Here how the Lord was at the well and the Samaritan woman came.* . . . Inscription: *Here how the Samaritan woman came to the well and spoke with the Lord.*

The iconography of this scene is nearest to the normal type, but the picture is used in its correct place in the narrative sequence. See above, note to no. 170.

172 (p. 187).
Fol. 102ro., 1. Christ and the Samaritan Woman: the Return of the Disciples.
Instructions: *Here how the disciples return and find the Samaritan woman and Jesus at the well.* Inscription: *Here how the disciples return to Jesus.*

The representation of this moment is sometimes combined with the normal type (like no. 171); here it is given as a separate text illustration. See above, note to no. 170.

173 (p. 187).
Fol. 102ro., 2. Christ and the Samaritan Woman: the Departure of the Woman.
Instructions: *Here how she returns to the city.* Inscriptions: *Here Jesus is with the disciples; how she returned to the city.* . . .

See above, note to no. 170. The left half of the picture, the picnic, is mentioned not in the narrative but in the commentary on it. The instructions also omit mention of the meal, but perhaps the lesson of humility meant to be taught by the story requires the inclusion of this motif.

174 (p. 188).

Fol. 102vo., 1. Christ and the Samaritan Woman: the Woman Arousing the City.

Instructions: *Here how she went into the city and communicated. . . .* Inscription: *How she aroused all that they should come . . . and thus it was.*

See above, note to no. 170. This is an unusually active expression of the haste of the Samaritans to reach the feet of the preacher to whom they listen so attentively in the next picture.

175 (p. 188).

Fol. 102vo., 2. Christ and the Samaritan Woman: Christ Preaching.

Instructions: *Here how the disciples were with Him and He talked . . . and a great crowd left. . . .* Inscription: *Here how He preached to them.*

See above, note to no. 170. The intent audience includes both men and women, but seated in separate ranks.

176 (p. 189).

Fol. 103ro., 1. Christ and the Samaritan Woman: the Entry into the City.

Instructions: *Here how He preaches to them.* Inscription: *Here they lead Him to the city.*

See above, note to no. 170.

177 (p. 189).

Fol. 103ro., 2. Christ and the Samaritan Woman: Christ Preaching in the City.

Instructions: *Here is how He went to the city with them.* Inscriptions: none.

See above, note to no. 170.

178 (p. 191).

Fol. 104ro. Christ Rejected at Nazareth.

Instructions: *Here how our Lord returned to Nazareth with the disciples and many people came toward Him.* Inscription: *Here how He goes.*

The passage in Luke iv, 29, 30, gives three almost unprecedented scenes (nos. 178–180). The first, the rejection of Christ, is represented by the picture type of journeying. This had been illustrated in Byzantine Gospels (e.g., Florence, Laurenziana, Ms. Plut. vi, fol. 109vo.) in very simple form.

179 (p. 192).

Fol. 104vo., 1. Christ Chased to the Top of a Hill.

Instructions: *Here how He passed through their midst going out of the city.* Inscriptions: none.

See above, note to no. 178.

180 (p. 192).

Fol. 104vo., 2. Christ Hiding in the Rock.

Instructions: *Here is how He climbed down and hid Himself, and the stone made way for Him.* Inscription: *Here how the crowd pursued Him on the mount and He hid Himself in a stone, which made room for Him.*

See above, note to no. 178. The same Greek Gospels mentioned in that note includes an additional picture for the sequel, but it is not an illustration of the story of the rock "like wax" of our text.

181 (p. 193).

Fol. 105ro. Christ Healing the Man with the Withered Hand.

Instructions: *Here how Pharisees . . . in the synagogue . . . withered hand.* Inscription: *Here how going through the streets. . . .*

This subject is rarely illustrated in the period of our manuscript Here the man with the withered hand is represented twice, in accordance with the "healing formula." His gesture of supporting his arm can be paralleled in both Byzantine and western art.

182 (p. 195).

Fol. 106ro., 1. The Multiplication of the Loaves: Christ Pitying the Multitude.

Instructions: *Here He speaks to the disciples about the great crowd.* Inscription: *Here how He goes with a great multitude and says of them to the disciples that they should give them something to eat.*

Occasionally represented in Greek Gospels, but here presented with the narrative force of a text illustration, the scene emphasizing the emotional factor of Christ's pity for His followers.

183 (p. 195).

Fol. 106ro., 2. The Multiplication of the Loaves: the Miracle.

Instructions: *Here how they all sit on the ground and the disciples serve them . . . bread.* Inscription: *Here He gives them food.*

This is a popular theme with a long history but seemingly without parallel as a narrative picture in the period of our manuscript. Elsewhere it exists symbolically or hieratically;

444

here it is exploited as a story. The Virgin is not included (although the text justifies her inclusion); and the usual array of baskets is lacking.

184 (p. 197).
Fol. 107ro. Christ Sending Away the Apostles in a Boat.
Instructions: *Here is how He tells the disciples to board the boat.*
Inscription: *Here how God tells the disciples to enter the boat.*
Text illustration, based on the Gospels (Matt. xiv, 22, and Mark vi, 45) but never before illustrated, to our knowledge. The artist adds another touchingly personal element in the helpful gesture of Andrew towards his brother, not mentioned anywhere in the text but fully in its spirit.

185 (p. 198).
Fol. 107vo. Christ Climbing the Mount.
Instructions: *Here how the Lord climbed the mount (?) after the disciples were in the boat.* Inscription: *Here how Jesus climbed the mount (?).*
This is the first of three episodes bringing out the loneliness of the prayers of Christ. Only the middle scene (no. 186) is related to a known picture type of meditation; the other two are devised as illustrations of the text.

186 (p. 207).
Fol. 112ro., 1. Christ Praying on the Mount.
Instructions: *Here how He prays on the mount.* Inscription: *Here how He prays.*
See above, note to no. 185.

187 (p. 207).
Fol. 112ro., 2. Christ Descending from the Mount.
Instructions: *Here how He descends.* Inscription: *Here how He descends.*
See above, note to no. 185.

188 (p. 208).
Fol. 112vo. Christ Walking on the Water.
Instructions: *Here how He walked over the sea to the boat, and Peter came to meet Him on the sea and then went down.* Inscription: *Here how the Lord walked on the sea, and St. Peter when he saw Him went toward Him on the sea with great faith and then, discouraged (?) went down, and the Lord immediately. . . .*
Here the artist expressly departs from the best-known representation of the subject, the *Navicella* of Giotto, with its excep-

445

tionally important ship. In Ms. ital. 115, the whole point is the action of Christ. Even the text demanding His use of His right hand only is ignored to make a more telling expression of Peter's salvation. The two-fold depiction of Peter is not normal iconographically, although it is to be found in Ottonian art (e.g., Escorial, Real Biblioteca, Ms. Vit. 17, fol. 38vo.; Albert Boeckler, *Das goldene Evangelienbuch Heinrichs III.*, Berlin, 1933, pl. 52). The distressed ship before the appearance of Christ is not chosen for depiction. It would have made a characteristically emotional scene, and the instructions seem to call for it (see below, note to no. 189). Many pentimenti exist, especially in the boat and in the Peter who is grasped by Christ.

189 (p. 213).
Fol. 115ro. Christ Healing the Infirm.
Instructions: *Here how He goes over the sea to the boat, and St. Peter leaves it and walks on the sea and Jesus pulls him up.* Inscription: *Here how He cures the infirm while walking.*

The instructions do not agree with the picture but require the second part of the miracle of walking on the water (see above, note to no. 188). The position of the picture in the manuscript is near the text for this miracle; but a healing scene of regular type has been represented and described in the inscription. The picture may refer to the text of the beginning of the next chapter (pp. 219f.).

190 (p. 221).
Fol. 121ro. Christ and the Canaanite Woman.
Instructions: *Here how the Canaanite woman called out.* Inscription: *How He healed the Canaanite.*

This known scene is represented in an original manner, giving it the quality of an illustration of the text. It is traditionally shown with the woman beseeching Christ by kneeling at His feet or extending her arms towards Him. Here she makes a gesture of wild abandon calling to mind that of Mary Magdalen in the Crucifixion or Entombment in Italian paintings of the period. The daughter and the demons are omitted, as occasionally elsewhere. The intercession of the apostles for the anguished woman is faithful to the narrative. The inscription is misleading, for not the Canaanite woman but her daughter was healed.

191 (p. 224).
Fol. 122vo., 1. Christ Rebuking the Pharisees.

Instructions: *Here how He speaks with the Pharisees.* Inscriptions: none.

This rare scene is introduced as a text illustration, almost certainly without any influence from the few examples, mainly Byzantine, previously existing.

192 (p. 224).
Fol. 122vo., 2. Christ Repudiated by Some Disciples.
Instructions: *Here how He is in the synagogue with the disciples. . . .* Inscriptions: none.
Another rare scene introduced as a text illustration. The choice of types for the dissentient disciples is curious, for they appear elaborately dressed rather than as the simple persons one would expect as His associates.

193 (p. 226).
Fol. 123vo. Christ Answering Peter.
Instructions: *Here how the Lord was speaking with His disciples.* Inscriptions: none.
The final drawing in the manuscript is unfinished, with many pentimenti, but of the highest quality. From this point on, there exist only empty frames, with instructions for the pictures that were never achieved.

194 (p. 228).
Fol. 125ro., 1. Christ Questioning the Apostles.
Instructions: *Here how He is sitting with the disciples and questioning them.*

195 (p 228).
Fol. 125ro., 2. Christ Giving the Keys to Peter.
Instructions: *Here how our Lord gave the keys to St. Peter.*

196 (p. 228).
Fol. 125vo. The Transfiguration: Ascent.
Instructions: *Here how He climbed the mount with three disciples.*

197 (p. 228).
Fol. 126ro. The Transfiguration.
Instructions: *Here how He was transfigured and Moses and Elias came there.*

198 (p. 230).
Fol. 127vo. Christ at the Sheep Pool.
Instructions: *Here how the pool . . . with the infirm around it and Jesus and the disciples, and He asked. . . .*

199 (p. 230).
Fol. 128ro. Christ at the Sheep Pool: Healing the Cripple.
Instructions: *Here how the Lord said to the infirm man, "Carry away your pallet and go."*

200 (p. 230).
Fol. 128vo. Christ at the Sheep Pool: the Cripple Carrying the Bed.
Instructions: *Here how he carried his bed and some Jews . . . met him and asked him why he was carrying the bed.*

201 (p. 233).
Fol. 131ro., 1. Christ and the Apostles Plucking Corn.
Instructions: *Here how they go with the Lord picking the ears of grain in the fields.*

202 (p. 233).
Fol. 131ro., 2. Christ and the Apostles Reproached by the Pharisees.
Instructions: *Here is how they sit in the grain (?) to eat it and some Pharisees reproach them.*

203 (p. 233).
Fol. 131vo. Christ and the Apostles Eating Corn.
Instructions: *Here how they sit and eat, and the Lord with them.*
Here a sketch has been begun with two lightly-drawn trees.

204 (p. 245).
Fol. 140ro., 1. Christ Going to the House of Mary and Martha.
Instructions: *Here how He goes to the house of Mary Magdalen with His disciples.*

205 (p. 245).
Fol. 140ro., 2. Christ in the House of Mary and Martha.
Instructions: *Here how He is in the house of Mary and Martha with the disciples.*

206 (p. 245).
Fol. 140vo., 1. Christ in the House of Mary and Martha: Martha Complaining.
Instructions: *Here how Martha went to the Lord, that He should tell Mary to help.*

207 (p. 245).
Fol. 140vo., 2. Christ in the House of Mary and Martha: Martha Arranging the House.
Instructions: *Here how Martha arranges the house.*

208 (p. 245).
 Fol. 141ro., 1. Christ in the House of Mary and Martha:
 Mary Bringing Water.
 Instructions: *Here how she gives the Lord water for His hands.*

209 (p. 245).
 Fol. 141ro., 2. Christ in the House of Mary and Martha: at
 Table.
 Instructions: *Here how they are at table* (?)

210 (p. 291).
 Fol. 162vo. Christ Teaching.
 Instructions: *Here how He was . . . how He disputed with the
 Pharisees.*

211 (p. 291).
 Fol. 163ro. The Conspiracy Against Christ.
 Instructions: *Here how . . . together to . . to the Lord. . . .*

212 (p. 291).
 Fol. 163vo. The Conspiracy Against Christ: Questioners Sent.
 Instructions: *Here how they sent two disciples and four brigands.*

213 (p. 291).
 Fol. 164ro. The Conspiracy Against Christ: Christ Answering
 the Question About Tribute Money.
 Instructions: *Here how they are with the Lord and ask Him, and
 the Lord replied as was suitable to their bad intention.*

214 (p. 291).
 Fol. 164vo. The Conspiracy Against Christ: Questioners
 Returning.
 Instructions: *Here how they have returned and give the message.*

215 (p. 292).
 Fol. 165ro., 1. Christ Healing the Blind Man: the Approach.
 Instructions: *Here how the blind man rises to approach Jesus, who
 was coming with the crowd.*

216 (p. 292).
 Fol. 165ro., 2. Christ Healing the Blind Man: the Cure.
 Instructions: *Here how He healed* (?) *him.*

217 (p. 292).
 Fol. 165vo. Christ on the Way to Jericho.
 Instructions: *Here how He goes with the disciples toward Jericho.*

218 (p. 296).
Fol. 168ro., 1. Christ in Jericho: Zacchaeus in the Crowd.
Instructions: *Here how Jesus goes to Jericho with the disciples and in the crowd the small Zacchaeus. . . .*

219 (p. 296).
Fol. 168ro., 2. Christ in Jericho: Zacchaeus Climbing the Tree.
Instructions: *Here how he climbs the sycamore (?) to see Him.*

220 (p. 296).
Fol. 168vo., 1. Christ in Jericho: Zacchaeus Preparing the Dinner.
Instructions: *Here how he prepares for His dinner.*

221 (p. 296).
Fol. 168vo., 2. Christ in Jericho: Christ Dining with Zacchaeus.
Instructions: *Here how the Lord is at the table . . . in the midst, and Zacchaeus at His side.*

222 (p. 296).
Fol. 169ro. Christ Healing the Man Born Blind: the Meeting.
Instructions: *Here how He saw the blind man and made him come with Him.*

223 (p. 296).
Fol. 169vo., 1. Christ Healing the Man Born Blind: the Anointing.
Instructions: *Here how He bends down and makes some clay of His spittle and anoints his eyes.*

224 (p. 296).
Fol. 169vo., 2. Christ Healing the Man Born Blind: the Cure.
Instructions: *Here how he goes to the pool of Siloam to wash himself, and saw light.*

225 (p. 297).
Fol. 170ro. Christ Healing the Man Born Blind: the Man Defending Christ Against the Pharisees.
Instructions: *Here how he disputes with the Pharisees.*

226 (p. 297).
Fol. 170vo. Christ Preaching in the Temple.
Instructions: *Here how He preached in the temple in Jerusalem . . . many Pharisees.*

450

227 (p. 298).
Fol. 171ro. Christ Fleeing from the Temple.
Instructions: *Here how He fled from the temple and hid Himself behind a little wall.*

228 (p. 298).
Fol. 171vo. The Apostles Departing from the Temple.
Instructions: *Here how the disciples left the temple without the Lord Jesus.*

229 (p. 298).
Fol. 172ro. Christ in the Portico of the Temple.
Instructions: *Here how He was under the portico of the temple of Solomon . . . Pharisees and with His disciples.*

230 (p. 299).
Fol. 172vo. Christ and the Apostles Going Toward the Jordan.
Instructions: *Here how He (goes) toward the Jordan with the disciples.*

231 (p. 299).
Fol. 173ro. Christ and the Apostles Beyond the Jordan.
Instructions: *Here how He passed the Jordan with the disciples and. . . .*

232 (p. 299).
Fol. 173vo., 1. The Raising of Lazarus: Lazarus Dying.
Instructions: *Here how Lazarus lies in bed ill and Martha is near him and sent a message . . . servant.*

233 (p. 299).
Fol. 173vo., 2. The Raising of Lazarus: the Messenger Going to Christ.
Instructions: *Here how the messenger goes to Jesus.*

234 (p. 299).
Fol. 174ro., 1. The Raising of Lazarus: Christ Receiving the Messenger.
Instructions: *Here how the messenger has arrived and gives the message to the Lord Jesus.*

235 (p. 299).
Fol. 174ro., 2. The Raising of Lazarus: Christ on the way to Lazarus.
Instructions: *Here how the Lord goes with the disciples and the. . . .*

236 (p. 299).
> Fol. 174vo., 1. The Raising of Lazarus: Martha Going to Christ.
> Instructions: *Here how Martha goes before the Lord Jesus.*

237 (p. 299).
> Fol. 174vo., 2. The Raising of Lazarus: Martha at the Feet of Christ.
> Instructions: *Here how she throws herself at His feet.*

238 (p. 299).
> Fol. 175ro. The Raising of Lazarus: Martha Returning for Mary.
> Instructions: *How Martha goes for the Magdalen.*

239 (p. 300).
> Fol. 175vo., 1. The Raising of Lazarus: Mary and Martha Going to Christ.
> Instructions: *Here how Mary and Martha go in haste.*

240 (p. 300).
> Fol. 175vo., 2. The Raising of Lazarus: Mary and Martha at the Feet of Christ.
> Instructions: *Here how they throw themselves at the feet of the Lord.*

241 (p. 300).
> Fol. 176ro. The Raising of Lazarus: the Journey to the Tomb.
> Instructions: *Here how they go together, the Lord between Mary and (?) Martha and the disciples behind (?).*

242 (p. 300).
> Fol. 176vo. The Raising of Lazarus: the Arrival at the Tomb.
> Instructions: *Here how they arrive at the monument.*

243 (p. 300).
> Fol. 177ro. The Raising of Lazarus: Lazarus Raised.
> Instructions: *Here how Lazarus was discovered and resuscitated.*

244 (p. 301).
> Fol. 177vo. The Raising of Lazarus: the Return to the House (?).
> Instructions: *Here how . . . they go . . . many people behind. . . .*

245 (p. 301).
> Fol. 178ro. The Raising of Lazarus: Lazarus Visited by a Multitude.

Instructions: *Here how they are at home and a great crowd comes
to see Lazarus.*

246 (p. 301).
Fol. 178vo., 1. The Cursing of the Fig Tree: the Tree Seen.
Instructions: *Here how Jesus was going with the disciples and saw
the fig tree, fresh and leafy.*

247 (p. 301).
Fol. 178vo., 2. The Cursing of the Fig Tree: the Tree Cursed.
Instructions: *Here how He went for the figs and found none, and He
cursed it.*

248 (p. 301).
Fol. 179ro. The Cursing of the Fig Tree: the Tree Withered.
Instructions: *Here how the fig tree withered completely.*

249 (p. 302).
Fol. 179vo. Christ and the Adulteress: the Woman Brought.
Instructions: *Here how they bring her before the Lord in the temple.*

250 (p. 302).
Fol. 180ro., 1. Christ and the Adulteress: Christ Bowing
Down.
Instructions: *Here how the Lord Jesus bowed down.*

251 (p. 302).
Fol. 180ro., 2. Christ and the Adulteress: Christ Bowing Down
Again.
Instructions: *Here again He bowed.*

252 (p. 302).
Fol. 180vo. Christ and the Adulteress: Christ Dismissing the
Woman.
Instructions: *Here how He remained with the woman and sent her
away.*

253 (p. 302).
Fol. 181ro. The Chiefs and Pharisees Conspiring Against
Christ.
Instructions: *Here how the chiefs and Pharisees arrived in the
synagogue. . . .*

254 (p. 303).
Fol. 181vo. Unidentified Scene.
Instructions: *Here how He goes into the house with the mother and
the Magdalen. . . .*

255 (p. 304).

Fol. 182vo. Christ in the House of Simon.

Instructions: *Here how the supper in the house of Simon took place, with the disciples, and there was our Lady and Mary Magdalen and Martha. . . .*

256 (p. 306).

Fol. 184ro., 1. The Entry into Jerusalem: the Journey to Bethphage.

Instructions: *Here how the Lord goes with the disciples and the disciples. . . .*

257 (p. 306).

Fol. 184ro., 2. The Entry into Jerusalem: Disciples Sent for the Ass.

Instructions: *Here how they have arrived in a town (?) all together, and the Lord gives the charge to two (?) disciples.*

258 (p. 306).

Fol. 184vo., 1. The Entry into Jerusalem: Disciples Going to Fetch the Ass.

Instructions: *Here how the two disciples went for the ass.*

259 (p. 306).

Fol. 184vo., 2. The Entry into Jerusalem: Disciples Taking the Ass.

Instructions: *Here how they are in Jerusalem and take the ass and the colt.*

260 (p. 306).

Fol. 185ro., 1. The Entry into Jerusalem: Disciples Leading the Ass to Christ.

Instructions: *Here how they lead it to the Lord.*

261 (p. 306).

Fol. 185ro., 2. The Entry into Jerusalem: Christ Mounting the Ass.

Instructions: *Here how the Lord mounts the ass and the disciples surround Him.*

262 (p. 306).

Fol. 185vo., 1. The Entry into Jerusalem: Christ Mounting the Foal.

Instructions: *Here how He dismounts from the ass and mounts the foal.*

263 (p. 306).
Fol. 185vo., 2. The Entry into Jerusalem: People Spreading
Garments and Branches.
Instructions: *Here how He goes to Jerusalem and a great part of
the people comes to meet Him, putting their clothes under the ass and
branches of trees before the feet of the ass . . . how . . . adorns. . . .*

264 (p. 306).
Fol 186ro., 1. The Entry into Jerusalem: Entering the City.
Instructions: *Here how He enters Jerusalem with the whole crowd
and His disciples.*

265 (p. 306).
Fol. 186ro., 2. Christ Purging the Temple.
Instructions: *Here how He went to the temple and chased out those
who were selling and buying.*

266 (p. 306).
Fol. 186vo., 1. Christ Preaching in the Temple.
Instructions: *Here how He goes preaching publicly.*

267 (p. 306).
Fol. 186vo., 2. Christ Departing from Jerusalem.
Instructions: *Here how He leaves Jerusalem with the disciples . . .
and the Magdalen.*

268 (p. 307).
Fol. 187vo. Christ Returning to Bethany.
Instructions: *Here how they returned to Bethany, with the mother
and the Magdalen . . . disciples.*

269 (p. 308).
Fol. 188ro. Christ in the House of Mary and Martha.
Instructions: *Here how He had supper with the disciples in the
house, and the mother and the other women by themselves in another (?)
part of the house, and Mary Magdalen served the Lord at the supper.*

270 (p. 308).
Fol. 188vo. Christ and the Virgin Sitting Together in the
House of Mary and Martha.
Instructions: *Here how the Lord Jesus sits with the mother.*

271 (p. 308).
Fol. 189ro. Mary Magdalen at the Feet of Christ and the
Virgin.

Instructions: *Here how Mary Magdalen went to the feet of the Lord and the Lady.*

272 (p. 310).

Fol. 190vo., 1. The Last Supper: Peter and John Sent to Mt. Sion.

Instructions: *Here how the Lord was with His disciples, and Peter and John . . . the message about the supper.*

273 (p. 310).

Fol. 190vo., 2. The Last Supper: Peter and John Going to Mt. Sion.

Instructions: *Here how the two disciples go to Jerusalem.*

274 (p. 310).

Fol. 191ro., 1. The Last Supper: Peter and John Giving the Message.

Instructions: *Here how they are on Mt. Sion and give the message to the one (who had) the dining room, the friend of the Lord.*

275 (p. 310).

Fol. 191ro., 2. The Last Supper: Preparation.

Instructions: *Here how they prepare the supper and the Lord stays in one part of the house with some disciples . . . and John. . . .*

276 (p. 310).

Fol. 191vo. The Last Supper: Christ and the Apostles Entering.

Instructions: *Here how the supper is prepared and the Lord with the disciples from the part of the house . . . to the supper.*

277 (p. 311).

Fol. 192ro. The Last Supper: the Washing of the Hands.

Instructions: *Here how they are all in the dining room and wash their hands, and some of the seventy were staying to serve.*

278 (p. 311).

Fol. 192vo. The Last Supper: Christ and the Apostles at Table.

Instructions: *Here how they sit down on the floor, three on each side and our Lord in one corner, and two (?) others of the seventy were staying to serve at the supper.*

279 (p. 311).

Fol. 193ro. The Last Supper: Christ Dividing the Food.

Instructions: *Here how the lamb is served them and the lettuce (?)*

is placed before them, and the Lord breaks it into several parts and places it before the disciples.

280 (p. 313).
Fol. 194vo. The Last Supper: the Washing of the Feet.
Instructions: *Here how He rises from the table and makes them . . . to wash their feet, and the other disciples . . . the other things that were necessary.*

281 (p. 313).
Fol. 195ro. The Last Supper: the Supper Resumed.
Instructions: *Here how He returns to the supper with the disciples, and the other disciples of the seventy serve. . . .*

282 (p. 314).
Fol. 195vo. The Last Supper: Christ Giving the Sacraments.
Instructions: *Here how He communicates His apostles in His body and blood.*

283 (p. 315).
Fol. 196vo. The Last Supper: Judas Departing.
Instructions: *Here how Judas leaves the apostles and goes to the chiefs of the priests.*

284 (p. 315).
Fol. 197ro. Judas (?) Hurrying Away.
Instructions: *Here how he goes hurrying. . . .*

285 (p. 317).
Fol. 198ro. Christ Giving the Sermon on the Way to Gethsemane.
Instructions: *Here how the Lord goes to the garden with the disciples close (?) to Him.*

286 (p. 320).
Fol. 200vo., 1. Christ Concluding the Sermon on the Way to Gethsemane.
Instructions: *Here how He rises from the sermon, and the disciples with Him, and they go.*

287 (p. 320).
Fol. 200vo., 2. Christ in Gethsemane: Entering the Garden.
Instructions: *Here how He entered the garden with the disciples.*

288 (p. 320).
Fol. 201ro. Christ in Gethsemane: Going Apart to Pray.

Instructions: *Here how He left the apostles and went to one part of the garden to pray.*

289 (p. 322).
Fol. 202ro. Christ in Gethsemane: Returning to Apostles.
Instructions: *Here how He returned to the disciples . . . awakened them.*

290 (p. 323).
Fol. 203ro. Christ in Gethsemane: the Angel Appearing.
Instructions: *Here how He stays in prayer and sweats all blood, and the angel comes to Him.*

291 (p. 323).
Fol. 203vo. Christ in Gethsemane: the Angel Departing.
Instructions: *Here how He still prays and the angel leaves Him.*

292 (p. 325).
Fol. 204vo., 1. Christ in Gethsemane: Praying with the Apostles.
Instructions: *Here how the Lord prays with the disciples and reasons with them and has awakened* (?) *them.*

293 (p. 325).
Fol. 204vo., 2. Christ in Gethsemane: Betrayed by Judas.
Instructions: *Here how . . . Judas came to give the kiss to the Lord, and He . . . disciples.*

294 (p. 325).
Fol. 205ro. Christ in Gethsemane: the Arrest.
Instructions: *Here how all the people, armed and with lighted torches, came to take Him.*

295 (p. 325).
Fol. 205vo.
Instructions: lacking.

296 (p. 325).
Fol. 206ro.
Instructions: lacking.

297 (p. 326).
Fol. 206vo.
Instructions: lacking.

INDEX

INDEX

References to the illustrations that were executed (nos. *1–193*) appear in italic throughout the index to differentiate them from the illustrations planned but not executed.

Bridegroom, Bride, *see* Bernard, *passim*

Caiaphas, 303, 319, 325, 348
Calvary, 319, 332, 333
Cana, Marriage at, 48, 135, 140ff; nos. *121–132*
Canaan, Canaanite woman, 161, 219f, 292f; no. *190*
Capernaum, 150, 156
Cecilia, 1f, 133, 388; no. *1*
Cedron, 317
Ce(li)donius, 296
centuplication, 225ff, 234
centurion, 156, 337
charity, 112f, 172ff, 249ff, 281, 315; of Christ, 8, 314, 316f, 318, 321, 336
chastity, 112f
cheerfulness, 3
Christ, before Incarnation, 7ff, 11; Incarnation, 5, 15ff, 98, 307; conception, 19f, 22, 24, 29f; humanity, 19ff, 262, 263ff; as pilgrim, 21, 374, 381, 382; Nativity and Adoration of Shepherds, 32ff, 66; nos. *26–33;* Circumcision, 42ff, 66, 107, 243; nos. *34, 35;* weeping, 43f, 84f, 300, 306f; named Jesus, 43; Epiphany, 45ff; nos. *36–41;* receiving alms, 52, 79f, 106; stay at manger, 53ff; nos. *42–44;* Presentation, 56ff, 66; nos. *45–52;* journey to house of Elizabeth, 64f; nos. *53–55;* Flight into Egypt, 65ff; nos. *56–60;* life in Egypt, 69ff; nos. *61–63, 65, 66;* return from Egypt, 78ff; nos. *67–71;* meeting child John the Baptist, 81ff; no. *68;* life in Nazareth, 84f, 94ff; nos. *72–74, 85–89, 113;* journey to Jerusalem, 85ff; nos. *75, 83, 84;* Among Doctors, 89f; nos. *81, 82;* in hospice for poor, 92;

 journey to Baptism, 102ff; nos. *90–94;* Baptism, 47f, 107, 109, 114ff, 117, 130, 135, 182; nos. *95, 96;* in wilderness, 117, 275; nos. *97, 98, 102, 104, 106, 107;* Temptations, 121ff, 202f; nos. *99–101;* recognized by John the Baptist, 129f; nos. *108, 109;* first disciples, 131ff; nos. *110–112;* unidentified miracles, 123, 134, 155, 175, 192, 194, 220; nos. *151, 152, 158, 189;* opening book in synagogue, 135; no. *114;* calling disciples, 135ff; nos. *115–119, 133;* covering disciples at night, 139; no. *120;* Marriage at Cana (calling John), 48, 135, 140ff, 147, 150; nos. *125–132;* Sermon on Mount, 151ff; nos.

134–137; healing servant of centurion, 155ff, 161; nos. *138–140;* healing son of petty king, 155ff; nos. *141, 142;* healing paralytic, 159ff; nos. *143, 144;* healing Peter's mother-in-law, 161f; nos. *145, 146;* stilling storm, 162f; nos. *147, 148;* raising widow's son, 165f; nos. *149, 150;* healing Martha, 166f; no. *151;* healing daughter of prince, 166ff; no. *152;* converting Mary Magdalen, 169ff; anointed, 172; nos. *153, 155;* with disciples of John the Baptist, 175ff; nos. *157, 158;* mourning John the Baptist, 184f; no. *168;* on way to Galilee, 185, 186; no. *169;* meeting Samaritan woman, 123, 185ff, 191, 367; nos. *170–173, 175–177;* rejected at Nazareth, 191ff; nos. *178–180;* hiding in rock, 193; no. *180;* healing man with withered hand, 193f, 233; no. *181;* Multiplication of Loaves, 48, 123, 194ff; nos. *182, 183;* sending away apostles and praying on mount, 197ff, 285, 304; nos. *184–187;* walking on water, 213f; no. *188;* healing daughter of Canaanite woman, 161, 219f, 292f; no. *190;* rebuking Pharisees and repudiated by disciples, 223, 233; nos. *191, 192;* answering Peter, 225; no. *193;* questioning apostles, 228; no. 194; giving keys to Peter, 228; no. 195; Transfiguration, 228; nos. 196, 197; purging temple first time, 229; healing paralytic at sheep pool, 161, 229f; nos. 198–200; apostles plucking corn, 233; nos. 201–203; in house of Mary and Martha, 245; nos. 204–209; charge to Peter, 285; parables, 290ff; no. 210; tribute money, 291; nos. 211–214; healing blind men, 292, 295; nos. 215, 216; foretelling Passion, 292; with Zacchaeus, 296; nos. 217–221; healing man born blind, 296f; nos. 222–225; stoned and departing from temple, 297f; nos. 226–231; raising Lazarus, 299ff, 302, 306; nos. 234–245; cursing fig tree, 301f; nos. 246–248; with adulteress, 301, 302; nos. 249–252; conspired against, 302f; no. 253; flight to Ephraim, 302f; return to Bethany, 303f;

 Passion, 57, 228, 292, 297f, 301, 304, 305, 307, 317ff, 348, 351, 369f, 381; Entry into Jerusalem, 301, 304, 305ff; nos. 256–264; supper in house of Simon, 304f; no. 255; preaching and purging

fasting, 117, 121
Flagellation, 318, 328f
Flight into Egypt, 65ff; nos. *56–60*
food and health, 337f, 239ff
Francis, 2, 3, 36, 241, 312, 320; no. *2*

Gabriel, 9, 15f, 20; nos. *11–13*
gate of St. Germanus, 332
Gloria, 41
gluttony, 122, 233, 236ff
God the Father, 5ff, 15ff, 38, 60, 63, 85f,
 114, 185, 228, 303, 308f, 314, 316, 321ff,
 327, 334ff, 347, 370, 375, 380, 382, 384;
 nos. *3, 11, 14*
grace, 10ff, 23, 109ff, 161
gratitude, 297
Gregory, 45, 74, 201, 368, 381

Habakkuk, 124
Heliopolis, 68
Hell, 350, 360
Herod Antipas, imprisoning John, 174;
 Feast, 177ff; nos. *160–164, 166, 167;* trib-
 ute money, 291; Christ before, 319, 328
Herod the Great, 65, 89
Herodias, 182; nos. *162, 167*
Historia scholastica, 140, 329, 331
Holy Spirit, 23, 29, 33, 57, 101, 106, 112f,
 118, 130, 209, 217ff, 227, 228, 239, 368,
 380, 382, 384; nos. *10, 96*
holy fathers, 350f, 365f, 374, 375, 376,
 378f, 382, 384
Holy Women, family of Virgin Mary, 84f,
 140, 303, 304, 306, 307, 337, 338f, 347;
 buying and preparing spices, 349; going
 to tomb, 359, 360; at tomb, 360f; ap-
 pearance of Christ to, 363f; *see also* Mary
 Jacobi; Mary Magdalen; Mary Salome
honors, 201f
humility (and pride), humiliation, 17, 19,
 30, 37f, 52f, 54, 111ff, 196, 216, 220,
 339, 375; of Christ, 35, 52f, 68, 69f, 71,
 92, 96ff, 106ff, 143, 145, 147, 157, 162,
 167, 169f, 190f, 296, 314, 320f, 364, 367,
 372; of Virgin Mary, 23, 54, 111f, 339

idols, falling, 68
Incarnation, 5, 15ff, 98, 307; Feast, 20f,
 381
Israelites crossing desert, 68, 82, 380

James Major, 136; no. *116*

James Minor, 364, 373
Jericho, 292, 295, 296
Jerome, 12ff, 136, 140, 364, 373
Jerusalem, 22, 31, 56, 64, 85f, 89, 94, 104,
 122, 159, 229, 292, 296, 299, 301, 304,
 305f, 308f, 325, 373, 376, 380; supernal,
 381
Jesus, *see* Christ; name of, 43, 243, 388f
Joachim, no. *4*
John the Baptist, recognizing Christ in
 womb, 23, 182; birth, 24f; no. *18;* cared
 for by Virgin Mary, 25; circumcision
 and naming, 25; no. *19;* visited after
 Presentation, 64; no. *54;* child in desert,
 82ff, 182; no. *68;* baptizing in desert, 82,
 104, 106f, 114, 299; nos. *95, 96;* pre-
 cursor, 97; recognizing Christ, 129ff;
 nos. *108, 109;* imprisonment, 135, 174;
 sending disciples to Christ, 174ff; nos.
 156, 159; death, 177, 182ff; no. *165;*
 praise of, 182, 241
John the Evangelist, as boy with Christ,
 84f; wedding, 136, 140, 143; nos. *126,
 131, 132;* called, 136, 147, 150; nos. *116,
 131, 133;* in events of Passion, 310ff, 326
 et seq.; nos. *272–275;* death, 373
Jordan, 82, 84, 104, 106, 114, 129f, 136,
 299
Joseph of Arimathea, 340ff, 345, 364, 373
Joseph the carpenter, marriage, 14; no. *10;*
 journey to house of Elizabeth and Visita-
 tion, 21ff; nos. *15, 16, 20;* in house of
 Elizabeth, 24; doubting Virgin Mary,
 26ff; nos. *21–24;* first dream, 29; no. *23;*
 journey to Bethlehem, 31; no. *25;* as car-
 penter, 32, 76, 100f; no. *64;* at Nativity,
 32, 34f; nos. *26–31, 33, 35;* at Epiphany,
 nos. *37–39, 41;* stay at manger, 54f; nos.
 42–44; at Presentation, 56ff; nos. *45–52;*
 visiting Elizabeth, 64f; nos. *53–55;* second
 dream, 65; no. *56;* journey to and life in
 Egypt, 65ff, nos. *57–61, 64–71;* third
 dream, 77f; no. *65;* fourth dream, 84;
 no. *70;* life in Nazareth, 84; nos. *72–74,
 85, 87–89, 113,* journey to Jerusalem, 85ff;
 nos. *75–84;* at departure of Christ, 103;
 nos. *90–92;* as father of Christ, 97, 98,
 115, 133; sending food to Christ, 125;
 nos. *103, 105.*
Judas, 304, 312, 313, 314, 315, 317, 322,
 325; nos. *283, 284, 293*
judgment day, 371, 378
justice, personified, 6ff

462